Poet & Painter

Poet & Painter

LETTERS BETWEEN

GORDON BOTTOMLEY

AND

PAUL NASH

1910–1946

with an introduction

by

Dr Andrew Causey

REDCLIFFE
Bristol

First published in 1955 by Oxford University Press.

Republished in 1990, with a new introduction, by
Redcliffe Press Ltd., 49 Park Street, Bristol 1

British Library Cataloguing in Publication Data
Bottomley, Gordon *1874-1948*
 Poet and painter: letters by Gordon Bottomley and Paul
 Nash.-2nd. ed.
 1. English paintings. Nash, Paul, 1889-1946 2. Poetry in
 English. Bottomley, Gordon, 1874-1948
 I. Title II. Nash, Paul *1889-1946* III. Causey, Andrew
 759.2

ISBN 1 872971 15 6

Printed by The Longdunn Press Ltd, Bristol

PREFACE
TO
1955 EDITION

ALL the letters in this correspondence that have been found are represented here, but the editors regret that they cannot all be printed in full. A few cuts have been made in deference to people living or lately dead, and many of the less important letters have been summarized or printed with large omissions. This was inevitable if the book was to be published now at a reasonable price. In many cases the reader is spared detail, sometimes tiresome and of little general interest; but it must be acknowledged that something is lost which at some future time may well be restored.

The texts printed are transcripts of the originals, retaining Nash's peculiarities of punctuation and spelling except that such recurrent mistakes as *Rothenstien, freind, concieve, concieted* have been silently corrected. A punctuation mark has occasionally been inserted in square brackets where it is felt that the meaning is not clear at first reading. All dates, however written in the originals, have been altered to the standard sequence of day, month and year. In undated letters and postcards the editors have inserted in square brackets the postmark date or Bottomley's pencilled note (if certain) or their own conjectures. Superscriptions and subscriptions have been omitted when in the conventional forms but retained when more characteristic. Omission of a whole paragraph is shown by a line of dots: omission of a phrase, sentence, or sentences within a paragraph by three dots. When the writer of the letter himself makes use of three dots these, to discriminate, now become five.

The question of annotation is always a difficulty. Too much may sometimes have been provided for some tastes, but the editors had in mind the general rather than the instructed reader. The illustrations explain themselves. The reproductions of Nash's work have been chosen exclusively for their relation to the text. Some of these early pictures have not before been reproduced and they are of great interest as representing the first manifestations of a visionary quality that found mature and personal expression later.

The editors wish to acknowledge with gratitude the help received in various ways from Mrs. Paul Nash, Miss Barbara Nash, Miss Margot Eates, Mr John Nash, R.A., Mrs. Anthony Bertram, the London staff of the Oxford University Press, Miss S. M. Gifford, the staff of the Alderman Memorial Library, University of Virginia, and—a large debt—the staff of the Reference Library, Newcastle upon Tyne.

CONTENTS

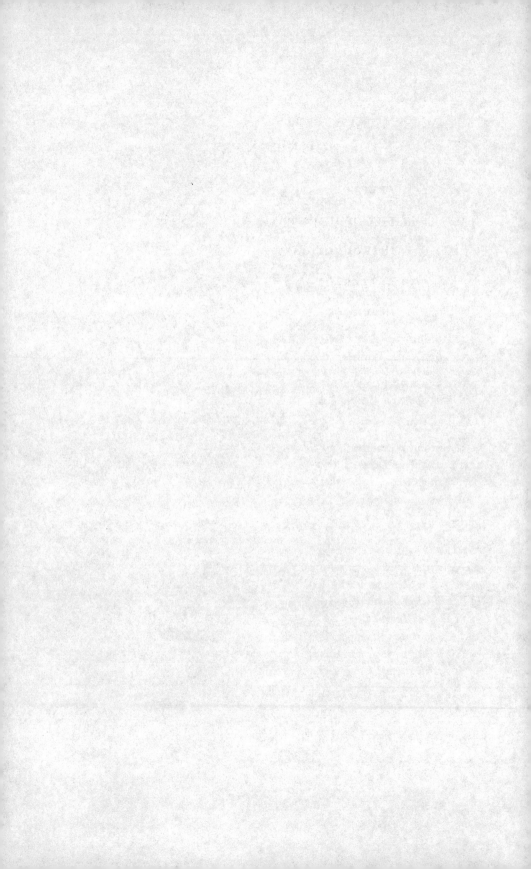

ILLUSTRATIONS

INTRODUCTION

Poet and Painter is an exchange of letters between Gordon Bottomley, a poet with an enthusiasm for the visual arts, and Paul Nash, a painter who wanted at the start of his career to be a poet as well. Bottomley was a discerning collector of paintings and drawings, was friendly with artists and commissioned illustrations for some of his own work. Nash saw the imaginative values regarded as typical of poetry as appropriate to painting also, and in later years preferred to have his painting described as poetic rather than Surrealist.

The correspondence, dating between 1910 and Nash's death in 1946 (Bottomley died two years later in 1948), coincides with the maturing of the modern movement. As nineteenth-century social and intellectual edifices crumbled, developments in the arts were shaped by doubts and uncertainties about the future, by the novelty and complexity of modern urban society, and by a freshly self-critical focus on the part of artists of all kinds analysing the nature and function of their activity.

In 1910, when the correspondence began, Bottomley was 36, an established and, within confined literary circles, admired poet and verse dramatist influenced by Yeats and the Celtic Twilight. Nash was 20 and a student at the Slade School of Art. The age difference was important: at the onset of modernism Bottomley, who reached intellectual maturity in the 1890s, was committed to themes and styles of expression that soon began to look old-fashioned. Nash's commitment pointed at first in the same direction as Bottomley's and the strength of his mentor's appeal ensured that his own path for the time being would also be within existing traditions. But Nash was ambitious and restless and gradually began to look around him to expand his field of expression.

Poet and Painter illuminates the ambivalence of the English response to modernism and bears witness to the staying power of Pre-Raphaelitism. When it was first published in 1955 modernism was accepted less critically than it is now. The questions the book raises are the same: in times of rapid change how essential is it to confront new forms and ideas, what are the penalties of isolation and how much does an individual's age and degree of personal development influence choices at radical artistic turning points? But today's answers may be different. The modern movement stood for the exclusiveness of different forms of artistic expression, while part of the appeal of *Poet and Painter* lies in the freedom with which the writers cross the boundaries between the visual arts, theatre and poetry. Now that intensity of expression, however achieved, is

seen as relatively more significant than the technical problems that preoccupied modernism, some of Bottomley's arguments, in favour of emotional richness and opposing the need for technical progress, seem more persuasive. Nash is seen as an artist whose individuality always grew from the contrary forces at work on him: the pull of modernism in one direction and in the counter attraction of traditional themes inherited from an earlier artistic world which he never wanted to cast off completely.

Bottomley, born in 1874, was the son of an accountant from Keighley in Yorkshire. Though he wanted to be a doctor, Bottomley was placed by his father, of whom he spoke admiringly but with a certain awe, in a bank, a position from which he escaped only on account of ill health. He had a weakness in one lung which caused periodic haemorrhages, and left him for much of his life a semi-invalid. His mother was Scottish by birth, and more approachable to their only child than her somewhat stern, distinctively Victorian, husband. Bottomley's maternal grandmother was an enthusiastic theatregoer and introduced him to drama.

Apart from his particular ailment Bottomley was robust, very different from others of his generation like Beardsley, in whom physical disability led to general neurasthenia. Nor was Bottomley a decadent: he was less interested in Aestheticism, *The Savoy* and *The Yellow Book*, than in the Arts and Crafts movement, William Morris and the style of illustration that came out of the Kelmscott Chaucer; he was influenced by the Celtic Twilight of Yeats and Fiona Macleod, the later inheritance of Pre-Raphaelitism, especially Rossetti, and the tradition of the Ancients going back to Blake. He started to publish in 1896, and though his books came out in very small editions, he had an established following by the time he knew Nash.

Bottomley built up a remarkable collection of some six hundred paintings, drawings and prints which he bequeathed to Carlisle Art Gallery. It consists mainly of British works, from the Blake followers, Samuel Palmer and Edward Calvert, to a group of Rossettis and other Pre-Raphaelites, including Madox Brown, Arthur Hughes and Burne-Jones. Contemporary work includes an interesting group of paintings by Bottomley's friend Charles Ricketts, a drawing given in 1940 by Stanley Spencer, and a collection of Nashs acquired by gift or in exchange for books, but extending only to 1920. Bottomley's pictures are often small and are characteristic of a man who bought without thought of fashion or display, in order to share personal tastes with friends rather than to show off possessions. It was not a modern collection.

Bottomley started buying in the 90s despite his immobility and with the improvement of his health in the 30s continued collecting until late in life. In his pursuit of Pre-Raphaelitism he visited May Morris several times and was a buyer when some of the contents of her father's house,

Kelmscott Manor, were sold in 1939 after May's death. Prices were not high as the success of the modern movement made Bottomley's purchases deeply unfashionable. Postwar scepticism meant that Pre-Raphaelite medievalising, the anxieties of frustrated love and the harrowing penalties for forbidden relationships were either parodied or ignored. The doggedness with which Bottomley pursued his ambitions is impressive; he was remarkably tenacious at a time of great change.

Bottomley's isolation was self-imposed. Living most of his adult life at Silverdale on the southern tip of the Lake District in a hilltop home surrounded by woods, with higher hills behind and the sweep of Morecambe Bay in front, he was cloistered in a remote, unspoiled landscape. The choice was his own, made in 1892 when the gravity of his condition became clear. As a near-invalid living remotely he was physically unable to take part in the meetings and debates which helped disseminate modern ideas, but for a Yorkshireman with Scottish connections it was a rational decision, an affirmation of his sense of being a northerner and belonging to a harsher and what he called "more angular" culture than that of the south. The result was limited professional as well as social contact. His first meetings with Nash, in November 1912 and the winter of 1913-14, took place at the home of the poet Robert Trevelyan near Dorking where he sometimes stayed when in the south, in an area where he could have lived if he had wanted to be within reach of London.

Born in 1889, Nash was the son of a barrister and his family had no connections with the arts. A Londoner by birth, when he first encountered Bottomley in 1910 he was living in the family home at Iver Heath in Buckinghamshire. Nash was not an ambitious traveller and as a landscapist he was interested in the familiar terrains of southern England. Coming to maturity as the Celtic fashion declined, he visited Bottomley in the Lake District only once, and the more remote fringes of Britain never at all. Nash's training up to that point, at Chelsea Polytechnic and the London County Council's Bolt Court School off Fleet Street, had been directed towards graphic art and his ambitions were focused on illustration. He had had some success as a designer of bookplates in a medievalising late Pre-Raphaelite style and his interests broadly coincided with Bottomley's.

Nash's first contact with Bottomley came at an unsettled moment in his life, two months after the death, in February 1910, of his mother, who had suffered from depressions and had lived away from the family in nursing homes. It was a fact Nash did not like to speak of and never referred to in these letters. He was fond of his father and in practical ways they were close, but in matters to do with art and the emotions they shared little. Nash's friendships at this time with older men—especially Bottomley, and the painter William Rothenstein—are reflections partly of the

absence of guidance within his family, although partly also of the fact that Nash was never a straightforward student (the early letters in this book record the vicissitudes of his short career at the Slade), and liked to learn by himself, taking advice from established authorities.

The alliance between poetry and painting in England has been both fruitful and uneasy. Nash lived much in his imagination, composing verses, envisioning passionate dramas in the night sky and scenes of elemental conflict which he sometimes tried to draw. He was ambitious and determined, immature but inspired. Nash's exemplar was Rossetti, though the complexities of Rossetti's art and poetry were only poorly understood. Rossetti is in some ways the hero of *Poet and Painter*, the object of a shared admiration at the beginning of the book and again at the end—though Blake, Calvert and Palmer as well as modern illustrators like Ricketts and Guthrie also interested both correspondents. Nash's unsettled frame of mind at the time he encountered Bottomley found a mirror in the way spiritual and human emotions interweave in Rossetti's dual expression. Bottomley, the older by 15 years, had personal experience of the 90s, when the collaboration of poet and illustrator was a central form of artistic expression; he was thus able to authenticate and approve Nash's direction.

The friendship was professional rather than domestic; wives played little part and neither couple had children. The relationship did not depend on personal contact and the correspondence reveals few meetings: the two early encounters at the Trevelyans, a visit of Nash and his fiancée, Margaret Odeh, to Silverdale in 1914, a brief meeting in London in 1917, a weekend visit of the Bottomleys to the Nashs at Dymchurch in 1921, and an encounter when both were staying with Percy Withers at Souldern near Banbury in 1922. The letters show several later occasions when Bottomley travelled south but opportunities to meet were passed by, and later on Bottomley was even uncertain of Nash's address.

After the initial period of mutual discovery when each endorsed the other uncritically, slight tensions began to appear in 1912, as the younger Nash observed new developments while the older poet defended well established positions. A slight testiness in the correspondence, followed by lengthening gaps from the mid-twenties, says as much as the letters themselves. But it is a generous dialogue, founded on mutual respect and affection established in the early years. By the 1940s, with the first triumphs of international modernism past and wartime isolation reviving interest in more local traditions, the two were able to extend their common interests in Blake, Rossetti and William Morris, and to look back from the vantage point of maturity and review the early years with a measure of dispassion.

Contact was first made when Nash borrowed a copy of Bottomley's 1902 play *The Crier by Night* from a neighbour at Iver Heath, a Mrs

Goldsworthy. Nash made two ink designs in the book, drew a border round the title page and stuck in a full page illustration, *Blanid at the Door* (plate 1) returning the book apologetically to its owner. Mrs Goldsworthy, a connection of the Craven family, who owned the bank in which Bottomley had briefly worked, passed the illustrations on to the author who wrote encouragingly to the artist a letter which is now unfortunately one of the few that is lost. Bottomley said then, and confirmed later, that Nash's interpretation fitted precisely with his own meaning.

The Crier by Night was based on a local legend of a spirit inhabiting Lake Windermere. The story told how an Irish bondwoman Blanid, enslaved to the earth through love of her master Hialti and jealous of his wife Thorgerd, unable to satisfy her love for Hialti, calls on the powerful earth spirit the Crier to inveigle Hialti into a bog at night where he drowns, followed by Blanid.

Nash wrote in his autobiography *Outline*: "I had lately been reading Yeats's early poems, *The Wind among the Reeds*, which had made a strong appeal to me. When I began to read *The Crier* I soon realised by whom it was inspired. But its voice was distinctive, a harsher, even stranger voice and more compelling. Throughout the ghostly drama a dark mood prevailed, impregnating the scene, and giving its puppet characters a superreal life. This mood, the nocturnal scene, the mysterious, horrific nature of the Crier and the extravagant poetic language seemed to accord with my own imaginative experience—my familiar world of darkness . . . and the giantesses of the night sky."

Nash soon embarked on a design for a second of Bottomley's verse dramas, *The Riding to Lithend*, based on the Icelandic Njal's saga: its hero Gunnar will not betray his native land when it is under attack, but, surrounded by his enemies, he needs a lock of hair from his wife Hallgerd to renew his bowstring, which she refuses. Bottomley's short one-act dramas involve extremes of emotion and polarities, love turning to hate, loyalty and betrayal, masculine strength and feminine beauty. They are too short to allow for subtleties of characterisation and their message is easily understood. They have a certain modernity in the clipped language, but beside contemporary works that look for similar depths of feeling in everyday life, the world of distant myth they portray seems less relevant.

Though, before 1914, Nash was scarcely more drawn to modern forms of expression than was Bottomley, he was not content to follow his friend's urging to give sole priority to the elemental figure compositions in which their tastes coincided. When the veteran Academician William Richmond counselled Nash in 1912 to push ahead with landscape Bottomley urged him then, as later, to concentrate rather on his figure work, arguing later (1917) that "man's deepest knowledge is of man" and that treatment of the human figure is central to art in a way landscape

could not be. Bottomley never fully appreciated Nash's mysterious landscape drawings with their unseen presences and human implications which have little to do with the straight topography both would have deplored. Landscape played a minor part in the visual arts for Bottomley's generation, as background to the kind of human conflicts Nash drew and Bottomley wrote about. While Spencer among Nash's contemporaries used landscape to expand figure designs, Nash was unique in drawing landscapes with human connotations but without human figures.

When Nash announced a plan to study in Paris, Bottomley argued strongly against this, advocating on the first of several occasions the cause of Englishness. Bottomley disliked modern French painting, particularly the nude, which he felt represented in extreme form a limited art of the senses that lacked grandeur, mystery and spiritual value. Like many who have pleaded for Englishness, Bottomley did not analyse deeply what he meant by it, implicitly acknowledging the position of the Italian primitives and the Quattrocento within the English tradition while excluding France. It had been common among Victorians who resisted industrialism and the modern world to look, as the Pre-Raphaelites did, to the purity of the early Italian and Flemish schools for spiritual uplift, and Bottomley was not essentially different. But as the idea of the modern entered England mainly through French art, a problem arose when Nash began to look to Paris. Though Nash soon abandoned his plan to study there and his art was untouched by France before the war, the grounds were already laid for the sometimes quite fierce debates the two were to engage in in the 20s.

The war brought an end to the radical modernity of Vorticism and also to the more old-fashioned intensity of emotion expressed in the lingering prewar fascination for Pre-Raphaelitism and the fin-de-siècle. Nash, who had been at the front and periodically in London, understood the new taste, which emerged in painting in the kind of modern French technique allied to conservative subject matter typical of Bloomsbury painting. Bottomley, detached from events, was slower to see the extent of the change and unwilling to acknowledge it. In December 1919 he delivered a swingeing attack on the modern trend, defending what he regarded as the true Englishness of medieval church painters, Hogarth and Rowlandson and lamenting the way foreigners constantly intervened and degraded English art.

As England searched for cultural identity after the trauma of the war, anti-internationalism was common, and a cultural ambience emerged— albeit not without resistance—that was enclosed and self-protective. Folk art and national traditions were brought to the fore as if to recapture innocence in isolation from foreign influences. When Bottomley wrote to Nash in 1922 after receiving a parcel of Nash's drawings, "you've done it

again, and I am delighted all over. You go back to the spirit of a primitive life in an unspoiled land in the very way I do myself, and I feel at one with you in sympathy about everything you have done", it was this innocence he believed he recognised in his friend and shared.

Nash's position was more ambivalent than Bottomley's enthusiastic endorsement suggests. He was increasingly interested in vernacular traditions, took up wood engraving and illustrated chapbooks and rhyme sheets; and his favoured subject, landscape, was increasingly the one through which English traditions from Romanticism and beyond were revived. At the same time, however, he staunchly defended formalist pro-French positions. He had read enough of Roger Fry and Clive Bell to muster arguments for the primacy of technique over subject, and his 20s' landscapes, which do not always exhibit the intensity or emotional force of the early works he and Bottomley had enjoyed together, show how the new theoretical precepts were carried over into his painting.

Bottomley's integrity, his refusal to be swayed by fashions, is attractive. The more Nash's art in the 20s is recognised as having lost something of its early individuality, the more significant Bottomley's repeated challenges to Nash's modernist positions become. Bottomley's dogmatic rejection of Paris demonstrates the limitations of his taste, but Nash's uncritical enthusiasm for contemporary French developments was not a logical development from his earlier work. Bottomley was to some extent right in sensing that Nash was denying his real self, though Nash's predicament was no different from that of many British artists trying to do justice to modern ideas in a difficult, conservative decade. The taste of both painter and poet was for mystery and strangeness subjectively interpreted, and neither was entirely at ease with the cool and objective, modern but comprehensible, art that the 20s preferred.

Alongside the debate about French emphasis on form, the postwar letters contain parallel arguments over the standing of the increasingly rejected Pre-Raphaelite tradition. In 1922 Bottomley met Stanley Spencer, whom he saw as the true torch-bearer of the English and Pre-Raphaelite tradition. Nash responded cautiously: before the war he remembered regarding Spencer as the "real thing", now he was less sure. Contemporary taste might not link the Spencer of the twenties so directly with Pre-Raphaelitism as Bottomley did, but it honours Spencer's ferocious individuality and refusal to be swayed by modern French taste.

Before the war Nash and Spencer had belonged, with Mark Gertler, Isaac Rosenberg and others, to the loosely defined Edward Marsh circle of artists, for whom intensity of expression was more important than being stylistically up to date. The rich and intense art of the Marsh group had a distinct place in English taste before 1914, but it did not match the postwar mood, the circle broke up and Spencer, arguably, was the only painter to pursue the ideas it had stood for. Marsh's most successful

contribution to the arts was the Georgian Poetry series, started in 1911. The peak of Bottomley's public recognition came with Marsh's singling out his verse drama *King Lear's Wife* for publication as a centrepiece of the 1915 volume, and the level of success of Georgian Poetry became something of a measure of Bottomley's reputation. When Marsh terminated the series in 1922, realising that its moment was past, there was an implication for Bottomley. In 1925 he published his collection *Poems of Thirty Years* and wrote to Nash: "I repose upon the peaks of middle age and have laid my never-too-laborious pen aside for good. Somebody even called me an Edwardian the other day: which of course put the lid on it."

In 1927, when the international versus English debate within the correspondence had almost run its course and the friendship was under some strain, Bottomley turned to recent French art and wrote that he liked painters who painted like gentlemen (Manet, Gauguin) and those who painted like peasants (Millet, Van Gogh) because gentlemen and peasants lived "real lives". But he rejected the art of Monet, Cézanne, Signac and Matisse because they painted like bourgeois, "and bourgeois are always a little dull". Bottomley judged artists, often quite superficially, by their subject matter, and his occasional opinions of individual modern French artists should not be taken too seriously. But the idea he seems to be searching for, that there is a kind of painting, perhaps landscape or still life, that is an object of pleasure rather than a sign of work or spiritual commitment, is important. He really feared that in the era of "significant form" art would descend to triviality, to displays of stylishness and virtuosity, and he dreaded lack of seriousness, with art relegated to the role of a plaything for the well off. His distinctions between different French artists may suggest that he felt figure painting was serious and other subjects not. Certainly, his regular advice to Nash (from 1912 to 1941) was to pay attention to the figure, coupled with expression of his regret that Richmond seduced Nash into landscape. As in the correspondence Nash had effectively made himself champion of the French artists Bottomley was talking about, it is hard not to infer that Nash himself was part of Bottomley's target. Bottomley was sad to see a close friend whom he also regarded as a distinguished artist pursuing phantom goals, and 1927 marks the low point of the relationship before it temporarily ceased five years later.

In the same letter in 1927 Bottomley made other remarks that look astonishingly fresh today. Distinguishing art from science, he rejected the assumption of need for progress in art, claiming that modern art was not a revolution in vision that invalidated what went before, but created the need to look at the past in new ways. "Art has always been complete since it first began . . .", he wrote.

The friendship held together in the early 20s largely because Nash was

involved with theatre design and worked on several of Bottomley's dramas, though none of his designs for them was used in production. Already in 1914 Nash had started to rework *The Crier by Night* in a design (plate VIII) which is more technically accomplished than the earlier one—although some of the emotional force is lost because the faces, so dramatic before, are not shown. "The crier", Bottomley observed, "is nearly as good [as the 1910 version], but he is mortal and not equal in conception to the terrifying little immortal you evolved at that first shot long ago."

Nash was led further into theatre work by an invitation to design the sets and costumes for a dance and mime drama by J.M. Barrie *The Truth about the Russian Dancers*, produced at the Coliseum in 1920. He was then asked to contribute to the International Theatre Exhibition, which opened in Amsterdam in 1922 and went on to the Victoria and Albert Museum and an international tour. For this Nash made stage models for two Bottomley plays, *King Lear's Wife* (see plate XI) and *Gruach* (see plate XII). The former, written in 1913 and first performed in 1916, was an imaginary prelude to Shakespear's play, in which Lear seduces his wife's maidservant while the Queen is dying. *Gruach*, written in 1918 and first produced in 1923, is an imagined prelude to *Macbeth*, in which the young protagonist loses his way while on a mission for the King of Scotland and arrives at a thane's castle on the eve of his daughter Gruach's wedding. The play ends with Macbeth riding off in the night with Gruach, the future Lady Macbeth. Gordon Craig, who opened the exhibition and also reviewed it for *The Times* found Nash's model for *King Lear's Wife* the best in this major international show.

The correspondence, which had been diminishing since 1925, ceased in February 1932. It was almost six years before Nash reopened it with a letter which, like Bottomley's first in 1910, is lost. The decade from 1929 was a time of great achievement for Nash in which he came to terms with modernism in a more profound way than he had before. Whereas the 20s in England had seen enormous advances in modernist literature but had been a fallow period for advanced art, in the 30s the situation was largely reversed. As the decade ended there was a marked change, with Nash—and many others—casting a more critical eye on continental developments and being readier to revalue English traditions. Well before the war articles started appearing on artists like Blake and Palmer whom Nash and Bottomley had enjoyed together. In 1938, also, Nash was working on his autobiography, published in 1949 as *Outline*, and casting his mind back to his early years.

It is not surprising, therefore, that it was Nash who revived the correspondence. He started by recalling advice his old mentor had given in 1912. Bottomley replied: "You tell me to take heart because you are now on the short way home (to the kingdom in which we first met); so I

feel really entitled to remind you I once wrote to you that the best place for an artist to work is in his own parish, but that it is not enough for him until he has gone right round the world and entered it from the other side! Was I truly a prophet?" Nash had moved so far since the early days that it is difficult to see a revived interest in Rossetti and others as a return to base. Certainly Nash was more interested in English art than he had been, but his involvement was wider than Bottomley's, including watercolourists like Cotman and Turner, and there is nothing Rossetti-like about his work—though he engaged enthusiastically in discussing him.

In 1941 Bottomley outlined a view which saw the Pre-Raphaelites as a "reawakening of an essentially British art, lost sight of ever since the Puritans won the Civil War and checked aristocratic patronage". Bottomley repeated his remarks of 1919 on the destructive influence of France and praised late medieval art, manuscript illumination, stained glass, Gothic carving, the Wilton Diptych and Elizabethan miniatures. His endorsement of aristocratic patronage is misplaced as he omits mention of the baroque which he disliked: in a sense his love of pure, linear art was in itself puritanical. In effect he was supporting a not uncommon view that the integrity of English art was contaminated by later forms of classicism, and that the Pre-Raphaelites, looking back to early Italian painting had re-established the true pedigree. Though much of this returns to Bottomley's comments of 1919, the letter ends differently, with the idea that the decline in the Pre-Raphaelites' later work occurred because "the Industrial Age got hold of them, and bribed them to standardise their success". If the early Italians, he implied, were successful for longer, it was because they had not had to combat the consequences of the mechanical age and the demands of an increasing number of uncultured patrons. Bottomley saw himself as part of a pre-industrial era of creative individuals who were not responsible to a mass market, and whose culture was not complicated by problems of commodity value and exchange.

Nash was not interested in the history of art as such and did not try to rationalise what the "English tradition" might mean. He was far too committed to modernism, and thus effectively to French painting, to sympathise with his friend's views on that. By engaging with modernism Nash had created a complex art with a wide range of ideas and allusions in such a way that when he "returned to his parish" he did so as a different person with broader perceptions and viewpoints than Bottomley's. Nash did, nonetheless, share Bottomley's Morrisian sense of wanting to recapture pre-industrial values. Like Bottomley he was not a city dweller by choice; in his writing there is nostalgia for a lost world which seemed from the modern perspective simpler and more humane, and even if he had not worked out a concept of Englishness, there is a sense that the values he aspired to were pre-Victorian. There was a patrician element in

both men's characters, a sense of being cultural possessors to the exclusion of the wider population.

Nash was preoccupied in his late art with ideas about the seasons and nature cycles, myths connected with gods and the sun and moon, stimulated partly by Frazer's *The Golden Bough*. Though his painting was discussed with other correspondents, new work is hardly mentioned in letters to Bottomley which are not reports on current activities, as they had been at the beginning, but are largely concerned with shared interests from the past. They are conversations between friends completely at ease with one another, reading like the spoken word, as if the two men, who had not in fact met for 20 years or more, were in the same room.

ANDREW CAUSEY
OCTOBER 1990

NOTE

The footnotes to the letters are as published in the original (1955) edition of this book.

The following books are referred to frequently in the Notes in abbreviated form:

A Stage for Poetry: My Purposes with my Plays by Gordon Bottomley. Printed privately for the Author by Titus Wilson & Son, Kendal, 1948.

Poems and Plays by Gordon Bottomley. Chosen and with an Introduction by Claude Colleer Abbott. The Bodley Head, 1953.

Outline: An Autobiography and Other Writings by Paul Nash. Faber & Faber, 1949.

Paul Nash. Edited by Margot Eates. Lund Humphries, 1948.

1

PN to GB

Dear Sir

I thought I would like to write to you and was wondering it over when Mrs Goldsworthy suggested it to me herself so I am trying to write and thank you. I find it no easy thing to do. Your letter left me gasping! I said oob, oob, oob, inwardly after each sentence like the fish in the Wallypug of Why[1]

First I think it is most awfully good of you to trouble to write all this even if you think it What you have said is going to help me a long way. It is only lately that I have had *much* encouragement in my work and never such praise as you have given me. It has made me feel very happy & very astounded. But it is going to help too. I'm just at a difficult place on the road. Mrs Goldsworthy & my designs will have told you that my drawing is rotten bad. You see the gods have given me a head full of golden pictures and precious little natural ability to carry them out—and the impatience of a fire horse! And Ive *got* to learn to draw. And I've got to avoid a *course* of drawing, which I suppose would make my own drawing hard & unfeeling & yet I must not muddle along and never learn. Just neither one or the other but in between! And I mean to nip along in between like a wily threequarter thro' the scrum & reach my goal some far day. And you have, so to speak, been one who has given me a straight pass. And I want to thank you very sincerely, you have incidentaly given me splendid advice by your criticism.

Yrs sincerely
Paul Nash.

PS

I was so delighted that I had interpreted your ideas of the Crier[2] a little sympathetically. And so especially that you should see that about the drawing[3] of Blanid. I *did* shirk drawing her feet & purposely because I wanted to try and make you see her *swaying* sick with terror & loathing It is the supreme moment isnt it? and I tried to make you understand what she was feeling. I didnt dare draw in her feet even if I could. Also her arms are out of drawing I think but I wanted to get her strained, intense, wrung. Your play, The Crier by Night fascinates me. And I am so glad we may try and act it some day. It is a great

[1] By G. E. Farrow, published in October 1909 by Pearson.
[2] See Introduction, p. xi.
[3] The drawing is reproduced in *Outline*, p. 92, and *A Stage for Poetry*, p. 9.

thing. I love it for its beauty of language very much and for the beautiful hatred of Thorgerd, I use the word meaningly because to me her hatred is so deep so soulful a hate inspired by love, that it is a beautiful thing.

I hope you will not resent my rambling expressions but believe me I am a sincere admirer.

2

Well Knowe House, Cartmel, By Carnforth
GB to PN *14 April 1910*

Dear Mr. Nash,

Very many thanks for your letter: I was glad to have it, and I am still more glad if anything I have said has been of any use to you in your work, or has exhilarated you to farther work.

I do think you have true imagination in a degree which you can develope to very fine insight and vision if you will. Workers in all the arts need to watch and wait to understand the nature of things: and it is only by such understanding that we can express our ideas and emotions well enough to create them anew in other minds.

The sudden leap of intuitions and surmises, the magical way that light suddenly emanates from within something that we had previously and vainly endeavoured to illumine from without: these are the only foundation for true creation of beauty, and all else is useless if they are not vouchsafed. But to have them is only a third of the battle; and the remaining two-thirds are dogged hard work and illimitable patience. Art needs stedfastness and endurance just as much as tropical exploration or football do. Many weaklings can be brilliant at a spurt; but it needs much concentration of nature to do even as much steady glowing as a glow-worm does.

And I don't think you are a weakling, or your drawings would not contain so many rugged and (if you will forgive my saying so) sincerely uncouth places.

Perhaps you have more natural ability than you think; but if you have not it does not greatly matter. If you *live* your idea ardently enough it will help you to its own proper utterance.

In the meantime you must learn to express yourself as naturally by drawing as you do by words, to be ready for the idea when it comes. Natural ability would give you facility; but facility does no more than help such people as Arthur Rackham to fill in with curly unmeaning curves the bald places of their hasty drawings. The real thing is to get used to saying with a pencil what you want to say, until you instinctively think in lines and masses.

The ordinary art-school, even that most sublime specimen the Sth. Kensington Royal College of Art, is of little use to you: that kind of school only teaches people to draw with a smooth steady sweet nerveless line which enables them to avoid making a positive and personal statement about anything with much elegance and grace.

Externally there appear to be two kinds of drawing: that which expresses inward ideas, and that which expresses outward appearances; but the first depends on the man himself and cannot be taught—the second can be taught and is needful for the perfection of the first.

Such a school as the London Slade can teach the second: it has taught many fine men that. It taught Augustus John; and now he is equally master of the first. His classes would have been the best for you—but, alas, they are discontinued now.

If you have many chances of seeing the work of great imaginative draughtsmen, they can help you greatly. Rossetti's early pen drawings and his Tennyson illustrations, C. S. Ricketts' illustrations to "The Sphinx" and to Lord de Tabley's "Poems" and to "Daphnis and Chloe" all seem to me perfect, especially in their making it clear that the greatest mystery comes by the greatest definiteness,[1] and that wonder comes by being certain about things. Perhaps Ricketts' finest drawing is the "Oedipus and the Sphinx" in the "Pageant" for 1896.[2] Do you know anyone who has that precious volume? If you do, look how rich and full of meaning every line is in that drawing.

It is very charming of you to like *The Crier* so much: I hope you will see some of my other things someday, especially those I mean to write when I am rid of the stupid illness that has disabled me for a year. Perhaps, though, you will not like them so much; for they carry a different burden—but I shall comfort myself by thinking that you will like them, also, when you have reached a similar stage in your own work.

Well, your Blanid *did* sway and *was* sick and strained; so your drawing was justified. You got your effect by not daring to draw more; but someday you will get it by daring to draw more. But, indeed, her limbs were not far from adequate in their own way: it was the Crier's own feet which were not really adequate, I thought.

I shall always be grateful for Mrs Goldsworthy's kindness and earnestness in bringing your drawings to my notice; and I thank you too for enabling her to do so. I shall look for much fine news of you and your real talent in the future, and I shall always be glad to hear from you.

Believe me your sincere well-wisher

Gordon Bottomley

[1] This doctrine deeply impressed Nash. He refers to it in Letters 82 and 104.

[2] *The Pageant*, ed. by C. Hazlewood Shannon and J. W. Gleeson White; 2 vols., 1896, 1897. GB owned this drawing.

I have been wondering often who wrote the verse at the foot of your "Combat".[1] It feels like the work of my friend Lascelles Abercrombie but I cannot locate it. Or is it Browning?

3

PN to GB [c. *end of April 1910*]

How very kind of you to write. I am *most* grateful to you for this letter and I have been a little time before answering it because I want you to know you gave me something to think about and that I have carefully thought it and now tell you my thoughts I think most of all I would like to thank you for the expression 'live your idea ardently enough'. Immediately I saw the truth of that and mean to, and am already trying, to act upon it. You mean, let it simmer and form in the mind and become so definite a part of your thoughts that when you come to draw it you know exactly what you mean & since the picture is painted or drawn on the tablets of the mind there is no fear of vague expression on '*uncouth places*' and being sure and calm you may give time & patience to drawing. You mean that dont you? Even if you dont I have gathered a sound idea I believe from your expression What can I say to your expressions about concentration & stedfastness & the endurance of drudgery, only that I *do* find it hard work that last night I spent two hours drawing a foot & know what a long battle this is to be learning to draw—gaining a facility. No I believe I am not quite a weakling here or anyway I am just beginning to feel a will within me and using it more often so that it is growing stronger And this because I so long to be able to express myself beautifully to draw hands & throats & the fall of the hair as beautifully & with the meaning & feeling that they give to my eyes.

Yes this is an awfully bright notion—thinking in lines and masses— never really thought of it before but now I see the importance of it. I'm glad you feel that about the schools with their conventions and their expressionless drawings correct drawings but not beautiful drawings I am very lucky in being at a school—6 Bolt Court Fleet Street

[1] The verses, which were by Nash, were cut off the original, but the following copy has been preserved by Mrs. Paul Nash:

A place of gibbet-shapen trees and black abyss
Where gaunt hills brooded dark and evil
Girdled by dense wet woods and rushing streams
A dread place only seen in dreams
Of which there is no history but this
That on yon' stony shouldered tor
An angel fought a devil.

The drawing is reproduced in *Outline*, p. 64.

one of the LCC schools[1]—where now that I have had a little fortune in my designs sent in and attracted the interest of the masters, they are kind enough to help me in every way and give me advice and criticism. For a long while I worked there very much to myself & doing not very much good to myself but lately I have felt the help given me so kindly & tho I feel my failure to express as yet the expressions & character of what I draw I believe that in time I shall get what I want. I work occasionally from the costume model simply to try & draw the head or the hands in drawing & stifling as well as I can my desire to idealize and exagerate for my feeling of expression but O its hard to do as yet!

I read your words about Rossetti's drawings. Rossetti to me is a very great man & I would rather see a picture of his painting than that of any other artist. Whatever sense of beauty or line I may have or may develope I seem to owe to him. And I have only to look at his designs to feel a burning desire to create something beautiful. The wonderful sweetness & strength of his work is like stimulant & inspiration to me & I can never be sufficiently grateful to his memory.

Of course I am not so blind but I cannot see & understand his faults but I admire no one's work quite so much. Yes I know Ricketts drawing & admire what I have seen greatly but have never seen much I have got some reproductions of the Tennyson woodcuts—arent they fine & how wonderfully imaginative! Im delighted Blanid did sway & *was* sick.

.

I roared laughing over your postscript about the verses beneath the Combat[.] Browning! Oh my Aunt they're my own, also the lines for the Flumen Mortis[2] Its my secret weakness I scribble—cant help it *love* it, long and long to paint word pictures. I should cry like a kid I believe if I ever heard myself called a poet—a true poet. It is a passion: and if I work at my art that I am called to do, I work no less & with no less seriousness & sensitiveness at the art to which I was never called and feel my failures perhaps harder. There, theres a confession for you. Treat it as kindly as you have treated my work. I must really apologise for such a preposterous long letter. You must not feel you should answer it I hope you will not feel that. I feel that I have never thanked your wife (I hope you will not think me impertinent) for the share she took in interesting yourselves in my drawings. May I do so. Your 1st letter spoke of "we" & I only thanked you.

[1] Nash attended this school from the autumn term of 1908 until he went to the Slade in the autumn term of 1910.

[2] Nash describes this drawing in *Outline*, p. 81. The accompanying prose poem was destroyed but a copy survives in a manuscript book of verses belonging to Miss Sybil Fountain.

4

PN to GB

You were good enough to say that you would always be glad to hear from me. Well I am taking you at your word and writing you an exhausting long letter all about what has been happening to me. And if I have taken your meaning too literally, you must gently & firmly supress me when you write. The first thing I have been wanting to tell you is that I have secured a volume of the Pageant '96 A few days after I had your letter I was hunting vaguely in a bookshop when I spotted that precious volume, & secured it & its sister, the number for '97, with a feverish haste. Wasnt it luck! Ricketts drawings in these books delight me: it's a peculiarly beautiful style of drawing & full of meaning. I have been fortunate since I heard from you—William Rothenstein[1] saw some things of mine & asked me to go & see him & take some more designs I went and he was most awfully kind and encouraging—gave me some useful advice to think about and I think seems likely to be interested. I am to go to his studio when he has a model & he thinks he can show me something about learning to draw. I showed him your letter—I hope you will not mind that—and he said you must be an artist yourself to have written such advice and of course agreed with every word of it.

I am grinding along slowly with my drawing and have had great help from the Principle of the schools Cecil Rae who has suddenly become interested & given me an enormous amount of help in criticism of drawing in the schools. I have made very slow progress I think but already comes a little greater facility, & at the least, a great *desire* to draw. I correct my drawings myself. Dont you think that is right. So often a master will correct & redraw until the thing is *his* drawing and you are merely left the polishing. I think by insisting on this I have learnt more and at least when a[t] last it *is* finished it is my own work. I find painful difficulties in drawing from the model! I know what I want to express—all that I can see beautiful of line & expression, and away goes the correctness—the true proportion! It wont do. So I gave up drawing from life and went back to the solid expressionless casts of feet & hands & the Torso. It was better. I forced myself to draw accurately. But of course I dont believe casts can last one always[2]. The holidays are here now & I mean to draw my unfortunate brother & sister[3] till all's blue! no matter how unlike them it is simply because

[1] Sir William Rothenstein (1872–1945), painter; Professor of Civic Art, University of Sheffield (1917–26); Principal, Royal College of Art (1920–35).

[2] Written over 'long', cancelled.

[3] John Nash, R.A. (b. 1893), and Barbara Nash (b. 1895).

of drawing—training eye & hand. For Im going to the Slade in October —if I can scrape enough monies together for the fees! It is Rothensteins advice but *my* determination I want to go because I want to go back to school & because for a time I mean to become what Stevenson calls a 'Snoozer' one who makes studies. I am going to the Slade because I want to make studies and friends But I feel I must be fairly presentable when I get there I must be able to draw—yards better than I do now. So I shall be drawing things all these holidays & I believe by October I *shall* be presentable. Lately I have done more colour than anything else and in a few days I am to go and see Selwyn Image[1]—another friend lately accrued, with new designs for his inspection. Also I've had the supreme luck to be introduced to Ricketts & Shannon[2] & I am expecting to hear from them any day to ask me to go & see them! I still strive with verses. I think I am unreasonable to hope to be able to write when in my own calling in life I have not yet learnt to draw! but I cannot help it I must write as I must eat or drink or walk and tho' I feel what I produce is very weak & empty, *at times I think it helps the carr[y]ing out of an idea.* I wish you would tell me about that—what do you think? I have chattered a great deal. I can almost hear you yawn. I hope you are very well & strong again by now. Forgive this very long letter.

5

Well Knowe House, Cartmel, By Carnforth
GB to PN *2 August 1910*

Of course I was glad to hear from you, and I certainly meant what I said. In fact I was particularly glad to have your letter, for I had had it on my mind that I had been unable to answer your last one (owing to my stupid health, distractions of relatives, and Things in General); so now I can answer them both at once and practise economy—a thing I am not usually successful in doing.

And first and belatedly let me say how delighted I was to know that the verses under your angel and devil drawing were your own. Something Childe-Rolandish in their flavour altogether took me in; my wife has been ostentatiously triumphing over me, for she hazarded the possibility that you might have done them and I assured her that they must have come from an older hand than yours.

I think they are good—even very good, and I congratulate you. If you can keep it up for long at that level you are an undoubted poet

[1] Selwyn Image (1849–1930), author and Slade Professor of Fine Art, Oxford (1910–16).
[2] Charles Ricketts, R.A. (1866–1931), painter, founder of The Vale Press and joint editor of *The Dial* with Charles Hazelwood Shannon, R.A. (1863–1937).

and may become a considerable one. To tell you the truth, I did not care so much for the decorative prose under the "Flumen Mortis" drawing; for that needs no originating power, and can be done by almost any one well read and with a cultivated mind; but your verses have a feeling for words and for simple noble style that is remarkable and hints big things; and I am so pleased with them that, for their sake and for the sake of your drawing of Blanid swaying, I send you a little book which you said you wanted to have.

I strongly advise you to go on with your verse; it can do you only good—and I think that any one who follows one of the arts does well to be cognisant of what is going on in the other arts, and that he will find support and fertilisation in them.

(One reason why British musicians were for so long either dull dogs or noodles and knew nothing of their art, was that they knew nothing of any art, and were especially ignorant of the poetic nature of all the arts.)

It is true that Rossetti said "for a long time my poetry and my painting got in the way of each other"—but by this time every one is grateful that they did. Someday, when you are well launched and deep in mid-career, you may be, like Hokusai, "mad about drawing", so that poetry will have to fall behind; but that is not yet, and I believe that if, in the meantime, you give your instinct for poetry its due place, you will strengthen your purposes, clarify your vision, and make surer of what you want to do.

You will see that all this amounts to no more than advising you to do what you want to do. And when any one has a guiding passion that is the only safe advice to give him. In this connexion I was delighted to hear that you would rather correct your own drawings than let the teacher correct them; that is the only right way, but there are few people who ever find it out.

Yet it is difficult to learn to be steadfast in doing what one wants to do; especially as the artist always has to work in spite of the world.

I am sure you are doing well to go to the Slade; if you are steadfast to what you want to do, the people there can help you to learn how to do it. The only danger in art schools is that people usually go to them to learn what to draw.

You are fortunate to be able to be in Town and in the midst of things; and if by now you have been to see Ricketts and Shannon you will have had the finest counsel in the artist life that Europe can give you in this generation.

And now that you know Ricketts and Shannon and Rothenstein and they are interested in you, you are well started and need no advice from me; for they can tell you much more of what you need than a poet can. I think you are going to do the real thing, if you work faith-

fully; and someday I am going to be happy that I was one of the first to see it in you.

You are fortunate in having attracted Rothenstein's attention; I daresay Ricketts and Shannon's themes and outlook feel more like what you aim at, but there is an honest grave poetry in Rothenstein's work that makes it as fine in its way—its reality is magnificent and steadfast and inward. I have never met him, but I am always proud that he was born in my part of Yorkshire.

You were fortunate to find the "Pageants". If you can find Lord de Tabley's "Poems, Lyrical and Dramatic" (Mathews and Lane, 1893), illustrated by Ricketts you will have another such joy. It contains a drawing of Nimrod and the destruction of the Tower of Babel that is one of the most tremendous things that ever any one has done. Nimrod is sick and sways!

I must not begin another sheet to-day; but I am always glad to hear from you, and always your well-wisher

<div align="right">Gordon Bottomley</div>

I have never thanked you for the book-plate,[1] but I do now. It is a great advance on your previous ones, and the lyrical intertwining of motives is very charming.

<div align="center">6</div>

<div align="right">Wood Lane House, Iver Heath</div>

PN to GB [Early August 1910]

Your letter made me so happy that it is difficult to find adequate words for my return thanks But before I say anything about the main subject of the letter I must thank you for this book. I am purely delighted over it and I am as proud as Motherhood to posses it with the inscription inside. I show it to all the available (sensible) people I meet in sheer pride. But of course I love the book for itself and it is a delight to feel it belongs to me and I can often turn to it.

I dont think you can conceive how happy I was to read what you said of my verses but I am dreadfully afraid that this little verse you liked may be what is in slang called 'a fluke'—But I am so keen to put this fear to the test that I am going to ask you this—since you are so obviously kind [of] heart & good natured*—Will you read the one or two other verses I send in a few days? I think even if you tell me after that, that you made a mistake and there is nothing really of promise in them —I shall not mind very much because you have told me that it can do

* Tho' its rather hard you should suffer for your virtues!

[1] Possibly the plate reproduced in *Outline*, facing p. 65.

no harm to go on and it may do some good. Your letter was altogether a cheering one—thank you ever so much for all its kind words. But this that you say about my being able to dispense with your advice & criticism now that I know Rothenstein & Shannon, is not at all right. You have given me more help & hope by the letters you have sent than anything that has been said to me or done for me since I started on the 'narrow way'. . .

At this time I am trying to make money enough to pay for my fees at the Slade it is rather a wild undertaking but I daresay I shall get there. The only thing is I have rather a limited source of income— Book plates & the whims of my patron who bought 'Our Lady of the Stars'. I dont believe Publishers will look at my work yet it is too immature in technique. And yet Im sure I could do decorative designs & work them to a finish if I had enough time given me. Well I'm not worrying much, I shall paint gates if I can get them to paint. This is all that I keep in mind until October—the making of 21£ and the drawing of studies for my souls-good—and cricket! Thank[s] again most awfully for your letter & the book. . .

<div align="center">7</div>

<div align="right">Iver Heath, Bucks.
30 August 1910</div>

PN to GB

It is with great fear and trembling at the last that I send these. I am sorry I have let my 'after a few days' run into weeks but it was not because of any carelessness. I have been working at the verses.

Heretofore I had never done much chiselling & re-modelling— mostly because I didn't know quite how to set about it & perhaps also because they were too frail to stand it. But a fellow-versifier—who has the advantage of good criticism always at hand in the advice of James Douglas[1] and Alfred Noyes[2]—passed on to me a few rudimentary ideas of verse mending and in the light of these I could do much and have been reading & reading thro' each 'poem' 'till the flaws became plain & then thinking & worrying until I found better words & lines This has been a long work for *me* and as I could only give odd evenings & solitary walks o' mornings to it—the result is you have been kept waiting. But here they are at last—like shiverers on a diving board about to take the plunge and with the closing of this letter & the lick of the envelope I metaphorically shove them over.

P.S.

I am going tomorrow for a short tour with a delightfully misguided

[1] James Douglas (1867–1940): journalist and director of London Express Newspapers. [2] Alfred Noyes, poet and prose writer: born 1880.

PLATE **I**

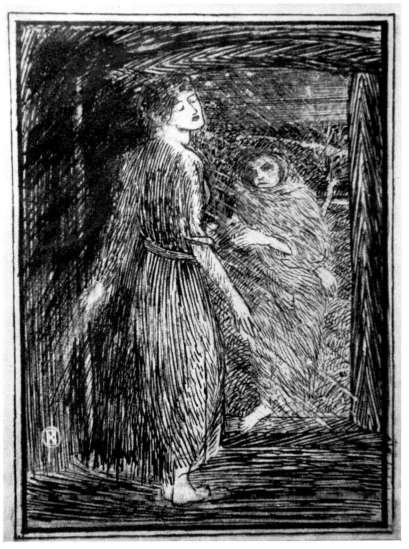

The Crier by Night, *by Paul Nash, 1910. Pen and pencil,* $7\frac{1}{4}'' \times 5\frac{1}{2}''$
From a drawing made in a copy of the play

PLATE II

Well Knowe House.
Cartmel.
 by Carnforth.

Believe me your sincere
well-wisher
Gordon Bottomley.
I have been wondering

April 14th
1910.

Dear Mr. Nash,

Very many thanks for your letter : I was glad to have it, and I am still more glad if anything I have said has been of any use to you in your work, or has exhilarated you to farther work.

I do think you have true imagination in a degree which you can develope to very fine insight and vision if you will. Workers in all the arts need to watch and wait to understand the nature of things : and it is only by such understanding that we can express our ideas and emotions well enough to create them anew in other minds.

The sudden leap of intuitions and surmises, the magical way that light suddenly emanates from within something that we had previously and

Facsimile of Letter 2, from Bottomley to Nash, 14 April 1910. The first page

Aunt & Uncle, thro' Normandy & Brittany. I have never yet been abroad sh'an't I go perfectly mad! If you write here they will forward to me but I may not get it very directly.

P. N.

8

Wood Lane House, Iver Heath, Bucks.
15 October 1910

PN to GB

I'm in an awful perspiration of fear! Have been for weeks! I fear that your kindness is preventing you damning my all too hopeless verses. Please dont let it: but when you can, write to me and give the verdict. Ill take it standing I promise you. That is really why Im writing but since the envelope goes so many miles I must fill the sheet contained in it to make it all worth while You will be a little astonished when I tell you I am not yet at the Slade but its thro' no fault of my own & by Tuesday I shall be there. I dont remember if I told you I was going to try & make the money for the fees. Well I've made it at last altho' some of it has yet to come to hand for work still in the doing & a promised order. Enough, that in time I can stand up & hand it all over to my Pater as earned in the time I gave myself! Well I neednt go on blowing a trumpet for you can see from that that Im absurdly cocky! The other day I went to see Rothenstein before he left for India and as we have often talked about you I showed him your last letter. He was very keen to get some of your work so I lent him The Crier & have just heard from him. He was *tremendously pleased* & is very anxious to get hold of the other poems. I wish you could see his letter for he is a charming writer and puts into words all I feel about The Crier—he loves it as I love it. You must not feel any offence in this priggishness of mine it is not really priggishness but sincere enthusiasm & I lent the play to Rothenstein because I wanted to introduce you to him & because I am so proud of you as my friend & if you object all you have to do is to metaphorically punch my head for 'cheek'!

I hope you are well. Please will you remind Mrs Bottomley of me.

9

Well Knowe House, Cartmel, By Carnforth
23 October 1910

Emily Bottomley to PN

My husband has been afraid you would be feeling anxious about your manuscript, and he is sorry to have appeared to neglect it so long;

he had hoped to let you have it long ago, but he has had three haemor-rhages and has been in bed more than a month—quite unable to do anything and often having to lie propped in one position—forbidden to move for days. He will write to you when he can, but in the mean-time I am sending your M.S. with this note as we think you may be wanting it.

My husband says you have no reason to fear his opinion of your poems for they show true poetic power. And there is often a beautiful feeling for lyric movement. . .

My husband says he feels there is more poetry than there are poems in your sheaf, because the form is not always complete enough to make a shapely whole—but the right feeling is there, and that is the main thing. He says too that there is nothing quite so impressive among these poems as the Stanza under your Angel and Devil picture, but that is only because the latter treated of a bigger theme and needed to be done in a bigger way. Otherwise the same qualities are apparent in these as in that. He most earnestly advises you to go on with poetry for it will be well worth while. When reading other mens poetry he would, if he were you, notice especially their uses of metre and the way they get variety of metre, for that will increase the scope of your expression instinctively.

My husband was delighted to hear that Mr. Rothenstein liked his "Crier"; we were both deeply interested in what you told us of him and we should very much like to see his letter about "The Crier" if you could sometime spare it. . .

10

From P.N to Emily Bottomley, Yately, Hampshire, 29 October 1910. Thanks her for last letter and expresses sympathy with GB. He is reading Milton and Browning and thinks he has learnt something. He will send Rothenstein's letter.

11

Wood Lane House, Iver Heath, Bucks.
15 November 1910

PN to GB

I am so sorry I have not let you have the promised letter before. There seems so little time for writing letters these days & I wanted to write to you at the same time I sent it. I was extremely sad to hear of your illness I am hoping that by now you may have shaken it off & got stronger It was so *very* kind of Mrs Bottomley to write me that long

cheering epistle! Thank you both, most awfully for your encouragement. Just at present Im feeling rather absorbed in my drawing I go four days a week to the Slade & work six hours—at present—only from the Antique. I was sickened & frightfully discouraged at first—chiefly to find I was so backward, but now I'm happier and feeling my feet a bit. Tonks[1] is a good teacher one learns a great deal from him but until one gets used to it, his manner & sarcastic comments rather damp hope. He never praises and can find more faults in five minutes than another man could think of in a fortnight The great thing tho' of it all is that *I* feel I've learnt more there in a fortnight than I did thro' five years! To revert to the writing. I have to plead guilty to having written a play in verse[2] finished some months back & very soon now to be produced at the Town Hall in Slough, the adjoining town to Windsor. The only drawback to it is, that beside being author, I must be to a great extent manager and that, at the present time, is a nuisance as I want all the time for drawing

These days are glorious. There is a delightful piece of music by Mackdowl called ' The Joy of Autumn'[3] & isnt that right?—there *is* the wildest & most happy-childish joy about Autumn The mass of people go about saying 'how mournful, how sad' I never did sympathise with them these are the jolly days. I want to make a picture of great bowed trees against a wide sky of clouds with all the birds suddenly flying up from the field & all the yellow leaves falling down & the shafts of the sun turning them all golden I pray I can do it Please give my kind regards to Mrs Bottomley I hope you are better.

P.S.

And after all I must send this letter without Rothenstein's for when I came to look for it lo! it had vanished. Of course it can't be lost but I am afraid Im rather untidy & expect it has got between the leaves of a book I must hunt it up & send it on. I am so sorry.

12

From GD to FN, Cartmel, 23 November 1910. He is better but 'not good for much writing'. A mere acknowledgement of the last letter.

[1] Henry Tonks (1862–1937), painter and instructor at the Slade School from 1892. 'Tonks was the Slade and the Slade was Tonks' (*Outline*, p. 89).

[2] This was a verse play for children which has never been published and was probably never performed even by family amateurs. Its nature becomes clearer in the following letters.

[3] Edward Alexander MacDowell (1861–1908), American composer. 'The Joy of Autumn' is No. 10 of *New England Idyls* (1902).

13

Wood Lane House, Iver Heath, Bucks.
26 December 1910

PN to GB

I am simply delighted with the present you have sent me.[1] And I am very proud of the inscription. Thank you most awfully. And now I must confess my disappointment at not being able to send you what I had intended. I was making you a drawing with all care to give you and had arranged that a friend should stand for the figure. Twice an appointment was made & each day something occured to prevent the 'sitting' Then came the avalanche of Christmas businesses and I had to be content to wait But this week I shall carry it out & send it you, hoping you'll accept it kindly as the sy[m]bol of my greetings & good wishes for New Year. And again there's another thing to be sorry for. At last I have solved the mystery of the missing letter I hunted high & low everywhere & then it occured to me I had left it at my Aunts house in Hampshire. Enquiries were soon made & O horror! it had been thrown in the fire! . . . The only thing I can do now is to remember what Rothenstein said & write it here for you.

He said first how much he had enjoyed reading Mr Bottomley's drama with its strong sense of beauty and insight into life Then he rather drifted into criticism & said the attitude of Hialti was very Irish & too listless "perhaps a little too Irish for me" but he loved Blanid. He was rather quaint after that, having made about a page of criticism about the attitude of Hialti & saying "a little too Irish for me. I feel the vitality beating thro' life far too much—" etc (which is very Rothensteiny!) then says "but indeed I do not want to criticise at all but only to read more; feeling that later work will bring even richer fruits & deeper insight"

Im not quite certain about this last expression but it was all to that effect.

More I cannot remember and Im extremely sorry I could never send you the letter. I shall lend him my copy of the Riding to Lithend when he comes back in March he'll *love* that. I am tremendously exited over it I read it last night in bed & I think it is a splendid thing. It all so much appeals to me That great dim weird house full of odd women & the huge figure of Gunnar wielding the bill. Then it is more suddenly dramatic than the Crier & so deep and charged with feeling. The end brought the tears in my eyes.—I can't tell you [how] glad I am to have it to read.

[1] *The Riding to Lithend.* Nash wrote to his cousin, Nell Bethell, that GB had sent him this, and added: 'it's a great thing' (26 December 1910).

I am very keen about my work at the Slade & have got into the Life Class for two days out of four: next term I mean to get right in. I like Tonks more & more he is so full of thought & care for the strugglers, & teaches wonderfully. My poor play had to wait until Easter as my co-operater was put 'hors de combat'. We shall have more time now & a better chance of doing it well. Here Im going to ask you a favour. Would you read the Play. . . I have had nothing but friends' praises on it I would so like a friends criticism & 'blue pencil'!

Blame is so much more good for *me* than praise. Will you give to Mrs Bottomley my heartiest wishes for the new year. I hope you both had a happy Christmas I was very happy to hear you were at last better & down again I hope this year will be easier. With all good wishes

14

Well Knowe House, Cartmel, By Carnforth

GB to PN *29 January 1911*

Your letter has been by me all these weeks—I must have seemed a callous and selfish pig (I suppose all pigs are callous and most of them selfish, though), but I hope you do not think very badly of me, for I have not been unmindful, and I would have written sooner if I could.

All my story is that another haemorrhage abrogated me the day after Christmas—I have been wanting to write, but I could not manage it before.

.

I shall be happy, too, to read your play if you can spare it. I have to restrict my writing, so that I may not be able to write you as fully about it as I should like; but I will make notes of anything that occurs to me. So please send it whenever you can spare it.

The end of the Rothenstein letter was a woeful misfortune. . .

You did your best; I can feel you have given me the essence of what Rothenstein said, and I am *very* pleased to have it and to know it. I think he is quite right about the defect in Hialti, though I should describe it as Anglo-Saxon stodginess rather than "Celtic listlessness". Looking at the play now, across the ten years since I made it, I see that all I strove for then was to bathe those three lives in an atmosphere of the impending mystery that is everywhere about us (even when we forget it), to render the strangeness of life and fate and of man's isolation amid nature. I am afraid I thought too little of character, and (with Hialti in particular) trusted I had drawn the individuals just enough to enable actors to embody them. I like Rothenstein's criticism hugely, and I do thank you for telling me of it; (Forgive this scrubby scrap.) it is the kind of criticism that is best worth having—the sharp, clean-cut

personal point of view of a man of creative and originating power, that enables one to stand outside one's work and realise how other people are seeing it. Beside, Rothenstein's vision in his own art makes one trust his vision in other things.

I must write no more to-night; let me send you a greeting and a wish for a kind new year to you from my wife and myself.

15

Wood Lane House, Iver Heath, Bucks.

PN to GB *20 February 1911*

At last comes a hard & bulky parcel. I have had such bad luck with my drawings for you. When I first wrote I had begun a large pen drawing of 'Blanid at the Door'—all went swimmingly up to a point & then I began to *hate* Blanid. At first she had seemed to express well what I meant but by degrees she grew all wrong I found her proportions had got all bad (she did it in the night I believe) All the rest o' the drawing was well but Blanid spoilt it all. I began a fresh on a new subject & I send you the sketch which is about full o' faults. Tonks advised me to pull it about—of course its a devilish bad composition —I fell into the error of thinking of the scene from a front-row-of-the-stalls point of view & forgetting the composition *as* a composition. But you send it back & Ill pull it about & make something of it in the end —the idea is there dont you feel? And after all this time thats all I have to send you (except Blanid just to show how wrong she did go)!

But then here's a heap of other things for your amusement. I thought as you were not able to work Id send these for you to look at but very likely you will be well again by now—I very much hope you may be— & I shant mind in the least if you dont look at any of 'em. Still I know youre going to read the Play—there is no hurry for that, read it when you will. I have had rather a striving, barren time at the Slade lately —feeling incapable & slow & hopeless but I drew much better today & feel happier—O its a long way off that time when I wake up to know myself a draughtsman! William Nicholson's[1] son is there & a struggler like myself we have made friends & seem to suit each other. Tonks is becoming quite amiamble & one invariably learns from *his* lessons. Brown (Proffessor)[2] seems little use to one but he wears a frock coat (a barbaric article of clothing dont you think?) and that gives an air of respectability to the Slade in the face of its otherwise eccentric

[1] Sir William Nicholson·(1872–1949), painter and poster-designer. His son is Ben Nicholson (b. 1894), painter.

[2] Frederick Brown (1851–1941), Slade Professor of Fine Art, University College, London.

sartorials Russell[1] & Lees[2] are helpful sometimes tho Russell *always* says 'Well, its better'. Today we had a model as deaf as any post & very swayey about. She was rather distressing. O I want to apologise for the Play being all in rhyme. It was written absolutely for the very young & that is why it jingles, in fact it is mostly doggerel but I hope you will have patience with the first nonsensical scene to get to the next & the 2nd act where I think it improves a little & is not so worrying. The short story is my last & latest effort but is only put in the parcel as a make weight.[3] By the way that ungenerous lady Mrs Goldsworthy was here to ten the other evening & told me—she is ever on the look-out to annoy—she had described me to you as unpoetical in looks & far from thin—this is grossly untrue if she leads you to suppose I am fat! And I would retaliate by saying that Mrs *Goldsworthy* is far from— no, that would be unkind.

These days are glorious here, sun outpoured over the land in lovliest lights & great clean warm winds to keep changing the skies & have the trees swaying & the blue streams scurrying And the nights are as beautiful with their keen clearness & brilliant stars. The lanes are exciting beyond words to anyone who looks for 'signs' & on Saturday I saw a wonderful sight—an orchard where bunches of snowdrops grew in the grass—somehow a thing like snowdrops wild in the grass took my breath away & set me marvelling greatly. This is an infernal long letter. Please give my kind regards to Mrs Bottomley I do hope you will get quite fit again soon

16

GB to PN [*PM: Criccieth, 13 March 1911*]

Your splendid parcel arrived just as we were setting out for this place. I will write as soon as I can, but in the meantime I send this to tell you of its safe arrival. I am *greatly* delighted with its contents. The *Lithend* composition is first rate—most beautifully invented—and Hallgerd is superb.[4] But I will write more of this afterward. I sit all day long by one of these windows and watch a wonderful and enchanted sea, and see the sun set on a castle of romance across the bay.[5]

[1] (Sir) Walter Westley Russell, R.A. (1867–1949), assistant at Slade School, 1895–1926.
[2] Derwent Lees (1885–1931), landscape painter, assistant instructor at Slade School, 1908.
[3] 'The Dream Room.' A manuscript copy exists in the collection of Miss Sybil Fountain. It was never published.
[4] See Plate IV, "Hallgerd Refusing her Hair to Gunnar" (1910). It is also reproduced facing p. 10 of *A Stage for Poetry*.
[5] This is written on a picture post card of Criccieth.

17

GB to PN

Dear Paul,

(I hope you will forgive this liberty I take with your name, for I seem predestined to it. Mrs. Goldsworthy, in her letters has taught us to speak of you so, and we have grown so used to it that we shall be sure to forget the "Mr." when we see you—so we thought we had better confess to it in advance.)

.

We have read your play with great pleasure, and we both agree that it shows much promise in its freshness and straightforwardness and the way it walks into the middle of things without tiresome explanations; and there is a truthful kind of feeling and tenderness in the latter portions which we find especially charming.

.

You have done a most delightful cover-design for "Snowdrop":[1] which brings me to the drawings.

We are delighted with these; you have a charming fancy and invention, and your qualities of deeper imagination are as much there as ever while your power of realising them strengthens. I daresay it is strengthening even more now, and I am relying on you not to let the powers of expression you are learning at the school lead you to forget the delightful things you have in you to express.

Perhaps most of all we like the feeling in the little "Sleeping Beauty" picture; it is very delightful, and the colour both in it and the two banner designs is full of originality and richness. We like very much the Shower with the gold tresses leaning from the sky; but the foreground is too literal, don't you think, for so fanciful a theme? The two tall trees that reach up to the figure are beautiful, and exactly right; but I feel that the petite little trees dotted about their feet do not get into the logic of the composition. The Lady Playing Music is charming, too; and I like the poem underneath. Which reminds me that I like your "Dream Room" story too; though not so much as your play, because it is not so personal. It has a great feeling for beauty and suggests a kinship with Morris' "Hollow Land" and other early stories —I wonder if you know them?

It was mournful that Blanid went wrong in the "Crier" drawing, for the rest of the picture is absolutely all it ought to be. I am hugely pleased with the piece through the door, and I have wonder[ed] if you

[1] Presumably the title of the play.

could not cut that out and inlay it in another sheet of paper (Rossetti used to do such things) and have another go at Blanid—making her swimmy as you did in the early drawing?

Both for dramatic and pictorial composition your "Lithend" drawing is by far the biggest and most complete thing you have shewn me yet. Your idea of Rannveig took me by surprise with its fineness; the grouping of the girls is beautiful; and Hallgerd is the real right thing and no mistake.

.

We were amused by your description of Fred Brown's frock coat. We agreed with you for we are always disposed to believe that no work which is interesting enough to be worth doing can be done adequately in a frock coat. But that may be green envy because I have no frock coat.

Mrs. Goldsworthy said nice things about you, so it would be kind in you not to feel very bloodthirsty. And you can be comforted, for you could not possibly be either as fat or look as unpoetical as I do. Beside, the only really poetical looking people I have ever met are bad poets.

I shall always be gratified if you care to send me a batch of drawings to look at from time to time; for they give me deep pleasure, and I have always a vivid interest in what you are doing.

My wife joins me in kind regards.

O, forgive me! I haven't put the Sleeping Beauty[1] in after all. It is so delightful I could not say good-bye to it just yet. I wonder if you would care to have some of my books in exchange for it? But that is only a suggestion, and if you have other ideas about it, or purposes for it, you must tell me and I will send it on as soon as ever you want it.

18

Wood Lane House, Iver Heath, Bucks.
PN to GB *16 April 1911*

Thank you ever so much for this letter . . . Your parcels came while I was down at Rottingdean where Ive been spending a most happy week at the Nicholsons—William Nicholson's son is at the Slade & he & I have been entirely occupying their house with ourselfes & our voices during the Easter holiday. It was great fun we painted & drew & talked all day & most of the night. One day the Downs were put to sleep under a four inch deep coverlet of snow & we tobogganed merrily all the morning. Work was relieved by games of golf & cricket & fotball (all between 2 people!) and we got on famously. I have not

[1] Bequeathed by GB with other pictures and drawings by PN to Carlisle Art Gallery.

met his Father yet but if he is there when I go to stay next time I am to try painting in oils & learn the first steps! Wont that be glorious.

Thank you a thousand times for the care & trouble you have taken to think & write all these things of my work. I was mightily pleased reading your letter but when I came to the post script I was staggered You have paid me the greatest compliment of all. No praise comes up as far as this Oh do have the picture. I am awfully happy, for you to have it. I only regret it aint far far worthier. It's the veriest sketch-club 'done-in-a-hurry' thing & the drawing's vile. I dont know what to say about the books. I should *love* to have *any* but I dont feel my beastly thing is worth any books. I leave it to you but I cant help adding—*do* give me some if you possibly can! Theres a hint for you! . . . You'll be frightfully amused with this magazine[1] I send you but it *is* going to be good! Three of us at the College are mad to make it really an interesting and arresting thing & when that happens Ill send you another number! The editor & I are friends & are going to work it up together in spare time. Any way I am to write regularly!!

I was so delighted you liked the Lithend drawing. I think you are right & I beg you to keep it & I will try another later on. I *will* dodge up the Blanid drawing & see if I can make something of it. One thing *did* buck me up in your letter your appreciation of the *colour* in the designs. People have always annoyed me by saying I like your pen drawings—*of course* they are much better than your paintings! Of course *I* didnt mind what the Dickens they said but it somehow made me determined to find a colour sense somewhere inside of me. So hurrah! I knew Id got one! . . . Give my kind regards to Mrs Bottomley I am glad you are going to call me Paul. No one calls me Mr Nash for very long & I dont like my surname its a absurd word. So I am proud & glad & only now want to meet you both. Even that may happen one day!

19

Wood Lane House, Iver Heath, Bucks.

P.N to GB [*July 1911*]

There arrived some days back to my wild delight, a parcel of books from your publisher The Gate of Smaragdus[2] & Chambers of Imagery.[3]

[1] *University College London (U.C.L.) Union Magazine.* A poem called *Under a Picture* by PN appeared in the issue of March 1911.

[2] *The Gate of Smaragdus* (1904) is an experiment in 'the book beautiful'. It was made under GB's close supervision by a local printer at Ulverston. The poems are printed in small capitals, following the example of Ricketts. It was published 'At the Sign of the Unicorn', but almost at once transferred to Elkin Mathews. It is illustrated with Shannonesque drawings by Clinton Balmer.

[3] Published by Elkin Mathews, 1907; second series, 1912.

Joy! I have waited to write because I wanted to read first. Now that I have read most of both books I am puzzled what to say. Of course The Gate of Smaragdus is simply the most extraordinary & remarkable thing Ive ever read. The almost intoxicating richness of words & the unusual imagery produce a strange haunting feeling to me. Often I confess my mouth gets too full of doubled words. I enjoy the impression rather than the music or the meaning. But the colour of some! Oh my word its like Rossettis painting & 'Daphne'[1] is a simple joy to my mind —gorgeous purely lovely! . . .

Of course its quite hopeless to give you any idea of how much I like the poems. I am going to make a picture for 'In the Rose Room'—try to at least. The White Watch[2] of Shannon's seems to have interested you. it did me too & I like your versions. Perhaps the one in the smaller book appeals to me most. Now the smaller book 'The Chambers of Imagery' enslaved me entirely—I was delighted with every one from start to the end. Most of all the Hymn of Form. That is splendid to me. Im glad this is a small book because I can take it about easily. The 'get-up' of the other is truly beautiful & amuses me greatly. Who is Clinton Balmer—Im afraid I dont like his work much. Poor drawings, they have a rotten time up against such big poems! . . . The country is in a very romantic mood just at this time something about the trees & the light across shorn fields is always making me wonder Then the garden is full of birds; the nights are mysteriously lit & rain in the night holds me listening spell-bound. In fact I do nothing but walk about marvelling at the wonder of the world in general—perhaps I shall paint a picture or write a poem one day. I am at last beginning to draw a little better, thank God. I draw much more directly & fear-lessly, at the advice of Tonks & have found it help me greatly. I want to get a great deal done in these holidays & some time in the Autumn shall send you another parcel! Thank you most awfully for your books my picture is a poor exchange. Give my kind regards to Mrs Bottomley

20

Well Knowe House, Cartmel, By Carnforth
GB to PN *3 September 1911*

I treat you very badly, and there is no excuse for me: the only com-fort I can offer you is that I have behaved even worse to Mrs. Golds-worthy, for I have owed her a letter even longer than I have you. If I

[1] A revised version in *Poems of Thirty Years* is dedicated to PN.
[2] A well-known lithograph by C. H. Shannon. There is a poem suggested by it in *The Gate of Smaragdus* and another in *Chambers of Imagery*, first series.

am graceless enough to offer you this comfort, it is that I may beg you to tell her that I am keenly conscious of my sinfulness and that I beseech her indulgence until I can do better.

It is not that I have been worse, for sometimes my lung has been kinder than it usually intends to be; but during all the great heat I was unable to do anything, so that my correspondence is still in a hopeless mess, and my endeavours to get another "Chambers of Imagery" together are quite at a standstill.

All the same, I was glad to have your letter, and to know the books had reached you safely.

And I was a good deal interested in your impressions of them, for I thought they were shrewd and to the point. . .

Of course, I am very fond of "The Gate of Smaragdus", and I think it is a very nice book indeed: but perhaps that is because I do not need to read it. When I wrote it I believed too sincerely that poetry was the language of the adjective: I believe still that the poetry is safely there under the frills and flounces of the adjectives—but perhaps the book's eventual use will be to teach unborn generations exhaustively how not to do it.

Perhaps I agree with you a little, too, about the drawings; but if I do I am bound to stand up for them, all the same—for I think you have diagnosed their faults more completely than their merits. Seven years ago Ricketts and Shannon said of them "They contain a sense of beauty not usual in the present day"; and W. B. Yeats praised them; so they cannot have stopped entirely at their rotten tune-up. One reason why they seem worse than they are is that they are drawn in the art-school convention of ten years ago; and nothing looks staler than a convention or a fashion that has just gone out. But look behind the sometimes vacant drawing and you will find a subtler rhythm, much fine and really expressive composition, and an often original invention.

But they do not show Clinton Balmer at his strongest, for he is essentially a painter and colourist, as you will see when you come to see me. He is a Liverpool man; but some years ago, I am sorry to say, he settled in New York, where, I fear, he is not able to do the kind of work he does best.

What you say of his drawing makes me anxious to ask you (and you must not think me interfering, for I do not mean to be)—to ask you not to let the Slade teach you to put all your trust in a smart tune-up and a sure hand. After what I said in encouragement of your going to the Slade, and in anticipation of all the good you could get there, it cannot be thought that I am unsympathetic or prejudiced toward the Slade. But you go there to learn to express the visions that are in you —and such a man as Tonks can help you to widen your means of expression enormously; but you must not let him teach you what to

22

express, for he is the slave of his eyes and will never see anything but what is there.

Perhaps you would not have cared for my first letters if I had dwelt too much upon the tune-up of your early drawings; but it would have been wrong in me to do so, for what mattered was the moving and intense poetry which only wanted making secure by technical skill. The world will want to make you paint its subjects before it will let you be successful, and there will be plenty of people ready to tell you that such accidental and skilful realism as that of the New English Art Club is what you must aim at: but, in truth, you must never forget the visions which launched you into art, for you will never find more authentic and immortal themes than those. I know that painters must first be judged by the power of their technique to convince: but rich poetry is at the bottom of even that, and in the end they are judged by the grandeur or mystery or wonder of what they have to say, as in Michel Agnolo or Leonardo or Rossetti.

I hope I shall be better enough to see you before another year is over, and then you will be a Paulo-post-futurus no longer. I am keen to see the new parcel of sketches you speak of sending.

Forgive my middleage preaching and believe me always yours

Gordon Bottomley

Have you seen Lecoq de Boisbaudran's wonderful book[1] on drawing, translated by Luard, and published by Macmillan? He was the master of Fantin and Legros.

21

Sinodun, Wallingford

PN to GB *11 September 1911*

I was really glad to have your letter. it was very cheering. I am most happy to hear you have not actually been any worse, and absolutely joyed to know another 'Chambers of Imagery' is forthcoming. Please forgive my rude treatment of Balmers drawings it was foolish to be so one sided and sweeping about them. But really it was, what looked to mo, thoir olaviah imitation of Shannons & Ricketts' work which annoyed me I *did* appreciate very often the compostions & fancies of the designs but after that they seemed so dull like all imitations. But I might have been more thoughtful when I wrote for as it is, I feel I have been abominably rude to you in that Clinton Balmer is evidently a personal

[1] *The Training of the Memory in Art and the Education of the Artist*, translated from *L'Education de la mémoire pittoresque* . . . by L. D. Luard, with introduction by Selwyn Image, 1911.

friend Forgive me, I am extremely sorry. Also I have lead you to suspect that I am come to put all trust in 'tune up'—or too much trust at least. No, dont be anxious that has not happened a bit. The Slade has taught me something—many things, and chief among them perhaps to widen my means of expression—not so much by better drawing, for tho' my drawing is a bit better it is dreadfully slow in improving but more in the way of saying things—developing a sense of the dramatic, a greater feeling for form & shapes and a way of seeing things more simply, more as a whole. You understand? I agree with every word you say about Tonks I found it out soon but at least he is sufficiently interested in me now to be quite worried that I draw so badly! I sent in two drawings the end of last term to the sketch club and altho' he said he couldnt in the least understand them—Lord only knows why not—he made a speech and warned me not to be vague, thought that sort of work rather dangerous, but knew I was very sincere & wanted to do better: all of which showed he was interested but rather puzzled me for I couldnt see where I'd been vague or dangerous; but that is Tonks all over, 'he does not see anything but what is there'. But he is most kind now a days & gives me long lessons and much kind, helpful encouragement.

And now at last I am to have a real chance. My Brother has left college and I am free to go & live in London & try & really work. I have never really *worked* yet. It is almost impossible to do so at home, it is very difficult to do much at the Slade when you have an hour & a half's journey to & fro each day & many interruptions. But this winter I go to London, find out a room somewhere and make my way with my work. It is the only thing and if I can make myself strong enough I shall be able to do something one day I feel it, but it'll need all I have in me and more—which Ive got to find, for me to win. Thank you for all your help I am glad to feel I have such a friend as you. Please write to me when I am alone in London beginning my real life. I hope I shall never disappoint your hopes of me but one day realise them—fully.

Give my kind regards to Mrs Bottomley

.

22

From PN to GB, Iver Heath, 16 October 1911. Sends a parcel of drawings. He is moving to 19 Paulton Square, Chelsea, 'almost immediately'. Asks whether GB thinks his verses good enough for publication and if so whether he would introduce him to Elkin Mathews. He hopes to go to Paris.

23

From Emily Bottomley to PN, Cartmel, 21 October 1911. GB is ill but very much enjoyed the new drawings and verses. 'We wish you as much financial success as you need to live your own life there [London] and no more.'

24

From PN to Emily Bottomley, Chelsea [c. end October 1911]. He acknowledges the last letter and describes his rooms. 'It is the wonderful feeling of being *alone* and free in the only sense of the word, which is such a joy to me. I am shocked & hurt with myself to find I am so happy away from home, but it is so. Of course there is always the feeling that I can reach home whenever I like, that is a touch like a hand stretched out to meet yours in the night.'

25

From PN to Emily Bottomley, Chelsea, 7 November 1911. He is 'most distressed' to hear about GB. [A letter seems to be missing announcing more serious illness.] 'I wish you'd call me 'Paul' too. wouldnt it be proper.'

26

From PN to Emily Bottomley, Iver Heath, 12 November 1911. He thanks her for sending him private view cards for exhibitions which he has visited and enjoyed.

27

A letter out of Chelsea
19. Paultons Sq.
PN to GB *22 November 1911*

What a poor fellow you must be thinking me, but I have had so little time to write any longish letters since I came here. I was keen to have my room made as I planned it and that has taken some doing, now however it is right except for the quaint fact that my wall paper, chosen plain grey brown, turned out to be a job lot as the saying is and so my wall is in amusing gradations of tone, warm browns & cold brown greys—I rather like it now I am used to it, satisfies more than one mood you know. Do you know Chelsea? how it goes—anyhow you realise theres a river & embankments & things like that well Paulton Sq runs down from the great noisy King's road to the quiet easy going old river

and just round the corner at the bottom is Chelsea old Church. I have been most lucky I have one room on the first floor, it has two down-to-the-floor-up-to-the-cieling sort of windows which look onto trees—God be thanked. My landlady is of that rare class the good, do-all-I can for-you kind, she is originally from the country and tho' that's perhaps 30 years back the roses in her face still bloom! She washes my shirts & irons my ties darns my socks and mends my coats she feeds me & waits on me & rents me my room all for a guinea a week! She has hosts of buxome daughters who go singing at their work and an odd little husband all of 'em kindness personified So you need feel no anxiety for me, if it ever occured to you! for I am quite happy. So far I have only taken my drawings to three people. John Lane seemed interested & said he thought he could give me some work, after Christmas I am to go & see him again It was an ill starred moment to show him my work for just as I came in he was suffering agonies from a foreign body in the eye & dancing about the room very red & condensed and wishing all drawings to the devil. Smith Elder does hardly any illustration for books but promised to send me work if he had any in my department. Lamley of South Kensington bookseller, publisher of the rather seldom type & very good little fellow was quite enthused about my work & advised me to go to Dent & some of the younger publishers. For the time however I have called a halt, there is in my portfolio no drawing sufficiently highly finished to act as a show piece of technique this want must be supplied and until I have accomplis[h]ed such a drawing I shall not try any more publishers. Also I have to carry out a design for the Slade sketch club by the beginning of December. I hope all this interests you I seem to have got rather running. Caley Robinson's[1] designs were the right thing he is an artist. . . I have often thought of you lately and wondered how you were, how I pity you, lying still in a bed and not able to do a thing I do hope that is past tho' by now and you are freed again. Im sure you'll be amused to hear that Paul Nash is reading a lecture upon The Poetry of Dante Gabriel Rossetti on Friday at the meeting of the London University Literary Society! Ive said lecture because I'm hanged if I can stand up & solemnly read an essay—I must talk & wave my arms about It will certainly stagger humanity.[2] Talking of poetry—O the poetry of London! I have come to love London my eyes have been opened to its inner beauty I only pray I may be able to write about it or paint about it! It is great fun too having so many friends and being able to go to theatres more often and a hundred other things. I feel I am

[1] Frederic Cayley Robinson (1862–1927), painter. Designed costumes and scenery for Maeterlinck's *Blue Bird* (1909).

[2] Drawing of PN haranguing an audience, with the caption 'Paul ain't *much* like this'.

expanding (mentally!) my orchards & my fields, my deep woods they seemed everything,—enough; but they were dreamy, I was inclined to moon and moon[,] here I am more alive things pulsate, it is life warm, tingling and inspiring all about me and something in me begins to wake up & stretch & gaze eagerly on every side. And yet I can easily escape[;] there is the great quiet river going by and at night it is a wonder place for my eyes[;] it is not possible to tell you what my mind has seen but if I am let I may show it you some day in my art. I begin to talk too big, forgive me. When is your new book to be published I am longing to see it I've seen no good plays yet tho' several just amusing ones. Saturday was such a dispiriting day that my friend Wilkie[1] & myself decided we must go to the Gaiety and be amused I am one of those absurd mixtures that can be pleased to shakings of laughter by the vulgar wit of Connie Eedis & Edmund Paine[2] and at the same time appreciate every good thing of good acting—I am thankful for it. (To me Pickwick is the funniest book going and Sheridans 'Critic' the next But I drivvel.) So we tubèd to Trafalgar Square and ran down the Strand as hard as we could safely or unsafely go the rain streamed down & the narrow pavement was crammed with hurrying umbrella'd people so the race was exciting in the extreme, I won by the width of the last road! The play was as bad & as good as usual we sat in the gallery & shook. I say, isnt Lavengro one of the finest books ever writ! —real poetry Im trying to make a drawing of the fight with the Flaming Tinman!

I must stop now as Nicholson is coming in to supper & my table is strewn. Good bye and all my wishes to you & my kindest regards to Mrs Bottomley[3]

28

PN to Emily Bottomley

Wood Lane House, Iver Heath, Bucks.
Christmas Eve 1911

Dear Mrs Bottomley

Thank you so much for your splendid letter[4] and for calling me Paul both noble efforts and both charming. I dont think I believe you have white hair its too good to be true—I mean it would really be just the

[1] Ivan Wilkinson Brooks (?–1952), an intimate friend of PN at the Slade. He appears frequently in *Outline*, generally as 'Wilkie'.

[2] Connie Ediss and Edmund Payne in *Peggy*, a musical play by Geo. Grossmith jun., music by Leslie Stuart, lyrics by C. H. Bovill. It ran for 270 performances from April to December 1911. Payne took the part of Mr. Albert Umbles. Connie Ediss is not listed as a member of the cast at the beginning of the run.

[3] Here follows the drawing reproduced opposite p. 15.

[4] This letter seems to be missing.

final thing, the last touch to my picture of you and Gordon Bottomley and your far little house. But still it makes you seem older than I imagine you to be, but then after all I expect my imaginings about you both are absurdly far out. As for your imaginings of me—what between Mrs Goldsworthy's libels and my drawings I must seem the oddest person. Well I am, so you're right.

Tell Mr Bottomley I have been having a shockingly gay time these few days before Christmas I went to the Arabian Nights Ball and also the never to be forgotten Three Arts Ball The last was a very wonderful sight 5000 people in brightest costume all so gay and dancy it made one ever so happy to be among them. There were many interesting people there. I was with a party collected by Harrington Mann[1] & John Lavery[2]—Lavery is a quaint old fellow with huge horn rimmed spectacles—you think hes the dullest chap, he burbles along, staggering heavily with his sentences Harrington Mann is quite a pleasant chap with a most charming wife and delightful children—these are my latest new friends.

I was very sad to hear what a bad time your Husband has had—I only hope something may come of an operation how good it would be to make him well—I do so hope it may be. I am delighted to know he is so cheerful. I am sure he would be—O I wish you both a real happy new year with all my heart.

O yes & Im sending you a proof of my first & only etching. perpetrated the year before last[3]

29

Emily Bottomley to PN

Well Knowe House, Cartmel
[c. *early January 1912*]

Don't refuse to believe the white hair It is really rather nice! and I don't want your unbelief to have an evil effect upon it. The white hair is older than I am, having begun to arrive ere I had left my teens. (Excuse me while I turn the chestnuts which are roasting on the hob) I am a much older person. That you may see and believe I enclose the enclosed. Gordon Bottomley you may be interested to hear has black hair and a red beard with one white hair planted in the middle. That one white hair prompts my husband to say to you as you dash and splash about in the various clumps of artists "its the right way to sample them

[1] Harrington Mann, R.P. (1864–1937), portrait painter.
[2] Sir John Lavery, R.A. (1856–1941), painter.
[3] The only known etching is based on the theme of PN's short story 'The Dream Room' (see Letter 15 & no. 3). His remark here, therefore, suggests that the etching preceded the story. The only other known print is in the collection of Miss Sybil Fountain.

28

all while one is young, until the time comes when one grows old and has to make a choice."

What a ravishing picture—the Three Arts Ball with its dancing colours. We imagined Lavery as unsubstantial as air. All his ladies are so very flat it seems impossible for him to be round. Have you met Roger Fry[1] yet? If not see as much of him as you can at the enclosed Exhibition. We like Fry very much. . .

We are delighted with your etching. It makes a pleasing arabesque of lines with the right romantic feeling of richness about it.

How dare you insist upon operating upon my husband. No good cutting away any lung when that is just what he is short of! I only said a specialist was coming to see him but not to carve him!!

With lots of good wishes to you for a [*illegible*] New Year,

Your friend,

Emily Bottomley.

P.S. I have found a photo of my husband which I will also enclose. He insists he is not so fat in real life the camera pointed itself at his stomach and upset his perspect[ive].

30

From Emily Bottomley to PN, Cartmel [*? end January 1912*]. She refers to an imaginary portrait of GB which PN has sent. 'He objects to the colour of his clothes (having a decided preference for brown [)]'. It is pinned up opposite the bed and visitors say 'what a speaking likeness, at which you may hear a rustle in the bed clothes, nothing more'.

31

PN to Emily Bottomley [c. *February 1912*]

My dear Mrs Bottomley

Ever so many thanks for your letter. I am much tickled to imagine the discomforture of Gordon Bottomley I can almost hear his bedclothes rustle. But what a lucky shot to get it like him I *am* sorry about the brownlessness of his clothes I might have guessed he'd wear good brown clothes even from reading his poetry—a sort of rich warm, browness eh? I admire his taste I wear darkish blue & greys & black myself as you might gather from my drawings—tho' indeed I do not colour my designs to match my clothes. . .

. . . I have been passing through a time of blue humps lately, trying to work and getting nothing done and going gloomily about in the rain

[1] Roger Eliot Fry (1866–1934), painter and critic. Editor, *Burlington Magazine* (1910–19), Slade Professor, Cambridge (1933).

afraid of myself & feeling like hating all things. Now thank Heaven it is past and Im full of energy and clear sightedness! Youll be amused to hear Sir William Richmond[1] has taken me under his wing more like a schoolmaster than a patron but with a certain grandfatherly interest which is rather touching. To be precise he sets me drawings of things to do & bring him o' Sundays.—fear not I am in danger of the contamination of his art for I have no admiration for it at all but to *have* to get something done along with other efforts of the week is to me a real blessing for when I am uninspired & unable to go out (owing to rain) & drawing from nature to have a task to turn to is the saving of my spirit such a confession sounds weak but I think you & Gordon Bottomley will understand it. Richmond I think is sincerely interested & means to be a friend. I am awfully sorry to take you round these corners so fast.[2] Here's an end! Goodbye.

32

PN to GB [*26 March 1912*]

How are you? it is so long since word came of or from you. I have been rather silent too being busy with a drawing of dire importance. 'Tis of Isobel [Isopel] & Lavengro in the dingle and I have thought of little else for weeks. First I looked cannily around for my models and lo! found first Isobel then Lavengro in real living friends a girl who could have been an Isobel[3] & a man who was a Lavengro.[4] Of these I made two good drawings—at least they were good compared with any I have ever done afore, and then after thinking & walking & exploring & experimenting evolved a good dingle. Then came a 'orrid tussle between Paul & the picture. The picture said at the end of each day— 'ah! youre beaten now, Im like nothing on earth Im a beastly mess, you *cant* right me, tear me up.' But I said Im damned well *going* to right you, so goodnight & blew out the light. And at last I got its back broken and now its comparatively docile tho a little odd. Soon I shall send it for you to see. I have done a good many drawings of heads of late & feel at last getting beyond the board school standard of drawing. Richmond has been kindness personified and seems pleased. I have written some verse but feel much discouraged in that quarter and frightfully dried up. Is your new book out yet? The spring breaks, a clear green note is struck in my grey Chelsea Square. The river shimmers in the sun &

[1] Sir William Blake Richmond, R.A. (1843–1921), son of George Richmond, R.A. (1809–96), the friend of Blake. Portrait painter. Slade Professor at Oxford, 1878–83.
[2] Written round the edges of the page.
[3] Mercia Oakley, now Mrs. Gerald Grimsdale.
[4] Rupert Lee, painter, fellow student of PN at Slade. His portrait drawing of PN is reproduced in *Outline*, p. 124. It now belongs to Mrs. Paul Nash.

the gulls are off their heads with joy. In all the Parks the animals are mad. The squirrels have a kind of St. Vitus dance from bough to bough & the pheasants at Battersea behave *most* peculiarly. . .

I hope you are both v. well.

33

Bed. *Well Knowe House,*
Cartmel, By Carnforth
GB to P.N *28 March 1912*

Yesterday morning I awoke intending to write to you; but the post that brought your letter brought me also a bundle of proofs (the final revise of my book)

.

I fancy I owe you some six or nine months' letters: I don't see how I can ever catch up with them—but here goes.

I know I was to thank you for a copy of the U.C. Magazine containing your poem about the green-haired angel: I liked to have it and to see it in type, so let me thank you for it now.

Then I meant to reproach you for disparaging your name. 'Tis a reasonably good name; and you ought to be thankful, for it gives you a start with the right associations—think of that admirable Elizabethan Nash who wrote the lovely poem containing

> "Queens have died young, and fair,
> Dust hath closed Helen's eye".

Go to, Paul; you are an ungrateful fellow; consider what you would feel like if some one said Bottomley to you every time they wanted to speak to you—or if you were asked every time you turned up in Town if you were a relative of Horatio.

.

Then I meant to congratulate you on the chance that had opened to you of making a start for yourself in London. It is the right thing, for no man can test himself and find his right proportion to the world so long as he is sheltered in his parents' house; and I feel, too, that every artist especially needs ten years of London life in his youth, before isolation in even the most beautiful country can be fruitful for him. My illness deprived me of this, and I was hampered for many years in consequence. The only thing to remember is that you have got to justify to your father the opportunity he helps you to take; you must love art even more than you love life, and work hardest at art. If I were you I am not sure that I would altogether throw up the Slade, or, at any rate, working at some life class—and the Slade is probably the best.

.

31

There were lots of things I wanted to say about your parcel of draw-ings, but times and tides have effaced them (the things, not the drawings). At any rate, they were proofs that Tonks had led you well and not astray. I thought they showed an advance in the power of realising conceptions, and that your invention was as good as ever. The only criticism I had to make was that the texture of the whole drawing was often not rich or complete enough, and sometimes not adequate. The "Fight for a Nymph",[1] for instance, is first-rate in invention and com-position, and the group of the little fighters is superb; but the filling in of the masses left a feeling of vacant masses; the little pot-hook pattern in the trees was inexpressive as well as too open. The wreaths and ripples of the foliage wanted working into the pattern and rhythm of the whole arrangement. "The Quiet Lane"[2] has heavenly beauty in it; technique and texture are beginning to be expressive in it, and if they had been a little less shy and hesitant, the whole would have been real masterwork. I liked the tall trees and small tall ladies, too, for their intention and purpose; but again the interspaces were vacant. The "Passing of Sybil"[2] is remarkably beautiful; Blake would have loved that still recumbent figure in the flame, and I loved it. I only thought the manikins beneath needed more realising. I was delighted with many things beside—such as the sinister significant little people hunched at the bottom of the sculptured house drawing, they are splendidly seen and realised, and give me great hopes that you are going to have a power of dramatic draughtsmanship of a fine and unusual kind.

I am still wondering, with amusement and respect, how you managed to add old Richmond to your bouquet. Though his own imaginative pictures are bad, I dare say he can help you really, for he has plainly a sympathy with fine imaginative art which is not common nowadays. When he was young he did delicious portraits of ladies. There is one of Lady F. Cavendish in a house near here which is a sheer delight for melting delicate colour, all daintiness and petal-like charm like fine Oriental porcelain. There is his portrait of her husband, too, in the same room, but that is not much but a nice colour.

He should be interesting; make him tell you about Blake and Samuel Palmer and Edward Calvert.

· · · · · · ·

I meant to talk about your new poems, too, in the letters that were never written; there were many things I liked in them, and I was pleased to see the Angel and Devil verses again, and other older ones. I liked the song about the March Wind very much, and thought it marked a great advance; and the poem about the lover at his lady's window seemed to me *very* beautiful, with a gracious and pure atmo-

[1] In Mrs. Paul Nash's collection.
[2] Nothing is now known of these drawings.

sphere that was delightful to me. But you spoilt the effect of the latter by choosing a stanza-form whose essential effect lay in its regularity, and then admitting irregularities that were far too marked. You can make your own laws in art, and make them afresh for every work if you like; but once you have made them you must keep them, and if you want to be wilfully irregular you must choose an irregular form.[1]

.

There is just room to send you very kind regards from us both.

34

From PN to GB, Iver Heath, 1 April 1912. Concerned only with some friends who had failed to find GB's house. PN had previously asked if they might call, in a passage cut from Letter 32.

35

Wood Lane House, Iver Heath, Bucks.
PN to GB 8 April 1912

All my thanks for your noble letter I have looked forward to its coming for a long time and was delighted when I opened the parcel to find my hopes realised. Thank you for all the nice things you say about pictures and poems. I am sorry rather you have lost the things you had at first collected to say about some of the drawings but I was pleased you found Tonks had not turned out an *evil* influence. I accrued Richmond thus. A very charming lady[2] came to stay in these parts in the summer & I was introduced to her, subsequently she came to see my

[1] The Angel and Devil verses have been given in a footnote to page 4. The song about the March Wind cannot be exactly identified. In a manuscript book of verses preserved by Miss Sybil Fountain, dated 11 May 1910, there are verses about the wind in April, beginning:

Wearily gray fly the clouds in the moonlight . . .

'The poem about the lover at his lady's window' is almost certainly one preserved by Mrs. Paul Nash, called *At Night*. It has five seven-line stanzas and one six-line. The first stanza is given as an example:

Across the cool gray fields beneath the stars
Across the roads and meadows of the night,
Beneath the sleeping trees my spirit goes,
Beyond the river lying silver-white;
I fly, I fly unhindered through the night
Until within the tangle of the rose
I stand close-pressed against thy window bars . . .

[2] Mrs. Harry Ashworth Taylor (*née* Minna Handcock), daughter-in-law of the poet, Sir Henry Taylor, and sister-in-law of the Hon. Mrs. Handcock, daughter of the third Lord Tenterden and PN's future step-mother.

work & fell in love with it! She then told me she would like to introduce me to the older artists Richmond[,] Poynter[1] & Tadema[2] who were her personal friends Richmond came first on the list and I went to see him. Since that day he has shown me great kindness and even discussed me, over the port I imagine, with Tonks! he also read my poems & I believe thought them good anyhow he said they showed him what I was driving at & enabled him at last to understand me! He lends me enormous books & once gave me his Academy lectures to read writ viley & in MS and more or less illegible!! Poynter & Tadema I have not yet come across, they are very old & generally rather ill & at this moment my nice lady is in Florence. However she has written to the first of these two so I expect I shall soon meet that figure head of modern Art(?) You are quite right I shall not altogether give up Art classes & mean to return to my old LCC school for night classes next week. The Slade, not yet, for many reasons one being the fees! I rather wish I could have had your introduction to Elkin Mathews—may I still have a word to him from you?—remember he has not yet seen the bulk of my work & what I want introducing is my verse *If you think it worthy*. I leave it for you to say for I feel quite unable to realise the worth of my poetry or if it has *any*. This reminds me to speak about the Guthrie[3] drawings. I am a little embarrassed are they lent to me or do you mean me to keep them?!—if they are a present my remarks I feel like making upon some of them will be rather 'looking a gift horse in the mouth'—Well anyway you are not likely to be hurt. There are only two I *really* like The Evening star & one of some trees by a pool. But I have moods of them. When I first glanced thro' them I was greatly impressed & thought them rather wonderful, afterwards they interested me little save for these two which are *beautiful*. Of course they are all charged with a fine feeling of mystery & imagining & I think the Poe illustration about as near illustrating Poe as anyone can get. But often the curly wiggleness of the trees irritates me they *will* all writhe so! What I admire in them is their curious successful technique how do he do it! Thank you ever so much for sending them—if you mean me to keep them I am delighted—I feel a little uneasy as if I knew you expected me to rave over them. I cant do that somehow, they've just missed me. But I should like to possess the 'Evening Star'.

.

Alas alas the Lavengro drawing has failed.[4] But Im going to begin

[1] Sir Edward John Poynter (1836–1919), P.R.A. from 1896.

[2] Sir Laurence Alma-Tadema, O.M., R.A. (1836–1912).

[3] James Guthrie (1874–1952), friend of GB, artist and printer. The work done at his Pear Tree Press, South Harting, Hants (established *c.* May 1905) deserves a small monograph. He printed GB's *Midsummer Eve* and *The Riding to Lithend*.

[4] See Letter 81.

it a new directly & tackle it in pen and wash. I became muddled you know & dreadfully un-simple Oh it was heart breaking. Im down here a week making many new designs, soon I shall have another parcel to send you I hope. I say, do get well dear patron saint, its always a letter from Bed I am getting.

My best wishes to you & Mrs Bottomley

36

Well Knowe House, Cartmel, By Carnforth
GB to PN *17 May 1912*

It is all right about the Guthrie pictures: I begged them on purpose for you, and I meant you to keep them. I can't for the life of me tell whether I wanted you to like them or not: I think I wanted most of all to find out how they would hit you.

I think you hit on a point about the curly trees; but every man worth anything has some such singularity of vision which seems strange to every one else until they get used to it. And Guthrie has a serenity of intense vision in his best things, a sense of romance and mystery and wonder, which makes me happy to look over his curly trees and to look beyond his turbid technique.

I wish I could tell you how he gets that rich crumbly quality. Probably only the Lord knows. So far as I have seen he takes a piece of granulated cardboard and washes it over with a few brushfuls of a thin mixture of plaster of Paris. Then he digs into that with a pen and Indian ink. Then he puts on a film of Chinese white. (Paris, India, China, what riches all at once.)!

Then, he says, he shaves it.

At this point it is usually heavenly; but he has the arrogance to think he can improve it, so he practically does it over again—and worse —on the top of the original. I have his worst drawing; it is $\frac{1}{16}''$ thick with Chinese white, and underneath that Chinese white is buried a drawing of heartbreaking loveliness.

The moral for you in this story is that, whenever you think you can make a drawing better, MAKE IT BETTER ON ANOTHER PIECE OF PAPER. It keeps things clearer and saves us from the worst consequences of misjudgement and the tired eye.

If you are still exploring the mid-Victorian ages, stick to Richmond; he is more good than Poynter, on the whole, just as Poynter is more good than Alma Tacadema.

Did you ask Richmond to tell you about Blake and Palmer and Calvert? He should have Palmer's etchings, I should think. If he has,

make him show them to you; I should like, *very much*, to know what you think of them.

My chest is horrid to-day, and I can't write any more; so here is a little book to make apologies for my other shortcomings.

We both join in regards to you.

37

Wood Lane House, Iver Heath, Bucks.

PN to GB [*c. end of May 1912*]

I was so delighted to have your humourous letter & your new book[1] what have I done to receive so many joys. Your letter was a fine one & I thought & hoped you were much better in health till I came to the last & heard you had a 'horrid chest' we are all so sorry. I suddenly introduce you thus to my Father & my brother, (my sister is at school) by all of whom you are of course so well known & admired. My father reads not your poems. he does not care for poetry he says with sadness, but he reads your letters to me & regards you with a respectful awe I think and always thinks of you with gratitude for all you have done for his son. My brother is a reader & admirer of your work & Barbara is not unmindful of it. In fact the name of Gordon Bottomley is a household word!

I want to say how much I enjoy this last 'Chambers of Imagery' Some of the poems sadden me they seem so full of your life as I picture it. I realise keenly thro them the point of view of a poet prisoned in a room, looking out over the fields. I am surprised by the almost dramatic change of form & expression I mean the contrast to the poetry in the Gate of Smaragdus. I have lately been reading that book a good deal so have become used to the 'poetry of the adjective' & now I read these simple Landor like verses with wonder. Of course there is as strongly as ever your personality there & everything which is so absolutely you. But it is a change. 'The end of the world' is beautiful to me, some others made my heart ache somehow. The Hymn of Imagination is a great unusual thing like your poems on Form & Touch & I love them & never tire of them. They seem to supply a want as no other poems have done—to be a hitherto unattempted expression of thought, very interesting & keen & searching & satisfying Im afraid Im talking rather like a book! I was going to send you a great parcel of drawings but owing to people (buyers we pray!) wanting to see the work & Sunday being the day I have to submit it to Richmond there is no time yet & I must wait. Instead I venture to try & amuse you by sending you some of the drawings of John N[orthcote] Nash brother of Paul. These start for

[1] *Chambers of Imagery*, second series; a small pamphlet with yellow paper covers.

36

the North tomorrow (if Jack will let them) with the hope you will see the fun of them. To me they're great & like no one else's. What an atrocious joke on Tadema! Oh fie! Your description of Guthrie's 'underhand methods' is awfully funny I suppose he *is* rather a marvel: thank you *very* much for those drawings for keeps. You *wont* say anything about Elkin Mathews & me submitting pomes to him you simply wont. . . . Give my best Sunday regards to Mrs Bottomley & say I hope shes very well & Im going to write to her soon so as to get one of her pleasing letters Best wishes & hopes you will be soon better

38

From Emily Bottomley to PN, Cartmel, 3 June 1912. She thanks PN for a parcel of drawings and says they are leaving for Buxton the next day.

39

Well Knowe House, Cartmel,
By Carnforth
GB to PN *7 July 1912*

I always treat you badly, and now I have been treating your brother badly as well. Forgive me. I meant to write to you from Buxton, but getting well made me so unwell, and succeeded so imperfectly, that I could not. I hope you received the drawings safely.

We enjoyed your brother's drawings greatly (being particularly impressed by his profound belief that the human countenance fundamentally resembles a bird's), and we were constantly finding touches and passages to admire. We think he shows real promise—considerable promise. I don't know how the instinct for draughtsmanship entered your family, but it is there and it would be useless to try to chill it. He has not only a good sense of decorative disposition of his masses, but his blacks have a beautiful quality, and his pen-touch is crisp and clear and delicate and exquisitely balanced. You do not say what your father is thinking of making of him; but in any case these are qualities of tact as valuable in human conduct as they are in art, and it can do him nothing but good to give rein to his feeling for drawing. In facility and lucidity and directness of expression, and in his faculty of keeping his material untroubled, he has advantages over you; but of course it remains to be seen if he can preserve these qualities when he has as much to say as you have. His fun is first-rate; we adored the foot-and-mouth asylum hugely. In another way we thought his railway nocturnes full of good qualities and of feeling for beautiful night. In still another way we found his Madame Mysterieuse interesting; for if he has never

seen work by Conder[1] or Gordon Craig[2] he has made in it quite remarkable discoveries about the handling and quality of water-colour. Please thank him for letting us see his drawings, and urge him to go on.

I do apologise for not answering you about Mathews before: I really thought I had done so. Of course I shall be willing and most pleased to ask him to consider your verse and to say that I believe it to be full of fine qualities and promise, whenever you would like me to do so. But even if he likes your work he will want you to pay him from £10 to £15 before he will publish it. That is all right, of course, if you think the money will be of the most use to you spent in that way; but you cannot be certain, especially with a first book, that the sales will recoup you for the outlay. On the whole I should be inclined to urge you to wait a year or two, and in the meantime to work for a firmer and firmer grip of verse-architecture. And it will be good experience to send verses to papers that only print good verse, like *The Saturday Review*[3] and *The Nation*,[4] that pay for verse, and also to artists' magazines like *Rhythm*,[5] and *Orpheus*.[6]

I was very pleased with what you said of my yellow bookling; you take its significance in the way I mean it to be taken, and not many people's praise has gratified me as much as yours. In a few years there will not seem as much difference in our ages as there does now; and by then you will know that one always feels to be just beginning. I am always sure that I have found the right way at last, and that I shall do the Real Thing next time.

Please give my respect to your father, and thank him for not being annoyed with me for inoculating his son with strange doctrine. You have a good father, as I have, and it is half the battle for an artist or a poet to have his father's sympathy; and if he does not care for poetry, as you say, still he will care when you prove to him that poetry makes for the deep and worthy things of life, the significant and important things that are reached as truly by way of poetry as by any other way.

I can't write any more to-day, Paolo. My wife joins me in remembrances to you.

40

PN to GB [c. *12 July 1912*]

I was right glad to have your splendid letter you have a seemingly inexhaustible store of generous words. Jack is very much 'set up for the

[1] Charles Conder, painter (1868–1909).
[2] Gordon Craig (b. 1872) is, of course, the famous actor, theatrical producer and designer, son of Ellen Terry.
[3] Ed. Harold Hodge. [4] Ed. H. W. Massingham.
[5] This short-lived periodical ran from summer 1911 till March 1913.
[6] Published at Paisley.

rest of 'is natural', as the vulgar have it, upon your high praise—I dont mean he has swollen his headpiece for he ever expresses a mild surprise at any appreciation upon his drawings, which he does at odd times on odd bits of paper when he has nothing else to do. I, from time to time, raid his desk or the waste paper basket or the corners of the room & collect the odd bits of paper rather like a park-keeper in Kensington Gardens. and after a sorting of chaff from grain tho to be sure its all 'chaff' I select the best & cut them into a decent shape & mount them. At first Jack used to be so delighted at the good appearance of his drawings when mounted that he fully believed it was entirely owing to the way I set them up & drew lines round them; gradually it has dawned on him tho' that it must be he has done a good drawing—this is a pity because he now becomes a little too concious & careful, with the result his designs are not so naive & simple. At present he is working on the staff of a country paper & gaining experience for a journalistic career. All his abilities lie in that direction and he will tell you his ambition is to be 'a man of letters'. These drawings are as yet his only expression of himself. He is very observant and writes excellent descriptions of things that strike him, always with the same quaint touch you see in these designs. He has so far done very little actual writing save a few articles in the paper & some essays when he was at Wellington. The work for the paper takes all his time & he is riding about & reporting all over the county & at all times of day & night. Unfortunately his time is up in August for this has been experience & work quite unpaid as regards salary, and then I really dont know what happens—a London paper I suppose is the next thing—he likes regular work & routine, unlike me, & works well; at the same time he is not constitutionally robust & v. hard work in London would not be good for him I fear. I myself have no doubt he has a most interesting self to develope, & work to produce, but how & in what direction I really am not certain.

Thank you so much for your promise to reccomend me to Mathews I shall take your advice I think & wait. I have good news for you at least it sounds good, I only hope it may *be* eventually good. As you know, I still visit Richmond & take my work. He has been a great help & as a spiritual pastor & master so to speak has been kindness & wisdom personified. Well, in the Spring I did some out o' door landscapes—during Easter week I think, and in due course showed 'em to Billy. Says he 'My dear dear boy you have a great feeling for Nature I think' & turning on the taps of his wisdom & kindness to the full he made a long speech. At the close of which says I 'I am grateful to know you think all this of me but you know I want to go to Paris & I must make some money, my development is no doubt interesting but my selling powers are feeble & unproductive. (or words to that effect) Says he 'Ill help you go & work at landscapes for a month & Ill send them with a letter

of reccomendation to the Carfax Gallery.' (by the way have I told you this before do interrupt me if so) I went & made pictures in the country I got rather few done but some were goodish—I stood again before the Richmond. And that good old man got quite excited & over come with emotion swore I was going to be a great landscape painter & burbled about a 'mission' & no end of wonderful things. And 'Go on, go on my dear boy' says he 'and do some more & I think you might have a show in London in the Autumn for that is a better way to gain attention & strike your own particular new note'. Well this is a devilish long blast of Paul's trumpet and I think thats about all. Billy thinks I see landscape in a new way or something and now I have given up my Chelsea room for the present & am working hard down here at landscapes & other drawings. Imaginative inventive drawings still happen but I keep them separate from the Nature ones. My aim is to amass enough pictures for a show, make a little money, join my friend Wilkie[1] in Paris, live in the Quater & sweat at the nude 'till Im dizzy. There!' These wonderful old Nature drawings go bumping down to Cartmel next week for you to see & many others of various odd things. Thank you very much for all the things you said in your letter I felt so proud I had given you pleasure by my appreciation of your book. I have just lent a man your "Riding to Lithend", this is a new friend of mine, Nugent Monck,[2] the producer for the Irish Players at the Abbey Theatre. He kindly gave me seats for 'Countess Cathleen' at the Court last Thursday which I greatly enjoyed Marie O'Niel[3] is a most beautiful & wonderful player. There is not room or time now to tell you all about it. Monck saw some of y[r] poems & wanted immediately to see yr other work so I am lending him what I have. He is going to present me to Yeats—rather fun. Give my love to Mrs Bottomley & say I *will* write & ask her to forgive me.

.

41

Well Knowe House, Cartmel,
By Carnforth
GB to PN *15 July 1912*

I was glad to have your letter this morning, and to hear of your plans. From the backgrounds of many of your figure drawings—and from

[1] See note 1, p. 27.

[2] 1878–1953. Best known for his work as director and producer at the Maddermarket Theatre, Norwich. He started the Norwich Players in 1911, was producer to the Abbey Theatre, Dublin, in 1912, visited America with that company in 1913, and returned to the Norwich Players in 1914.

[3] Maire O'Neill.

"The Quiet Lane" too—I can understand that Richmond is right about your new landscape works; and I am much looking forward to seeing the latter.

But I am an argumentative fellow, and what you say in your letter makes me want to develope my theories of the nature position and relationship of nature and landscape to art. However you are spared that boredom because the heat has dished me; but here is an article in The Times[1] (written, I fancy, by an acquaintance of mine) which so completely expresses my feeling that I should like you to see it. So I send it with this. And, as I feel so strongly that the great painters express their feeling for nature as much by representing men as by representing trees, I hope you will never forget to do imaginative inventive drawings too. One will help the other, and the real Paul will not eventually stand on both feet without both of them.

Is you[r] heart set greatly on Paris? It would all be education in life, and you would have a gay and gorgeous time; but it would not be the least use in the world for your kind of art.

The cosmopolitan kind of art evolved there is a gutless and eviscerated turnip-lantern that would guide you nowhere. A real will o' the wisp would be better. I have seen lots of people who went to Paris to grow dizzy over studying the nude: the impostors learnt a highly organised series of tricks which enabled them to pass as up-to-date real artists with nothing to say; the true artists, by absorbing the same recipes for avoiding thought and inspiration, were only delayed for about ten years from arriving at their true talent. My wife agrees with all this, and adds that there are enough nude people in England for your purpose, so why go to Paris to study the nude.

I was greatly interested to hear of Nugent Monck, and should be glad to hear more about him when you have time. I believe he is a first-rate man.

[1] *The Times*, 17 May 1912: *The Royal Academy, Third Notice; Portraits and Landscapes.* These sentences seem to be in question:
'Modern landscape painting, at the Academy as elsewhere, suffers from specialization. Able landscape painters . . . lack that sharpness of accent which, apparently, can only be acquired from figure-painting and which is an expression of our peculiar interes in humanity. The problem of the landscape painter, among many other problems, is to apply this sharpness of accent to the forms of nature, and by means of it to produce a composition which shall not be merely an harmonious arrangement, but shall express the artist's own individual interest in the objects which he paints. Great masters of the figure like Tintoret and Rembrandt did lay this peculiar emphasis on trees and the contours of the earth. They could paint a landscape as if it were a human being and give to it an intensity of grandeur hardly found in modern landscape art except in the greatest works of Turner.'

P.N to GB [c. *1 August 1912*]

Im so sorry you have had to wait so long for the drawings. I have kept them back to show someone and later to polish up before they went on parade. I was delighted to have your letter and hasten to assure you now on all points. First I have privately & inwardly felt what is expressed in the article you send & welcome its timely utterance which gives my thought relief and you may be sure of me trying to attain thro converging directions of my art the desired straddle, like the Colossus of Rhodes.[1] Not that he arrived in that position by converging arts exactly, but he arrives in my mind when you talk of the 'real Paul' standing on two legs. Only the other day I stood before one of Titians paintings & thought first, "my *only* Aunt', what a gorgeous landscape! & then 'my Hat', what tremendous figures!—why damme, the figures are no greater than the landscape, the landscape is no more tremendous than the figures!—then by Jove, they are *one* they are *it* the picture is complete—*thats* what I want." And all this in the article is to my mind absolutely, 'I feel, I feel it all.' True I have tried along with those others mentioned in the article, to paint trees as tho they were human beings not that I realised myself in the same boat with any one, or that the Chinese masters had succeeded where me in the boat had failed; but because I sincerely love & worship trees & know they *are* people & wonderfully beautiful people—much more lovely than the majority of people one meets. Again I turned to landscape not for the landscape sake but for the 'things behind'[,] the dweller in the innermost: whose light shines thro' sometimes I went out to try & give a hint in my drawings of those sometimeses. (I cannot express myself I cannot trouble to express myself it is Sunday they took me to Church all the windy morning and I have just eaten my Sunday lunch why does Sundays lunch feel so heavy—I dont eat any more than other days yet I am left to the cutle-fishy clutches of a coma for the rest of the afternoon—hence a stuggy brain & uninspired expressions.) Well, you with your fine sympathy & touch will know what Paul is trying to say! I am *not* giving up inventive imaginative designs but I must take most time just at present for land-scapes; imaginative expression in the other direction, because of com-piling pickers for my hoped-for show in Octobre. Now as to Paris. I aint going to Paris to learn tricks or because 'you ought to go to Paris' as every one who knows nothing about it tells every artist who hasnt been. No, but because I feel if I can get away into the world & have to fend for myself more I may be driven to eating bread & chesnuts & painting peoples gates or something which would put me on my metal & bring

[1] A drawing of a self-confident PN bestriding two hummocks illustrates this.

PLATE III

Hallgerd Refuses her Hair to Gunnar, *by Paul Nash, 1910. Chalk and pencil, 9¾″ × 15¾″. An illustration to the play* Riding to Lithend

PLATE IV

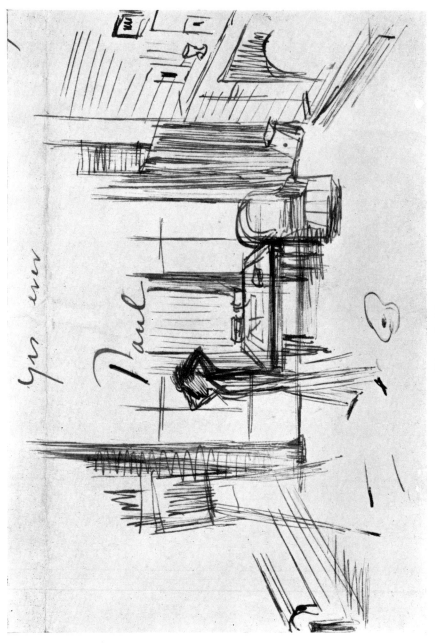

The end of Letter 27

out what is called 'the best' in me. Also I might be able to walk to Rome at last which is one of my dreams also I want adventure and to embrace the whole world. My friend Wilkie has now got a studio in the Quarter which I could inexpensively share I should not go to Julians or who ever I should be supposed to go to, but draw from a nude on my own with a bunch of other people in a smallish room where no master comes. As well I should go about drawing Paris & people. Mrs Bottomley's remark about there being enough nude people in England is one of the most amusing things Ive heard, I did laugh over it—she is right but tell her these things I set down here & she will understand that my idea of going to Paris contained more than met the eye & that I am not going to Paris because its Paris; Paris only happens to be the name of the place I am going to. And then of course it may not be Paris after all, I may find what I want thro another gate but at present that seems to be the way.

Do you think that working in the way I have suggested I should be infected & contaminated as an artist by what you fear in Paris?

Now about the drawings in this ungainly postman hated parcel. I have written some dates on the backs & marked the few which are very wanting in finish & looking them all over I feel they are very far from satisfactory. Oh if I could paint my visions, if I could tell my dreams— it is an old useless cry but indeed I feel how little I have attained. Try and give me some shrewd knocks among that inexhaustible kindness of back pattings I am sure of from *you*! Lately I have been writing more I have many ideas but find it difficult & slow forming them I send one verse—not very exciting but perhaps better built than some. Tell me about it when you have leisure to write. Dont hurry to write because I know you shouldn't—Send the drawings at the end of the week— Saturday or something adjacent if you have had enough of 'em. I will write about Monck when he returns 'The Riding to Lithend' I hope he will talk about it. He's a sound earnest fellow, simple like a child and quite unpracticle: when he wears a wig & no trousers he is said to dance like any nymph; in real life he is bald and wears baggy trousers.

My best Sunday regards & wishes to Mrs Bottomley & hopes from us all that you are better.

Ever yrs. Paul

Later. 11.30 pm.

NB. My father wishes to say he is deeply sensible of your kindness to me & the interest you take in my work. He quite appreciates the sentiments expressed in your little message to him & has just made a long speech between pipe puffings which I cant for the life of me remember as I was writing a verse at the time. However I have given you the drift of it in the above sentence. He joins with Jack & me in wishing you a quick

43

recovery & return to good health. This sounds like a manifesto or a circular of some sort—but Im getting sleepy. Good night

<div align="right">PN</div>

Had this parcel sent back by the P.O. so have unmounted one drawing

<div align="center">EVENING</div>

Upon a thrushes last late notes
I felt the evening fold her wing
About the garden soon to sleep
In its close covering.

Dream-laded trees seemed half to wake,
Rapt to the splendour in the skies;
And brood upon the fading day
With countless hidden eyes.

Soon to a silent-twinkling star
Their eyes must fall on deeper dreams
Beyond those past at bird-thronged noon
Or under morning beams.

Late down the spaces of the sky
I watched a lark fall thro' the west
'Till grasses drowned him, where his mate
Hid, waiting, her brown breast.

The kine upon the hill low faint
Beneath the chestnuts, down the fields
Then no more notes, but emptiness
As when a bell has pealed.

In these last moments of the day
I saw two hands reach down the skies
I felt a wing fold round, I saw
Past skies to other eyes.

<div align="center">43</div>

From Emily Bottomley to PN, Cartmel, 5 August 1912. She acknowledges the parcel of drawings and mentions their preferences—*The Wind among the Trees, The Three, The Field before the Wood, Mercia Oakley, The Good Aunt, Lavengro, The Vision at Evening,* 'and perhaps most of all *The Falling Stars* if it had been properly done!!!'

[The last three are reproduced in *Outline*, pp. 112, 97, and 80. Others are in *Paul Nash*, ed. Eates.]

PN to Emily Bottomley [c. *10 August 1912*]

Thank you so much for your letter. I knew you would be likely to like 'The Vision at Evening' and I am very pleased you cared for it so much. I hoped however you would find as much individualism & character in my landscape drawings for they are very real to me and I feel I succeed better in 'finding myself' thro them than in any other direction. Nature is there before me, & any thoughts of how other people would express what I see there do not intrude on my mind—I go ahead my own way. But left to my imagination & invention entirely I *know* I sometimes become influenced by men like Rossetti, Blake & even Sime.[1] I say 'even', because I feel rather ashamed to be swayed at all by a lesser-modern. Just at the moment I am beginning a big imaginative design which has been a-simmering a long while in the brain pan —its from the psalm 'Lift up your heads, O ye gates; & be ye lift up ye everlasting doors.' There are many other ideas for designs swimming about my mind but I cant catch em quite yet Forgive a scimpy letter the morning is so full

45

From Emily Bottomley to PN, Cartmel [c. *13 August 1912*]. She acknowledges the last letter, reassures him about being 'swayed', and repeats their admiration for the drawings.

46

From PN to Emily Bottomley, 15 August [*1912*]. He acknowledges the last letter and has been made happy by it after a period of depression and bad weather. He has been to the Russian ballet—'real dancing. Gené[e] is a revolving hoop stick to such'.[2]

[1] Sidney H. Sime, a minor figure of the nineties, was chiefly a black-and-white illustrator. He was for a time joint editor of the *Idler* and is perhaps best known for his illustrations to Lord Dunsany's books and for pictures showing Blake's influence. He died in May 1941, aged 76.

[2] A blot has become the starting-place for a drawing of 'a rather marvellous Dancing lady'.

47

Well Knowe House, Cartmel, By Carnforth
19 August 1912

· · · · · · ·

Yes you must go to Paris if you want to; you shall go to Anywhere-you-like if only you keep out of the way of the people who go there to learn what to paint. I have been a vegetable so long that I do not always remember the stir in the blood that sets a man on the high road; but living comes first, and you are right in feeling that Paris is a good place to learn to live in. And even if Paris and Rome do not do much for you, the road between will do wonders. Our own parish is the only place we need when we would find subjects for our art; but we have to go round the world and enter our own parish anew from the other side before we can see those subjects.

Your drawing is getting surer and more truly imaginative in execution as well as purpose. Your good Aunt and Mercia Oakley are first rate; and I like parts of your sister nearly as much.

I was first attracted to your drawings by the glimpses they gave of the secret places of your mind; but I knew then that you would have to learn exteriorisation and observation before you could tell your secrets potently; so I am not sorrowful that you seem to be leaving your first love for the sake of interpreting the secrets of external nature: it had to come, and if you do not return to the old themes you will find new ones and I shall be enchanted by those also if you are careful not to stop growing in the middle of your career as most artists do; for I trust your essential vision.

The trees in "The Peacock Path" and "The Wind in the Trees" are very good; "The Field Beyond the Wood" is good all over, and nearly a masterpiece; *but* the "Falling Stars" and "The Three" are new and wonderful in a way that no one has achieved before, and Richmond says no more than the truth about you.

Now for the hard knocks you request. Your execution is not ripe and complete enough; the foreground of "The Peacock Path" is only a rude hint of what it should be. And, worse than that, your method lacks integrity; the way you have done that fine "Falling Stars" is as bad as getting goods without paying for them; you should not dig out stars and moons with a knife; it is cheap as well as wicked and it makes it impossible to look at the picture with any pleasure except when one is straight in front of it. (Incidentally, I do feel you ought to use better paper; and the black stuff you use for your black backgrounds will eventually break the hearts of all your admirers as it has nearly broken mine already. It will all be rubbed off in twenty years.)

What I really mean by all this offensive language is that when you

do things anyhow, in your present way, your picture has the look of having been broken in stubbornly and sullenly to your purpose; and, though you make your effect, it presents itself ungraciously to the spectator and the spectator receives it almost against his will.

Yet if you were considerate and thoughtful to your material it would help you to gain your effect by unsuspected qualities and subtleties that would seem like miracles of harmonised effort. I think this will come to you with difficulty, for your present method is to take a sledge-hammer and go through whatever comes in your way; but, if you have to fight hard for it, it will be all the more worth having, for it will increase the expressiveness of your hand and tools.

I feel it would be really good for you, on the one hand, to have to work in some compulsorily pure medium, such as silver-point, a little; on the other hand I think you need most to take to oil paint and canvas —oil-paint lends itself to the expression of great and deep things, and by its very nature it would do away with the subterfuges you employ at present. You might begin with monochrome, on your present scale, if you liked; but even then it would be painting, and not drawing, and would lead instinctively to your use of full colour. Of course oil-paint has its nature too and can look like veils and films and slices of translucent jewels and mosaics of opaque jewels on the one hand, and like smears of mud on the other; but at the worst it can be looked at from all points and does not shew shining scabs and scars as some of your finest drawings do when approached sideways.

Your "Evening" poem is beautiful, but it is not complete; I like it, but that is partly because I know the trend of your mind and can meet you half way; a stranger might not gather your meaning as completely. It is well built and arranged, but to get all the feeling into it that you want to do you will, I think, have to use simple unnoticeable quiet words; the sensation of that wonderful hour cannot creep in if the words are even noticeably beautiful.

I have preached too long; but you have this advantage in my church, that you need not sit still and listen any longer than you feel inclined. We both send you our remembrances.

48

Iver Heath

PN to GB *21 August* [*1912*]

I am most grateful for your letter. It came at a time when I was indeed low and shamefully depressed and tho' I have been down pretty low again since, it did much for me really by lifting me up a moment. I have spent nearly three weeks making pictures which, unknown to

me, are from the first, doomed; and when my eyes are opened to this tearing them up and beginning anew and muddling for days & tearing up again. Then when I was tired of that game I started a new outdoor drawing—but the devil or someone said 'no you dont,' and at half hour intervals I was interrupted by heavy rain—this lead eventually to another up-tearing. So I began some 'imaginative' landscapes indoors, they went most damnably wrong: my brain seemed a hollow tunnel thro' which stupid meaningless trains of thought rushed, or just aimless winds of nothing at all. At last I nearly wept; indeed I *did* cry inside and made an attempt at weeping but returned soon to my board and suddenly did a queer drawing of pyramids crashing about in the sea in uncanny eclipsed moon light;[1]—this promises thank God; & today at last, after what seems an age of rain, has been sunny & fine and I have begun a good drawing in an orchard. So you see I stand a chance of pulling round now. What haunts me is the thought of the 'show' and if I should not get enough drawings done in time! However, as they say. Your lecture is most needed to Paul he is a born ass the way he messes up his drawings. Tonks always curses me for it but it is not all perversity, I have an unhappy thirst for bad paper I always do my best drawings on bad paper, Im positively superstitious about it. Once I had a shilling block of cartridge paper from which I cut the sheets for three of my best drawings—it used to inspire me somehow. And as soon as I begin a design on a pure white Whatman sheet I feel uneasy and invariably shave it & bathroom tap it to a state of emaciated collapse before I have any success upon it.

But with regard to my mixed methods & muddled mediums I know I am rather a crawler and deserve several months 'hard' for most of my last pictures. I feel tho' it all points to beginning oils I *want* to and I *ought* to, so I shall.

I am so delighted you are pleased with the new drawings—curiously enough Richmond hasn't seen 'The Three' & only a beginning of 'The Falling Stars' the drawings he likes are The Field before the Wood, The House among queer trees & Spring at the Hawk's Wood.[2] O yes and The windy trees one. The back ground of the star drawing is blue ink first, then chalk, then indian ink then conté and the holes & scars are the places where a moon, some too-many stars, two embracing figures, & a fairy have been not quite successfully obliterated. I dont generally behave like that but this is an unfortunate case—dont disown me on it! You have touched me by calling yourself, pathetically a Vegetable it is a mournful thought but you're a jolly active sort of vegetable too, a sprout I should think you come nearest to—one of those chaps who is always putting forth chubby juicy beautifully constructed bunches

[1] *Pyramids in the Sea*, now in the collection of Mrs. Gerald Grimsdale.
[2] Reproduced in *Outline*, p. 84.

48

of leaves—the simile is little involved but your mind must meet me half way as in the poem! Yes I understand about the quiet words—I try not to be a word wallower but I'm afraid I am not strict enough one must be a monk simply—so simple & severe. I will send you some more verses soon. Monck aint sent home 'Lithend' yet but has promised to, he is very busy I believe—he wants to get hold of everything you have ever writ. I am going to Wallingford in Berkshire next month and there hope to find some fine things those wonderful Downs and wild woods down by the river I have haunted them often and now I am going to try & interpret some of their secrets.[1] I shall send you another parcel, if you're up to it, about October—perhaps before that. If we should not meet till then—goodbye with our united good wishes & kind regards & all that & hopes that you will keep well

49

Iver Heath
PN to GB [c. *October 1912*]

Here's news here's news! The Carfax are *giving* me a show on the 7th November. Not in the gallery room proper for that is booked years ahead but on the wall as you go in. And Im to have press notices and a private view & fame—or ridicule—success or failure—or neither! 20 drawings I can show—all landscapes of a kind, 5 of which are moony ones. Isnt it fun! Oh how I wish you & Mrs Bottomley could be there —how proud I should feel. but if it is a success I shall have made a little money & then confound & curse me if I dont come up & see what you are like—just for the day & back again!

It was Richmond's idea to try the Carfax—he was so pleased with the 22 drawings I had to show on his return from Italy that he went himself to the Carfax but as a matter of fact the manager was out, so Richmond saw no one & spoke no word & in the end the drawings stood on their merits & were accepted. The private view is to be the same day as the man who has the gallery proper Maxwell Armfield[2] so I get a double crowd.

It has never been done before—thats the joke of it—two shows at the same time & its all my own idea too thats another joke—and if I sell some pictures & get a little known that'll be the greatest joke of all! Of course I have to pay for printing the cards & catalogues & they get 25% on each picture sold. They might sell you know just *might*. But

[1] The Nash family stayed with relations at Sinodun House near Wallingford every year for the shooting. It was close by Wittenham Clumps which he frequently drew and painted, early and late in life.

[2] (Born 1882), writer, lecturer, stage designer, and painter. His work is represented in the British Museum.

Im rather weary with it all even so soon & shall be glad when it's all done. But I must ask you a favour—would you send some cards to people you think would be good ones to go? I hope you will not mind me asking—you know many folk of an interesting feather if you could induce 'em to fly there—critics especially if they would write. What do you think? If you will, send *me* a card & I will send cards a few to you. Now goodbye tell me how you are—& give my kindest wishes to Mrs Bottomley

<div align="right">

Yrs ever
Paul Nash

</div>

This is a poor selfish letter—forgive it. I will write again. P N

50

From Emily Bottomley to PN, c/o R. C. Trevelyan, The Shiffolds, Holmbury St. Mary, nr. Dorking [early November 1912]. They are at this address for the winter. [It was the home of the poet and classical scholar, Robert Calverley Trevelyan (1872–1951).] She will be able to be at PN's private view but GB will not be well enough.

51

<div align="right">

Iver Heath, Bucks.
[*Early November 1912*]

</div>

PN to Emily Bottomley

The show is not going well The people of sense & sensibility admire and desire but cannot afford—& the people of ignorance and affluence are afraid to buy because no one has told them they ought. So between the two the pictures hang there looking silly and I am rather miserable. I have heard many praises from great people but no real general excitement as I hoped—vainly & foolishly hoped, I suppose. I met Hamilton Hay[1] with great pleasure & was so glad he liked the drawings.—ah yes how eagerly I looked for *The* White haired Lady—never mind, I shall see you on Saturday . but come in *the morning* the gallery closes at 1 oc you know. How *is* Gordon Bottomley tell him I am being a disappointed discontented pig but will get over it soon. I 'aint seen Sturge Moore:[2] do get him to review to some purpose—as yet the notices have been curt & scrappy tho' kind. I wish theyed cheerfully *damned* me—but then

[1] James Hamilton Hay (1875–1916), artist, close friend of GB and Emily Bottomley. A Memorial Exhibition of his works was held at the Goupil Gallery in March 1917. The catalogue contains an appreciation by GB.

[2] Thomas Sturge Moore (1870–1944), poet and artist.

landscape drawings *must* be eminently respectable & people wont go & see things unless they think they really *ought* not to. I mean I have no scope for impropriety & be it confessed, no inclination conscious or subconscious for its expression—so 'hiegh ho, the wind & the rain' So far 3 pictures are sold & two being negotiated for but 2 out of the 5 are bought by dear friends—they are sincere *likers* too but still—friends. I want a totally strange man of taste & wealth to appear, admire, & buy because he wants the thing; then I shall be content; so far I am unconvinced and gloomy.

52

Iver Heath, Bucks.

PN to GB [c. *mid-November 1912*]

My dear Gordon Bottomley

(I say, do you mind me omitting your Mister, I feel it is a piece of puce & periphrastic pretence for I never *think* of you as *Mr* Bottomley & *speak* of you as sich so why should I *call* you Mr Bottomley?) The show has woke up & is now crowing. On Thursday in bounced W Rothenstein with great keeness, tho' dashed at first to find he was a week late for the Private View, earnestly scanned the drawings & then with beaming eyes proceeded to cover me with compliments & confusion. Then he tried to buy two pictures which alas were irrevocably sold to an aristocratic aunt & eventually insisted on taking 'The Falling Stars' Damn!—in a way, for I was going to give it to you after the show, never mind I shall do better things later. Rothenstein then threatened to write to the papers & demand why the divil people hadn't bought my drawings or liked them, or something & then—oh well, he said such a lot & it was all so interesting & encouraging I shall tell you it when I see you. Which brings me to the cause of my letter now, to say, *when shall I come*? Thursday or Friday this week could I come? What vast excitement for me! Dont bother to write but ask Mrs Bottomley to kindly send me a card, so I may make my arrangements Oh by the way, Roger Fry who I especially wanted to see come has been & gone & not gone nor Sturgius Moorus neither.

Now I must cease these outpourings I was delighted to hear you were better & hope you'll go on keeping so until we meet

Yrs

Paul[1]

Eight pictures are now sold!

I *did* enjoy meeting Mrs Bottomley.

[1] Drawing of a delighted PN throwing his hat in the air.

53

From Emily Bottomley to PN, Holmbury St. Mary, Monday evening [c. *mid-November 1912*]. She invites him to come from Saturday to Monday.

54

From PN to Emily Bottomley, Iver Heath [c. *mid-November 1912*]. Accepts the invitation in last letter. 'I shall have a black at.'[1]

55

From PN to Emily Bottomley, Iver Heath [21 *November 1912*]. The week-end has been put off. A letter or telegram from Emily Bottomley must be missing. Rothenstein is going to give him lessons in tempera.[2]

56

From PN to GB, Iver Heath [c. *end of November 1912*]. He is sending GB 'a bunch of drawings' to choose one from. He is returning to the Bolt Court school, 'because I'm a damned ignorant brute and lack knowledge of gents & ladies shapes & anatomy'. He and Rupert Lee are 'starting a society for the propagation & admiration of Gordon Bottomley If you dont mind its quite a serious affair'.

[They appear to have met in the interval between this and the preceding letter.]

57

PN to GB

Wood Lane House, Iver Heath, Bucks.
Friday [c. *end of November 1912*]

here are a few rather grubby & unfinished drawings. I remembered I had promised to send them but it would have been better to have sent finished things, than these. The pink un is really supposed to be at the Carfax, for sale, but I borrowed it t'other day to show someone & then I thought I'd keep it to send you; but it must come back rather quick I suppose or Clifton will be wondering. The 2 light pen & wash

[1] Drawing of him wearing the same.
[2] Drawing, 'the end of the show'. PN prosperous in a frock coat pointing to a cane and what is 'confidently supposed to represent a tophat'.

drawings are from the Show but 'The Archer'[1] & the cliff one are new: the first a commission. The big one is that picture I started last year for 'Lavengro teaching Isopel Berners Armenian, in the dingle,' I had spoilt it & consigned it to the failure drawer when one day I realised its possibilities so took & washed it & built it up as far as you see it at present. Of course there is a lot to do to it yet. I am at work on three drawings of heads & have some ideas for new pictures & at nights I go to Bolt Court school & draw the figure I wonder if you'll like the Pink picture. I tried to suggest that wonderful emotion that comes over one at dawn or sunset on some days when beauty is so great & over-powering that it simply beats you down. On those occasions I want to thank someone or something upon my knees & I think most people do; so I have drawn here a collosal kneeling figure upon a hill at sundown. Some people seem to get behind the incompetance of the drawing & the crudeness of the paint & do really like the damn thing other folk I think hate it. I wish I could realise things better I'm such a hinter of beauty a drivveling inuendoeist only, at present. I do so hope you will be able to ask me down soon. In rather a hurry

.

58

From Emily Bottomley to P.N, Holmbury St. Mary, Wednesday morning [*end of November 1912*]. She acknowledges the parcel of drawings and asks him for the following week-end.

58A

From GB to P.N on the same sheet as 58. He is very enthusiastic about 'the pink picture' [this cannot be identified], *The Archer*, and *Under the Hill*.

59

From P.N to Emily Bottomley, The Presbytery, Overstrand Road, Cromer, 'till Tuesday', *1 December 1912*. He is on a visit to his Slade friend, Claughton Pellew-Harvey and unable to accept the invitation given in Letter 58.

60

From P.N to Emily Bottomley, Iver Heath [? *mid-December 1912*]. He has left a letter [missing] from Emily Bottomley too long unanswered. He has been rushing about and meeting people.

[1] The figure was removed from this drawing and it was renamed *Night Landscape*. It is reproduced in *Outline*, p. 85, and now belongs to the Arts Council. It has no connexion with the later picture called *The Archer*.

61

From P.N to Emily Bottomley, Iver Heath [? January 1913]. He suggests a meeting in London for her to take back a picture they want to see again—*Spring at the Hawk's Wood*.

[The order of letters 58 to 61 is doubtful, but they chiefly concern arrangements of meetings and are not important.]

62

PN to GB

Wood Lane House, Iver Heath, Bucks.
[c. early March 1913]

I am so sorry to have kept you all waiting so long for Jack's parcel & the portrait of a poet. But I have been admid wonderful happenings of late and have been 'wildered. I can scarcely write now for the excitement that stirs me like a thing in some magic caldron, round & round & up & down & round again. I am what the servants called 'flummuxed'. now then I have met the woman I am going to marry & marvel of marvels she loves me—& that is all to tell. There is no doubt about it all & now that I am no longer afraid of waking from a dream but rather know I hold a reality I may descend to facts which I feel you would want to be instructed upon & so tell you the whole wonderful story. Her name? Margaret O'deh, [Odeh][1] but always called Bunty and when you meet her you know she cant be called by any other name—She is just Bunty, that by the way. She's a Suffragette (not militant) and a B.A. Oxford, she has her own work to do as a secretary to an important personage.[2] She writes, speaks and plays musick & she is going to look after Paul & Paul's going to be all the world he can to her. In fact she is what he has been seeking for & she says he is what she was seeking for too. And there my dear Gordon (forgive the liberty!) you have it, & I am so damn happy I dont know what to do. We met at Lee's house in Chelsea where Bunty was sitting for a portrait & we have seen each other now & again during about a month 'till last Sunday night the impossible the wonderful thing happened. Of course we cant marry yet we shall just go on working at our own lives until I can somehow earn my living. Bunty nearly keeps herself as it is. Then eventually we shall join forces but I think we shall be rather uncon-

[1] Daughter of the Rev. N. Odeh, previously chaplain to the Bishop of Jerusalem and later to St. Mary's Mission at Cairo, and of Mary Ann Eleanor Dickson. She was born in Jerusalem and educated in Cairo, at the Ladies' College, Cheltenham, and St. Hilda's College, Oxford. At the time of their meeting, Mr. Odeh was chaplain to Hillingdon Hospital.
[2] The organizer of the Tax Resistance League, a suffragette body.

ventional. A villa & a perambulator is not my ideal at all nor Bunty's; we shall wander some time before we find the 'small far house, 'mid apple boughs & laurel boughs'.[1] You need not be fearful for me I have done the absolute right thing & it will advance my art not deter it. Bunty cares for it too much to let that happen. I expect there will be many hard days ahead & big difficulties to surmount but we are both sure & both sound. Give us joy dear patron Saint & tell Mrs Bottomley —to whom I send my love. And say to Mrs Trevelyan I am writing her a description of the Dolmetsch concert. Oh & will you send me this & the other head of you soon as I want to improve No 1 from No 2.

63

c/o R.C. Trevelyan, Esq. The Shiffolds,
Holmbury St. Mary, Nr. Dorking
GB to PN 18 March 1913

We are so sorry we are not to see you at Easter; and so altogether delighted to hear of the cause. I am writing as soon as ever I can, and I should have written sooner if my lung had not been rather naughtier than usual.

We are happy in your news, and happy too that the most beautiful and wonderful thing that life has to offer has come to you. Moreover, we have learnt already to have such serene confidence in the power of your perception of beauty that when Paul assures us that he has found the right lady we have no doubt whatever that she is the right lady.

Of course, in common with all your friends, our first impulse is to want to congratulate the lady; but no one will be more ready to pardon us that than she will, and we should like to beg for your intercession with her to persuade her to think kindly of us because we too love Paul, and to inscribe us in the number of her friends. There is still ever so much of life left for us, and we hope there is still more for her and you; so we like to think we shall employ it in seeing you both happy and working for beauty together, in full and various life, going from strength to strength and from success to success, and that our friendship will go on bringing us joy in you both, and that you will be familiars in our old small house which is a happy one too.

At this point it seemed that I ought to speak like an uncle to you, and utter moralisings upon worldly wisdom; but there isn't any room, and the fact is I have disqualified myself all at once by remembering that I was only a year older than you when I became engaged myself. I still walk in the transfigured light of those heavenly days, and I hope you

[1] From dedicatory poem (1908) to *The Riding to Lithend*. See p. 255, n. 1.

always will too; perhaps you will not want to wait for your fulfilment as we had to wait for ours; but, if Fate says you must, you will have your happiness none the less, and waiting will feel as worth while as everything else. I know.

Please make pretty bows for both of us to your lady; and think of me as your affectionate friend,

Gordon

Jack's drawings are the delight of our hearts; please thank him. We think the portrait of me has ripened finely, and we will send it and the other soon.

64

From Emily Bottomley to P.N, Holmbury St. Mary, 18 March 1913. She encloses this short letter of congratulation with GB's and endorses all he says.

65

From P.N to GB, Iver Heath [c. *21 March 1913*]. He addresses him as 'Gordon' for the first time and thanks them for both their letters.

66

From P.N to Emily Bottomley, Iver Heath [c. *end of March 1913*]. He asks whether they will ever be in London so that he can introduce 'Bunty'.

67

From Emily Bottomley and GB to P.N, Holmbury St. Mary, Saturday, 4 April 1913. They address him as 'Dear Mr Bunty' as 'the correct way of addressing the belovëd of a woman in these sufferaging days'. They are not to stay in London but they hope to come south again in about six months.

68

From P.N to GB and Emily Bottomley, Iver Heath [c. *7 April 1913*]. He thanks them for their last letter. 'We go on famously up our path of roses'. They hope to have a holiday together in Berkshire. He has sent two drawings to the New English Art Club.

69

From Emily Bottomley to PN, Holmbury St. Mary [*c. 12 April 1913*]. She cannot agree to a proposed meeting at St. Pancras on their way through. [A letter from PN must be missing unless he telegraphed.] GB must keep quiet and not be excited by talking 'to avoid bleeding on a long journey'. They hope to see PN and Margaret Odeh in the north.

70

From PN to GB, Iver Heath [*early June 1913*]. He thanks GB for a missing letter. He speaks of marionettes 'under our management' [nothing seems to have come of this] and of Rupert Lee's engagement to Gordon Craig's secretary and of various friends. 'So we are all very happy Bunty and Paul and Rupert and Rosalind [Pemberton] and Jack and Lord knows *how* many Ruths [Ruth Clark, a friend of Margaret Odeh's who became a life-long friend of both] & Marjories'.

71

Wood Lane House, Iver Heath, Bucks.
Margaret Odeh and PN to GB *15 June 1913*

Dear Friend of Paul,

I was delighted to receive your kind messages, & feel I want to thank you for them on my own behalf instead of through Paul—

Such wonderful happiness has come to me that I can scarcely speak of it, but I know that in writing to you I am speaking to someone who understands us & our joy—so it is not necessary to say more than that the joy is constant & ever-increasing.

I do hope some time soon to have the pleasure of meeting you. Paul has told me a great deal about you, & of how you helped him with his work, so that you are not quite a stranger to me.

You will be glad to hear that in addition to having his pictures accepted by the New English, Paul has had the "Lavengro" one taken for the "Blue Review".[1] Albert Rothenstein[2] was most enthusiastic about it, & about his work as a whole, & seems inclined to help him in various ways. We are both very excited over this.

× × × × × × × × ×

[1] Ran only from May to July 1913 (three numbers). It was a continuation of *Rhythm* published by Martin Secker with John Middleton Murry as editor and Katherine Mansfield as associate editor. [2] See p. 59, n. 1.

(Collapse of Margaret & her dignity) Paul continues)

Poor Margaret cant keep it up no longer: she has a thousand charming things to say to you but cant get 'em out somehow & has banged the pen down & given up the ghost: so I write on to say how much we two love you & Mrs Bottomley & nither of us can express it. I have been trying to for five years so how should Bunty give you any idea in her first letter. We send you our best wishes & love

<div align="right">Margaret.
Paul.</div>

72

74, *Upper Gloucester Place,*
Dorset Square, N.W.[1]

PN to Emily Bottomley *Saturday* [c. *late June 1913*]

We are both so distressed to hear bad news of Gordon this morning. Do tell him how sad we are & that we are going to pack him a great parcel of pictures & odd amusements to try & cheer him up. Margaret will surely write to you & thank you for a most charming letter while I send you here an apology for not sending your twa husbands the noo. Oh I have a grave tragedy to relate. I have murdered one husband the last one. I could not stand the drawing after a while & attempted to build it up by a thin wash & stippling—and it went to the devil. Never mind it is better so. I would rather that all the portraits I do of Gordon Bottomley be good drawings than chancey likenesses. The *other is* a decent drawing & also rather like so I shall send it back with the new parcel. Then when next we meet I shall do much better ones all together. . . .

Well goodbye for a while

<div align="right">ever yr devoted
Paul & Margaret[2]</div>

73

From PN to GB, Iver Heath [*early July 1913*]. He sends a parcel of his drawings and his brother's.

74

74 *Upper Gloucester Place,*
Dorset Square, N.W.

PN to GB [*Early July 1913*]

My very dear Gordon

There will have arrived by now my parcel of drawings for your amusement. Many are still to be finished but you will see how they're

[1] The home of Mr. Odeh.
[2] There is a profile drawing of the two standing together.

going. The two big ones I had to dismount as the Post Office people wont let me send a much larger parcel—you must make paper mounts to show them off in for they look rather scraggy as they are.

We are all rather distraught today. It is a Hellish atmosphere & now has begun to pour with hot wet rain my poor Margaret has had to sally forth to a stupid meeting & I am writing by the green light of the London sky in a little upstairs room. To night we are too poor to get dinner Margaret tells me. Do you know a fat man who'll buy my drawings. Do you know a fat lady or a lunatic or a philanthropist or a blind man. Haint it awful! But we shall soon be happier—Margaret is coming home to spend quite some weeks to be at peace in the country & I shall shake the dust of this old town from my feet. In the country you can be poor you can be fed at the family board & pay nought: there are no shops; & flowers can be had for the picking. In the country therefore we shall have peace & put in the deuce of a lot of work. Our latest good friend is Albert Rothenstein[1] he is a charming fellow & loves us all—Paul is to help him in his theatre work—someday Paul will *do* a play as the saying is. He went over Granville Barkers[2] works tother day—vastly interesting & inspiring—New fields open to the eye of the artist he seeks expression thro new forms—crafts—designs for tapestry, fans, & other things where new beauty may be embodied. The artist's brain is seething with new ideas. You shall see great things. Jack does good work and is getting known but so far with all the adulation, encouragement, appreciation—no practical help is at hand the hands outstretched are most confoundedly empty they bear no gold. Paul & Jack feel this *keenly*. Will Rothenstein is so delighted at Bunty's head hes going to draw her & give me the drawing!!!

.

75

Well Knowe House,
Cartmel, via Carnforth
GB to P.N *17 July 1913*

Yesterday we sent off your father's portrait[3] and Jack's drawings. The former is full of fine qualities, and I am sure that both Holbein and our 18th Century men would have admired it. Jack's drawings gain in power and certainty. Now that he has taken to landscape seriously

[1] Albert Rutherston (1881–1953), brother of William Rothenstein, painter, illustrator, and scenic designer. Ruskin Master of Drawing, Oxford, 1929.
[2] Harley Granville Granville-Barker (1877–1946), actor, dramatist, critic, and producer.
[3] This can be confidently identified with the drawing reproduced in *Outline*, p. 30, which is dated June 1913. It is impossible to identify the drawings by John Nash.

there are going to be Two of You; perhaps he does not feel the romance and poetry of landscape so much as you do, but he gets a vivid actuality (rather like Piero della Francesca's at points) which in itself promises an intense vein of poetry. The large bluey-green picture with the row of pale poplars is a real discovery, a stunning invention, and full of immense promise.

Emily says that his football picture is full of chestertons.

As for you, you go from strength to strength. The Andrew's field pictures[1] are very remarkable and shew a kinship with the early work of both Meryon and Girtin; their solid luminous shadows alone shew great mastery growing in you. The Goddess in the Garden[2] is a very wonderful thing—all new and your own, and conceived with the right kind of imagination—perhaps not quite *done* yet, and wanting farther ripening in your mind (and on *another* piece of paper), but neverthe-less all there potentially. The Three by Night[3] takes my heart altogether, and I cannot look at it enough. Old S. Palmer would have liked it too: it is the real right thing all over and no one has ever done trees and night like it. Is it quite new, or was it at Carfax?

The new portrait of your sister is first rate and more than that;[4] and the psychic portrait surprises me with knowledge of how dis-quieting beauty can be when chronicled in gold.[5]

I see you have opened My eyes: I think I like Me better so, but it was always a good drawing, and you know how I value and shall cherish it.

O, I wish I could jolt you out of that huge park the South of England, and show you rocks sticking out of England, and lean trees and real rolling hills and abrupt mountains.

.

I'm not better enough to write any more to-night. But we send our love to you and Ma'am'zelle.

Tell me more about Albert Rothenstein: I like the sound of him.

Mr. Trevelyan said I must tell you he had seen Roger Fry who said yours were the only things he liked in the New English.

[1] *In Andrew's Fields*, No. 1 and No. 2. They were exhibited at PN's second exhibi-tion which was held jointly with his brother at the Dorien Leigh Gallery in November 1913. See Letter 80. No reproduction of either is known. The first is in the collection of Mrs. Paul Nash, the second was destroyed.

[2] Nothing is known of this drawing.

[3] *The Three in the Night*, presumably. Exhibited at the same time as *In Andrew's Fields*. Reproduced in *Nash*, ed. Eates, pl. I.

[4] This was probably the drawing now owned by PN's brother, John Nash, R.A. It is signed but not dated.

[5] In a letter to William Rothenstein, dated April 1913, PN wrote: 'I have some ideas for psychic portraiture.' Only the one seems to have been carried out. It is of a girl and is partly in gold paint. It is now in the collection of Mrs. Paul Nash.

76

Wood Lane House, Iver Heath, Bucks.

PN to GB [c. *21 July 1913*]

My dear Gordon

I am delighted to find your letter awaiting me on my return to day & am altogether made happy by your jolly appreciations & glowing prophecies. I am glad you see such promise in Jack: for my part I think he is going to do really fine work & he is so extraordinarily productive

I stand by in amaze & envy. . . . Within 3 week I will send you another parcel with some drawings of Margaret. She is coming down here for some weeks O be joyful! so I can draw her again & again. How jolly of Roger Fry I am really most pleased. I wish the damn things had sold as they say—however they go to the Carfax now—I dont mind about

anything if only I can sell one picture of some sort to keep me going. Albert is a dear man—I am now really working a little with him—he's doing the new Shaw play Androcles & the Lion Barkers [Granville-Barker] is bringing out in September. I go & make bits of Albert's model theatre for Androcles while he designs costumes: then we dash of[f] to

Burnetts & spend the afternoon choosing stuffs for the wonderful dresses & then to the workshops & so on. I am learning a lot—with a purpose—hoping some day to do a play as I think I told you. It is interesting to observe Albert[1] he's frightfully quick & clever & has a thorough way of working & a real knowledge of all the things he comes

[1] At the top of this sheet is a drawing in profile of Margaret's head.

up against. Many of these theatre artists seem too remote: they direct operations from the studio; design amusing costumes, choose a few stuffs, & leave the rest to Providence & anyone who understands the business better than they do. If I *am* to do this sort of thing one day I think I am learning under a good master. Albert is a charming fellow beside and is our very dear friend in many ways, he has the same wonderful enthusiasm & keenness about young people & their works that Will posesses. He is very pleased at my new drawings more especially 'The Three in the Night.' & thinks Jack's Poplar Picture one of the most beautiful things he has seen for some time. Now as to the Blue Review . . .—*this* about it. That the controller—editor, manager, or whatever . . . suddenly went *under* & there will be no more numbers & no pay for anyone!! The very month tho when our drawings were to appear: in fact the blocks were being made. . . . We went to the Russian Ballet again last evening & saw those wonderful people. Spectre de la Rose is a most lovely thing.[1]

Oh yes by the way all the drawings I sent are new ones done within the last month or so. Barbara is an earlier drawing of last holidays. Well now goodbye & love & best wishes to both of you from Margaret & Jack & Paul

77

From PN to GB, Iver Heath [c. *24 July 1913*]. He thanks GB for a card— 'that is a splendid plan & we may have good luck'. [The card is missing but see next letter.] He asks him to put a mount round 'poor unclothed drawings' and asks if it is possible to send a case by rail—'I could then send them in their mounts all happy & comfortable'.[2]

78

From GB to PN, Cartmel, 31 July 1913. He has returned the drawings. He has been trying to sell a picture. 'I got the man to admiration point completely enough, but he lacked faith in himself and so shirked the rest of the journey'. He is sorry for the disappointment but urges PN not 'to do things that will sell . . . if you do the things that will sell, they will only sell'. He longs to bring PN north and show him 'a real landscape with Bones in it'.

[1] See drawing on opposite page.
[2] Drawing of GB conjuring up a very fashionable 'prospective buyer' examining a picture.

From PN to GB, Yately,[1] *Hants* [*? early August 1913*]. He thanks GB for his letter. Perhaps his pictures will not sell because they are 'unfinished or immature or something[,] people wont buy what they think is amateurish'.

I should like to see a bony landscape

ys ever
Paul

[1] PN's aunt Susan May Nash (Mrs. George Chapman) lived at Yately, where he often stayed until her death in 1936.

Iver Heath, Bucks.
[c. *end October 1913*]

PN to GB

My very dear Gordon

how on earth are you. It is long since I have spoken with you across
the expanse of bony & bonless landscape that streatches twixt me and
you. I grow uneasy. It has crept about that you are flying south again

I hope this is true! how is Mrs Bottomley, give her my very best love.
We are upon the verge of many excitements on November 14th Jack
& I hold a show of recent drawings at a private gallery[1] adjoining South
Kensington Station very good room with exceptional advantages as
they say 2£.10 for eight days—dont you think its rather good!—I
discovered the place by great luck—its very get at able and will hold
our work comfortably. Now we both hope as hard as we can that you
will *both* be able to come there—is there a chance? The next excitement is
one I trust will prove more permanent than the last of the same kind—
a new book—a glorious book indeed if it ever appears—to contain about
40 reproductions of drawings & paintings by the younger generation!

[1] The Dorien Leigh Gallery.

to be representative of all that is most progressive in modern work —and Jack & I are both asked to allow our drawings to appear! Aint it grand. If only it happens. One Howard Hannay of Howard Latimer Lt. publishers (I presume) are attempting this & a great deal depends upon their appeal for subscribers being cheerfully answered. The book will cost 10/6 not more, possibly less at first and if the venture be successful the price will be lower. I am very keen on the plan. How splendid it would be not only for us and our friends but for everyone to be able to see what work is being done There are to be no older Gods like John, Rothenstein, or others & I do pray they keep to that idea—it is the best ever.[1] Hannay is particularly pleased at the moment with Jack's landscapes and wants to buy some. I have so much to do at this time I cannot write more tonight when I send you cards I will tell you more things. do write if you can & say how you are

81

PN to GB and Emily Bottomley

Iver Heath, Bucks.
[c. *mid-November 1913*]

My dears Gordon & Mrs Bottomley
 The show is already a success beyond our highest hopes. Twelve drawings sold or nearly half the exhibit! The whole thing woke up upon the moment Professor Sadler[2] entered the room. He bought as all right minded public-spirited & sufficiently well to do people *should* buy. He would like that & that & that & that. He eventually relieved us of six two of mine & four of John's this was good but this again is almost better. The drawings go to his house at Leeds but are to be hung in turns at the University for the edification of the students & the general people! Here is an honour. The first of the two of mine he took was Lavengro! Dear old Lavengro that I started two years ago in my Chelsea lodgings—which afterward was crossed out & flung aside & later washed & scrubbed with a nail brush & redrawn & just lately finished & extra drawn upon. What a past!
 On Saturday morning Charles Rothenstein[3] the collector who had been in before & obviously meant to buy, came in & took my Landscape at Wood Lane—dont think youve seen it. A good one. Clifton[4]

[1] This publication was to have been under the editorship of Sir Edward Marsh as a companion to his *Georgian Poetry*, and to have been called *Georgian Drawings*. The war killed the scheme.
 [2] Sir Michael Ernest Sadler (1861–1943), at this time Vice-Chancellor of Leeds University and later Master of University College, Oxford. Collector.
 [3] Charles Lambert Rutherston (1865/6–1927), brother of William Rothenstein. Collector and founder of the Rutherston Loan Collection, City of Manchester Art Gallery.
 [4] Arthur Clifton, manager of the Carfax Gallery.

bought Jack's 'Football Match' & I have just heard someone has bought my gaunt cliff drawing You know the one[1] Jack has now sold seven & I four, tho' in value my four make nearly as much as Jack's seven. It is a great joy to us both we have so many expenses and there is so much to get—tempera paints, a stove for the studio, material for tapestries, fans etc etc. and now we are provided for. The lastest amusement is that Spencer Gore[2] the head of the Campden Town Group has asked us to show SIX drawings each at a show he is organising at Brighton next week. I think this will be very useful to us both but we shall only just be able to scrape six each to send as we have sold so many & others have gone in to the New English. All I desire now is peace & quietness and recovery from an inflamed nose & a horrible cold & then to work with great vigour. The Show is open until Saturday evening. I shall be up then but am not well enough to go out these two days.

Looking forward to see you both soon if kind Mrs Trevelyan wills it

<div align="right">Yrs</div>

<div align="right">Paul</div>

Margaret sends her love.

82

PN to GB and Emily Bottomley

<div align="right">*Iver Heath, Bucks.*</div>
<div align="right">[*27 December 1913*]</div>

thank you more than I can say on paper—or off for this book.[3] No thing could have given me more pleasure to have. I have read it but only once as yet. I shall read it many times before I venture any opinion likely to be worthy for it is so strange a play in such wonderful language that as yet I am left still thinking. It has all the atmosphere of such a play as The Crier, but it is different and I cannot grasp it so easily as a whole. It is full of a deep mystery which perhaps a woman could glimpse at (or even understand) before a man. That it is full too of beauty I feel at once, and it is full of pictures. I want to make drawings for it & I should like to have done the frontispiece here. I like Guthrie you know, but I deplore his vague drawing. You, Gordon, once said to me 'the greatest mystery is obtained by the greatest definiteness' I have always remembered it & from that time have sought to be definite because I realise its the only thing. Now I wish youd said it to Guthrie, or he had realised it!

Jack & I went a while back to the Liebichs & heard fine music. Especially interesting was the modern work—I am not altogether in

[1] Small sketch at side of page.

[2] Frederick Spencer Gore (1878–1914), landscape painter, early English Post-Impressionist.

[3] Possibly a copy of *Midsummer Eve* (1905) printed at the Pear Tree Press.

love with it yet—again *that* is vague, it leaves me a little lost and feeling as if my braces had burst & my socks slipped down. But I am going back to hear more and get to grasp it better. The Ls are charming I love them very much. We met a Amurrican Pote there, very nice man indeed —Frost.[1] Before I forget it I must say I am so sorry I forgot to tell you what Roger Fry said about our show. He came [to] it & was immediately enthusiastic. I thought I knew who he was so I up & spoke to him & he was simply delightful. Of course he's the most persuasive & charming person you could ever meet. Dangerous to work with or for but a frightfully shrewd & brilliant brain and pleasant as a green meadow. He was obviously *very* pleased with our work & stayed some time talking & inspecting. Oh! I buttonholed Ricketts 'tother day in the New English[2] He was most surprised & at first looked 'who-the-deuce-are you' at me but I was not to be quenched & afterwards he talked very nicely & amusingly I am not sure if he likes my work, he calls everything "amusing" & sometimes 'very talented' but as I had to go off I did not have very much conversation. He is not so alarming a personality as I had expected.

Hurray! I have sold my picture in the New English, isnt that good! And Jack & I have both been elected painter members of The Friday Club.[3] So we are quite the rising young men. . . . I hope you are well. I look forward enormously to seeing you. Give our best wishes to Mrs Trevelyan for the New Year & take them for you both—by the way, my Christmas present must needs be late I am afraid but it *is* coming

83

From PN to GB, no heading [early 1914]. He is sorry that he cannot send him some drawings 'before Wednesday'. [This evidently refers to some request in a missing letter, probably that mentioned in the next letter as from Emily Bottomley.] He is working on another drawing for *The Crier by Night*. 'I failed to bring off a good enough Lithend tho' I mean to try again'.[4]

[1] Robert Frost (b. 1875). He lived in England from 1912 to 1915, and was a friend of Edward Thomas. His first two books *A Boy's Will* (1913) and *North of Boston* (1914) were published in London by David Nutt.

[2] There is a drawing of this meeting—a jovial PN and a reluctant Ricketts.

[3] The first exhibition of the Friday Club was held in 1911, and the exhibitors included Albert Rutherston, Mark Gertler, C. R. W. Nevinson, Roger Fry, Duncan Grant, and Vanessa Bell. The last exhibition was held in 1922. Paul and John Nash exhibited in 1914 and 1916. Members were entitled to exhibit up to three oils and three works in other media.

[4] Drawing of PN and John Nash 'hugely amused' by R. C. Trevelyan's 'Sysiphus'.

84

PN to Emily Bottomley [c. *March 1914*]

I have had this letter heavy on my chest some weeks. I expect you and Gordon think me a sad faller off[1] Well I *am* a third-rate letter writer and no mistake and I have come to be a beastly busy person. For first of all I had to work hard for the Friday Club and then I became a worker at the Omega[2] and also a restorer of a fresco along with Mr Fry, at Hampton Court.[3] and then the corporation of Leeds invited John & me to exhibit at Leeds and all in a hurry because their director is a vague man—so I had to work night & day to send there. And now we are invited to send to the Twentieth Century Art Exhibition at Whitechapel in April so I have got to do more pictures for that Then comes the New English in May and then, thank God, a holiday from shows, and that brings me to my great scheme for travelling to the North.

.

If you could possibly have us then, we would start out about the end of June . . . What say you? Think of the fun of being all in a good company among the mountains! Hurrah!

This is only a small letter as I had to stop it in mid carreer for dinner & after there rose a 'Suffrage' discussion which has nettled me because all the family are so compromisic and unbelieving and so by an immense effort I held my peace at the opening of the word war and tho' I longed to launch my opinions I kept myself corked & let them say their say into silence. So I feel indignant and rather truculent. But I am writing a letter soon to Gordon. God bless him how is he? & also I have something to send you both until then your devoted Paul.

J. & I sold 2 each in Friday Club Show

85

From Emily Bottomley to PN, The Sheiling, Good Sunday morning [c. *April 1914*]. [The Bottomleys had moved to The Sheiling, Silverdale, near Carnforth in March 1914, and from then on it was their cherished home.] She says they are delighted with the proposed visit. They have now settled in their new home. They have heard that PN has been seeing Mr. Marsh. [Sir Edward Marsh (1872–1953), eminent civil

[1] Drawing of GB and EB regarding magisterially an upside-down PN.

[2] The Omega Workshops were founded by Roger Fry in July 1913 to produce furniture, textiles, pottery, &c., by a group of young Post-Impressionist artists. PN began working for it in February 1914 but did little.

[3] Roger Fry was entrusted with the restoration of Mantegna's *Triumph of Julius Caesar* at Hampton Court. He invited many young painters to help him.

servant, editor of *Georgian Poetry*, translator of Horace and La Fontaine, collector of contemporary art.]

86

From PN to Emily Bottomley, no heading [*Card postmarked 26 May 1914*]. He thanks her for her letter and says they hope to come at the end of June or early July. 'Say how proud I am to know the man who wrote King Lear's Wife'.[1]

87

From PN to Emily Bottomley, no heading [*c. early June 1914*]. He expects the visit will be in July. He and his brother have sold at the Leeds exhibition and John sold a drawing at the London Group exhibition. 'So the little fellows go on going along you see . . . Yes I see a good deal of Eddie Marsh he is a charming fellow & v. kind to us all'.

88

From PN to Emily Bottomley, International Women's Franchise Club Ltd. 9 Grafton Street, Piccadily [this was Margaret Odeh's club] [*c. late June 1914*]. He announces their visit for after the first fortnight in July.[2]

89

From PN to Emily Bottomley, no heading [*c. 10 July 1914*]. He asks what their station is and from which London station to leave. 'Only a scrawl'.[3]

90

PN to Emily Bottomley *Wood Lane House, Iver Heath, Bucks.*
 [*PM: 14 July 1914*]

 thank so much for your letter. Of course both Margaret and I dont expect to be spoilt & fed on luxuries it agrees with neither of us & we never like it. A butler is our only bogey in life & we steadily prefer donkey carts to motor cars. This dont mean we shall be sick if there isnt a donkey, only to show our sort of taste. Our ambition is to live in a little cottage & be as happy as you & Gordon. . .

 Now all is excitement my box is packed & so are the drawings we send luggage in advance tomorrow & start on Wednesday. Hurrah!

 Paul

[1] *King Lear's Wife* was first printed in *Georgian Poetry* in 1915. It would seem that PN had read it in manuscript.
[2] Drawing of PN and Margaret climbing, *not* that reproduced from Letter 90.
[3] Drawing of these two dancing and rejoicing.

The Seven League Boots.

91

From PN to Emily Bottomley, Grasmere [c. *21 July 1914*]. He sends a preliminary letter of thanks. 'I never felt so near weeping as at leaving you both yesterday'. He asks her to tell GB how impressed he is by the country, 'rocks & crags against last night's sky were simply terrific—& this is a very Sammy Palmer village at even'.

P.N to GB and Emily Bottomley [c. *mid-August to early*
 September 1914]

I am so sorry not to have written before but of course we have been
rather disturbed [by] my War eventualities and I have not felt like writing
letters. I hope you are not greatly upset at Silverdale & they wont
regard your house as a temporary fort or watch tower or be taking it
over as a hospital here I was obliged to leave your letter and go
off a harvesting: novel amusement for me and great fun—Jack & I
have worked hard—tossing sheaves onto a cart and pitching 'em off in
the yard to make a rick. Most farmers are short of hands by men en-
listing or being otherwise called out so we are volunteering for all sorts
of jobs and making ready for all emergencies. I am not keen to rush off
and be a soldier. The whole damnable war is too horrible of course and
I am all against killing anybody, speaking off hand, but beside all that
I believe both Jack & I might be more useful as ambulance & red cross
men and to that end we are training. There may be emergencies
later & I mean to get some drilling locally & learn to fire a gun but I
dont see the necessity for a gentleminded creature like myself to be
rushed into some stuffy brutal barracks to spend the next few months
practically doing nothing but swagger about di[s]guised as a soldier *in
case* the Germans poor misguided fellows—should land. There is more
to do at home attempting to relieve the sad wretches who are left
hard up and miserable.

But to pleasanter matters. We spent a great time on our tour. From
Grasmere, haunt of Wordsworth & Southey's ghosts, to Thirlemere
where we found the charmingest cottage by the shore of the lake, facing
the threatening height of Helvellen and there spent a happy day &
night. The people were so kind to us—spoilt us shockingly and their
house was so snug we are determined to return one day. If you ever
want a grand tea for six pence, set out in a cosy garden shouting
with flowers, from where you may gaze upon the lovely Thirlmere
Lake, while white pigeons sit upon the green old table and gaze very
haughtily at *you* in return—all these delights are provided by Mrs
Bainbridge The Bank Wythburn. Also a very trim and pretty little
girl will wait upon you, whose name is Nellie which you will find is the
name of all trim and pretty daughters who live in jolly farms & serve
sixpenny teas. Alas we could only stay at this Elysian spot one night,
so next day after making some drawings and sheltering at the White
Swan out o' the rain, we took coach and went to Keswick. I know it
will sound scandalous to mention two pretty girls in one page of my
letter but at the White Swan there presides a real 'Early' Rossetti
maiden—see over

Damn! [Drawing crossed out] not the least like[1]
I cant draw the type—it's the Siddal cum Miss Herbert sort—awfully
attractive. We didnt see much of Derwentwater it being gloomed in
mist, but it was a romantic impression. It rained all the way to Keswick
& I made Bunty travel inside at which she was fearfully annoyed but
she made the aquaintance of charming Canadians within who gave her
sweets while I sat wet on top next to a dead-dull lady. The Canadian
girl inside was very fair with a ducky profile[2] we met her & her momma
again coming away from Keswick. K is a hole & we were very lucky to
get rooms cheap, and next day we started for our long tour. Keswick
to Penrith, from there by motor to Pooley Bridge—across Ullswater—
a very gorgeous Lake! and *then* by coach over the Kirkstone Pass. This
was superb. The really big design of this particular part of the country
is exhilarating. The little gills & torrents rushing down the hills was my
greatest delight at first and later the amazing villages between the top of
Kirkstone and Ambleside—my dear Gordon you would have crowed
with pleasure! such barns and granges, such stunning cottages All
hanging on the edge of precipitous places, all grey and ruinous—it is
impossible to give any idea of them.[3] I must return to that marvellous
place. We had to wait at Ambleside some time for the steamer, but at
last crossed & reached Lakeside.

.

And so to Leeds where we lunched with Sadler & saw his very excel-
lent collection. He lives in a great palace of a place overlooking the city
and we were charmingly entertained. He has some v fine pictures—
French Romanticists Montchelli [Monticelli] (where Steer came from)
Courbet, a beauty, Diaz etc. Four gorgeous Gauguins many fine
C J Holmes'es, some Steers and many Constables and early water
colourist fellows. From there to dear Charles Rothenstein [Rutherston]
at whose house we stayed that night & half the next day. He was
delightful & entertained us splendidly. His is far the more interesting
show really. Stunning early Johns, all sorts of Conders and *the* picture
The Doll's House,[4] which did quite floor me, and a landscape of Will's
[Rothenstein] too, quite wonderful & rather of the same order as the
Doll's House. His collection of ancient bronzes & Chinese pots is the
finest I ever saw—simply gorgeous they are. Among other pictures
there were two knock-out early drawings by Rossetti, a marvellous
Rodin drawing—Whistler, M. Bone, Steer, McEvoy & many others
& O such a Hokusai! Everything is first rate. I felt v proud to see my
drawing hung up there. Charles very much liked the big Orchard
drawing & I think would have had it if War had not just broken out

[1] Words written beside two heads of a girl.
[2] Drawing of this. [3] Landscape sketch.
[4] Not Ibsen's play but Rothenstein's picture, now in the Tate Gallery.

& caused everyone to think twice about buying a thing. Now goodbye this is a very long letter, I hope you wont mind it. Our love to you both & thank you many times again for the splendid time you gave us.

<div align="right">Paul.</div>

I forgot to tell you Charles sent us a lovely motor drive all over the Yorkshire Moors—it was huge!

93

From Emily Bottomley to PN and 'Bunty', Silverdale, 27 September 1914. She says that GB is in bed again with a bad cough 'and each cough we have expected to end in haemorrhage. Fortunately we have not had much blood but the anxiety has been there none the less'. They have been interested in PN's letter. She speaks of the war with horror but ends 'However, talk about the war seems as foolish as the war—not that I think there was anything for us to do but fight under the circumstances'.

94

<div align="right">

Iver Heath, Bucks.

[c. *27 September 1914*]

</div>

PN to GB

it is so long ago since I first meant to write to you that I thought I had written. I am now an Artist in a wider sense! having joined the 'Artists' London Regiment of Territorials the old Corps which started with Rossetti[,] Leighton & Millais as members in 1860.[1] Every man must do his bit in this horrible business so I have given up painting & bid it adieux for—who knows how long, to take up the queer business of soldiering. Every day I travel up to drill. There are many nice creatures in my company and I enjoy the burst of exercise—marching, drilling all day in the open air about the pleasant parts of Regents Park & Hampstead Heath. We are not camped anywhere yet so live at home —later we may pig it at the Tower a dirty, haunted sort of a place I hear, but good in a way as it keeps me in London & near Bunty & my dear people. How are you both? I never thanked you for kindly sending on my left-behinds—Not much time for a letter today so forgive this short-winded note. Bunty sends her best love & so do I.

95

<div align="right">

The Sheiling, Silverdale, Nr. Carnforth

2 October 1914

</div>

GB to PN

Our letters have crossed again, so while we were reading yours you would be reading that I should have written to you long ere now if I had not been disagreeably ill.

<hr>

[1] He enlisted on 10 September 1914.

74

PLATE V

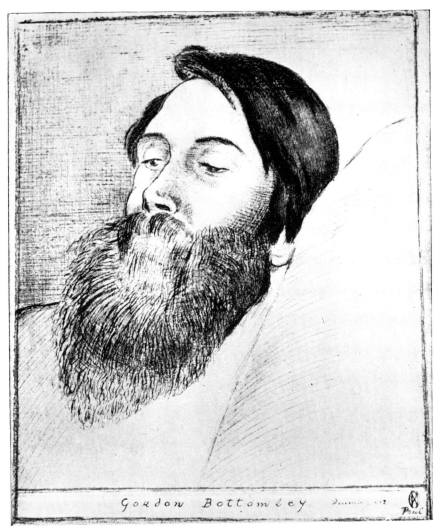

Gordon Bottomley, by Paul Nash, 1912. Pen and wash. $13\frac{1}{2}'' \times 11''$

Carlisle Art Gallery (Bottomley Bequest)

PLATE VI

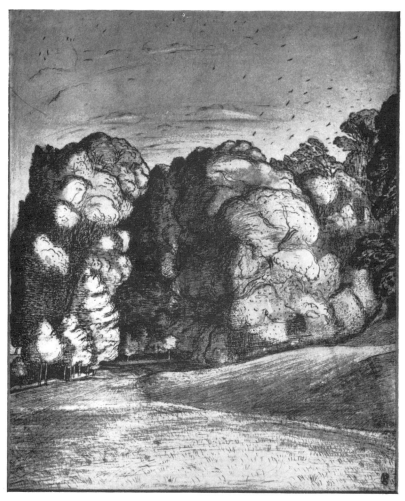

Under the Hill, *by Paul Nash, 1912. Pen and wash,* $15\frac{1}{2}'' \times 12''$

Carlisle Art Gallery (Bottomley Bequest)

I still dare not attempt a letter, but I could not rest until I had scrawled you this line to send you our benediction on your new enterprise. Having set out to do so worthy a share of our country's duty you will feel a contentment within yourself, both now and in times to come, that is better than anyone else's praises; so I will only say that we are happy in your choice. We love art and poetry better than war; but this is one of the times of the world when men must fight if they want to preserve the foundations on which art and poetry can alone be possible, and as I lie helpless I am bound to envy you your share. You do not say if your corps is for the front or for home defence; I hope you will not be called on to break the peace, but if you are I shall hope still more ardently for your safety, and for good days to come when you can bring a new world of experience to your art. And so say we both.

Rathbone[1] never never brought me that BLAST[2] until Tuesday of this very week. It looks amusingly stale and old-fashioned already, now. The text would be trite if it were not so very black, and the pictures look like theories that have gone cold too soon. The only pictures by the living men that appeal to me, and that seem to have an original feeling for beauty are the two (*Dancers* and *Religion*) by W. Roberts; as for the pictures by Lewis, Wadsworth[3] et Cie, they would look far more convincing, reasonable, and valuable, if carried out by the yard in silk broché and made into opera cloaks.

Our remembrances to Ma'am'selle Bunty, please.

96

PN to Emily Bottomley [*? late October 1914*]

you must have thought me a heartless fellow for never writing again after your letter about Gordon. We were both so distressed to hear he had been bad again and felt for all of you, boxed up with a cold-plague raging. Do let me know you are well again, and Gordon going on nice and steady and no tricks. I was awfully pleased to get both your letters they were so sound and I enjoyed them. I should have told you I am only a home defender but it is for many good reasons. Personally I should like to get over to Belgium but in the ordinary way there is no chance of our battallion going and to sign for foreign service simply

[1] Perhaps George Rathbone, the composer who set GB's *A Carol for Christmas Day* to music.

[2] *Blas: Review of the Great English Vortex*, ed. Wyndham Lewis: John Lane, the Bodley Head. No. 1: 20 June 1914; No. 2 (War Number): July 1915.

[3] William Roberts (b. 1895), Wyndham Lewis (b. 1884), Edward Wadsworth, A.R.A. (1889–1949), all painters.

means you get sent off to Egypt or India and there you stay for 4 years. Now if we are wanted at the front it will be in an emergency at a later date and in that case I shall probably volunteer, but I dread 4 years separation & kicking my heels in an Eastern barracks. I know this sounds selfish but I am only out to do what I can see is my duty and as yet I cant see it to that extent. There are any number of men yearning to go out anywhere and I know it will be quite surprising if *they* all get accomadated. Of course Bunty dreads the whole thing and that's another reason for *signing* for Home Defence at the beginning she dont think about the day when I am called out—and all that. Poor dove she fears much too much for me as it is! I met Rupert Brook[e] tother day fresh home from Antwerp trenches he said it was marvellous. I expect I should hate the slaughter—I know I should but I'd like to be among it all it's no ordinary War. Tell dear Gordon I'll write to him next— I am greatly enjoying my drilling in a way—sometimes I stop & wonder over to myself what the devil is a sane man about to go edging up & down and stamping & trampling here & there like a herd of beasts. From my position 'at ease' in the front rank of my company today, I watched some sparrows & a starling a few yards away, pecking at crumbs oblivious or indifferent to our stationary column—it struck me I'd never seen them behave like that except in the proximity of cattle— so sociable & fearless: I believe they knew. Goodbye love from us both to you both.

97

Emily Bottomley to P.N

The Sheiling, Silverdale
[c. *late November 1914*]

Is it really true? We hear rumours of an approaching marriage. And this makes us feel grandmotherly and grandfatherly and we feel almost anxious. From the opinion we formed of you and Bunty we decided you would need quite lots of money to marry happily. And, oh, wouldn't it be a pity to marry so soon and to feel the drag of making ends meet all along life's way, with little time left from the making of ends meet to truly joy in each other, feeling always the beautiful wonder of life. It is difficult to do this with a harrassed mind. Of course you will think this all very impudent and it is possible you may have had a fortune left you since last we met, so forgive me. Gordon and I were engaged for ten happy beautiful years before we lived together and made our home, and knowing what these years were to us—that sweet prolonged wait-ing—perhaps makes me speak as I have done. Couldn't you be happy loving each other still a little longer without so soon bringing upon your-selves the worries of housekeeping. Do forgive me.

People always tell us we are Early Victorian in our ideals as regards

married life, so write back quite cheerfully—damn you old fashioned folk; we Post Impressionists and Later Ones have different ways and we mean to marry on a penny and this is the new order of things. I'll forgive you because I know I'm old fashioned—but oh so happy that I don't really mind.

When we read your letter about the war and how you feel about it we were very glad, because I am sure you are doing wisely. To be as ready as you are making yourself is, I believe the duty of every able man—but the present need to offer for other than home defence does not seem to call for more, for as you say there are many so anxious to go, and it is no good putting yourself in their way when you can just make yourself quietly ready in case of other needs which we truly hope may never come.

Gordon is I am sorry to say not so well. He has been more or less in bed for some time. Winter days are not his best days.

.

<div align="right">Your old fashioned friend</div>

98

Wood Lane House, Iver Heath, Bucks.

PN to GB and Emily Bottomley [c. *early December 1914*]

My very dear friends

I was about to write to you when your letter arrived. What a surprise! to receive 'cautions against' from *you*. Well I think I can defend us both. It was the War made us conceive the daring idea of *really* being married. before then I had quite expected to have to wait long years. I think the need of meeting a practical necessity made us think quicker and finally we asked ourselves could we not afford it—a thing we had never seriously considered before strange to say. We then found our respective incomes were as follows. Bunty £100 a year from her Father. (I didnt even know of this) Bunty from her work very soon, about 100 or 150 a year. Paul from his Father £25 allowance a year—now raised to £50 Paul from his work—on an average the last two years £100. Under present conditions, Paul rather more than £1 a week and if married 12/6 a week extra—War may last 3 years Paul may be shot. why delay and delay?

Is it such a risky business as you think? We have our little flat[1] and all our furniture nearly all our linen & plate the rent is 10/6 a week including electric light—it is situated 3 minutes walk from my headquarters (saving of daily fares), it is just the right size, it has all we

[1] 176 Alexandra Mansions, Judd Street, facing St. Pancras station. This was Margaret Odeh's flat which the Nashes retained as a London base until about 1936.

require. the best charwoman in Europe cleans it like a new pin & washes up each day for 4/- a week. Below us is a restaurant where you can dine 3 courses of good ample food for 1/-. Both of us have our work all day. In the evening we are together in our dear little home happy and at peace. The whole arrangement is most sensible most practicle most poetical. What can you say against it? As for housekeeping and the cares of it we do not mean to indulge in the luxury. And what has made you think we are so thriftless as to need lots of money to be happy at all. No I dont think our happiness depends on more money than will feed and shelter us—pay for my paints and some pretty clothes for Bunty & I hope to be able to manage that much.

I am distressed to hear Gordon is not so well—will he not come South —I so much hoped he was better by now. Two Lake drawings are in the New English Thirlmere & the one from your window towards the Mountains. Do not think I do not value your letter—indeed, thank you very much for it But I hope you will be reassured by mine.

<div align="right">Ever your headstrong young friend
Paul.</div>

Our love to Gordon. The date is Dec. 17. at S^t Martins in the Fields. 12.0c.

<div align="center">

99

</div>

<div align="right">The Sheiling, Silverdale
[c. early December 1914]</div>

Emily Bottomley to PN

Well now everything is all right. Now I can look at things from your point of view and feel sure nothing could be wiser. But now you must see my point of view before you can understand how distressed we were. When you were with us you so often said you hadn't any money to get married. And there were moments when you thought you hadn't money for a night's lodging and must needs sleep under the stars and live all day on sixpenny teas and Bunty's dress allowance you thought would have to pay for that. We had no idea that you had £225 a year and Bunty £250 and so you can imagine the picture we sadly drew of you and Bunty living always and every day on sixpenny teas—often having to sleep under archways or in the open fields and poor Bunty with no dresses at all at all because her dress allowance was all spent on sixpenny teas. And we said dear, dear, how hard it will be for them if they have no money to housekeep with how difficult it will be to house-keep. And here have we been distressing ourselves in this way, not knowing that house, linen, plate and income were all secure and happiness as well. Forgive our moments of depression—allow there was some excuse for our feeling unhappy.

This is not a letter but just a line [to] say all joy be yours And why did you fill our minds with forboding. I expect it was all just a joke. But we are quite reassured for we know we could live quite comfy on £475 a year. We are so glad.

100

The Sheiling, Silverdale, Near Carnforth
Emily Bottomley and GB to PN *16 December 1914*

I, with my defective breathing arrangements, pant helplessly after you in your present rate of progress: I have just got myself accustomed to the idea of your being married, and now I realise with a jump that it is to happen this week.

If we had been in the South this Winter I am sure that one of us at least, and both of us if Fate had been kind, would have slid into St-Martin's-in-the-Fields about 10.35 to-morrow morning, to watch your launching and to wish for you and Ma'am'selle Bunty the joy that my wife and I have found in our coming together. As it is, our thoughts will be with you, and we shall wish all fair and true and delightful things for you both. I take it as a good omen that the course of events has made St Martin's prove to be the church appointed for your purpose; for it so plainly indicates that the very nature of things will thus find you in the best position to cross the road to your eventual destination of the National Gallery.

But you will, of course, first turn East for a little—perhaps for a wedding breakfast, and certainly for many breakfasts afterward. So, after the manner of friendship on these occasions, we should like to be represented by a remembrance in your establishment; and to that end there comes with this epistle a slight contribution to your hardware department. It is not large enough to contain our good wishes, so you must imagine them running over on to the table-cloth and all about you when you use it.

Dear Paul, I give you my word you stand at the entrance to Paradise; and all the more so because you are an artist. So far as I can see, the arts are the highest of human activities—so that if you open the right door you will find a greater treasure to add to love than ordinary men can claim, and if you see vividly the conditions on which art can remain with us you have a surer hold on happiness than they can claim. That this happiness may be yours and Ma'am'selle Bunty's is the deep and earnest wish of my wife and myself.

Pray think of us to-morrow as your sincere friends,

PN to GB [c. *20 December 1914*]

Dear, dear Gordon

it was a great delight getting your letter. A very good letter indeed
from which sly humour was not absent! However your wit is always so
engagingly drest I love to provoke it. We were a little alarmed at your
first attitude and wondered why Mrs Gordon should think we would be
so silly as to venture upon the life of misery and hardship she painted for
us! Now, I realise it is my unfortunate turn for romancing that gave her
a wrong impression On the other hand she has made us out far too rich
in her last note, and you must understand we are neither going to live
on nothing or on plenty: but upon just enough if we go steady, and are
given good health to work and earn—Well that is as good as a feast is
it not? especially if Love and Comradeship help serve, at the board.
Later in life we are both provided for anyway, in the ordinary course
of things, so look to us for some good work before we die & dont get
anxious.

Your letter said many fine things and we could hear you saying them,
far away tho' you are. I have entered Paradise and I know all you say is
true. Le bon Dieu has blessed us lavishly—all we could wish is ours: tiny
things, all contributing to our joy, have been given. A fine shining blue
day for our wedding, a happy gathering of dear friends—less two very
dear ones alas!—the jolliest presents and this best of presents almost,
this old Somersetshire house in a valley of its own—lent to us to live in
these few happy, happy days. It's a gorgeous place Gordon and I have
made three drawings & gone nearly mad with excitement—alas we
leave tomorrow & have just heard I had to go and live in barracks
next week—no home after all—isnt it cruel. Never mind the war shall
end at last and peace come home and Bunty & I run to our cot and
start life in joyful earnest. How long afar is that day? Thank you dear
friends for thinking to send us a present I havent seen it yet but Jack
tells me it is a stunning cream jug We are so glad we need one & when
we use it we'll have a napkin to wipe up the wishes & not waste *any*.
Bunty sends you much love & a kiss!

 *3 Adam S*ᵗ*, Adelphi WC*¹
PN to GB and Emily Bottomley [*1 January 1917*]

My dear Gordon & my dear Mrs Gordon

how do you survive the rigours of this most beastly winter—I often
wonder how it is with you up on your little hill under the spleen of this

¹ Margaret Nash had been lent a flat at this address while her own was let.

incredible climate, as vaccilating pulsinanimous & treacherous as poor old Mr Asquith himself is supposed to be. Sometimes I get word of you and sometimes I read about you as when t'other day I found the review of the last Georgian Poetry in the Fortnightly was it? by a man called Mais I think, anyhow giving you your right place & saying how fine a play was Mrs Lear. I hope he never saw Lady Tree try & act it or any of the other miserable inefectualites of that performance.[1] I think actors & actresses are terrible mistakes, Gordon. they spoil everything for me. But I didnt sit down to talk about actors & actresses. Let me announce I am now a 2nd Lieut.nt of the Hampshire Reg.t and will soon have all the accompanying cares & responsibilities of that position. I passed the exam on the 19th Dec: and was gazetted right away after about ten days leave, now drawing to a close. I join the regiment on Tuesday. I suppose I shall see France in a month or so. It is strange to stand on the edge of the year and look across and think of the extraordinary things that may happen during this new year—what does it hold for me I am wondering. A more crowded life than I have ever lived before, more anxiety, more pain, more excitement, more vivid impressions than I have ever felt before. Or just death. I feel most interested for I cannot say I have premonition of this or that, only I realise a rather dramatic moment, this, at the end of the other years, before the one that really matters, dawns. I wish things didnt matter so much, that I was answerable to none but myself. Well I trust to my luck—I have always been lucky. So that's enough of that.

Lately I have had several drawings photographed so that I can make a book of them for Margaret & also use them for reproduction if at any time someone wants to print them. This happened the other day when someone in America saw fit to bring out a book on Modern British Art & wanted some of my drawings to appear—this was a great excitement & I do hope the book really will come out. Things do in America dont they? One thing that troubles me always is that I have done so awfully little so far—never painted a picture *yet* only made a few queer drawings and oh, Gordon I did want to do something—useless repining; but I do want to get through & begin in earnest. . . By the way some hound borrowed the little copy of the Crier you gave & I suppose you can't spare us another & write in it as you did in the old one. Bunty has been so miserable over losing it & we have both hunted high & low with no result. We should be fearfully joyful if you could spare us

[1] *King Lear's Wife* was performed in London at His Majesty's Theatre in May 1916. Drinkwater produced the play. Viola Tree was Goneril and Lady Tree the Queen. The play had been first performed at the Birmingham Repertory Theatre under Sir Barry Jackson in September 1915. Kathleen Drinkwater (Orford) played the Queen, Mary Merrall, the young Waiting Woman, Ion Swinley, Lear—'all' says GB, 'so finely, that I do not expect ever to see the play better done or with so beautiful an ensemble'.

another. Mrs Goldsworthy said something about the play being done in America is that so? do let me hear about it. Do you know what is become of Thomas,[1] he has passed from my ken—dear old Thomas I was sorry to part with him, he was a great companion. Do you know Jack is in France—he got into the Artists & almost immediately was shunted out to the first Battalion in France to do his training out there. Rupert Lee is in The Queens' Westminsters & is now trying to get a commission—poor old chap he has had a bad time but nevertheless looks twice the man he used to be. Bunty's Industry[2] has done marvels and is now being turned into a Company if it survives the banns, restrictions and general persecution of the next few months There were many exhibits at the Arts & Crafts Show, over half of which sold & many orders came in subsequently. I suppose you cant think of anyone who will buy a drawing because Im going to be ruined over this commission. I never quite realised how hopelessly inadequate the pay is until now. Do let me know Gordon, if you can think of anyone as I have plenty of pictures I could send you. More letters must be written & the making up of my accounts with Bunty—dread hour!

Best wishes to you both dear friends from Bunty & me

103

The Sheiling, Silverdale, Near Carnforth

GB to PN *7 January 1917*

It gave us great pleasure to have a letter from you the other morning and to hear all the things about you which we have been wanting to hear. Some news we heard from Thomas until he left Romford, and some from Mrs. Goldsworthy; but it was never recent enough. We have often wondered about you, and wished we knew what was happening to you.

Your last letter told of the critical eye with which a sparrow watched you drilling in a London Square; and now you have your commission. I wish the interval of preparation could have been prolonged, for to tell you the truth I had rather you were in England. But I have no doubt you would rather be in France, and, as I often wish I could be there myself, I feel to understand. We are glad you have your commission: you will often þe in our thoughts and we shall want to know about you and to hear that you are safe; and we shall rejoice and be thankful when these cataclysmic days are over and you can "get through and begin in

[1] Edward Thomas (1878–1917), poet and man of letters. He had been in the Artists' Rifles with PN at Hare Hall, Gidea Park, near Romford, Essex.

[2] An organization for hand-weaving.

earnest." I know you are going to take more chances of death than you would be doing if the old days and the old life had continued: I wish it were not so. Yet the chances of life are still greater, and I feel with envy that your vision of life will be keener and more various for these next months' experience, and that you have the mental energy to let it all feed the various purposes of your art.

Real artists are always "beginning in earnest" so long as they don't make concessions and compromises to gain popularity and success; when you are sixty you will think about the pictures you have done as you now do of the drawings you have done; and you will say "But next time, by God. . ."

In the meantime you can take to France with you the feeling that what you have done has been your own, and that it has "proved your hand" (Dürer's phrase to Raphael) to many men who know what real drawing is; and that it is making many people eager for you to come back safe and go on.

Beside, what an artist has done he has gained for ever; so wherever you go you will take your riches with you and go on from there.

· · · · · · ·

Thomas was gazetted to the Artillery in December, in the middle of his long leave after finishing at Trowbridge. He was here just before for three memorable days, and afterward went to Lydd for experience with some special kind of gun.

He was always nice, but I think he was nicer than ever then, and we were as happy as our thoughts would let us be; and after he left us he sent us a treasure of a poem about The Sheiling.[1] We talked a good deal about you, and about your time in the Artists' together, and about your work, and we showed him your pictures; he liked the Sleeping Beauty, and still more Under The Hill.[2] The latter impressed him a good deal, and he said it gave him a new idea of your powers.

When last we heard he said he did not know if he was for Salonika or The Somme. At the moment we are feeling anxious, for this morning our handmaid said that news came last night of an artillery transport being torpedoed in the Mediterranean. But we take heart when we remember that our maid is a forlorn and helpless noodle. Some months ago she returned from fetching the letters one Sunday morning, and said it was announced at the post-office that a battle-ship had been sunk by a submarine. "Whose was it?" we enquired in uncomfortable suspense. She replied "I don't know, but it was either English or German."

· · · · · · ·

I am delighted to hear that you liked Lady Tree's performance of Queen Lear as much as I did. I liked Lady Tree, for she seemed rather

[1] Printed in his *Collected Poems*.
[2] Both drawings were included in the bequest by GB to the Carlisle Art Gallery.

a dear and proved much more considerate than her daughter, as well as more conscientious about her work.

It is quite true that The Crier has just been produced in America. It had a trial-trip at Wyoming in September, and was put on in New York early in December.[1] I have just had the first report from my old friend the painter Balmer,[2] who says the mounting was very good, and the stage-management of the Crier himself wonderful; and that the audience was worked up to a great tension.

There are two N.Y. companies wanting Mrs. Lear; one of them belongs to Peg o' my Heart, who wants it for a series of matinées in a big theatre.

I look forward to a day when actors and actresses will not spoil everything for you; for Birmingham assured me that this need not be. Sometimes I wonder if a perfect solution would not be the banishment of actresses; for it is harder to find good actresses than good actors. The Elizabethans did without them, and the Elizabethans knew quite a lot. I have just been hearing wonders of the Japanese court theatre, where plain men play beautiful women more beautifully than beautiful women could.

.

I cannot promise to be much good as regards selling drawings; for everybody hereabout is either stumped or hoarding and afraid to spend money on anything reasonable. But I will do my best, and if you can let me have the photographs to have by me they will be a great help.

After I saw you in London I went to the Shiffolds and had gastritis. This dogs me yet, and in addition the Winter has destroyed me. I hope you have missed the worst of it, and that all the bad weather has come first; and that you will have an early Spring when you reach the trenches.

Our thoughts will be with you and our fervent wishes. Write to us from the trenches.

We join in the kindest regards to you and Bunty.

[1] At the Princess Theatre by Stuart Walker's Portmanteau Company. *The New York Times* (19 December 1916) writes: '*King Argimenes* (by Lord Dunsany) makes handsome amends for the dank and noisome tragedy by Gordon Bottomley which was the other new thing in yesterday afternoon's program. . . . Here are shadowed tarns and banshee wails, and all that is creepy enough to have rejoiced a box party that included Edgar Allan Poe and Emily Brontë, but here also is a gratuitous violence and an audible accent of degeneracy that makes the play intolerable.' The leading lady, Florence Wollerson, eventually settled in England and played leads, as Florence Buckton, at the Old Vic for two seasons. She was Princess Nest in GB's *Britain's Daughter* in Robert Atkins's production.

[2] See Letters 19 and 20.

104

P.N to GB [c. 23 August 1917]

how long it is since word passed between us! You never wrote in
answer to the letter I sent you before I went to France and I sadly
missed that looked-for reply.[2] My time in France was very wonderful
and I never stopped gaping. I made as many drawings as I could and
by a queer lucky accident fell down a deep trench one dark night and
was sent off home with a broken rib, a week before the big offensive.[3]
When I reached England I was able to finish my drawings & arrange
a small exhibition at the Goupil Gallery.[4] And it was successful: more
than that, it was interesting, for it brought me a new & very dear
friend—John Drinkwater[5] and my first genuine appreciation in in-
telligent criticism I sold half the drawings which was a great blessing
as I was very hard up and thro' the show gained a better reputation I
think, which I hope will stand me in good stead now when I am trying
to get a permit to make drawing[s] in France when I return. In this you
could help me if you would as the man who has the disposing of permits,
John Buchan,[6] wants me to get letters from one or two sound men giving
appreciations of my work and assuring him I am a worthy young artist
to be employed on the job. Im sure a letter from you would help me if
you would write something likely to impress Buchan. Can you do it for
me, Gordon? I am sending you a copy of Land & Water in which a few
of my drawings appear they are reproductions from photos: of the
original watercolours—rather remote but they have not come out so
badly, also you will read the article written by John Cournos[7] who is
described as my friend—indeed he is now, but I had known him very
little before & altho it is made to sound rather like a conspiracy he
wrote quite off his own bat—having come upon the drawings while I
was in hospital He then said how they interested him & he would like
to write about them. The result was this very good article here, at which

[1] At the end of August 1917, after his discharge from hospital, PN was attached to
the 3rd (Reserve) Battalion of the Hampshire Regiment at Gosport. He lived out with
his wife at this address.

[2] The letter precedes this as 103. It turned up later. See Letter 113, postscript.

[3] War Office records give the accident as happening on 30 May 1917. A letter to his
wife printed in *Outline*, p. 205, implies that it was on the 25th.

[4] 'Drawings made in the Ypres Salient by Paul Nash.' The catalogue is undated
but the exhibition was undoubtedly held in June.

[5] John Drinkwater (1882–1937), poet and dramatist.

[6] John Buchan, later the first Baron Tweedsmuir (1875–1940), author, Director of
Information under the Prime Minister (1917–18), Governor-General of Canada
(1935–40).

[7] 'The Ypres Salient. An Appreciation' (*Land and Water*, 28 June 1917). The first part
of the article is anonymous and Cournos's contribution follows in quotation marks.

I was frankly delighted—not thro' vanity but because he seems to have explained things so well, & to be intelligently explained is a pleasure to any artist—Think, O, think of the Critics! with capital Cs and their meandering & musing and their abyssmal humour. When Cournos first read his essay to me I recognised things—"someone has described a certain poet's work as possessing the quality of 'accurate mystery' that is, mystery expressed with precision, for in many peoples' minds the idea of *mystery is not dissociated from vagueness and mistiness*" I am glad that has come into my work. Years ago when you first wrote me those fine letters which did so much to correct my mind you said 'the greatest mystery is obtained by the greatest definity' (is there such a word?)[1] I never forgot that lesson & I always knew its truth. I know I am a very, very long way off accomplishing anything greatly significant but to have qualities which make for significance recognised in my drawings has encouraged me much. Oh but I want time & freedom. So far I can but make drawings as I go from place to place. I know how secret & reserved Nature really is and what devotion and homage must be paid to her before she will yield her mysteries. Sometimes I am desperate at my impotence. And I see so much more now: the world is crowded with the most marvellous things; everywhere I see form & beauty in a thousand thousand diversities. Only old Whitman poured out what I feel in his endless magnificat of rapture in the created world. I have discovered a longing to draw people which is causing me much pain and despair It is a great joy to live with a woman and be able to see new beauty every day in lines and forms & colour dwelling in her and growing out of her. Margaret is my never-fading joy and we spend the happiest times together. Both of us stayed at Oakridge with John & Kathleen Drinkwater. I think they are dears, John the kindest and most lovable person. He is arranging an exhibition for me in the foyer of the Repetory Theatre Birmingham to open on Sept. 1st. Rothenstein has written an introduction to the catalogue[2] and it is to be the opening of a series of shows of the work of the younger men. I will send you a catalogue later on.

How is Emily? give her our best love and if you are not well enough to write beg her to do so. I shall not be going back for about 3 weeks having got a poisonous nose which riots at intervals causing me much pain and annoyance but prolonging my stay in England which is useful & a comfort to Bunty.

You are to keep the paper & later I will send [you] a book of photographs to look at if it will amuse you. Pictures I cannot send just now as they are in use & the difficulty of postage rather puts it out of the

[1] See Letter 2.
[2] *Catalogue of the Exhibition of Drawings by Paul Nash.* With an introduction by William Rothenstein, Professor of Civic Art at Sheffield University.

question. I do so hope you are not suffering—I want to hear of you & what you are writing and how Silverdale is and the old hills & those enchanted woods and dales. You have so often been in my thoughts while I was out there—do write, Gordon—

105

From GB to PN, Silverdale, 25 August 1917. [This is the rather formal letter intended for John Buchan to see and referred to in the opening paragraph of the next letter. It recapitulates his views of Nash's work.]

106

The Sheiling, Silverdale,
Near Carnforth
GB to PN *26 August 1917*

I hope by now you will have received (i) the postcard, and (ii) the Buchan letter which I sent you last night.[1]

The great pleasure of having your letter has been at moments almost clouded by the painful knowledge that you never received the letter I wrote you on the eve of your departure for France in January last. It distresses me to think of it, and to think too how callous I must have appeared.

.

It was nice to hear a little while ago of your being with the Drink-waters in the Cotswolds: John is charming and friendly and we always admire his witty and vivacious wife too. I wish you could have seen her play my Queen Lear;[2] she was the real thing, and made the part into melody and steered superbly clear of Lady Tree's irrelevant realism. I think there are few more earnest lovers of the arts than John, and his theatre is the most hospitable abode of the arts in England, beside being the most beautiful theatre in England and the only one worth paying to go into. John has done wonders there which put all London to shame.

There is not much news of us. This hot summer has rather dished me, and now the damp completes its work. Which does not mean that I am ill, but only that I cannot get about much; and as Emily is at a constant strain with her mother's recurrent illnesses, and the impossibility of getting any workpeople to do anything nowadays, we are oppressed by a kind of stagnacy of life which we do our best to transcend

[1] The postcard is missing, the Buchan letter has been omitted (see 105).
[2] Performance at the Birmingham Repertory Theatre in September 1915. See p. 81, note.

with our books and pictures and crystallised music. Two griefs have come to us and we feel they have impaired and impoverished our lives for good; first the death of our friend Hay[1] last October, a horrible and protracted death from cancer at the base of the brain and encircling the throat; and then the death of Thomas on Easter Monday at an artillery observation post near Arras. They were both men of sweet and noble nature: Thomas was here on his long leave just before he was gazetted, and he was more than ever like a hero out of a saga. We spoke of you, and he asked me for news of you after you left Romford.

We were delighted to hear of your accident and your sojourn in England: but you had no business to get better so quickly. However, I hope fervently you will carry Buchan's permit with you when you return to France, and so have your own special work. You must tell me if my letter was not right and I will do it again. In my last I asked you to write to me from France; so I hope you will.

I could not help feeling satisfaction to hear that you are longing to draw people again, however much despair it causes you. I always suspect old Richmond of switching you on to landscape because your figure-drawing was not academic enough for him. But there was a singular and enchanting rapture in your early figure drawings which I mourned to see you abandon (Lavengro and Isopel, and the woman shooting arrows against the stars[2] are still your masterpieces), and you can do something personal and memorable, with an enlarged range, if your mood brings you back to figure-work again.

Sometimes we go to spend the day with the Editor of English County Songs,[3] who has come to live at the other side of Carnforth; and whenever the book is mentioned I think of you singing "Green Willow."

.

107

19. Clarence Square, Gosport, Hants

PN to GB [*4 September 1917*]

many many thanks for your letters, both greatly appreciated, the one for Buchan will do nobly & I think he cannot but be impressed. I wait now to hear the result. How strange that I never received that January letter. I never blamed you but was afraid you had been too ill to write & always hoped it would come some day. I shall make enquiries in London but the post office people are glaringly unscrupulous

[1] See p. 50, note 1. [2] Probably *Night Landscape*. See Letter 57.

[3] J. A. Fuller Maitland (1856–1936), musician and editor of the second edition of Grove's *Dictionary*. He edited *English County Songs* with Miss L. E. Broadwood. He lived at Borwick Hall and was a friend and neighbour of GB. For many years he was music critic to *The Times*. See his *A Door-Keeper of Music*, 1929.

when they are not dense and obstinate. In spite of filling up numberless forms about letters after leaving Adam St, they continued to send them there & yours must have been unlucky & never forwarded or mysteriously lost. I am furious about it. It was good to get a letter from you again & hear all the fine encouraging things that have always helped me so much. and altho' [I] do not quite agree about those old figure drawings I am anxious to make new ones. I have not got far or accomplished much at all but I am sure my best drawings so far are among landscapes. At the same time I have felt tied lately & have been lunging out in all sorts of odd directions as you will see later. I think I can find you a print of Lavengro & Isopel which you seem to like. It came out in a quarterly called The Gypsy[1] the 2nd number, perhaps you might pick up a copy of that as I know you deal largely with the old second hand folk. I met a Calvert[2] admirer the other night, quite a rare find—as few people ever hear of that delightful artist he (the admirer) is putting me on to finding some reproductions of C's work, always difficult to obtain.

I can sympathise with you over poor Thomas & Hamilton Hay—most tragic & wasteful Death! why does it always make such freakish robberies—Thomas tho', poor fellow always seems to have been oppressed by some load of sadness & pessimism. I believe I saw one of the happiest bits of his life while we were in the Artists—he was always humourous interesting and entirely lovable but others who knew him speak of him as the most depressed man they ever met. I wish now I had written to him after I left I shall always regret it. I never knew till now how Hay came to die—what a fearful thing. I had simply no idea he was ill until one day a friend of his told me he was dead. You will indeed miss both of them, they were fine chaps.

.

We both send all our love to you both and do pray for a fair Autumn for you to bask in. I am thrilled to think you may be in Birmingham—the pictures are there for two months—I only wish it was a better show for you to see still there are one or two jolly ones.

Write & tell me what you think of them

Ever yours
Paul

I want to make a bargain. Some devil to whom I lent your books—The Mosher[3] copy of the Crier and Midsummer Eve—never returned them [and] I dont know who he or she was—Margaret never ceases to make moan over this and we are both unhappy over our loss. Will you

[1] Two numbers of this periodical appeared, in May 1915 and May 1916.

[2] Edward Calvert (1799–1883), painter and engraver, follower of Blake.

[3] The Crier by Night was reprinted in U.S.A. by T. B. Mosher of Portland, Maine, in The Bibelot, vol. xv, No. 9, 1909, pp. 293–331.

give me another copy of each—or most coveted of all! an original copy of the Crier, Unicorn Press, in exchange for a new drawing. You know how I value the Crier—in there are treasures of beauty—lines of poetry and deep wisdom which to my mind you have never surpassed—and I cannot buy it anywhere. If you will do this write in the books as you did originally it would make us so happy.

.

108

GB to P.N *8 September 1917*

I am so glad to have your jolly letter and news of you, and to know that the John Buchan letter was the kind of thing you wanted. And I was very much interested to hear of one of your friends being an admirer of my old devotion E. Calvert. If you hear from him of the reproductions he has promised to tell you of I hope you will pass the good news on to me, for I only know of four sources of such, and as these are now mainly inaccessible I should like to have them supplemented. He seems to me one of the most complete lyrical-elegiac artists in the world, especially in his earlier work, which alone contains all his intensity.

I shall go into the deepest mourning and wear a bushy and tall black plume nodding on the top of my head if I have caused you to believe that I undervalue your later (and especially landscape) work. For such, my Paul, is very much not the fact. I hold that you have the most interesting and personal landscape vision of our time, while in technique, texture, and accomplishment your landscapes are whole ages ahead of your early figure pictures. But man's deepest knowledge is of man, and I value those early pictures most because they called on more, and more various, sides of your nature to achieve them, and when they succeeded they achieved a subtler and more complex balance of qualities and surmises and insight. Besides, when an artist is an artist he is an artist and not a landscape artist, and if he wants to rank among the stunning fellows he must be up to everything.

And, furthermore, if I am out to own up the whole of my sentiments, those early figure pictures of yours command my deep respect because every time you began a new one you tackled its problems on their own merits, as if virginal beauty should now come to pass for the first time; whereas it is the pitfall of specifically landscape artists to evolve a formula in the course of time and to codify their work, which rules out so many of the surprises that are worth most of all. I have felt once or twice this threat impend over you, so that the charming, amusing green-brown forest-glade with a skittish lady in one corner, which appeared a

year ago in 'Colour'[1]—to take one instance—has always seemed to me to be not quite good enough for Paul to have done. So I feel it is the best of good news to hear that your thoughts turn to figure-work again, and I look forward to learning that there you have found new worlds to conquer.

.

I am so sorry to hear of your ill-fortune with the books—but most flattered to know you think they are worth a drawing apiece; I have not had such a princely price offered before, even by the multi-millionaires of America: in truth, the books could never hope to be worth so much. I wish for my own sake I could take you at your word instantaneously, but, alas, the books are not there to do it; I have sent a good many to America and have divided the rest as evenly as I could among my friends, and now I have only one or two copies left which I am bound to keep to form part of some complete sets about which I have had enquiries from America. So I am afraid there are no more chances of my being able to give my friends my extinct works, as I like to do, until Constables have the collected volume of my plays ready—and I think that this is beginning to move at last. It will contain *five* plays, Paul; but you shall have it for one drawing, not five.

.

109

Iver Heath, Bucks.

P.N to GB *Sunday* [c. *mid-September 1917*]

many, many thanks for your letter. I am so sleepy tonight I cannot write you a decent one in return but I hurry this off to ask you if you approve of a head of you by me appearing in "To day"[2]—Holbrook Jackson wants me to[,] having seen a drawing [I] made of Drinkwater[,] do him a head of you to accompany an article on you & your work which he tells me is coming out shortly. Now I seem to remember doing a fairly good Drawing of you at The Shiffolds—have you got it & can you tell me if it is good enough, if you think it is, and you would like it to be used, will you post it to me at *176 Queen Alexandra Mansions, Judd St W.C.1.* as soon as possible then if I think it a good enough drawing I will show it to Jackson. Failing the drawing you should get

[1] *Colour* was an illustrated monthly published in three series—from August 1914 to October 1924, from January 1925 to January 1927, and from November 1928 to May 1932. The picture here mentioned was *The Nymph*, now in the collection of Sir Osbert Sitwell. It was reproduced in the issue of July 1916.

[2] *Today*, edited by Holbrook Jackson, ran from March 1917 to December 1923, when it was absorbed by *Life and Letters*.

him to use that magnificent photo which Leibich possesses & I always covet—Photos & respectable letter later—

<div align="right">Yrs.
Paul</div>

If possible let me see drawing in a few days I may sail for France by the end of the week. Foreign Office has decided to employ me in doing drawings but there is a delay will explain later.

110

<div align="right">c/o Miss Redfearn, Hawthorn Villa,
St. John's Road, Buxton
19 September 1917</div>

GB to PN

I was delighted to see your envelope. But now that I have opened it I am depressed. I am dejected.

What can I do? You see my address. Voilà tout.

When our extended outing proved out of the question, we made the shorter journey hitherward, as Emily was very much run down and felt she must have a change in view of further anxieties with her mother which loom ahead disquietingly. So the Sheiling is shut up and there is no possibility of our being able to get at the drawing for another fortnight or three weeks at earliest; and, from what you say, that will be too late.

I am really sad, for nothing could have made me happier than to see your name and mine thus associated on the frontispiece-page of "To-Day."

If only I had been in Birmingham I would have made the short journey forward to London to get you to make a new drawing; but the prodigious railway-fare from here puts that out of the question.

I believe that solution would have commended itself most to you. Very shortly before we left home we had that old Shiffolds drawing out of the portfolio one night: it struck me as an impressive and remarkable piece of drawing, with something large and grand in its dispositions. It must be well thought of wherever it is seen: yet it does not represent either you or me at present; on the one hand the reclining posture, the cushion that looks like a pillow, the downcast eyes that seem to be closed eyes, all combine to give an impression of illness and exhaustion that is perhaps now less characteristic of me than it was then, and would, I feel, have an appearance of playing for sympathy if it made so public an appearance: while on the other hand your deftness and certainty of handling have increased even more than my health has done in these five years, and I believe a new drawing would follow up your Goupil show better and more completely.

All of which should not, of course, prevent this one appearing if you wished it. It would be best to have it photographed to save the risks of the journey, and the negative might even do for the reproduction. But it will be well into October before this can be done, and I do not know if this would be in time.

· · · · · · ·

We are so very hugely thankful that you are to do drawing for the Foreign Office: I hope you will let us know as soon as the preliminaries are cleared up and your destination is certain.

· · · · · ·

We send our love to both of you.

<div align="right">
Yours always,

Gordon Bottomley
</div>

111

19. Clarence Square [Gosport] until Tuesday—then

176. Q.A.M.,[1] *Judd St. WC 1*

PN to GB *[28 September 1917]*

My dear Gordon

you are quite right neither you nor I wd be represented favourably by that ancient drawing. Your Description confirmed me in my rather vague recollections of it so the fact of your not being able to let me have it does not matter at all. . . By the way, I suppose it is altogether impossible for you to get to Birmingham because Margaret & I expect to be there next Thursday & Friday or rather we arrive late Thursday night. I would give a great deal to see you as you may imagine & it would be splendid if I could bring off that drawing of you for Today. I feel particularly jealous of anyone else, artist or photographer doing your headpiece for this occasion, & if only I had long enough leave I would pawn something & make my way to Buxton—this I fear is impossible simply because I have not enough time to do it in, so I wonder with a wild hope if you could possibly reach Birmingham. Mahomet to the mountain indeed! I see by your letter you speak of the prodiguous railway fare putting a journey from Buxton to London out of the question. What is the fare from Buxton to Birmingham? and how long does it take do send a card telling me this. And then tell me if it is your only obstacle, because you & I are both poorish men but your a poet & I'm an artist so except for you being my senior, and to reverse somebodys lines about the sun and a cricket ball,—'You a great ball I but a little 'un'—, I see no reason for jumping on high horses or standings on dignity, if I suggest straight off that I pay your fare! I've

[1] Queen Alexandra Mansions.

sold some drawings at Birmingham & I never collect money so if Ive got enough to stump up I'd like to spend it on spiriting you, & Emily of course, from one place to another more than on anything I know, if it brings you into our midst. Margaret would go mad with joy and, I know, sacrifice her years dress money—a really great sacrifice you know —to help me accomplish it; for she loves you and Emily as deeply as I. Now do turn on a piece of crystalized music and meditate upon it, for I shant see you again for God knows how long having just been warned for Eg[y]pt! Yes, it is pretty alarming, isnt it, but I have written to the Foreign Office to tell them & trust I may get it revoked—if not, 'good-bye' to all chances of making drawings in France—which is rough luck after virtually getting the job. I'm bounding along with the figures and have just finished two designs from Blake's poem Tiriel—also two large pen drawings of landscape with figures and three rather queer water colours in which figures of women come in to the design I have besides done some heads of Margaret. All the wisdom of your letter before last read, marked, learnt and inwardly digested, but am sorry you sniff at the glade with skittish lady. It was a design made from a sketch of a glade at Silverdale—a mysterious place that enchanted me. Perhaps it it is a little oriental but I had regarded it as possessing colour and rythm and a certain ruggedness of form which I liked. I think I have got better than that since, but I must stick up for it as it was rather a friend. Also I was always pleased because dear old Hay, I was told, wanted to possess it tremendously and I had meant to make an exchange or some-thing with him.

It is sad about the books—can I not get one of Mosher thro' you? 'The Crier' I want especially—It is immensely exciting to think of a book of five plays—when O when are you going to let me make a draw-ing to accompany a book of your poems or plays. I'll do a dozen to arrive at one to satisfy you enough—nay two dozen if necessary. Very shortly I am going to have another try at 'Blanid' hoping for better results with more knowledge & greater power. Love to you both from Paul

112

at Miss Redfearn's, Hawthorn Villa,
St. John's Road, Buxton

GB to PN 1 October 1917

The Southern mails have been delayed, and your letter of Friday has only just arrived. I am afraid you will have thought me negligent.

It is most charming of you to write so tenderly and generously, and I should like you to believe that I am not unsympathetic or unrecipro-cating to your very sweet delicacy of feeling. Thank you so much.

But, and of course we ought not to arrange our affair in this way. It is true that the strange uncertainty which impends over us all just now made it seem wise for me to leave my money in the bank rather than deplete it on an expensive visit to London; but, as you will remember, the shorter journey to Birmingham was actually planned, and we should have been there now if my lung had not proved unequal to the journey and a town sojourn. In spite of a fortnight in this good air, I am still unequal to the latter, or otherwise the journey from here would have been still easier.

But, since you have a mind to waste such good money on so obscure and middle-aged a person as I, why not snatch a night or two to come to Silverdale and do the drawing? You do not say you leave England just yet; so can it not be fitted in? We leave here on Tuesday next week and could be ready for you by Thursday.

If the Foreign Office fails you we can think of you with more equanimity in Egypt than in Flanders; for the casualities are fewer there, and there are topping things to draw. But if the F.O. keeps its word then we shall be happier in your returning to Flanders in more fortunate circumstances. We hope you will have good news for us before long.

You must shew me your drawing of the lady in the glade one day: I daresay the reproducer has done its colour more than one injustice.

I am grieved to say that the Mosher "Crier" is out of print as his "Bibelot"[1] has stopped and he only has enough copies for binding up into sets. So I can't hope for the "Crier" to be available again until the Constable edition is available.

But I must not try to answer your letter, or I shall miss another post; and I have lost too many.

Tell me what you find it possible to arrange, and I will write again soon.

<div style="text-align:right">Our love to you both.</div>

113

19. Clarence Square, Gosport
PN to GB
10 October 1917

My dear Gordon

I was indeed sorry for the cause of your letter do forgive me not writing before. . . . I fear my little sudden wealth will not take me as far as Silverdale even supposing I could find the time and anyhow now it is made impossible. Some day Gordon—I have good news. I returned here Sunday night. at nine oc. orders came thro' for the officers warned

[1] This interesting periodical ran from vol. i, 1895, to vol. xx, 1914. In it was reprinted much prose and verse difficult to find in England.

for Egypt to report at Southampton at 2. oc same day Almost at the same hour a wire arrived from the War Office cancelling my name from the list. Otherwise by this I should be on the seas without having bid goodbye to Margaret or any of my people and without a single part or kit suitable for the hot climate. I sweat to think of it. It was damned lucky I woke Buchan up last week he has been just in time to save me. I scarcely doubt now I shall be sent to draw in France, in which case B is sending me out for a month then I return to England to work up my sketches & while I am at this they are going to give me other work—probably drawing the Fleet! think of it. The pictures looked very well at the Repe[r]tory. John has arranged them admirably. Of course the Birminghamites regard them askance and the great Cadbury[1] who was to do so much neither understands them nor likes them tho' John is still trying to open his eyes. . .

<div align="right">

Love from us both
Ever yours
Paul.

</div>

PS Your letter of January has turned up thank so much Gordon it has given me very great pleasure. I have not got it here or would make this letter longer & answer it. I must read it again & write later.

114

From PN to GB, as from Alexandra Mansions, 22 October [*1917*]. He suggests that GB shall write an article to accompany the reproduction of his drawings for Blake's *Tiriel* in *Today*. He is going to France 'on Wednesday'. 'I'm sure you'll like the designs because they are a throw back to earlier things & all purely out of my head, Tiriel exciting me very greatly imaginatively.' He expects to be in France about three weeks.

115

From GB to PN, Silverdale, 25 October 1917. He is very attracted to the idea proposed in the last letter, but cannot possibly undertake it because of the pressure of work in hand, which includes an urgent contribution to a memorial volume on Edward Thomas.[2] He suggests that the most interesting thing would be for Nash to write the article himself.

[1] Edward Cadbury (1873–1948).
[2] No such volume appeared. GB contributed 'A Note on Edward Thomas' to *The Welsh Review*, vol. iv, No. 3 September 1945.

116

GB to PN 2 July 1918

One only hears of things a fortnight after everybody else in this belated and benighted wilderness, so the good news of your "Country Life" book of war-pictures[1] has only just percolated here accidentally by the casual agency of a cutting from a halfpenny newspaper sent to me by a neighbour who had an idea it referred to a friend of mine. There was your portrait,[2] too, and as I hadn't seen you for two years it was nice to see how you are looking; and altogether I felt that the half-penny newspaper had justified itself at last.

Of course I sent for the book with a bang; and as the Post Office smashed it to pieces I demanded another with a greater bang on account of bad packing; and I want to tell you how delighted we both are with it.

I had seen some of your war-drawings in Colour and The Graphic: they were not those with the most You in them, and I felt rather sadly that fashionable conventions were preventing you from getting yourself in: I had so much rather have the (to me) irresistible conventions you invent for yourself, and you don't need other men's fashions to help you out. I must make an exception of the St. Eloi one in The Graphic, which I found considerably attractive: but it was unjust to you that the reproductions should be so small.

Then I was suddenly and overpoweringly delighted to find the one which James Bone[2] reproduced in the Manchester Guardian. I didn't even object to the Futurism of the Past flicking out a final kick in the sky; the whole thing is magnificent, and it was delightful to me to see you coming into your own so unmistakeably. It has the grandeur I once saw in a battle-piece of Gericault's, and it is more downright and straight and free from conventions than the Gericault was. I felt it to have in it a deep and moving beauty.

And now there is your fine book, with the added delight of a really adequate hint of your characteristic colour in the admirable reproductions. Your father must be very proud of it, and all your old friends who believed in you from the first—from, shall we say, the days even before Flumen Mortis when you inked a book of Mrs. Goldsworthy's?[3]

.

Putting aside a noble drawing of ruins by Rothenstein (which is

[1] *Paul Nash*. Introductions by John Salis [Jan Gordon] and C. E. Montague. Drawing of PN by William Rothenstein. British Artists at the Front Series. *Country Life*, 1918.

[2] A brother of Sir Muirhead Bone, on the staff of the *Manchester Guardian*. The picture reproduced was *Void*.

[3] PN's drawings in a copy of *The Crier by Night* that began this correspondence.

the only war-subject of his which I have seen), your book is by far the finest thing made out of the war which an English artist has done at the front; and I congratulate us all on your having done it for us.

I heard not long ago that you were not going to Flanders again, and that you might be drawing in the navy: I think it was W.R.[1] who told me at Birmingham. So you will join the navy after all! I hope you will make a book of that too, for I should like to see what the sea says to you.

Emily joins me in love to you and Mme. Margaret.

117

Tubb's Farm, Horn Hill,
Chalfont St Peter, Bucks.
PN to GB *16 July 1918*

I was so delighted to have your letter tho' it put me to shame. I have been to write for so long—first of all before I went back to France when I was going to send you some photographs of recent drawings, then later when my war drawings were done & I had many things I wanted to say, and finally I hung on till my book shd come out so I could send you a really important packet. And it all got delayed for one reason & another. Then last week I dragged down all the odds & ends to John Drinkwater's meaning to send them off from there. Here another accident occured for I found Will Rothenstein had not been sent a book and was rather pathetic about it, so I had to give him yours. Alas! when I got back here I found your letter telling me you had gone off with a bang & bought me. What a reproach. Dear Gordon do forgive me. I am so glad you do like what I have done. I felt dashed reading the first remarks but the drawings in the book & the reproduction of Void seem to have got you, so I think you would have cared a good deal for the real pictures. Unluckily the oils were not all finished in time to appear in the book and oils for me were a complete experiment you know—a piece of towering audacity I suppose as I had never painted before & the first three I did were purchased two for the Nation & the other (Void) for Canada. This was a real adventure & I did enjoy it. You have said so many nice things about the drawings[,] I can make but confused & inadequate acknowledgement. I am glad you like 'Landscape 1917' it is a favourite of mine. All that talk by Montague[2] in the prevace is nonsense of course. Wire does & did grow as it is shown here, and I was neither mad nor drunk or trying to show an abnormal vision when I drew it. I am afraid I dont look so beautiful & Blake-like as W.R has drawn me but I like to think so. Jack & I are both temporarily seconded & employed by the Ministry

[1] William Rothenstein.
[2] C. E. Montague (1867–1928), novelist, journalist, and critic.

of Information to paint pictures for records & propaganda—actually what we like, so long as it is interesting enough under these somewhat vague headings. To start off with we have each a large memorial painting[1] to do and this is exercising our rescources at the moment. My size is 10 ft by something so I am going to be busy. No I am not going to draw the Navy—yet! I must describe our present mènage down here. We have taken a large shed, formerly used for drying herbs. It is a roomy place with large windows down both sides, an ample studio—here we work. Jack is lately married—a charming girl whom we all adore... They live in rooms in a little house next the shed & Bunty & I have a room in the old farm—a charming place with a wonderful cherry orchard & fine old barns & sheep & rabbits & all that sort of thing. We all lunch together in the studio where there is a piano so our wives enchant us with music at times thro' the day. A phantastic existance as all lives seem these days but good while it lasts & should produce something worth while I suppose. France and the trenches would be a mere dream if our minds were not perpetually bent upon those scenes. And yet how difficult it is, folded as we are in the luxuriant green country, to put it aside and brood on those wastes in Flanders, the torments, the cruelty & terror of this war. Well it is on *these* I brood for it seems the only justification of what I do now—if I can help to rob war of the last shred of glory the last shine of glamour. I hope to go out again later on, to do new drawings but at present it is forbidden. And now today the new offensive—will it be the end—What ages back it seems to the day we left your quiet remote country & travelled South & saw those first sinister signs of change the excited people, the trucks of soldiers, and suddenly realised what was beginning, and the night we arrived in London War was declared.[2] When shall we travel back to you I wonder.

I am collecting a few photos: of pictures to send you—some I enclose now others will follow. I am so pleased you & Emily are proud of me, tho' I have done little yet. I feel very serious about this big picture it is going to have all I can muster. A kind of enlarged and intensified 'Void'; I pray I may carry it through. I heard of your visit to Birmingham how I wish I could have seen you. Do let us know how you are—we heard also of the monstrous treatment of you by the tribunal people, what came of it all? Here I must wind up, the photos I send are—3 designs to Tiriel & another pen drawing and a photo of my other painting & others. I am getting you prints of some others I think you might like to have including S[t] Eloi. Our love to you both & thank you again for all the stirring things you have said—

[1] PN's was *The Menin Road*, JN's *Oppy Wood*, both now in the Imperial War Museum.
[2] Incorrect. Letter 92 makes it clear that war had already broken out when PN and his future wife were at Manchester visiting Charles Rutherston on their return from their visit to GB.

118

GB *to* PN

Your letter, and all its news of you, and the parcel gave us the greatest pleasure—both because it helped us to pull ourselves up to date with regard to you, and because your new work is so jolly in itself and so full of interesting and exciting possibilities. Thank you ever so much for all, and for remembering we should like to have the photographs.

I was glad to hear you are tackling oils, for I feel sure their different potentialities will help you to discoveries and enchantments. I like the Ypres one nearly as much as the Manc: Guar: "Void", and they go together to supplement and enhance the "Country Life" book. "Lavengro" is equally welcome in another way; the things men do when they are young are full of a shy delicious grace and charm that can never come again, not even if they go on to do greater things; you will no more do another "Lavengro" than Rossetti could do a second "Blessed Damozel", and I love this one very considerably with its sensitive mysterious vitality and its wistful feeling that an irrecoverable moment is passing.

Of course I scanned the later drawings more keenly than the rest, to find out where you were and whither you were going. They were originally attractive, yet they grow on one considerably. I like the old man and his daughters perhaps best, for they are both an attractive plastic invention and a very incarnation of the text; but I also adore the woman with hair growing up into the sky and waving; the feeling of "Darkling o'er the mountains" is possibly the finest of all, but I think the execution would stand sharpening and ripening, being at present rather ruder than the life depicted warrants.[1] I feel pretty respectful to the grave and unusual beauty of "Flora"; it has great distinction and the disquieting charm of beauty that is unexpected and strange; perhaps it is the most remarkable of all.

I should want to praise the Tiriel set unreservedly, if I did not experience continued mental discomfort from a discord between the figures and the backgrounds. The backgrounds still feel, after a month, to be largely at variance with the admirable figures; I believe it is on account of your cavalier and offhand treatment of mountains. Euclid, dear Paul, does not anywhere furnish an expressive convention for the handling of mountains. A very very young lady once wrote to me disdainfully on her first visit to the South of England "There are large kinds of grass-hills here", and I feel that it is because you have been neighboured by

[1] These comments refer to the drawings for Blake's *Tiriel*, now in the collection of Mrs. Nash.

such grass-substitutes all your life that you express such opinions of real mountains so summarily. When martial ways and days are over you will have to return to the Silverdale Sheiling and take a more leisured look at the dear, noble, great presences that have more power to impose their wills on you than you have acknowledged yet.

Which reminds me how delighted we were to have the print of the drawing you did from our window; we had often wished to renew our friendly memory of it, and we are delighted to find it looking more fresh and attractive than ever (except that even there you are cursory with two jolly hills). It is not our view as we see it; we feel that the early Britons must have seen it look like that, and we enjoy it all the more for the difference.

Among the Tiriels I like most the landscape in which hair grows upward; but even there the very interesting trees are only a quarter as delightful in the detail of their pattern and colour as the deliciously, delicately, variously, perfectly, thrillingly, beautiful curving under-growth in the right foreground.

I was sad that you "felt dashed" by part of my last letter; for until you are 50 (I am getting on that way, Paul), you ought not to want praising all the time. After fifty we need it in order to overcome the diffidence of middle age and the disinclination to go on with creative work in face of the disparagement and discouragement of our youngers; but at your time of life, my Paul, you ought to be above such mundane considera-tions—otherwise you will use up your share of the necessary stimulant of our later years before you come to need it.

We have just bought "New Paths",[1] and the three pictures we really care about are Nevinson's noble wave (which is nearly as grand as a Korin), your tree-drawing, and Jack's heavenly delightful Italian landscape.

.　.　.　.　.　.　.

I wish we could look in on you in your jolly herb-room at Tubb's farm. You sound to be plunged deep in happy days, and we hope that the music and the merriment and the poetry and romance will settle deeply into your lives, to last when so enchanted a time has taken you along with it into ways of change.

There is one aspect of the war which I do not as yet hear that you have treated, and which I should like to see you treat—and that is its effect on civilians. Why not make one of your large memorial paintings a shell-torn church still whole enough to shelter unhappy heaps of refugees at nightfall—dreadful huddled hunches of beings crouching about fires lit on the church pavement, monstrous tremendous shadows

[1] *New Paths: Verse, Prose, Pictures 1917–1918*, edited by C. W. Beaumont and M. T. H. Sadler. Decorated by Anne Estelle Rice, published May 1918. Contains two drawings by PN—*Elms* and *Rain*.

of them cast on the walls and vaulting by the smoky flare, other pale beings prostrate in the darker places. You should embody your knowledge of broken towns and villages in some such way.

.

Please be sure to tell me when you are going to exciting places again, and how your work at Tubb's goes on. Isn't Tubb surprised?

With many regards to you and Margaret,

119

GB to PN

The Sheiling, Silverdale, Carnforth
23 November 1918

I don't know if you see "To-Day" regularly, so (on the chance that you might otherwise miss it) I enclose with this a sort of a kind of a poem, a mincing middle-aged affair, which I have in it this month.[1] The misguided economy of the editor has made it look sillier than it is by omitting a gap at the top of the second page. You've no idea how it hurts to have a hiatus torn from one's vitals like that: it was one of the best things in the poem.

I wish you could have seen that Viking mound out of that little chamber-window. You would have found a stunning drawing there.

I wonder if you and your brother have finished your decorations yet. I hope you will let us peep at photographs when you have.

Anyhow, the nightmare is over now and I hope they will let you get back to your very own work soon, for now are to be the years to reach after the biggest things—and your arm is long enough and sure enough.

.

We send our love to you and Monna Margharita.

120

GB to PN

The Sheiling, Silverdale, Nr. Carnforth
25 March 1919

Last year I sent you a very nice poem which I thought was the kind of poem that you might like; so I was sad when you took no notice of it. I hoped it reached you safely and that you did not dislike it too much? This card isn't a view from our Sheiling at all, but from the next common. However, you will recognise the stones and the water.

[1] *Littleholme.* Also printed in *Poems of Thirty Years,* in *Poems and Plays* (1953), and in a small separate edition.

121

Iver Heath/176 Q Alexandra Mans.,
Judd St, W.C 1

PN to GB [*Received 25 April 1919*]

you must try and forgive me. I saw your poem some time before
You sent it to me and was going to tell you how much I liked it when
I next wrote to you. The letter was further & further delayed till at
last You overtook me with one from you enclosing the poem & finally
came the reproachful postcard. So I am deeply in disgrace. But I
have had a queer time since last summer and passed thro' a very strange
and unpleasant experience.[1] For some time after I was rather ill, more
mentally than phsically, and altho' I have got thro' it now I hope, I
have been in a harrowed state up to quite recently. Beside all this I have
had a quantity of work to deal with—the chief task being the large
painting for the English government a canvas 7 ft by 10, which is at
last finished & is, I think I can say, by far the best thing I have yet done.
How it ever got painted I dont know for I have experienced every sort
of interruption, dissappointment & delay since the day I started to
work. It has been painted in four different places being begun in the
country in a large shed, then moved to a bungalow, then shipped to
London where I painted most of it in a tiny room & could only step
back a few yards from the canvas—finally I got it into a decent sized
room where it was finished. As soon as I can get a photograph of it you
shall have one. Bob Trevelyan came to see it the other day & seemed
very enthusiastic. As you may imagine this has occupied me pretty well
but work for the London Group & Friday Club which come in this
month, has filled in any spare time. In the evenings I have been work-
ing at lithography & the editing of a book of Jacks humourous drawings
which is coming out shortly. It's going to be great fun Title—'Dressing
Gowns & Glue.' verses by Capt. Lancelot de Giberne Sieveking—
drawings by John Nash. Introduction to the verses by G. K Chesterton,
introduction to the drawings by Max Beerbohm—isnt that rather a
triumph of editing?[2] But this is not all[,] my poor by-this-time-gasping
Gordon—I am putting up a good case you see! I have launched myself
into journalism & am writing articles fortnightly for The New Witness
but this is a dread secret & I use another name.[3] I have found this new

[1] PN and his wife had stayed in a house where they found the atmosphere and the
people peculiarly disagreeable, and PN was particularly affected because of his
nervous state at the time. Mrs. Nash writes that 'it was not at all an important ex-
perience, just rather a silly encounter'.

[2] The book, sufficiently described here, was published by Cecil Palmer who added
'something about all concerned'.

[3] Robert Derriman. PN contributed under this name or his own between the issues
of 25 April and 14 November 1919 inclusive.

effort very difficult at first, the actual labour of writing seems absurdly huge & inconvenient and clearing ones mind for such a different sort of action, almost impossible However I have done the first article which appears, I believe, this week. I mean to stick to it because I have much to say and can be of use I believe in many ways if I can express myself clearly enough. I will not bore you with all the schemes and reforms I hope to forward but when one or two articles have come out I will send them on to you and shall be most grateful for your criticism & advice, if you will give it me. These various activities carried me up to Easter when Margaret & I fled precipitatedly for the country & sank down among the daisies where we have more or less wallowed ever since & tonight return to London to begin again—but feeling much refreshed. The days have been perfect here and the country at its most enchanting moment—just upon the edge of flowering everywhere.

· · · · · ·

I have had sets of drawings to make & cover designs for Drinkwater's poems & Richard Aldingtons war verses which will be out next.[1] This letter is a selfish epistle about myself & my doings from beginning to end I wish I could see more of your work—I enquire pathetically again & yet again for your book of five plays—in vain. There is never an old second-hand book shop Margaret does not rummage & enquire into for that rarity The Unicorn edition of the 'Crier' or the Midsummer Eve—you're a monstrous rarity Gordon: booksellers draw in their breath sharply & raise their eyebrows when we mention you. 'Oh very scarce, madam, very rare sir.' damn your rarity you're as precious as an Auk.

We have all been delighted by John [Drinkwater]'s success with Lincoln[2] at Hammersmith. He has really had an immense triumph. I believe you saw it at Birmingham so have formed your ideas of it. What a fine thing it is, everyone is moved by it from the crustiest old dramatic critics to the most stolid "man in the street". I saw it from the stalls & then in the Pit & it was interesting to find both audiences equally held. Rea's Lincoln is a remarkable piece of acting dont you think?

How have you been both of you & how is the dear rocky country & the Shieling & the pugnacious kitten, no doubt by this time a torpid cat I must wind up now—excuse this pencil outbreak I am now in the train. We both send both of you our love . . . And forgive me for my neglect I will send a propitiatory drawing.

[1] *Images of War*, first published in a limited edition in 1919 for the Beaumont Press, and, with additions, in the same year by Allen & Unwin. For Drinkwater, see p. 105, n.
[2] His chronicle play, *Abraham Lincoln*, had a long run at the Lyric Theatre, Hammersmith.

<center># 122</center>

<div align="right">The Sheiling, Silverdale, Near Carnforth</div>

GB to PN 25 April 1919

I was glad to have your letter, for I had been feeling disgruntled about you. Singularly enough, just before it came I had come unexpectedly on your bundle of photographs, and your beautiful pensive Flora had mollified the precedent savagery of my sentiments. And just afterward my eye fell on the big E. Calvert book which you loved so much when you were here: and I remembered you again, for I can never help feeling nice to people who love E. Calvert.

We are, indeed, so very sorry you have had such a bad time, and we trust fervently that you are wholly recovered and in complete working order again by now; for the world has considerable need of what you can do. I hope Iver was as lovely in this gracious Eastertide as Silverdale has been, for then it will have helped you with healing. Everything is exquisite here.

I don't see how you, of all men, can expect an answer by return of post, though; however much you want one. You had better put down the amazing promptitude of this one of mine to your charm rather than your deserts.

<center>.</center>

I never saw the edition of John [Drinkwater]'s "Tides"[1] with your decorations, and I should *very, very* much like to do; if you will lend me your copy I will take the greatest care of it, . . .

I have not forgot my promise that you shall have a copy of my collected plays, and I only wish that I knew when they will be out; but the hitch about American copyright and publication still makes it indefinite, though I heard the other day that the printing goes on now.

<center>.</center>

The sad thing about Abraham Lincoln, Paul, is that I didn't see it at Brum: we meant to go for it, but the now-too-usual vast and inconvenient pain in my loathsome gizzard came on and laid me up that very week. The only time we were there was for the Shakespeare plays just a year ago, when I spent a long and happy day with John and his colleagues. I found out then what a very remarkable actor W. J. Rea is; so I was delighted but not surprised to hear of his success in Lincoln.

Of course I've read the play and enjoyed its great qualities, and especially its significant success in revivifying the form of the chronicle

[1] It was not *Tides* but *Loyalties* (see Letter 123). This was published by the Beaumont Press in an edition of two hundred in 1918. Nash designed the cover and decorations. The latter were in black and white: the coloured copies were issued without his assistance or approval, and were not his work.

play which began the last great age of English drama; and we have rejoiced in its London success as being the greatest stride made by any one yet toward recapturing the English theatre for the arts. It is all splendid.

How nice of you to remember the pugnacious kitten; only last week we were laughing about his epical behaviour while you were here. He did not grow into "a torpid cat", but became a grave courteous person of exquisite manners and strong prejudices—more like a dog than a cat, except that he was as graceful and dignified as only a very large dog ever is. He had a taste for music, and an unappeasable curiosity about the gramophone when a voice came out of it: the Loewe "Erl King" record excited him so much that one night (when he was a very large cat) he jumped on to the machine and bit the disc while it was playing. But there came a Spring (three years ago) when he was always a very sick cat indeed; and one day he walked out and never came back.

By the way, there is a thing I meant to mention to you. E. Bainton,[1] one of the best known of the young school of English composers, has made an opera out of your old friend "The Crier", and at the present moment Sir T. Beecham has it under consideration. I don't know if I shall be consulted about the mounting if it is accepted, but if I am I thought of recommending you as the designer (remembering that we once worked it out together), if that would be agreeable to you.

You had better not mention it, for it is not my affair exactly. And of course it does not interest me to the extent that a spoken performance would: whenever there is a chance of that it will naturally be more immediately my concern, and I should at once think of you. But if it is done by Beecham I should want to do all I could to save it from the usual dreadful mounting that Wagnerian opera is paralysed by, so I should like to have you up my sleeve.

We went to Manchester to the Beecham in February, and saw Le Coq d'Or, Phoebus & Pan, and the heavenly Seraglio. Le Coq d'Or had Gontcharova's original Russian dresses, and we loved it hugely.

We also looked in at the Art Gallery, and I was bowled over anew by that stunning old fellow Madox Brown—I think he was the most English of all our painters before you and Jack came along. He is so sturdy and full of a kind of husky sweetness, like nuts and russet apples, and a fierce tenderness.

And an incomparable dramatist too: my eyes pitched on four square inches of "Work" that glowed like stained glass for rich pure colour, but was concerned with a policeman moving on an old orange-woman —it is too little to see in the reproductions, but it is just like a bit of Shakespeare comedy in painter's terms.

[1] Edgar Leslie Bainton, b. 1880, friend of GB and at this time Principal of the Conservatoire of Music, Newcastle upon Tyne.

PLATE VII

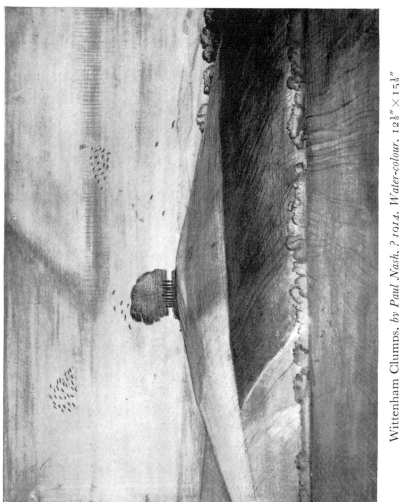

Wittenham Clumps, by *Paul Nash, ? 1914. Water-colour,* $12\frac{1}{2}'' \times 15\frac{1}{2}''$
Probably the drawing exhibited at the Friday Club in 1914 as Castle Hill

Carlisle Art Gallery (Bottomley Bequest)

PLATE VIII

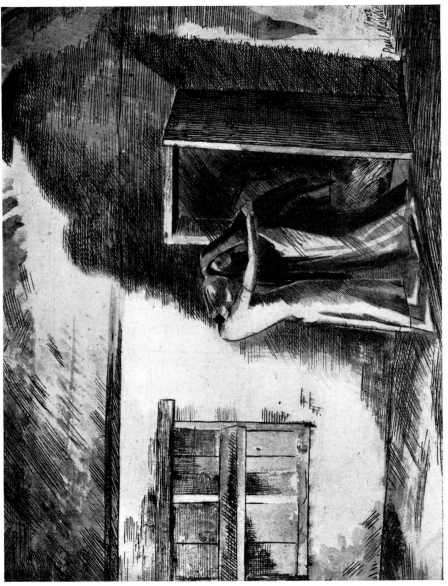

The Crier by Night, *by Paul Nash, 1914, revised and redated 1922*

I must shut up if you are ever to get this. Our love to Madonna Margharita and you.

<div align="right">Ever your
Gordon Bottomley</div>

Do you remember your very long ago little watercolour of the Sleeping Beauty? It is still in its original white mount, but, I am never content with it, as I feel the white glare weakens the luscious colour. I have thought sometimes of framing it like a little Rossetti body-colour watercolour or small oil, in a shaped thick sunk mount of gilded oak behind glass and a very wide gold frame round the whole. But I wonder what you think: if you have an idea you like better I will adopt it. The little darling simply doesn't shew itself at present.

<div align="center">123</div>

From PN to GB, Alexandra Mansions, 30 May 1919. He tells him that the Drinkwater book is *Loyalties,* not *Tides,* and sends a copy and three of his articles. He asks whether his wife and he could visit the Bottomleys in August. He is interested about the *Crier,* but adds: 'for Gods sake let us save it from Beecham'. He approves of the plan for 'the little old water colour.'

<div align="center">124</div>

<div align="right">*The Sheiling, Silverdale, Near Carnforth*</div>

GB to PN <div align="right">*11 June 1919*</div>

I was meaning to write to you when your nice letter and your thoughtful and welcome parcel came; but my disappointing haemorrhage has dished all my plans and left me struggling up to the neck in the ruins, and I can't catch up with my correspondence.

<div align="center">. </div>

I like your decorations of "Loyalties" a good deal; the compositions are suggestive and exciting, the colour is truly imaginative in its vivid sharpness; but I do not think well of the production of the rest of the volume, . . . the format is ordinary, the paper is without quality,[1] the type and typography are no better than you could get in any little trade printing-shop in any provincial town. . .

I am as nearly sure as possible that he has reproduced your designs by zinc-process—if they had been woodcuts I feel the blocks would

[1] An asterisk here marks an insertion written down the side of the letter. It is omitted.

have had a richer quality (especially at the edges) which would have made your colour still more potent. Why should not you and Jack set up a press of your own, so that you can see you receive justice in these respects?

.

I will confess to you that my copy of the catalogue of the American exhibition arrived at last by almost the same post as yours; but that does not lessen my appreciation of your thoughtfulness in sending yours, and my pleasure in seeing it in your parcel. It is a topping catalogue: I wish your part did not rather overlap with your "Country Life" book, for I should have liked to have eight new Pauls—but this is ungrateful, for I am as glad to have the "Mule-Track" as eight Nevinsons, and "Spring in the Trenches" as thirty-two Orpens, and I am happy to see you making such a brave and vital and convincing show in the new world.

I am also completely bowled over by seeing Jack in his full glory for for the first time. His picture of the front line in the early dawn is most impressive, and his French Highway is certainly one of the grandest things that has been made out of the war. Its noble design excites me every time I see it, and I feel like writing to tell Jack so—if only I ever did the things I want to do. His railway viaduct also and the wood of slim trees—of which you send me the photographs—are most beautiful, and we both admire them hugely: and the small picture of "dug-outs" discussing the war in a Pall Mall club we also greet affectionately in its order. I hope Jack will persevere in his good intention to send me his book of photographs.

We have both read your first essays in art-criticism[1] with much sympathy and interest; beside being really good in themselves they struck each of us independently as being much better than anything else in the paper. Your doctrine about exhibitions seems to me to be completely sound, and one that needs enforcing; and your own views on art are so attractive as to be worth developing with thoroughness and considerable length. In my opinion the thing you ought to make for is a further introduction of lively and searching personalities, always connecting them with your fundamental ideas; the article on the League of Service is very well in its way, and a thing proper to be done—yet you will find it harder to maintain both your editor's and your readers' attention if you often give so much of other men's suet instead of your own plums. If you are careful to keep your prose alive, as you can do, you can be a great success; and the only thing you have to guard against is using ready-made blocks of words,—such as "giving furiously to think". Make your own phrases: they will serve you better.

We like also a good deal both your and Jack's drawings in Art and

[1] *The New Witness*, 25 April, 9 and 16 May, 1919.

Letters; in fact nothing else in the paper comes up to them except the Matisse.

Be sure you tell Jack what a topping thing I think his French Highway: it is as grand as the Uccello battle-piece in the National Gallery. (I have lately been buying photographs of Uccello frescoes from Florence: there is a Noah's ark affair which I am sure you would enjoy as hugely as I do.)

Alas, I am afraid Beecham is off; but Bainton has so many connexions in musical quarters that he is sure to get his "Crier" opera done sooner or later, and then will be the time that I shall bear you in mind.

It is exceedingly pretty of Margaret and you to want to come for your first peace-holiday to the country where you spent the last peace-days of the old years. If you carry out your plan of going for an August tour in the Lake country we shall look forward to seeing you both here.

The only trouble is that all the friends one has in the world take their holidays in August, and my small energies cannot enjoy them all at once as completely as my will would like to do. A whole family of friends will be in the village all July, and three families all August; and in addition to these we are already fixed up with several friends who will be with us in the house here. So I think it might possibly suit us best if you had your Lake tour first; if you could take us on your return journey and spend a long week-end here with us then we should be so pleased; and by that time the complications of August might have cleared up a little, so that we should have breathing space to enjoy you more.

But I can't offer you a kitten for entertainment this time: Felix was unique, and we have never had the heart to try to appoint a successor to him.

I return all your treasurable and delightful things with this; and, with love from us both to you both,

I am always yours affectionately,

Gordon Bottomley.

P.S. I had nearly forgot one of my principal reasons for writing. A friend who has lately been staying here is very much attracted by your work and feels he would like to have some of it. His name is Percy Withers;[1] various committees take him to London from time to time, and when in the Autumn he is next in Town he proposes to call upon you and make your acquaintance and see what pictures you have by you if that is agreeable to you. But I will let you know nearer the time, when I shall hope to send more particulars.

[1] Dr. Percy Withers (1867–1945), author and lecturer on English Literature for the Oxford Extra-mural Delegacy. He later added several Nashes to his collection.

125

PN to GB *9 July 1919*

I was very delighted to have your letter. I am glad you got the American catalogue & that you like our contributions. Jack's picture *is* a fine one but I think the large oil he has just done for the I.W.M is better[1] I will try & get you a photograph of it.

This is most exciting about Mr Withers it is charming of you to introduce us and I shall welcome him in the studio: such business-like admirers are as rare as dodo birds. What sort of time in the Autumn will he be in London? This reminds me of my changed plans. I have been badly let down over my Regents Park studio and have had to go seek another, after moving all my things & imagining I was settled. I cannot have the new place I have found until the end of July which means I must take a sort of split holiday—three weeks now with Jack in the country then back to work at the Canadian picture,[2] which I have been so far prevented from starting, all August & September, then perhaps I can go away again in October, but I am afraid it will not be in your direction. We would rather wait until you can manage to keep us for about as long as our last visit if that was not found to be altogether *too* long! This summer you look like having rather a heavy fall of visitors. We are most concerned to hear about a haemorrage attack. I can never find out how you are in health as each person who knows or hears of you gives me a different account and your lines in any letter are far too vigourous & decorative to let me read between them. I can only hope you are something near as well as you sound. I have been having great fun lately organising a new picture book and I hope in a very short time to be in a position to make a very fine picture book indeed——at present I can only give you so much of a hint If it comes off you, & Emily shall have free copies & first editions & all sorts of good things! ...

It is tiresome about Beecham but you may have escaped unspeakable horrors: ... I must track down Bainton and talk with him. By the way I have started woodcuts—a most fascinating and absorbing game—you shall have my first fruits anon. I dont think you have ever seen any of my lithographs so if we do this parcel I will enclose some—in fact it shall be no end of a parcel.

I must end here. Love from us both to both of you

Ever yours affectionately
Paul.

[1] *Oppy Wood* (Imperial War Museum).
[2] *A Night Bombardment*, a large oil commissioned for the Canadian War Records.

Jack wishes me to say he is greatly pleased by your appreciation & thanks you very much—some swine has just lost his book of photographs or he w^d send you them. PN

126

The Sheiling, Silverdale, Near Carnforth
GB to PN
21 July 1919

It was very jolly to see your writing the other morning: an envelope of yours always gives me the pleasing sensation that I am just going to have a letter from Rossetti. The likeness of your fist to his is extra-ordinary.

(I say, I wish I had had a letter from Rossetti.)

We are a good deal disappointed to hear of your bad-luck with your studio and your changed plans consequent upon it, and especially because it makes you give up your Northern tour and all chance of our seeing you. You don't say what direction your October holiday will take; perhaps we may collide then (amicably, like buffers, I mean) as we too propose to take the road in October. I am sorry and woeful there is no chance of our asking you for the fortnight you suggest, for the last time was so full of delectable days that I should have liked to feel there was a prospect of their being repeated. But the plain truth is that we have never had any visitors for a fortnight since you and Bunty were here last; and the gaunt, bald reason is that my lung is not good for such a stretch of time all at once.

In the intervening time I have had to learn that if I want to have any good of my life or my friends I must take the latter in short and frequent doses; for if I go on too long at once I dish myself for weeks after and can see no one else during that time, and it isn't worth while living on such terms.

What I have learnt is the advantage of living near the main line to the North; for every one sooner or later either wants to come North or go South. Then is my chance: I ups and steps out and asks them into my parlour, like the celebrated spider, and send a fly to meet them at Carnforth. They stay a night or a week-end with me, then resume their journey while I go to bed to recuperate for the next one.

This by now, my dear Paul, is the convention in which I can work best; so I hope you and Bunty will find reasons to go to Edinburgh or Scapa by L. & N.W., or Dublin by Midland, or Isle of Man by Furness Railways, and look in on us as often as you can. And then do it again when your tour in the lakes comes off.

I am sorry not to have seen you in Town before now; but the £6 of railway fare often prevents our going when we should like to do, and my

haemorrhage this Spring smashed an enterprise that was just coming off. I hope to goodness fares will come down soon.

If you find you are able to send off the parcel of drawings, lithographs, etc, they will be respectfully and affectionately welcomed and enjoyed, and I shall especially be delighted to have the opportunity of shewing them to Lascelles Abercrombie[1] and his wife, who are staying in the village, and Bainton and his wife who are soon going to be.

But I will not disguise from you, my Paul, that I cannot shew them to Withers at the same time; for he lives in Worcestershire and was only here on his way to St. Andrews. He was very keen about you, and I won't forget to remind him when he is going to London; but it would not be wise to follow him up with the parcel, as he wants to meet you personally and would probably be put off by business-likeness.

Make my reverences to Jack, I pray you; and tell him I am keen to see the photograph of his I.W.M. picture. I am about to write to him.

I desire to have further news of your very fine picture-book and your woodcuts—the latter, being mentioned, make me expect heavenly little treasures like the Blakes and the Calverts.

Our love to you and Bunty. Is Bunty weaving?

.

127

175 Alexandra Mansions, Judd St, Bloomsbury

PN to GB 1 December 1919

My dear Gordon

I hope you did not misunderstand my not complying with your suggestion that I should send you a parcel of drawings. I had intended so doing and then came the railway strikes which postponed my project and when things were clear again I had conceived the idea of holding a show of the drawings in my studio. This rather clashed with the scheme of launching, rather perilously, the majority of my best work, since this was what I wished you to see, on a journey, and also I was inclined to keep all my drawings about me while I was working for the exhibition. So they were never sent. For another reason I have delayed writing as I wished to be able to send you something to look at and the bulk of the contents of the present parcel has only just come within my reach. I hope you will like the special supplement for Illustration & my attempt to give the public 'Art without tears'[2] I think now it should have been upon a larger scale but it is just the indication of a

[1] Lascelles Abercrombie (1881–1938), poet and critic. At this time he was Lecturer in Poetry at the University of Liverpool (1919–22), later, Professor of English Literature at Leeds (1922–9).

[2] *Illustration* was a trade paper published quarterly by the Sun Engraving Company and was edited by Gerrard Meynell. A supplement of drawings by contemporaries

direction. The prints of wood blocks are a modest Christmas present to you and Emily. Later in the month I hope to send you a book of photographs of recent drawings & some photographs of Jack's war paintings. With these will come a calendar he and I have compiled & illustrated for the Westminster Press.[1] I applied to Elkin Mathews for your poem 'January' but he would not give me leave under a guinea which the editors were not inclined to pay & I could not well afford, so we had to put in a 'deader'—William Blake instead of your very lovely 'O Shepheard out upon the snow'. I see your collected Plays figuring in Constable's list but they never materialise—will they ever come to hand? I hear you are writing a comedy which is most interesting news I should much like to know more about it. I have seen very little of your work about, are you involved in Monro's Chapbooks?[2] William Rothenstein visited my show yesterday and, I thought, glanced somewhat askance from his gig lamps. My new work is rather away from his highest ideals, tho' I believe you will find it more to your liking It is decidedly not hard, definite, in the take or leave it sense of the word, or tightly enclosed. Will murmured something about 'a visiting card left by genius to say how much could be done if only—' and then built me up a dizzy structure to emulate of probity, of integrity, of nobility It is sad when old enthusiasts wag their beards & say dear, dear, the lad is turning out rather sadly. But I did feel on this occasion that I *knew* and Will had missed my message. I hope this does not read very conceited but my new drawings are dearer to me than almost any work I have yet done. I cannot but help feeling *now*, at last I am rising—I have wings! I wish you could judge. Tomorrow night I travel well in your direction as far as Manchester to hang the show of the London Group which is being exhibited at Finnigans Galleries for three weeks, would that I had time and money to penetrate further North and reach the Shieling. The North by the way is rich in Nashes at the moment I have pictures at Aberdeen & both of us at the Scottish Artists Exhibition which I believe is in Edinburg, both also have work at Arnold Bennett's Show for the Five Towns at Stoke on Trent, & Jack gives a small show at the Birmingham Repetory next month or just later, I forget which. I hope your friend who wanted

including PN and his brother was published with No. 5, vol. iv. PN wrote an article introducing it and also notes on the artists which he initialled R. D. (Robert Derriman). For an account of this unhappy affair see *Paul Nash* by Anthony Bertram and Letter 130.

[1] *The Sun Calendar for the Year 1920*. Arranged by Paul Nash with illustrations by Paul and John Nash and Rupert Lee. The Sun Engraving Company, Ltd.

[2] *The Chapbook*, founded and edited by Harold Monro at the Poetry Bookshop, as successor to his quarterly *Poetry and Drama*. It ran from July 1919–autumn 1925 (Nos. 1–40), with certain gaps. It was an important miscellany, with gay covers, that printed much new poetry.

to buy some of my work will be able to take this opportunity of seeing it to advantage—as it is at present. My Studio[1] is a large white walled room with good light and I have never been able to show drawings under such sympathetic conditions. Also I should like him to be able, if he wishes, to get the best drawings before they go. The exhibition opened last Saturday and continues for a fortnight altho' I shall leave the unsold pictures up for rather longer.

I should so much like to have a long talk with you about all the new lights among modern writers and painters. I wonder what you think of the work of the latest brood of poets Sacheverel & Edith Sitwell for instance Robert Nichols,[2] Edward Shanks,[3] T. S. Elliot[,] Huxley, Aldington etc etc. I wonder too what you find in Wyndham Lewis's Caliph's Design,[4] how you like James Joyce and that queer fellow Barbellion[5] who by the way was a friend of Jack's and lived near him at Gerrards X. was'nt he a great pal of Hamilton Hay? I find no poet who has sprung since quite so good as dear old Thomas. He seems to give us something peculiar and rare, something perfectly distinguished & necessary to English poetry. I had a long talk with Hodgson[6] about him and his work the other day. Hodgson is a man of decided opinions.

I do hope you have been better. We both send our love to you & Emily and trust we may all meet again one day

128

The Sheiling, Silverdale, Near Carnforth
GB to PN *12 December 1919*

Your thoughtful and rich pacquet gave us great pleasure; it was very nice to be pulled up to date with regard to your doings and plans, and we marched through all you sent rapidly and rapaciously and with large enjoyment. I had a haemorrhage in the end of September, and I have been woffly ever since—with a consequent destruction of elaborate plans for spending the Autumn agreeably and Seeing Life; so your pacquet was an adventure and a welcome break in the too even tenor of our existence. In short, we were delighted, and we offer you our superb thanks, best assorted, 24 carat.

.

[1] A studio at 9 Fitzroy Street, Bloomsbury, which he lived in for a time. It belonged to the painter Wyndham Tryon (1883–1942).

[2] Robert Malise Bowyer Nichols (1893–1944), poet and dramatist.

[3] Edward Richard Buxton Shanks (1892–1953), winner of the Hawthornden Prize, 1919; poet and journalist. [4] Published in 1919 by the Egoist Press.

[5] W. N. P. Barbellion, pen name of Bruce Frederick Cummings (1889?–1919), author of *The Journal of a Disappointed Man* and other works.

[6] Ralph Hodgson (b. 1872), poet. Associated with Lovat Fraser in the chapbooks and broadsides of *The Flying Fame* Press.

We were very much amused by your animated account of Rothen-stein's visit to your show: I belong to his generation though, and I cannot forget that when I was 21 we all looked on him as just such an advanced and daring innovator as your generation consider you to be, and I have to own with humility that I too don't always understand what you are after: so that I can't help feeling that, though you have something he hasn't, yet he has also something which you haven't—that, in short, you possess the truth between you. I enjoy and admire, for instance, the rich texture of your wood-engravings, and the fantasy of Nos. 1 and 2; but I don't make out No. 3[1] at all, and both it and some of the Aldington blocks make me feel that they are paying homage to a fashion, a mode. Fashions and modes are all very well for the tail of a movement, the hangers-on who want someone to give them an idea what to paint; but the trouble is that fashions grow old-fashioned and modes are outmoded, and the triangles and general aerial geometry that are popular just now will look as sick in twenty years, as the Art Nouveau of circa 1897 (thought then to be an important discovery) looks now to you when you meet it in a declining or provincial café; and your original and fresh vision, your highly personal invention with the dew and the bloom on it, don't need recipes evolved by other men to help you on your way.

On the other hand, such blocks as Aldington 13 and 22[2] seem to me first-rate and full of qualities that will make them live longer than you or I.

You will be cursing me by now, and saying that I am neither for you nor against you: perhaps I am not—and just because I am for myself and what nourishes me—but, all the same, my sympathies are all with you and the other young Englishmen who are painfully (and, to my conception, uncertainly) finding their own way of keeping art vital and a portion of daily life. I don't at all rail at the uncertainty; for I con-ceive that certainty can only come with the complete discovery which means the goal of the effort.

The Italian Futurists bore me: the French Post-Impressionists some-times attract and sometimes aggravate me and always seem to me to have no concern with us (or message for us beyond one of general sincerity): I am a free-trader in politics and quite willing to let Germany sell me chemicals and France wines, but in art my Motter is "England for the English."

Think, my Paul: in spite of all that the lying art-histories (mostly written on the Continent) say, modern (i.e. 19th. Centy) art was at

[1] These numbers were probably for reference only and it is difficult to be sure which engravings they indicate. According to the *Chronological List of Wood-Engravings of Paul Nash* (*Print Collector's Quarterly*, vol. xv, No. 8, July 1928) he had made six by the end of 1919. [2] This refers to the pages of *Images of War*. See Letter 121, p. 104, n. 2.

root an English impulse. Bonington taught the French (who think they are It in art) watercolour, Constable taught them naturalistic landscape, Scott taught them romance in literature and their painting caught the infection, Turner taught them impressionism and the notion that "light was the only person in a picture", the Pre-Raphaelites started their decorative school for them from Grasset to Maurice Denis—at each stage they have but contributed their logic to the exploration of our instinct. And all the time our young generations turn humbly to France, or French-trained internationalists, to be taught what to do: Hamilton Hay and all his generation thought Whistler's qualities would save them: Wyndham Lewis thinks that he can save himself by rivalling and outdoing Picasso in a philosophy of painting: Paul thinks he can more quickly get to where he wants to be if he uses new traditions from France instead of old ones from Italy.

And he won't; and he doesn't need to.

Our medieval church-painters, Hogarth, Rowlandson, had glimpses of the soul of England taking on the flesh of paint; but some Fleming or Frenchman or Italian always dirtied their look-out window for them with recipes. Then the national genius flashed out fierce and clear with the Pre-Raphaelites, supremely in Millais; and Italy itself sent us a King from the East in Rossetti to do homage to the new vision. Yet in twenty years Italy and France had dished us as usual, once more: perhaps the destructive moment came when Burne-Jones felt he must change 'buses if he wanted to continue his journey, and never noticed that he had got into the wrong one. At any rate, he let in Italy, and Whistler let in France, and Millais let in the old régime of all our dreadful past: and there we were.

And now it seems to me that you and your companions are finding again the English secret, the English soul that the Pre-Raphaelites found and lost: so I am sad and sorry when I see you doing even the most surface service to the artistic internationalism that was springing up before the war.

I suppose "Illustration" is in its normal state a trade paper—which accounts for my not having been aware of it before. I am hugely grateful to you for making me aware of it now: whatever the Meynells touch they make valuable (and to have impressed the British Printing Trade is a proof of positive genius) and your illustrated supplement has given me the hugest delight. Your own picture[1] must be sheer loveliness in the original, for enough comes through the reproduction to make me believe it is the best thing of yours that I have seen; and I like Jack's nearly as much. I am also indebted to you for my first sight of Stanley Spencer's work: it made me literally joyful, for I thought it the most exciting new thing I had seen for a long time. But I liked all the plates

[1] A drawing called *Whiteleaf*.

116

except the Roberts: his things, quite inexplicably, always depress me and put me off just as maggots in cheese do.

By the way, does the R. D. of your literary coadjutor stand for Robert Dell?[1] I like your essay very much, it is hugely well-written. And I am obliged to agree with all you say, for I remember saying similar things to Mrs. Goldsworthy ten years ago in defence of your early figure-drawings: yet all the same I agree with you in wishing that you could have had space to make it twice as long, for the thesis cannot be left just there. Here again my elderly mind comes in: if your argument were logically extended you could not avoid the deduction that no one can completely appreciate an artist's work except the artist himself, and that the artist cannot make quite sure that his work will fall into the right hands unless he buys it himself. I daresay that once upon a time I was willing to go very nearly to such lengths: but now I seem to see that I need the appreciator and the buyer at least as much as they need me—and that, in consequence, one is surest of getting the intelligent sympathy which can reinforce one's creative energy if one finds out the things which can satisfy humanity everywhere (or at any rate the finest specimens of humanity) as well as oneself. And, in my belief, that is the way to do one's best work too.

The Elizabethan Drama is our nation's greatest success and pride because Shakespeare and the others had to satisfy the public and keep their theatres open before they could begin to satisfy their artistic consciences and such carping colleagues as Jonson: if their theatres didn't pay they were done for.

I thought it was a more than kind attention of you to include the Sieve-king book[2] in your parcel, and I appreciated it hugely—enjoying the book as well. Again your writing is first-rate; your preface is head and shoulders above all the others. Of course I like the verses, but not so much as I like Jack's drawings—they are topping virtuosities, full of quality and style.

.

I shall like to have your calendar,[3] too; but I grieve that I am not in it. Mathews[4] was only doing his duty, as there was a shark about last Spring against whom I had to warn him: I am more than sorry that the ricochet should have hit you. But why didn't you mention it first to me? I should then have told Mathews I had let you use the poem for nothing, but I can't go behind him now. However, perhaps there will be a next time?

[1] See p. 112, n. 2. Robert Dell was a critic in Paris who contributed to various English periodicals. He was a member of the Executive Committee which organized the first Post-Impressionist exhibition in England (8 November to 15 January 1910–11). [2] See Letter 121, p. 103.
[3] See p. 113, n, 1. [4] Elkin Mathews. See Letter 127, p. 113.

I umbly ope you will really receive my collected plays before long:
I corrected the last page of the last play last Thursday, and now there
are only trimmings and revises, so I ought to be out by Feb. or Mar.
I am anxious to be done with it, and so get on to my new plays which
amuse me more. Proofs and vexations have kept me from my comedy
all this year; but it is There, if only its huge length will let me finish it.
It is abounding, floriferous, and improper.[1]

I like Edith the best of the Sitwells; her impudences charm me; and
I adore her picture by Guevara.[2] I admire Aldington much at moments
—in your book, for instance; "Daughter of Zeus", "Earth Goddess",
and "Our Hands". Do you know his wife's topping versions of passages
from Euripides.[3]

I never heard Hay speak of Barbellion; but B. wasn't famous until
after Hay had left London, as it proved, for ever; so that might be just
the accident of talk or letters not tending in that direction.

You don't tell me what Hodgson said of Thomas; and I should
hugely like to know. I, too, am happy that E. T. had that two years
of poetry to shew us all himself in. I feel he was so purely lyrical, in
his instinct of form as well as in his ideas, that his lyrics bring him most
vividly to me; yet his blank verse flashes phrases of his daily being at
me so constantly that it also is dear to me. I miss him a good deal, and
I am going to miss him more and more.

The only Wyndham Lewis book I know is "Tarr",[4] parts of which
we liked a good deal.

Say nice things to Madonna Margharita for us. We send good wishes
to you both, for a happy Christmas and a still happier New Year; and
I am, as usual, Paul's Entire

G. B.

129

The Sheiling, Silverdale, Carnforth

GB to P.N *20 July 1920*

Promises is promises. Here is my book at last—it only came last
night.[5]

Now you owe me a picture. Promises is promises.

We hope that you and Madonna Margharita flourish: I have been
perfectly ill and am now imperfectly well.

Your agèd friend

[1] Nothing is known of this.

[2] *Portrait of Miss Sitwell, Editor of 'Wheels'*, by Alvaro Guevara (Tate Gallery).

[3] H. D. (Hilda Doolittle, b. 1886), whose translations of choruses from *Iphigeneia in
Aulis* and *Ion* were published in *The Poets' Translation Series* (1915–16) by the Egoist
Press. See also *Choruses from Euripides* (October 1919) and her *Collected Poems* (1929).

[4] Published by The Egoist, Ltd., 1918.

[5] *King Lear's Wife and other Plays* (*The Crier by Night, The Riding to Lithend, Midsummer
Eve, Laodice and Danaë*).

130

your book of plays at last! What a joy! thank you a thousand times.
I am at present far from my base so am not able to make a ready return
with my drawing but I return to Town next week and will do my best
to select one which you will like. The book is a noble volume—it must
be one of the richest of our day in real poetic thought and drama. I am
full proud of it. At the risk of seeming ungracious I must remark that
the cover might have been impressive one way or another, they should
have provided a better helm for so fine a head. Personally I am going
to amuse myself by re-covering it and attempting a design which shall
strive to be worthy of you—ambitious & conceited but may give me
some satisfaction. You, being an old and tried hand (old purely in a
Pickwickian sense of course) and a poet of many arduous & fruitful
years I notice—with certain regret I will confess—you are not allowed,
or do not allow yourself more likely, if I know you, the luxury of a
portrait. I know this is generally the privilege of the modern young
poet upon his positively second appearance in public when his admirers
have reached the stage of curiosity in his 'personality'. Even painters
may enjoy such a privilege but in self defence I may put forward that
Will [Rothenstein]'s portrait of me was sufficiently unrecognisable. You
have been *altogether* reticent. I expect you are right but I should have
enjoyed a jolly picture of you to round off my book—what ingratitude!
(This is a bowel-curdling nib I've got here I can tell you) Well, there is
much to tell you. I have meant for the last sixteen months to write to you
(got a new nib now) and send some books and drawings but I am most
incurably lazy about writing letters, and have failed you wretchedly
in consequence. However, I will make amends directly I reach home.
I remember having one thing on my mind in connection with something
I sent you on the last occasion That was the supplement of eight modern
drawings with the two articles. I have suffered so much over that pub-
lication that I have probably instinctively 'funked' referring to it. As you
know I contributed a foreword by way of introducing the designs to the
particular sort of public they had to face. I found myself with too little
space for an elaboration of my theme & too much to admit of 'padding'
what I had already written. I therefore decided to write something in
the journalistic vein on the artists themselves. An unworthy, stupid
move anyhow, as I can see now, but worse than that as I actually did
the thing. The article was written in the spirit of a 'stunt' and I at-
tempted to make my style the character of journalese biography, at the
same time I expressed honest opinion upon all concerned. Of myself I

set down the sort of thing which has been said of my work often enough
—a sufficiently vague statement I felt. Once under way I allowed my-
self to take advantage of my false position to write a word to dispel what
I have always thought to be a popular illusion & which I had often
resented as unjust—the confusion of Jack's work and my own. All this
I set down and signed under assumed initials R. D. This was the extent
of my crime. I showed the article to my friend Lee to Margaret and to
the editor and publisher (but it was not shown to Jack or the other
artists concerned) telling them of course that it was written by myself.
By some queer wrongness of vision and blindness of concience all were
merely amused, it was a great joke—we all saw it and we all missed
the point that it was a dishonest joke, if it could be called a joke at all.
Later I received a very rude shock. Of course the first people to see
the joke in its proper light were the people who had most interest in
doing so and these made as much out of it as possible. I was attacked
and directly the other point of view was shown to me I realised what
I had done. Up to that time I had not given it a thought. It is true I tried
to conceal my identity when I was first questioned on the subject, not
because I thought at *that time* I had done anything dishonest but because
it was a private joke Well my dear Gordon I really cannot bore you with
any more. It was a ridiculous piece of wrongheadedness on my part and
of course I had to stand the racket[;] it ended by my diligent denouncers
casting their last stone in the shape of a published paragraph setting
forth my dirty deed in plain terms—this after much mud had been slung
behind my back and a good many quite untrue versions spread around
—I promptly replied by[1] a frank apology for the facts and a stiff denial
of the rumours and upon that the nine days wonder expired.[2] During
its period I made some interesting discoveries, chief of which was who
were my real friends. Since then I have done something better than
write about myself. I have taken the more justifiable privilege of *examin-
ing* myself and I feel wiser and better! Perhaps you have heard some-
thing of all this before—it is possible indeed you have received a marked
copy of the late *Arts Gazette—Rutter* Green Phillips & Co. wherein the
accusing paragraph appeared it was annonomously sent to most of
my friends—a despicable part of the mud & stones-flinging campaign
which, so far as I can see, was a sad failure. I remain intact, my sales
are no worse than before nor have I met anyone yet who has had the
hardihood to cut me. I suppose I ran a grave risk of being blackballed
for the Chelsea Arts Club, had I ever felt the peculiar inclination to
enter that select circle—but I am ceasing to write seriously on this
subject—it is time it was changed for a better.

[1] MS. my.
[2] The exposure appeared in the *Arts Gazette* for 27 December 1919, over the signature
of the critic, Frank Rutter. PN's apology appeared in the issue of 17 January 1920.

Well, well, do forgive me dear poet, what a sordid tale, but I am too fond of you, and believe you to have too much affection for me, to be indifferent to what you might feel. If a man does something below his standard & below his friends' opinion of his standard I think he owes them at least an explanation—after all I did feel I had let myself down and I felt, as acutely, I had let down my friends. A few didn't stand it but only a miserable few. In reflection I find the whole experience has done some good to me. It has quite seriously taught me a lesson not actually in regard to behaviour—(there is no question of knowing better next time!) but just in regard to myself who, I discovered to be far less reliable than I had imagined. I suppose that's always happening thro' life.

I was indeed sad to hear you had been 'perfectly ill' poor Gordon, how unfairly you have been treated by life and how you've spited it—to have done all you've done at such odds—it's a grand thing, I do admire it. I wonder when these fine plays are to be seen. I cannot help feeling that now their time may be coming—the publication of this book should have an effect—I wish I could help. perhaps I shall be given a chance now I have penetrated to the edge of the theatre. The work for Barrie's play,[1] altho' not quite a fair field & no favour, was an opening I took some advantage of—when I send my mail it shall include photographs of the scene and costumes I am anxious to hear your opinion . . . My present activities are manifold. Firstly the panels for the Leeds Town Hall—six of us Stanley Spencer, Wadsworth, Albert Rothenstein[,] Kramer[,][2] brother Jack and myself. Jack and I have two each to do the same length as the others 14 ft but less in height, as they occur in the galleries at either end of the hall Jack is painting two pastorals one includes Kirstall Abbey—and I am doing A) Stone quarries, B) The Canals. Have just sent the sketch designs in for inspection. It is a great scheme and we owe everything to Will Rothenstein.[3] J & I visited Leeds for a week at the end of June & I was sorely tempted to take train on to you but it[4] was unpracticable both from the point of time & money—alas! Margaret and I are now at Dymchurch in Kent a small seaside village between Rye & Folkestone. At first there was a

[1] *The Truth about the Russian Dancers* by Sir J. M. Barrie, with music by Arnold Bax and choreography by Tamara Karsavina, who was also the première danseuse. It was produced by Sir Gerald du Maurier. PN designed the costumes and scenery, for which the original drawings are in the Victoria and Albert Museum. The first night was on 15 March 1920 at the Coliseum Theatre, London.

[2] Jacob Kramer (b. 1892). A Leeds painter.

[3] This was a scheme for the mural decoration of Leeds Town Hall, launched by Michael Sadler. Accounts will be found in *Men and Memories: Recollections of William Rothenstein 1900–1922* (Faber, 1932, pp. 348–9), *Michael Ernest Sadler: A Memoir by his Son* (Constable, 1949, pp. 319–27), and the forthcoming life of Rothenstein by Kenneth Romney Towndrow.

[4] MS. I.

party here including the Lovat Frasers[1]—you know his designs I expect —and Athene Seyler the actress beside a host of other folk—now all are departed and we live a quiet industrious time, the only friend in exchange being Charles Sims[2] and family. Sims has just been made Keeper of the Academy Schools and with that and Will's appointment to South Kensington there should be hope for England yet. Sims is a distinguished person in many ways—the only Academician I have ever seen who hasnt got a white beard and certainly the only one who has interest and sympathy with modern work outside Burlington House— besides he is a very charming man. We have just returned from a few days' visit to an old farmhouse outside Rye where I went to see an excellent man[3] who has initiated me in the delights and mysteries of etching which with engraving I find myself taking to quite kindly. In October I begin my first teaching! Albert R[utherston] has a school[4] at Oxford in the centre of the crusted culture of University home life—sons of dons & daughters of professors as material Albert & I are visiting pedagogues—distinguished artists from London—& in fortnightly parts —I am to ground the pupils in wood engraving Rather an excitement dont you think? and capable of much development. In May 1922 I hold my great exhibition at the Leicester Galleries—the turning point of my career! That's all my gossip I think. I'm so sorry so much of this letter is devoted to the history of my crime—it *was* such a dull crime. Margaret sends all her love to you both. When shall we see you again dear people? do let us come some day—with our united good wishes

131

The Sheiling, Silverdale, Near Carnforth
GB to PN 18 August 1920

Poor dear Paul! It was a nasty Contrytong; but I don't think you need be perturbed or in any way bother one bit about it. Because:—

(1.) The greater part of the British nation, and even the greater part of British art-lovers, never heard of The Arts Gazette even in its lifetime.

[1] Claud Lovat Fraser (1890–1921), painter and designer for the theatre. He is best known for the sets and costumes of *The Beggar's Opera* revival in 1920 at the Lyric Theatre, Hammersmith.

[2] Charles Sims, R.A. (1873–1928), painter, Keeper R.A. (1920–6), Trustee of the Tate Gallery (1920–7).

[3] Colonel Bertram Buchanan of Oxenbridge Farm, Iden, near Rye. He was to be a close friend of PN and his neighbour and landlord. PN had made one etching before (see Letter 28).

[4] The Cornmarket School of Drawing and Painting. PN and Rutherston visited in alternate weeks until it was handed over to Sydney Carline in 1923.

(2.) I have known of Ro[u]tter's existence for sixteen years, and in that time his opinion has not gained any weight or influence beyond a clique.

(3.) And chiefly a matter of this kind is decided eventually by what use was made of the pseudonymity. As you wrote nothing base or mean, injurious or treacherous, but only a plain statement which anybody might have signed, it doesn't matter what name you put to it—and no one will think it does when once the misrepresentation has died down.

It was probably a tactical mistake to put yourself in your enemies' power; but I think you take it too much to heart, and I should have liked to hear you proclaim you would do it again whenever you liked. Of course you have had all our sympathies, and we shouldn't have been likely to believe horrid things about you without mentioning them to you.

I note with delight that when you send me the drawing you are going to let us look at the photographs of your Russ: Ballet designs. I should very much like to see them, and especially the costumes, so that I could file them in my mind for possible future eventualities. I saw the plate in "Drama" and thought it gay and attractive: but I wished I could see the colour.[1]

.

The design on my book has suffered because the rise in cost of production made it impossible for it to be blocked in gold on vellum as it was intended to be; but even allowing for the resulting unfair meagreness I am well content with it, for it was done by the greatest designer[2] now in the world and it seems to me to show that in every line; he was the first man to achieve that significance of form which everybody tries for now, so I had hoped you would share my ardent admiration of it.

W.R's going to Sth. Kensington is the greatest news for a long time, and the advent of a man of European intelligence and achievement there should get the place on to the right lines at last.

I was much interested in your account of Charles Sims, though his pictures seem to me unbearably bad, and all the more so because some of them look as if he knew better; but he isn't the only Academician who

[1] PN's sketch design for the set used in *The Truth about the Russian Dancers* was reproduced as a frontispiece to *Drama*, vol. i, No. 5 (April 1920). This was a bi-monthly edited by Geoffrey Whitworth with the co-operation of the Council of the British Drama League. In the editor's notes on *The Last Two Months*, he wrote: 'Mr Paul Nash made it a thing of delight to the eye', but added of the whole performance that 'the little piece could only be enjoyed to the full by those who like their Barrie and their Ballet in equal parts and in a full dose'.

[2] Charles Ricketts designed the cover for the limited issue of *King Lear's Wife and Other Plays*. The book is bound in grey paper boards.

while doing wrong himself has been proud to help better men to do right—there was Leighton, for instance—so I hope he is going to be useful to you.

We are hugely pleased about your and Jack's Leeds commissions; we congratulate Leeds, and we shall go to see them when they are in position. I don't wonder you pitched on its canals: they always fascinate me when I see them. (N.B. A great-uncle of mine was murdered on the bank of one of them: subject for Méryon.) which reminds me that I should like to see your etchings.

132

Silverdale-in-Arcadia
9 February 1921

GB to PN
Paul Nash Esqre. R.A.

To

Gordon Bottomley

Bard, Connosher, Collectioneer and
General Æsthete. Dr.

1920 September		Per Sq. Inch £2.			
	To 1 masterly and romantic painting, A1 quality, genuineness guaranteed, according to solemn compact entered into with this firm in 1918, in exchange for 1 vol. immortal verse, Say ———————————————		600	–	–
	Compound interest from July 1920 at $9\frac{30}{9}\%$		41	7	11
	£		763	9	11
	Second application. An early settlement will oblige. With the firm's compts.				
	Interest Charged on Overdue Accounts.				

133

PN to GB *10 February 1921*

My dear ill treated Gordon

the arrival of your letter curiously coincides with the dispatch of a parcel to you which I had made up last night, so it *must* be telepathy!

I have been very puzzled as to which drawing you should have & if you do not *really* care for this will you tell me & I will try again. You will see it is 1918, yet out of a good number I felt it was your drawing & Margaret agreed. The lithographs with my love & there are to follow a set of my wood engravings when I can find time to print them off

In ten minutes I start for the country to work for 2 months & will write you at length from there. Our fond love to you both

134

The Sheiling, Silverdale, Near Carnforth

GB to PN *17 February 1921*

Your sympathetic parcel arrived duly and speedily, and gave us both a real and vivid pleasure which, even after a week of contemplation, has not proved to be limited. I assure you we are still without the least desire to ask you to exchange the drawing for another: your choice is admirable and appropriate, as well as highly satisfying; I am more than happy in possessing a work so good in design, so full of the very original charm of your colour and your valuable and equally original observation, and also with figures in it—for I always like your very expressive figures, as you know.

We are equally deeply interested in the lithographs which you so generously enclose, pressed-down and running-over measure in fulfilment of our bargain. Of course they make us mourn the absence of your delicate and enchanting colour that could so wonderfully complete them, but we are all the same attracted and impressed by the perfectly stunning and topping design of your breaking waves.

I need not add that none of your gifts will be parted from us while we are sentient to decide, and that we value and reciprocate the affection which made you inscribe them so charmingly. Accept our sincere thanks for all you send us and believe that we value and cherish them.

It was very nice to hear of you starting for the country and to think of your being there at the right time for making Spring pictures. I hope

I shall see them when you have your show at Cecil Phillips' gallery[1] in May.

But I mournfully fear I shan't at the present rate: so I am reduced to the alternative hope that Vogue will illustrate your show as well as it has done Jack's in the new number.

It is a large and keen pleasure to us to see at last, even in a dim reflection, so many of Jack's drawings. We like them enormously and without even a thought of a reservation, and their vision is completely after our hearts—my own favourites being perhaps the "Winter Landscape" and the engraving of a cat—though I really like all the other landscapes just as much.

I have lately also been enchanted and excited to admiration by the Vogue reproduction of young Gilbert Spencer's Surprised Shepherds at the New English. It is as fresh and attractive as the Wakefield Mystery, and makes one wonder if he is going to be as remarkable and cram-full of genius as his brother Stanley.[2]

Did I tell you that I am beastly ill—I mean beastlier than usual and with a new malady? I am entertaining a duodenal ulcer, and have been under the imminence of perforation and collapse and urgent operation. The medicine-man says I am recovering and past that now; but I still live on buttermilk whey, beaten eggs, fishes (little ones) and rusks like match-boxes; but I am thankful for these, they are better than being forcibly fed through my behind—which happened to me for three weeks in December, after which I lived on Olive Oil for a week. But I am consummately bored by a sempiternal stomach-ache—which now makes me too tired to write any more.

Emily joins me in love to you and Margaret; and I am always your affectionate first-believer

135

The Sheiling, Silverdale, Near Carnforth
19 October 1921

GB to Margaret Nash

Dear Bunty,

We were alarmed and grieved yesterday morning to hear of Paul's terrible and dangerous illness.[3] A thought of him had been creeping in and out of my mind for several weeks past, and I had been continually meaning to ask him for news of himself and you and his work as soon as ever I could get my head out of the tangle of work and correspondence which nowadays always seems to hamper equally my footsteps

[1] The Leicester Galleries.

[2] Gilbert Spencer, A.R.A. (b. 1892) and Stanley Spencer, R.A. (b. 1891), painters.

[3] PN had suddenly collapsed and been unconscious for a week when staying at Hillingdon in September. He was taken to a London hospital and his condition diagnosed as suppressed war strain aggravated by recent shocks.

and my eyes; and now suddenly comes this dreadful news, and we feel very anxious about him and wish we could hear something at first hand.

I know by the alarms which I give Emily from time to time that all the terrible weeks must have made heavy and exhausting demands on you, and I hesitate to encroach upon even a little of your resting hours, but if you could find a moment to send us a line to tell us how Paul is by now and what he and you are doing, we should be more than grateful. Are you in London, or have you taken him somewhere into the country for his convalescence? And is he able to see people, and does he care to? We may be in the South this Autumn (Sussex and perhaps Hindhead), and if we chanced to be anywhere in your neighbourhood we should not like to miss a chance of seeing you both, and helping him to pass a few hours of his convalescence if they are such a burden to him as these hours can be.

It would be nice so to reassure ourselves that he is safe for his work that no one else can do, and to renew ancient talks about the things we all care about; but in any case, and in the meantime, we hope you will be able to tell us about him and send us good news.

Please give him our love and good wishes, after you have nibbled off a piece for yourself; and tell him from me that I know by myself that these times are not lost for our art, and that while we must lie fallow things go on developing in us sub-consciously—so that when the time comes for work again we find we pick it up at a point further on than where we laid it down.

136

2 Rose Cottages, Dymchurch, Kent
PN to GB *[? November 1921]*

it was a great thrill for us to realise you were among us again[1] and I am greatly touched by your solicitude for this tiresome creature—myself. I am recovered—rather miraculously apparently—but recovered I am, to a state only just short of 'The pink'! Of course we are very anxious to see you and Margaret is writing about that now. We have had a visitation of people-in-law—very dear creatures—charming—beautifully behaved, but here they are & are to be. Few who come to Dymchurch want to leave it so our consolation is that if we can once get you & Emily here *you* might stick too.

I am busy designing a scene & costumes for King Lear's Wife—I hope you dont mind—if you dont and the designs prove interesting I propose to send them on with some others to the great Theatre exhibition at Amsterdam to which I have been invited to contribute. I hope

[1] It seems as if a letter from GB were missing. PN is hardly likely to have written in this way from the vague indications of a visit south in the last letter.

you will be able to come here. I should like to be able to show you a few things—but rather than miss you I will make a giant effort and come to see you! All news, as they say, when we meet

.

137

From PN to GB, Dymchurch, Thursday [? November 1921]. He is appalled at the difficulties of the journey for the Bottomleys [it is not known where they were] but gives particulars of a route from London.

138

PN to GB [*16 December 1921*]

thank you for a delightful letter[1] full of such charming compliments we quite blushed! It was a real joy to see you both and hear you speak again after so long. I am made very happy by your delight over the scene[2] & here is the photograph of it which you will agree has not come out so badly? The bed in the end was a great triumph—I made it out of the rather indifferent PreRaphaelite post cards—Burne Jones heads etc. was that naughty! but they were just the stiffness required for bed making. In colour it was a greyish pinky brown with curtains of an orange tint—looking very like leather & the posts & sides painted with

a pattern ⌄⌃⌄⌃⌄⌃⌄⌃⌄⌃ in vermillion. It

looked devilish Norse! On the outside backcloth I made an avenue of old old orchard trees & the same sort of trees seen thro' the windows

[1] This letter, presumably written after a visit to Dymchurch, is missing.
[2] For *King Lear's Wife*.

128

I am going to have the photograph enlarged directly I get to Town & will do you a tinted copy. Will you tell me the paper & process you mentioned—I have forgot. John Drinkwater turned up today—he was lecturing at Folkestone last night. He was v. distressed to have missed you, but says you never mentioned your address!

Here & now are too little place & time to say what I think of the new plays. Gruach[1] is a masterpiece to my mind a wonderful thing, Gordon. I do congratulate you heartily. I shall write again later this is rather in haste, I have had a bad rush to finish up here before London

<div align="center">
Adieu my dear folk

Your affectionate

Paul.
</div>

Written with a reed from Romney Marsh! . . .

<div align="center">

139

</div>

The Sheiling, Silverdale, Near Carnforth

GB to PN *28 December 1921*

My best Paul,

The photograph arrived here just about the time we did, and has been the joy of my heart ever since. I hope you have not been thinking me a pig for not saying so before now, though you have reason to: such a mess of things awaited our return, and then this infernal invention of Christmas topped everything and swamped me utterly and choked my sparking-plug.

Only now I revive and turn with affection and gratitude to you. The photograph is perfect, and I like the model more than ever. It is not "just what I want", it will not "do beautifully"; it is exactly what I mean, it is what my inward eye saw ten years ago, I feel it could not be otherwise. No one has been so faithful to another man's vision since Rossetti's great days were over: such sympathy is a miracle. I am enormously pleased with the orchard avenue: nothing else could have been as good, the feeling is lovely.

The bed is a triumph: it is more: it is IT. I am sure it solves all difficulties in the best possible way. I don't a bit mind your using the wrong Brum cards (but I hoped you spared one of the Sandys ones.) The proportion of the bed is perfect for the model: it seems, though, that if it were for a very wide stage, such as the Haymarket, you would have to make it longer to preserve the present significance—and that might have the advantage of letting the side-door be seen through the bed.

<div align="center">.</div>

[1] *Gruach* and *Britain's Daughter* were published in one volume in 1921.

Before now you will have been to the Leic. Gall. Lovat F.[raser] show,[1] and will have seen the models put into little boxes the exact size and lit by an electric bulb hidden at one side. I found myself liking his originals far better than the reproductions, especially the large single figures for Shakespeare. And of course I was thrilled with happy surprise when I discovered the design for one of my old women in "Lithend"—it haunted me for days that I should only know of it too late to thank him.

I am so happy you like Gruach, for I believe it is my best thing.

· · · · · · ·

All I managed to do in the way of visiting was to keep a many-times-broken promise to Eddie [Marsh] to dine with him, and I arranged that with him while we were still at Amberley, so that even if I could only stay the one inevitable night in London he would come first and I should not have to throw him over as I did in the Summer.

We enjoyed ourselves enormously, and Eddie was as charming as ever. We enjoyed his pretty house too, and his pictures. Anyone who wants to see at a glance what the modern school of painting is doing needs to go to Eddie's: he has chosen superbly, and the work of a whole generation is seen there at its best. Jack's cornfield is a topping affair; and he has your very finest landscape (the large one with the arching trees.)[2]

· · · · · · ·

We still think daily of our week-end in Romney Marsh and the pleasure we had in being there with you both. When do you return? We join in hoping that the New Year is going to be very kind to both of you there, and that you will go on recovering and regaining strength at your present satisfactory speed, and soon be in the full tide of work again. With our love to you and Margaret,

140

Dymchurch under the Wall, Kent

PN to GB *14 January 1922*

it was delightful to get your letter and altho' I feel you give my efforts far too much praise it is a triumph to have pleased you to such an extent. You must know, it's much easier than you think for to design things for your plays because they're the sort of plays I should like to write if I was a dramatist and they make the pictures I enjoy to see in my mind. Also I flatter myself I possess much in common with you! We belong to a select freemasonry of some world we both have secret knowledge of and are for ever trying to describe in our different ways.

[1] The Memorial Exhibition from 3 to 31 December 1921. [2] *The Elms.*

Anyhow there is no doubt Mrs Lear is a very inspirational drama and perhaps was the first wherein you came out fully in your true colours —I speak my opinion with all humility dear Poet—for altho' the Crier remains a firm favourite with me and Lithend has unforgettable moments, I can see that Lear suddenly leaps up higher, shaking off certain trammels, and takes up a place among the big things that have been written in our time. But having felt that—as it might be Carpentiers[1] left, one is quite knocked out by—as the saying is—a right to the jaw. For so comes Gruach; a veritable staggerer! I dont think I can say how much this play moves me and I pant for the excitement of seeing it staged! Eddie was most enthusiastic over it and we had an argument about the manner of its ending. He thinks it is too long a 'cooling off' after the thrill of Macbeths scene. I do not agree, but I can imagine that being a difficult piece of acting to keep things alive to the end. But the whole conception, the intense beauty of the whole —its language and action—I give you every praise. It is a great play. 'Britains Daughter' has not got hold of me yet tho' I think it very interesting. I am a slow absorber, so you must give me time. At present my whole imagination is held by Gruach & presently I hope to send you some schemes for a setting. . . Jack with whom we spent Christmas, was very delighted to hear your praises of his work & is sending you his latest engraving—if the envelope ever gets posted. He writes letters and they lie about—either unenveloped or unstamped—for weeks! it is a strange bad habit and horribly disasterous at times. I saw Lovat's show and was very impressed, but I don't like the little models in boxes the exact size and while I can I shall endevour to make my own models, but poor Lovat never had time, and these are the work of a professional model-maker and, I think, look it. We still cannot quite believe you visited us. It was like one of those dreams which one is sure is too good to be true. I should most likely not have finished my model to send to Amsterdam and I should certainly have missed encouragement which has helped me in many ways. So altogether it was a fortunate visit & we shall always be grateful for it. Our love & good wishes to you both for a new Year

141

The Sheiling, Silverdale, Near Carnforth

GB to PN *29 January 1922*

My Dear Fra Paolo,

Your good letter was very welcome, and I was glad to feel by it that your health is still marching to excellence and letting ideas of

[1] Well-known French boxer.

work be insistent: all the same I hope you will go on being careful longer than is necessary—just to make sure, you know.

It is nice, too, to hear of your being in that enchanted Dymchurch again. When I regard my invalidish 'abits and my inability to do anything I want to—especially on the spur of a moment—I am inclined to disbelieve I was ever there. I can still think about Dymchurch and Rye as I do about Venice, Beauvais, Prague, Munich and Moscow—places I yearn to see but only know by affection and brooding. That week-end has for us too all the quality of one of those perfect and delicious dreams in which life for once goes wholly as one has always longed for it to do—and which, when it is a few weeks old, recurs to one with a bewildering question as to whether one ever did dream that or whether it was just something that really happened.

.

I am very much looking forward to seeing your Gruach designs. I think I ought to tell you I have a nibble for her for next Autumn from a *very* good manager—the fly in this flattering unction being that he says the cost of special mounting is becoming so ruinous that if he does it he will have to simplify and make most of his effect with lighting devices. This isn't at all my ideal for Gruach; and I'm afraid he also has a designer On The Strength; but I have mentioned you to him first thing as wanting to do Gruach and being in complete accord with me, . . . So I hope he will be amenable.

I enjoyed your criticism of my plays with much relish. I agree with you altogether that something more was set free when I came to Mrs. Lear. I wish I could know that still more will be set free as I go on. I am enormously pleased you would say what you think so straightly —and you needn't have mentioned humility: it was real criticism, and I am contented with you when I know I haven't taken you in and that I don't make you want to be polite.

Perhaps I am most charmed by your saying my plays are the kind you would like to write. I am happy they strike you so, for the plays you would write would obviously be the real thing; but I am puzzled also, for I shouldn't have been surprised if you had thought them a little old-fashioned as well as likeable—mainly I think because we employ opposite methods, I by focussing observation of nature and detail in the whitest and sharpest light I can compass, and you by observing nature and detail just as closely and then getting your effect by contradicting or even denying it.

But all the same there is a kinship in that too; it is continually turning out that we have something in common, and that feeling of there being a secret world of which we have some initiated knowledge has recurred and recurred in me ever since I had your first parcel at Cartmel.

132

I was ~~enormously~~ (no, I was enormously higher up the page) super-latively pleased that Lovat F. had not made those models; they were cold and hard and prosaic, and some of the defects of "If" were attri-butable to them. I quite agree that the exact-size boxes are not ideal, but I thought they might be more useful so for sending to Amsterdam.

.

About the ending of Gruach: in England people have been swamped by the French bien faite play of the 19th. century, and will only let plays be ended one way. They always speak as if a play must be one specific thing: but that idea must be destroyed, it does not exist any-where else in Europe except in France—a country which is always either too conservative or too intelligent in a one-sided way; for the truth is that a play can be anything.

Viola Tree said the same thing about Mrs. Lear; she wanted me to have the curtain at Lear's exit two lines after her own, and to cut out the finale of the corpse-washers; and when I wouldn't she cut out half of it all by herself.

In the same way when Ellen Terry did the Vikings,[1] everybody at the last rehearsal agreed that the play should be finished with her disappearance, and the finale with the child's vision was dropped; and yet that had never been noticed by Ibsen and the Norwegians for about 40 years, and had never been noticed by the Germans and the Russians.

And if my Gruach ever reaches the continent, the end will be thought all right if the actors can make it interesting. All it needs is to be played lightly and rapidly, like an afterthought, and not with the weight and significance of the main action: then the vision of Gruach's future will emerge and seem unavoidably necessary.

I am very much wanting to see your friend P. M. Turner's new book on "Appreciation in Art"[2] ever since you told me that he had independently expressed my belief of many years that the French have much more fine painting than we have, but that the small bulk of our very great painting is finer than anything the French have to show.

I believe that more and more: and the reason seems to me that our painters have never been consummately expert and accomplished virtuosi in their technique and handling of materials, so that when the great moment comes they have to think it out and feel it out from the beginning and thus get their executions into harmony with their matter and avoid ready-made solutions: while the French are so virtuose, so full of professional adroitness and aplomb, that they can execute

[1] Ibsen's *The Vikings at Helgeland*. Ellen Terry gave Gordon Craig a free hand in producing this play at the Imperial Theatre, spring 1903. For a somewhat confused account see *The Story of My Life* by Ellen Terry, 1909, pp. 351–4. She played Hiordis.

[2] *Appreciation of Painting*, by Percy Moore Turner, Selwyn & Blount, 1921.

anything and beguile us by the beautiful manners and breeding of their execution into feeling that anything they do is right. I think, too, that it is this that gives them a mundane outlook and makes their art so poor in the element of fantasy—so that they have very little to show of such a spiritual world as Blake, Calvert in "The Cider-Feast," Rossetti in the little early watercolours like "The Chapel In The Lists," Millais in "Ferdinand and Ariel" or "Mariana" and Crome and Cotman lived in.

What a yarn. You will be bored long ago.

We hope there is no influenza in Dymchurch, and that you are making a lovely picture of Bunty weaving—Dymchurch being obviously a bewitched place, and both of you under enchantment, she will probably look something like the Lady of Shalott, but much better.

We hope your new year will bring you happy days and good fortune, and we join to send you both our love.

> Your affectionate
> Gordon

Silverdale youth has just banded itself into The Silverdale Village Players. Its first composite and corporate act was to come and ask me what to do and how to do it.

So there you behold me all at once and disconcertingly In The Soup. I spent yesterday afternoon with the village electrician in the village school, measuring for a box of curtains and a stage, and persuading him to turn a row of footlights which he has in stock into top-lights. I don't know what will come of it; for I suspect a militant minority of wanting to do Gilbert and Sullivan operas like a dozen villages all round us, and I can't be bothered any more with those dear and venerable machines.

N.B. I am Jack's debtor, and I await his missive with prodigious respect. His engraving is to be welcomed among my treasures. Need I say it has not arrived?

N.B.B. If, in the ardour of your youth, you had ever done anything so indiscreet as a Gate of Smaragdus, what would you do about it now? Would you scrap it all, or save any of it? I am withdrawing it and Chambers of Imagery from sale, and Constables want to issue in their stead a 1 vol. selection from all my books of poems. What shall I salve of that green, green book? Put down the title of anything you would care to read in legible type, if you can remember anything; it would help me hugely to make up my mind, which shies at the task.

> G. B.

142

From GB to PN, Silverdale, 13 February 1922. He sends PN a cutting from
an article by Gordon Craig praising a model of his at Amsterdam
[Amsterdam Exhibition of Theatre Arts and Crafts, opened by Gordon
Craig, January 1922. The cutting was from *The Times* (1 January),
where Craig writes: 'The best model is by an Englishman, Paul Nash'.
See end of next letter]. He hopes it is *Lear's Wife*.

143

Dymchurch, Kent
PN to GB [c. *mid-February 1922*]

Its all right Gordon old chap! its our model all right . . . I have been
thro' the green green book[1] but I find it hard to say quite what I *dont*
want. I want quite decidedly the following—The Last of Helen. La
Beale Isoud in a Lazar-Cote, Phillis, Harvest Home & I think perhaps
the White Watch (op 24 No 3) I take it Giorgione goes in anyway or
else is a separate consideration In the others I find I lose myself charmed
many times but emerging rather bruised and breathless from my
encounter with so many be-capitaled portmanteau words—like Mr
Pickwick after his belabouring between Mr Pott & Mr Slurk in the
hotel kitchen.[2] Am I rude, I hope not I love the green, green book.

I suppose it may sound inconsistant to say your plays are what I
should like to write myself, I had not thought of it as you put it down,
analytically—but my feeling remains, it was not intended as a compli-
ment! I am delighted by your criticism and altho you were puzzled
you have admitted, too, that there is something in what I said—for
which I am glad. I do not feel your plays are *old* fashioned in any
sense I am aware of—which could mean out-of-date. Wilde & Shaw
can give that saddening feeling but Shakespear does not. You have
followed the verse form of an imperishable tradition I suppose but it
is because your people are types of human beings speaking & moving
by the creation of a tremendously real imagination and a sensitive &
subtle understanding and are not so many puppets squeaking according
to plan, and hopping about a la mode, that your plays can grip our
emotions and satisfy our intelligence. I agree heartily in what you have
said in justification of the ending of Gruach. Viola Tree & dear Eddie
[Marsh] are neat-minded people. Eddie especially has a scrupulous
mind bordering upon finickiness . . . I like your remarks about the
French. Yes I think they can take one in but it is often a complete take

[1] *The Gate of Smaragdus.*
[2] *The Posthumous Papers of the Pickwick Club*, chap. li.

in because they are able to create a beauty independant of subject-matter suggestion—which is only another kind of take in—and to charm you not so much by actual manners but the state of harmony which results therefrom[,] a kind of delicious flattery of the aesthetic suceptabilities. At least that, I think, is how they appeal to me.

.

By the way I fear that will usually happen with managers—they *keep* a tame artist on the Strength and that is why I am laughing at Craigs tribute in The Times—It is ridiculous that I—the veriest tyro as [Wyndham] Lewis would say—with my *first* actually carried-out model should have the best model in the show. . . .

144

From GB to PN, Sheiling, 20 February 1922. He tells PN that he always means actor's right and left [PN had asked if he did in an omitted passage of Letter 143] and sketches his 'idea of the dispositions'. He praises PN's *Winter Wood* woodcut as his 'masterpiece so far'. [Plate 7 of *Places*.]

145

Dymchurch, Kent
PN to GB [*15 March 1922*]

just a line to tell you the construction of the Gruach model is pretty well completed and to send a sketch showing what liberties I have taken with your scene! I cannot help feeling the break in the back wall is very necessary as the feeling that both the outside door & the staircase door are in the same wall is uncomfortable and another 'depth' is more dramatic.

There have been many improvements since I made this sketch which is really a thin and rather misleading sort of statement—imagine everything twice as exciting and the whole a finer harmony of proportion. I send it really to show you the alterations in architecture & to beg your approval.

.

In an awful hurry

146

The Sheiling, Silverdale, Near Carnforth
GB to PN *19 March 1922*

O, Beato Paolo,

You've done it again, and I am delighted all over. You go back to the spirit of a primitive life in an unspoiled land in the very way I do

myself, and I feel at one with you in sympathy about everything you have done. Your pacquet was a great excitement, and on the day of its arrival I went over it all like a fire over the prairie, and then several times packed it all up so that I could have the pleasure of discovering everything over again.

Now we must get the lovely design seen, so that it may meet the eyes of those managers who are nibbling at Gruach and make them feel we are imposing it on them. It is a stroke of fortune that the Amsterdam show is coming to S. K.,[1] and so soon. I suppose it should be possible to have it inserted in your exhibit there. And mightn't it be a good thing to get it on to the front cover of "Drama"[2] before that shy flutterer goes into its midsummer hibernation?

I have about three small remarks to offer; but as this drawing only represents the first state of the design I hesitate to make them—for you have probably altered the very points before now. However, here goes—and you must remember that I am only speaking comparatively and provisionally, for all the main things are right.[3]

.

I have been gasping all these weeks with my head out of the wastepaper basket to answer your letter. I did thank you for the new engraving, which cannot be far from your very best: it still delights me with its tree-drawing, the planes of the earth, and Bunty in nice clothes looking like La Belle Dame Avec Merci.[4] . . . But I have never thanked you for taking all that trouble with the old green book. Let me do it now, for I was grateful and you have done the job more helpfully, and more exactly as I wanted it, than any one else has. The sympathy in your selection has made me interested again in my early misdeeds; I shall have to rewrite places in them all, but I hope that in that way I shall get something worth while, and I certainly think you have spotted the things that have potentialities and are worth bothering with.

Would you include Prophesy too if I could get the end as good as the beginning?

[1] South Kensington (Victoria and Albert Museum).

[2] Presumably the publication referred to in footnote 1, p. 123.

[3] A long passage is cut here, because it is not of great interest except as an example of the care GB took over the visual aspect of his plays. The following paragraph is important as an expression of GB's general opinion: 'I take it for granted that the high lights on the walls are not for the scene painter's guidance, but for that of the lighting expert's? I feel the painter should put *all* the stone work in as in the Lear model, & leave the light to make the saliences & omissions.'

[4] The only woodcut of 1922 which corresponds to this description is *Winter Wood* which was used in *Places*, 1922, a book of seven woodcuts designed and engraved by PN with 'illustrations in prose'.

I was pleased and comforted that you liked Phillis: when she is in ordinary type I fear she will look a little owdacious, and will have to be titivated. But I always rather liked her, and I was going to omit her because I thought no one else did; so I was happy you mentioned her.

Really, I think sometimes that my early impudences were twenty years before their time, and that I should have done quite well with them now alongside of the Imagistes, Firbank, W. R. Child[e], Aldington, Flint and Pound.

.

I agree with everything you say about French painting, both as to its good manners and aesthetic harmony. I only mistrust the achievement as a guide for myself, and that is because I feel it is a virtuosity that can be applied from the outside, instead of growing out of the subject-matter and being new and quivering everytime.

For myself, after swinging from North to South and East to West among varying excellences, I have come to the conclusion that nothing is important except the subject-matter, and that nothing gives me the real thrill except a sudden and surprising harmony and unity between subject, material, and use of material—texture, style, even originality of idea (that scarcest of birds) all depends on that.

It seems to me that Whistler's discovery that subject-matter was irrelevant and literary is out-of-date—in spite of Clive Bell's[1] rejuvenation of it; I mistrust it most of all because of its flavour of mystic and transcendental doctrine, it is really just the same humbug as St. Athanasius telling us about three people and then giving us his word that they are all one person. And what makes me most positive of all is that the stupidities in painting which Whistler and Clive call literary are just as stupid and inartistic and fatal and vulgar when they are done in literature; so that I have to look elsewhere for guidance, and to become convinced that the solution is in a wider conception of subject-matter.

Jack has written me the charmingest letter, and has sent me two engravings which are the delight of our hearts and the pride of our house. The pigs are a masterpiece, whether in subject, texture, colour or style, and as good as Dürer's; and the little Applegatherers is no less a superbity. They are as good as the best engravings in the world, and I must thank you for the joy of them.

Jack said something nice about our meeting; I should like it enormously and I hope I can bring it off this Summer. We are still servantless, and I think it is about time Emily had another rest; so we are planning to take the road again as soon as Easter is over. We shall start in Oxfordshire again; but we hope to get to Cambridge too. I fancy I shall have to go to London, but I doubt if we shall reach Sussex in the

[1] Arthur Clive Howard Bell (b. 1881), critic, author of *Art* (1913), *Since Cézanne* (1922), and other books.

138

PLATE IX

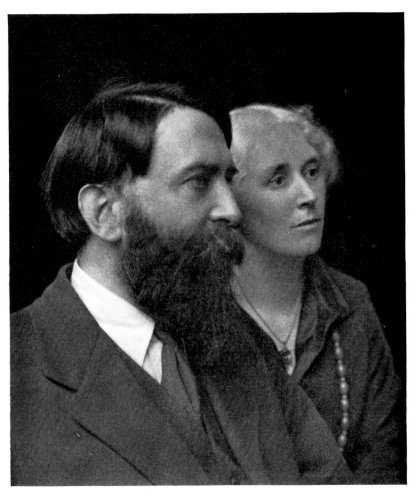

Gordon and Emily Bottomley, 1920

Photograph by E. O. Hoppé

PLATE X

The Corpse Washer, *by Paul Nash, ? 1921. Pencil and colour wash, 5″×8¼″. Design of a costume for a character in* King Lear's Wife

few months that we are away; if we do I will let you know—and perhaps you will be nearer London by the time we reach there. In the meantime we send you and Bunty our love.

<div align="right">Yours in admiration,
Gordon Bottomley</div>

P. S. I doubt if Viola Tree is even neat-minded: she simply wanted the curtain for herself.

<div align="center">

147

</div>

<div align="right">*Dymchurch, Kent*
[*4 April 1922*]</div>

PN to GB

My dear delightful Gordon

I expect you begin to think I have had a relapse—it has only been a relapse into silence during a period of intensive study. For you must know a great work is now in hand—Gruach being now finished & her box in the hands of the local carpenter—

A wonderful fellow proposes to bring out an edition of Shakespear more or less regardless of cost. Each play is to be given to an individual artist to work out & design therefor five colour plates & a number of black & white drawings to insert in the text. The first five are now given out to Craig, Albert R.[utherston], Schwabe[,] Lowinsky[1] & your humble servant to whose lot has fallen A Midsummer Nights Dream. Albert is art editor & it is said [Granville-]Barker will write the prefaces —& others will follow. If not more than a thousand pounds is lost on the first books the series is to continue. Other artists will be invited but certain of us—myself fortunately included—will continue at the rate of perhaps 2 plays a year. Is it not amazing? Of course there is a small fly in all this precious ointment—they want the work done too soon but that will not greatly distress me I think. I have decided to treat the Dream perhaps rather unconventionally taking for my model ancient Crete—Knossos etc. which of course is the time of Theseus but of which time there is no record in Greek proper—the earliest artistic period coming thousands of years later. But the Cretans are so obviously the most marvellous chaps that ever happened & they knock the Greeks all sideways as designers architects & all else that I shall plump for them. I have been steadily reading & thinking things out for the last month & have now thoroughly mapped out the play & am about to begin the drawings. My ambition is to make very rough models for all the scenes & drawings from the models. One thing I am trying to bring off is

[1] Randolph Schwabe (1885–1948), painter, illustrator and theatrical designer, instructor at Royal College of Art. Thomas Lowinsky (1892–1947), painter. The edition referred to is *The Players' Shakespeare*, published by Ernest Benn. The first batch appeared in 1924.

the Wood from two different points of view A) the Fairies—plants &
flowers the size of trees etc etc. B) The humans normal vision of a
wood, and these constantly changing almost imperceptably as A or B
hold the stage. This is now worked out almost mathematically but I
have yet to arrive at the answers to my equations!

Of course we were delighted you were so pleased with the Gruach
scene & glad am I to be able honestly to say that all your objections &
corrections [have][1] *already* been made & made. The scene has taken about
six times as long as Mrs Lear but I hope in the end it may be about three
times as good. I will send a picture or a photograph of it anon. I think
there is no doubt it will be exhibited at South Ken in the Amsterdam
Show. I am sending it in. . . Thank you ever so much for the splendid
letter it is very interesting. I will try & reply adequately later on just
now am up far beyond my armpits with work Our love to you both

.

148

The Sheiling, Silverdale, Near Carnforth
GB to P.N *11 April 1922*

Invaluable, Incomparable Paul,

Your delectable cornucopia arrived safely, and shed delights over
my bed just as I was thinking about getting up and going to Lancaster.
I went, and gallivanted so much—and then to a rehearsal of the
Village Players the night after—and then another last night—that I
have never been able to make a chance to thank you until this moment.

Of course we were happy all over to hear of your good fortune, and
especially that your share in the new Shakespeare is to be a substantial
one and to keep you going so long. I can see the choice of you for
Mid. Night's Dream as a fortunate one, and I find myself already
longing to see the delicate wild fanciful uncouthnesses which you will
get out of the faeries. You will guess that at first I cursed the fellow who
allot[t]ed it to you, feeling sure that he had done so under the halluci-
nation that you are a landscape painter; but I soon saw that he had
created a pretty gorgeous occasion for convincing him that he is wrong;
and anyhow it ought to be very much one of your subjects.

My idea of the Greece of it was for long the earlier vase-paintings;
and, as they come nearer Crete than anything else, I feel this rather
ties on my idea to yours. Anyhow, your exploration of Crete is a first-
rate idea, and ought to be fruitful unto the seventh generation of your
ideas, and in all sorts of unpremeditated ways. For instance, I am dead
certain its huge and primitive masses and designs afford far more

[1] MS. &.

suitable material for mounting the great Greek tragedies (all concerned with a far huger idea of life and effort than that of the age which produced them) than the conventional Athenian stuff affords. I don't know anything more deadly than the usual mounting of a Greek play, and your Mycenean excavations ought to provide you an inexhaustible fund of innovations—enough to revitalise that whole department of drama.

.

I am delighted to hear that "Gruach" is finished, and that my small suggestions had been anticipated in your own mind. I am keen to see it as soon as ever there is a chance, and the costumes, too, if you have done them: I remember the rich and concentrated feeling of those for Mrs. Lear. . .

I am so pleased you will send it to S. K. Please send me a post-card to tell me when the Amsterdam show will be open there. I hope for certain for London from about 24 to 29 April: thereafter we shall be moving about for some time, so that if I miss the show the first time I still might be able to make a dash for it and London before returning home.

.

Our love to you both.

149

PN to GB

Dymchurch, Kent
[*PM: 21 April 1922*]

Superlative Gordon

a thousand thanks for your last letter I fear this must again be one of those letters all out of proportion in reply a mere dotterel's pipe against the musical thunder of the sea.

I had just about enough work to keep me going all day & half the night when in tumbled four different demands for shows so, as I daren't miss the chance of selling something, I had to finish some drawings to send in. At the same moment arrives a fat parcel of students work from Oxford for me to criticise—and Im not really allowed to overwork myself yet you know! Well, here are the photographs. . .

I have nearly worked out all the 'Dream' scenes—the wood is great fun. I shall try to push in a design for a mask for The Crier to the exhibition so on the whole you will be well represented.

.

P.S I dont yet know the date of the theatre show.
P.P.S Alas, I have done no costume designs yet for Gruach, but I will.
P P S Bunty made the bell in the model.[1]

[1] In the model for *Gruach*.

150

GB to PN *22 April 1922*

Excellency,

The bell is gorgeous and all I ever dreamed of. Give my love to the
Beller—the Bella Donna—the Campanologist.

I am more pleased than ever with the finished state: it is all I ever
dreamed of, and you have cleared up every point marvellously as I
wanted it.

I have no criticisms, and but two suggestions on points of detail.
(1.) The figures on the fireplace-cowl (or pattern suggesting figures)
feel to me competitive, and as if they would jostle my mind when there
are people standing near. Could the cowl, might the cowl, O, Altesse,
be just plain masonry, or just be made to match the arcade pattern.

(2.) The door (R) to the servants' quarters I saw as *much* lower than
the other two, and flat-topped with a great heavy square piece of
ashlar: at present it is too competitive with the others, and does not
give the impression of oppression which I want—a way into hutches
and styes for a lower order of beings. That is absolutely all. O—except,
that I can't be sure if Mac isn't wearing a kilt. Do not let him wear a
kilt, Paul: I couldn't bear a kilt, I should hear bagpipes. How lovely
and perfect the figure of Gruach is: she couldn't be better—she makes
me shiver with delight. The print with the correct lighting is a marvel
of rightness: and the other tells me all the rest that I wanted to know.

.

151

Sheiling, 24 April 1922
"Upon a Monday morning"....

GB to PN

Altesse,

Another detail emerges in my mind; but I mention it dubiously
as it may be a cantrip of the camera, and not a thing to take notice of.
The masonry lines (and the dog-tooth pattern over the main door)
come out white in the print to such an extent as to destroy the feeling
of a black-stone castle—or at any rate to disperse the necessary feeling
of age by the suggestion that as the mortar is so white and sharp the
castle must be only just built. But I know all the time the [?that] your
colour can very well have put all this right before it was ever wrong,
and that perhaps you are going to tell me it is not white at all.

Did I get it in on my last card that I am just emerging from a beastly

cold, and daren't tackle London until my chest is safer; so we shall go to Banbury direct (G. B. V.), and then try to reach London for the S. K. show.

<div align="right">Votre G.</div>

152

<div align="right">c/o Dr. Withers,[1] Souldern Court, Banbury</div>

GB to PN
<div align="right">1 May 1922</div>

We got here safely on Friday—mourning a good deal our lost London, but uncommonly relieved to be able to get away at all; and now that I am here I am reviving quite nicely. This Oxfordshire that I love so much has an air that seems to suit me admirably (much better even than Sussex did), and I feel sometimes as if I should come to end my days among these little hills and lovely little olden golden houses.

<div align="center">.</div>

Briefly, and to come to the point first, I had a delightful letter from Jack the post before we left Silverdale. It told us of his new house and his new picture; and it said that he shortly expected to see you at his new house, as you were going to visit Oxford almost immediately. I suppose that will be in connexion with your class there, and that you will not be in Oxford itself very long?

As we are to be so near for a moment, it seems a pity not to meet; so I said to my host here last night that I should like to run up to Oxford (only a 20 miles journey) while you were there. He immediately said that it would be much better for me to ask you to come here, and also that he had long wanted to meet you and would have asked for my long promised letter to you before now if it had not been that he is not going to London nowadays.

So he asked me to write to you at once and say that Mrs. Withers and he would be glad if you could run down here while we are here and you are in Oxford. . .

<div align="right">Ever so much love from us both.</div>
<div align="right">Yours gaspingly,</div>
<div align="right">Gordon</div>

153

From PN to GB [Dymchurch, 3 May 1922]. He accepts invitation to Souldern provisionally. He will let them know for certain.

<div align="center">[1] See note to p. 109.</div>

From PN to GB [*Dymchurch, 3 May 1922*]. He sends 'just a thought' after the last letter. It is about representation of *Gruach*. 'Latest photographs of G are better & Macbeth is now in a cloak, he has been unkilted & now wears a sort of 'combination' garment—very 'chic'. 'Scenic alterations affected. Mortar is not white but greyish, castle is only *black* by implication. Flat refusal to do another stroke!'

<h2 style="text-align:center">155</h2>

Souldern Court, Banbury

GB to PN *6 May 1922*

Thank you for bothering about the telegram; which was pretty of you because it cleared up our host's plans in such good time. I gather you are leaving Paddington at 4.2 p.m.; so we will look out the concordant time at Bicester (O, I forgot; we've done it, haven't we) and I hope we can come with the car to meet you there.

I ought to have told you in my last that if you feel like bringing glad rags with you it will be all right. Percy lets me off changing on account of my invalid habits; but everybody else mostly changes, so you can take your choice either way.

I wave my 'and to you for your esteemed second postcard. I am glad there was plenty of time to get the bed mended; and I can die and go to my long 'ome quite 'appy now that you have got Macbeth out of tartan.

I can't write any more now, as I have just had my breakfast in bed and must now get up and go off across country to see Shakespeare— who lives fairly near here. It is very nice to go to a theatre in the daytime, a theatre in a garden and by a river as lovely as the Thames. Stratford would be a lovely place, too, but for the Shakespeare industry. There is a jolly weaving shop there. "Taming of the Shrew" this afternoon— very much the Elizabethan equivalent of "Charley's Aunt"— and yet I bet the latter doesn't last as long as the former has done. If the British theatre would ask itself "Why" and find out the answer it would find out also what is the matter with itself.

Ooray for Monday: I'm looking for you already. Our love to you.

<h2 style="text-align:center">156</h2>

Dymchurch-under-the-Wall, Kent

PN to GB [c. *mid-*]*May 1922*

.

It was a jolly time at Souldern & I shall long remember our talks. You will both come to *us* here wont you—we've worked it all out &

are sure it is the best way of doing things more especially as a late notice for rooms will be almost useless whereas you can let us know more or less at the last moment so far as I know at present. I am sending a sort of lucky dip parcel as I thought your charming hosts might like something for their scrap books. Your head I am going to engrave in the size indicated on the back of the drawing.[1] Tell me if you like the drawing enough to use in a book somewhere. Has 'Today' 'done' you yet? I cant help thinking we could turn an honest guinea between us! By the way I have decided to continue our series and am bent upon doing Lithend next—Icelandic papers please copy—The 'Dream' is now to be published next Spring not at Christmas so I can take it easy—all that scramble for nothing: I might have sent in two more designs for the Theatre show. Mrs Lear is now *seccotined* down, so the death chamber is positively realistic if you put your nose inside the curtains. Gruach is immaculate so now we just look forward to the opening in June when you must be there. In haste Our love to you both

157

c/o T. Sturge Moore esqre. Hillcroft, Steep,
Near Petersfield, Hampshire

GB to PN *2 June 1922*

Beloved, Revered,

An appalling number of agreeable things has happened to me since you last heard of me; and the consequence has been that the every-day-intended letter to you never had half a chance to get itself written. Also we have been living mainly in our trunks and bags from leaving Souldern to reaching here, with everything in such a glorious muddle that I couldn't find my cheque-book.

And when I did find it I found also that I hadn't any money in the bank; so instead of the promised cheque I am sending you with this a P.O. and stamps for the guinea in payment for the Mrs. Lear prints. Please receive my enormous thanks for bothering to get them done for me . . .

My esteemed portrait is safe and flat; I shall like to see it wood-cutted, and I will return it the minute I acquire anything stiff enough to pack it with—which, I fear, may perhaps not be until I am sitting on my own mountain again. If that seems exasperatingly long I will try to extract some packing from somebody—but it is far too hot to exert moral suasion on anybody, unless you stringently require me to.

[1] See Plate XIII. The engraving would have been seven inches by four and three-quarters, but was never executed.

I spent most of my time in London enchantingly with Will [Rothenstein], who helps one to sit without boredom, and was dear and charming to me beyond description. The longer I sat the more my affection and respect for him increased.

He worked enormously hard at me, and the portrait is topping. Also he gave me the most agreeable times at lunch with many exciting people—especially two conversations with the adorable unmanageable G. Craig, and ever so many with Martin Hardie[1] who is arranging the Theatre Show, and took me among it twice. If the show is a success it will be owing to Hardie's genius in managing Craig.

So far as I could see, our models out-top all the others; and, so far as I could hear, everybody says so. Hardie has chosen the Mrs. Lear for reproduction in the catalogue, and there are only 16 plates altogether.

On Tuesday night I went to Ricketts' and Shannon's. Ricketts had been hanging at S. K., and began immediately about your models. He said your drawings had never repelled him as most of the Post-Impressionist work did, though he didn't hold with your ideas; but that your model for Mrs. Lear had given him enormous pleasure, and that he thought it the best in the show and one of the most charming things he had ever seen—instancing particularly your treatment of the rushes on the floor, and speaking with particular delight of the little figures and the way you have made them. He thought your figures gave you a great advantage over the other model-makers, and spoke of their fine imaginativeness. He praised the "Gruach" model too, but he said he didn't like it quite so much as the other because the colour seemed to him both too neutral and out of tone. On the whole he praised you to a degree unusual with him, and seemed inclined to be a good deal interested in you.

A little while after he said the Lovat Fraser exhibit seemed to him thoroughly bad and entirely without merit, thin and superficial,* and I am bound to say I agreed with him. The "As You Like It" looked dreadful.

Alas and alas and alas, we never got to Jack's: the heat was paralysing in Oxford—we spent our last day from dewy morn to dewy eve on a Thames steamer, for I daren't move—and I was unfit for the up-and-down, rushing-about sort of journey that Meadle[2] meant. We were *very* disappointed and want to try again next time.

*and that he had been sorry to feel so about it, because he had liked L.F. himself very much indeed, and [thought him] one of the most charming men he had ever met.

[1] Martin Hardie (1875–1952), painter and etcher, Keeper of the departments of paintings, engravings, illustration and design at the Victoria and Albert Museum.
[2] John Nash's home at Princes Risborough, Buckinghamshire.

I had luck in London: the Vic. is to do "Britain's Daughter" for a fortnight on 13th. Nov.; and Basil Dean has fixed up "Gruach" for a fortnight's performances in his "Afternoon Theatre" in the New Year at the St. Martin's.

I tried hard to find if there was a chance to have your design for Gruach carried out; but he is installing a German mechanism which will provide a generalised, symbolic, interchangeable mounting for any number of non-realistic plays at a low cost per play, and was not accessible to any idea of carrying a special mounting out for my play. I will try to find out if there is any chance for special costumes when he puts the play in hand.

.

158

From PN to GB, Iver Heath [early June 1922]. He congratulates him about the news of productions in the last letter. 'There is no doubt I must stop making elaborate models & devise, instead, ingenious curtains or you & I will never "come out" together on the same night. I have been here for a few days with my Father in this lovely garden I used to draw so often, it is very dear to me.'

159

Dymchurch, Kent
PN to GB [c. *2 July 1922*]

Beloved Bard

I have just dashed off a letter to a Princess[1] so my pen's all of a flutter. It was to accept an invitation to make a drawing for the Queens Dolls' House but the invitation was couched in such a very chatty style that I had to write to Eddie [Marsh] for information as to how such a letter should be met before I could send my reply! Eddie says its all quite odd. For instance the Prince of Wales writes to the Colonial Secretary—'My dear Winston' but Winston replies (with austerity) 'Sir'. I have been hoping to hear from you altho, strictly speaking, *I* believe I owe *you* a letter. I hope youre all right & were not exhausted by your long journeys Can I have the 'head' back I should like to start on the engraving of same. It was most interesting & pleasant to hear what Ricketts had to say about things—I look forward to getting to know him rather better some day. I was carried away by the Theatre Exhibition & went as often as I could while I was in

[1] Princess Marie Louise.

London. The Press neglected it horribly hardly anything serious &
instructive has been written on the subject to my knowledge but I
understand a great many people have visited the show. Eventually I
have tried to write something myself which I will send to you if its
printed.[1] When I got back here I had a spasm of theatre designing &
have done two drawings for The Lady from the Sea, one for Hermon
Ould's Black Virgin[2] & one for myself & one for you—a grouping of the
Crier figures: parcel may be expected presently. Oh yes I did a new
drop curtain of fish & seaweed! This new lot will be added to my
rather meagre collection in I.T.E.[3] when it departs for the provinces
& the U.S.A. By the way do you know someone out there who w[d]
care to do an article on my Theatrical efforts with illustrations—one
of their many Theatre magazines might respond? I was interested by
what Basil Dean told you of his patent economical staging stunt. That
sort of thing can't be sat down under but must be met. I mean to have
a shot at contriving The 'Riding'[4] out of simplified means.

At this rate you & I will never appear on the same programme &
I'm quite determined we shall! I may be meeting Sybil Thorndike
this summer & shall so to speak rub her nose in the Crier . . . One of my
latest joys is the discovery of Martin Shaw's[5] music—do you know any
of it? He has done settings for 'The Dream' & we compared notes to
our mutual delight—its quite clear we must find a manager! By the
way my Dream designs are much improved now—I wish you could
see them—*heaps* better. Here we are given over to rough weather—
storms, squalls, downpours and general debility & are awfully tired
of it. I had the good fortune to sell a small painting in the New English
& now there are no more opportunities until the Autumn. I suppose
Withers is not likely to buy a drawing these days? What a dear man
but how stricken! Our great love to you & dear Emily

[1] Nothing is known of this article. PN had previously published one on the exhibi-
tion called 'Bad Plays, Bad Art' in the *Evening Standard* (21 June 1922). This letter
cannot possibly be dated before that as the Princess's letter is dated 30 June.

[2] Among the illustrations to GB's article, 'The Theatre Work of Paul Nash' (*The
Theatre Arts Monthly*, January 1924, pp. 38-48) are two settings for Ibsen's play and
one for *The Black Virgin*, said to have been a 'storm centre of discussion' at the Inter-
national Theatre Exhibition, London. The article is short and not of much moment.
It deals with PN's origins and keepings as a stage designer, and praises his work.

[3] The International Theatre Exhibition was held at Amsterdam in January and
February 1922. It was at the Victoria and Albert Museum from 3 June to 21 July 1922.
Besides the models for *King Lear's Wife* and *Gruach*, PN exhibited the costume designs
for *King Lear's Wife*, designs for a drop curtain, for J. M. Barrie's *The Truth about the
Russian Dancers* (including costumes) and a scene called *A Platform facing the Sea*. See
Letter 212. [4] *The Riding to Lithend.*

[5] Martin Shaw. Born 1875. Founded, with Gordon Craig, the Purcell Operatic
Society (1899), co-founder of the League of Arts (1918).

160

GB to PN *11 July* [*1922*]¹

Beato Fra Paolo,

Do forgive me. I couldn't help it. But all the same I am sorry. The parcel arrived at Silverdale, and as no parcels were being sent on to me my Father opened it and extracted your letter and sent it on to me at—Lord, Lord, Lord, I don't know where I was when he sent me your letter. But I could never get a minute of time to write, and the longer the time went on the more I was in a whirligig of events that left me without energy: I arrived home only a week ago, and now I am recuperating in bed and striving to catch up with myself. So *do* forgive me.

.

I was afraid you would be wanting the drawing, but I was also afraid of sending it without adequate packing, and I couldn't get any until we reached home. However, here it is now with my love, and I hope it will reach you safely. When you come to the engraving, do you think I might have a mouth? I am so rarely allowed to have a mouth; and I do long for one.

I think we have come off as well as any one in the notices of the Theatre Exhibition: the Mrs. Lear block was in The Sketch on 7th. June—and doesn't it look superb in the catalogue.

By the way two points suggested themselves to me when I saw the models with their proper illumination: (1.) when you repaired Mrs. Lear you set the King rather more sideways, so that in a frontal view (and especially in the catalogue block) he looks more like a monolith than a man and his lovely clothes don't tell as well; and (2) I noticed for the first time that in the Gruach model the servants' steps (in the low entrance at the right) go up; but my idea always was that they should go down, so that the servants would seem to emerge from the cellars and entrails of the earth. But how lovely those models looked with their little bulbs; they entranced me and I couldn't keep away from them but returned again and again. The "Gruach" in particular seemed to me ten times more tremendous even than before, with the proper lighting.

I went to the Exhibition as often as I could, but had not time or strength to do more than half see it. I think I was most impressed by the Americans—not because I think they come off, for they often don't, but because they are experimenting and trying things and keeping their minds open and doing everything that no one here will give us a chance to do. It is sickening, for if anyone cared, we could do more than the Americans can do; but they work in an atmosphere of

¹ Dated in error, 1920.

sympathy which is denied to us, and something is going to come of their innocent fumblings while we are still bound hand and foot.

How thrilling about the Princess: we felicitate you. I have wondered several times if it has been these two models which have put her on to your track: one can imagine how the regal mind would work—"O look at these dear little rooms; aren't they *too* sweet; of course they are the very kind of thing for *Mamma's Doll's House, and just the right size too!*"

I loved your story about Winston: don't you think his severe "Sir" rather makes him top dog after all?

Of course I am enormously pleased to hear of your "Crier" grouping, and I very much hope you will be able to let us see it and the other new drawings before you add them to your exhibit for America.

What exactly do you want with regard to an article on your theatre-work in an American magazine? Had you thought of sending a set of photographs along with an article from here; or do you want somebody to go and see your exhibit when it reaches the U.S. and do their own photographing and writing?

I imagine the Theatre Arts Magazine[1] might be inclined to listen to a suggestion from me, and I am open to make one if I knew what kind of one to make.

I'm enormously pleased to hear of Martin Shaw making music for you: I remember being impressed by his music for Craig's production of Ibsen's "Vikings" twenty years ago, but I haven't heard much of his since except his nice saucy songs from Uncle Remus.

I wish you good luck with The Crier chez Sybil Thorndike; it is so short she could make it into a curtain-raiser with almost any pro-gramme. . . . I would trust her with it, though I have only seen her once and in a very different kind of part—in an amusing farce "Thirty Minutes In A Street" in which she depicted an elderly lady who was refined, sensitive, aesthetic, delicate-minded, shy, retiring; and her petticoat was coming down. It was a gorgeous performance for richness, subtlety, variety, suggestion; she must be pretty nearly our best living actress, and on the strength of it I am ready to believe that she would be superb as Lady Macbeth, Lady Teazle, Rosalind, Cleopatra, Beatrice, Hilda Wangel, Millamant, Smike, Puck, or The New Magdalen.

I hope your article on the I.T.E. will get itself printed, so that I can read it.

Well, Ricketts expressed himself in an unusually friendly way about the model and about you. He says frankly that he cannot endure the young school of painters, but that he has never been repelled and annoyed by you and Jack as he has by the others, and has felt charm in you although

[1] *Theatre Arts Monthly.* See p. 148, n. 2.

he also feels that you obscure it by recipes that do not belong to you or your subject-matter (I don't think he meant by that a simple criticism of your attitude to representation, for he praised especially your treatment of the rushes on the floor in the Mrs. Lear model). The main thing was that he went out of his way to express himself kindly about you, and as he is an extremely generous-hearted man as well as now a potent one I think he might easily be very friendly to you if he thought you were responding.

.

We had a great time with Stanley S.[Spencer] at Petersfield: what an active little volcano he is, an amazing little fellow, and a painter after my heart. He has an amusing thing of the Last Judgment, with people pushing up the grass to get out of their graves. I feel he is not always secure yet in the realization of his textures, and not always able to keep his conceptions ripening long enough before he fixes them; but if he goes on he should be one of our greatest English painters.

What a lot of things I have done since I saw you. Had I been addressing the students at South Kensington when last I wrote to you? There I was at any rate, making a speech for the first time in my life and in an unplumbed funk about it, and all because the irresistible Will had willed it; and there was he listening like a gentle and loveable Rhadamanthus, and for all his gentleness and loveableness I felt that Rhadamanthus was weighing me in his balances—and of course I couldn't help feeling uneasy about the result.

And then I saw Craig and envied him his noble voice. And then we went to Petersfield. And to Holmbury. And London again, where we saw a lovely play—Spanish Lovers[1]—at the Kingsway, a lovely play and perfectly acted by unspoilt young people; and real Spanish dancing in it, which is the kind of dancing I like most. And then we suddenly found ourselves in Oxford again, on our way home, for four hours to see the OUDS do "Le Bourgeois Gentilhomme"; and then "Don Giovanni" in Birmingham (where that galleryful of Rossetti drawings nearly broke my heart with longing); and then home, and I am out of breath merely with writing about it all.

I very much doubt if Withers is likely for a drawing just now, although he talked of it years ago; for his investments have been doing exceptionally badly lately, and I know this has hampered him in a good many things he wanted to do. But I shall not fail to tell you if he mentions it again.

Our love to you both, and we hope Dymchurch is doing its best for you again.

[1] Play in three acts by J. Felin y Cordina, adapted from the French by Christopher St. John, music by H. M. Jacquet, founded on the popular airs of the Province of Murcia. The run of twenty-eight performances ended on 15 July.

The Sheiling, Silverdale, Near Carnforth
6 September 1922

GB to PN

Caro Fra Paolo,

Why don't you write to me, confound you?

Have you got so wet through Under The Wall this incomparable summer that your fingers are too sodden to retain a pen between them?

Or is it that you have written me innumerable letters—as many as you ought to, in fact—but that the rain ran over the eaves-troughs and down your pen so continuously that your letters were writ in water literally, and when they were dry were so invisible on the page that you forgot all about them and wrote other letters on the top of them?

Or has Bunty got her loom and woven you into some fabric so you can't get out again—so that you are two-dimensional like a figure in a tapestry; just in the same way as the man who saw an open door in a Chinese picture and one night walked through it and inside the picture, but the painter saw him do it, and immediately painted the door shut and the man couldn't get out again. It would be an appropriate end for a real Cubist to be thus transformed into a two-dimensional being; indeed, it would serve any Frenchman right just now, for their national mind has only two dimensions—length and thickness without breadth —; but you are too good for so dread a fate, and I shall if necessary implore Circe-Penelope-Armida-Morganlefay-Bunty to unweave her web and let you out again.

But the long and the short of it is I want to know what I am to do about that Yankee theatre magazine. Here I am waiting to know what you think of the esteemed proposition I made you in my last esteemed letter: am I to nurse and be attentive to the young woman who associately edits that magazine and writes me blandishing letters, in order to make sure she will take notice of your work when the Theatre Show reaches Ammurrica: am I to offer to write a note on it myself: are you going to tell me what line you would like me to take: are you going to let me see what you yourself wrote on the Theatre Show? I shall have to write to her sometime: I can't put her off for ever: the door will not stay open of itself indefinitely. Sleeper, wake! You did verily ask me if I knew anyone who would pat your head publicly in America: and *there* seemed the chance to hand. I hope it is still there.

.

I have a new poem 4 pages long for you to insert in your copy of K.L.W.;[1] but it is bad to pack, and I waited to send you it until I

[1] *King Lear's Wife and other Plays*: see p. 157, n. 2.

could enclose it in the packet of drawings of The Crier, Lithend etc. (which you are doing to add to the show when it goes to America) when you send them to me to look at and I return them with practical and praiseworthy promptness.

I enclose a prospectus with news of me. Pray for a good November like last year so that I can go and see my own play.

Emily joins me in sending love to you and Bunty.

162

My dear Poet

I deserve all your reproaches & cannot think how it is I have lagged all this way behind. I see your last letter is dated July 11. My God! It begins: 'Do forgive me—I couldn't help it. But all the same I'm sorry'—so you must have done something fairly awful—which I can't remember—and altho. I could have helped it I suppose—do forgive me & I'm dreadfully sorry! Yours was a lovely letter as always—but perhaps even more so than usual & I believe this impressed me & I have been subconsciously accumulating strength & wit for my reply Picture me a temporarily silenced battery hunting about for more ammunition before I raise my head & have a return shot. First to deal straight with a few questions . . . Yes you shall have a mouth when I come to engrave you but you must either get Emily to draw it & send it by post or you must get a looking glass & draw it yourself while Emily

holds your beard back, or else you must send me a photograph of your mouth—as I have no positive record myself.

I am mighty glad you feel we did well at the Theatre Show—I dont see why my sanguinary Press agency couldn't send me Mrs Lear in the Sketch of the 7th June. I think you are quite right about Lear looking like a monolith but I got a distaste for his clothes when I repaired the model & so rather turned him round & then he looked odd & I tried to mend him & in the end he just looked odder. I'm fearfully sorry about the servants quarters, how silly of me. We must put that right before the model goes into whatever National Collection eventually acquires it!

You're right about the Yanks—you see Gordon they have these swell popular theatres over there but beside they seem to have a slim concentric circle of little playhouses where art is cherished for its own sake and their producers & musicians & designers are experimenting all the time. In England we're all wrong—all the time & money goes on trash & the artists remain outside the theatre (see The artist outside the Theatre by Paul Nash. English Review enclosed!)[1] And then my dear boy *have* you ever read a paper called the Stage? I am sending a rather amusing little correspondence & a letter from Craig—but it does give you an idea of a large mass of English Theatre opinion towards anything which is beyond their Ken. Be a bearded archangel & send back all this stuff. All you tell me of Ricketts makes me anxious to meet & know him. Perhaps he would consider inviting me to go & call on him when I am next in London I have never yet been into his treasure-house & have always longed to. I am afraid I am a little unsympathetic about S Spencer. I used to admire him inordinately & believed him to be the real thing with all the right inheritance of the fine qualities of the mighty & something perfectly his own which caught one by a strange enchantment. and then and then—and now—Did you ever see his Slade competition pictures & the Apple gatherers—and its drawing & a drawing something about Don John? Poor Gordon addressing the Students in an awful dither. But I expect you gave them lots to think about. I have just associated myself with a 'push' called the League of Arts *not* the Arts League of Services by the way—they have a small stage which I froze onto & we have formed a dramatic group—Edie Craig[2] producer, Martin Shaw musical director—myself scenic designer. We mean to get an amateur dramatic society & produce plays by English authors as much as possible. There is one 'snag' I fear,—Pearcy Dearmer[3] who doesnt like your Crier which I put forward as one of the first we should like to do—he prefered Laodice & Danaë & we may ask you for permission to do that—I dont know *yet*. But do

[1] *Theatre Craft Supplement*, August 1922. [2] Edith Craig (1869–1947).
[3] The Rev. Percy Dearmer (1867–1936).

wish us luck. Its a great experiment & may give us all kinds of fun. I'm most thrilled by the Vic. doing Britains Daughter—how I wish I could

have had the chance to design costumes & setting. Lithend, I fear, has not yet matured—literally I have not been able to give the time to tackling it but it shall be done. . .

I have a new job which keeps me alive for a bit. Lawrence of

Arabia is writing a book on his campaign & all sorts of artists are providing him with drawings to illustrate it. To me he has offered the task of providing the landscape part of the book—all to be designs made from his photographs.[1] It sounds awful but having seen the photographs & reading Doughty's 'Arabia'[2] I think its going to be great fun—what a place! Petra the city of the Dead! O what a dream! Lawrence is of the salt of the earth & I know he's doing much of this simply to help painters who find a difficulty in *affording* to paint. You shall see some results a little later. By the way the picture he bought of mine—a coast scene—is now in the Tate after a terrific resistance but Aitken[3] likes it & seems inclined to keep it indefinitely! Poor Dym is swamped not with water but people, O what people, I almost wish the sea would come over the Wall & drown the whole bloody lot.

Sunday—Eddie is staying at Lympne & Sassoon[4] has invited Bunty & me to lunch! I rather think he has a great collection there which I am looking forward to seeing. This more or less exhausts my news— except that I have hopes that Heineman is going to bring out a book of my wood engravings & I have been trying to write sort of prose poems to accompany them—and am feeling uneasy over 'em & shall be bothering you soon with specimens & an S.O.S. for your kindly advice. Oh lord what about the Theatre Arts Magazine. Well, I didnt quite know what to ask for but now you have made such a sweet offer I feel very tempted. You're a dear, Gordon to suggest this. Of course of all things I should like a note *by you* but is that all right do you think? not back scratching? not 'not cricket' nor hitting below the intellect or 'not done' or any of those things? After all it's the poor what 'elps the poor' as the old song says. Of course I think it would be grand so if you really feel inclined—there you are. I send all my beastly designs & bits of odd information. Withers wants us to go there at the end of this month & I hope we may tho' the end of this month is rather obscured at present & funds for extra expenses are lowish.

Our united & devoted love to you both from Bunty & me

[1] The special edition of *The Seven Pillars of Wisdom* by T. E. Lawrence (1888–1935) was ready for private circulation in 1926. There were only five designs by PN, although seven are given in the index.

[2] C. M. Doughty (1843–1926). *Travels in Arabia Deserta*, 2 vols., 1888.

[3] Charles Aitken (1869–1930), Director of the Tate Gallery (1917–30).

[4] Sir Philip Sassoon (1888–1939).

163

GB to PN *19 September 1922*

Caro Fra Paolo,

Parcel received with empressement and delight, gutted, enjoyed, assimilated, and perpended. I should have returned it before but for distractions—the weather has taken a turn for the worse and is not expected to last long (I should think you live at Dymchurch-under-the-Marsh by now: it should be a wash-out for the trippers), my lung is sore with the damp, my liver is sick with a putative gall-stone, I have taken to bed. There is an alleviation underneath in the shape of Bob [Trevelyan] in the book-room, and when I hear a long low rumble I know he is all right and translating Æschylus;[1] but I don't get on with my correspondence, so I have kept you waiting as usual.

However, here now returns the part of the cargo which you want back; I like your point of view about the Show, and I like your writing always (send me your prose-poems by all means), and these articles give me just the kind of start I should need for an American article. Your pictures in the E.R. attract me too: there must have been something unsettling for Mr. Mapleson when he realised that trees might be made of wood; the chances for lighting are lovely. Your new sea-platform scene (I fancy you are beginning to feel that you never, never will desert Mr. Micawber) is, I think, the best of them all, and very vividly the thing itself; I love your wooden waves; your curveophobia causes me no discomfort. But I confess I have a criticism: I felt really scared when I saw you continuing the perspective on a backcloth: it was the dodge dearest to the hearts of the stage-realists; Sir Erbert Tree always fell back on it when in doubt. I suppose it only proves that you are a more daring innovator than I: to reinvent a back number is the ultimate proof of originality.

It really does look original, and I was a long time before I remembered that I had seen something like it in the 17th. century: but really and truly I would rather have a built-up and artificially foreshortened perspective of planking. I know one *daren't* walk about in an artificial perspective; but then one *can't* walk about in a painted backcloth; so that things which are equal to the same thing are equal to one another.

I am enclosing the money for the prints with this, with many thanks for your bothering about them for me. And I am also sending the poem[2] for insertion in the "King Lear's Wife" volume, as the magazines will

[1] His translation of the *Oresteia* was published in 1921 and reissued in 1923.

[2] 'To Clinton Balmer and the dear memory of James Hamilton Hay for the summer of 1900 at Cartmel'. It was first printed in the second edition of *King Lear's Wife and Other Plays* (1922) as a dedicatory poem to *Midsummer Eve*.

pack it nicely. It goes in after the "Midsummer Eve" half-title and before the poemless dedication in the same words.

(I know you won't ask me, as J. Drinkwater did, if there is a line dropped out at the top of the last page; but anyhow I will take this opportunity of assuring you with my hand on my heart that to the best of my belief and knowledge there is not.)

"Have I ever read a paper called 'The Stage'?" Do I remember a Queen called Victoria?

My chee-ild, thirty-one years ago I read 'The Stage' every week, and believed all it said. From this you can make a positively mathematical calculation of the distance I have travelled in the time.

Of course, as it is the journal of the theatre-trade it was bound to be the last quarter for the theatre-art to be heard of or noticed in; just as the journal of the painting trade 50 years ago was the last place to hear of Whistler's Peacock Room.[1] And such a journal is bound to shew incredulity and alarm when it is told that it isn't covering the whole ground. . . .

I was thrilled to read your cutting about the 'Benn' Shakespeare being so near issue. I do wish you would send me a prospectus when you get one. And I do hope the price isn't going to be ruinous.

I was interested to see Lowinsky[2] is in. Do you know much about him? Will once praised him to me, and I have just seen one picture of his (which I loved), but I can't hear any more about him.

P-p-p-p-p-p-paul, we don't agree about Spencer (Stanley)! The little volcano is capable of amazing things, and in my opinion is getting better. That drawing of "Apple-Gatherers" which you reproduced was my first glimpse of him, and it captured and enraptured me at once; but the painting of it at the Tate repelled me, and I still dislike it passionately and profoundly. His Slade "Nativity" in the same room, and the war-picture in another room, attracted me much more—indeed, I thought both of them first-rate—but his picture at this Summer's N.E.A. seemed to me a prodigious advance. It was unequal, but I thought all the right-hand side came off superbly and shewed an understanding of the use of paint on the monumental scale which has been lost since the early Italians. And a sketch for a church decoration of the Last Judgment—frightened little people pushing up the grass lids of their graves—which he showed us at Petersfield impressed me still more: it was as good as the best of the Lorenzettis at his best.

He also shewed me some really marvellous portrait-drawings by his brother Gilbert.

I think it should be all right about the American magazine: it will all be above-board and signed with my name—so there should be no

[1] Re-erected, in 1920, at the Freer Gallery of Art, Washington, D.C. (See Publication 4024 of the Smithsonian Institution, 1951.) [2] See p. 139, n.

suspicion of "back-scratching", even if I urge them to reproduce the blocks of our models. Anyhow, I will Approach the lady as soon as I get a chance (next week, perhaps), and be altogether above-board with her; so that she and the rest of the editorial board will decide and take the responsibility.

You don't say if you want back the "Lady from the Sea" photographs, so I will keep them until you draw your pistol. They please me very much, especially the one for Act II which I hadn't seen before.

You ask me to criticise the Crier drawing, so I will. I do not dislike it one bit: it pleases me greatly: in fact, in fundamentals and essentials it satisfies me completely. Blanid is everything I could want, she is as good as Rossetti could have done at his best: the Crier is nearly as good, but he is a mortal and not equal in conception to the terrifying little immortal you evolved at that first shot long ago. The masses of the room are first-rate but the illumination seems to me too great for dying firelight—only Blanid's body should be as bright as that. In detail the room suggests to me a modern workman's dwelling of the lath-and-plaster type, finished with machine-ripped deal boards: it is not remote, it does not evoke another age. The Norseman's hut would be built of great logs of wood, roofed with huge rafters (squared with the adze) and shaggy with thatch—window frame, doorposts, table and settle would have touches of twisty carving on them, and everything everywhere would have the character of having been done by men's hands, and would lack machine finish.

I'm sorry about the mouth, but we don't feel equal to drawing it and it doesn't seem to be in photographs to any extent; so you had better give me the kind you would like me to have. Your drawing of the situation, and the other one of me at S. K., are heartfelt expressions which we cherish. Will really sat just there and looked just so.

What august people you are, going to Lympne like the French prime-minister. I hope it will have worn off before next I see you, or I shall feel uncomfortable. Is Sassoon as beautiful as Max's picture of him? And is his collection a good one?

.

I think that is all, except The League of Arts; and to The League of Arts I send my benediction and assurances of my most distinguished consideration. Of course I will stand in with you and do anything and everything you want me to do: "You shall do as you like with me", as a matronly lady sang in a comic opera when I was young: I will even join The League of Arts

(α) If you would like me to do;

(β) If it would be more convenient, and also good for me;

(γ) If the L. of A. would like me to, and whether or not if you would.

Of course they shall do "Laodice and Danaë" if they want to. I always thought nobody would ever want to; and I chuckle enormously at the thought of it (of all my plays) getting to performance because somebody prefers it to "The Crier." It's all right, my dear; Penelope Wheeler and others are after "The Crier," but no one ever asked me for either Laodice or Danaë before, and may never again; so give Percy Dearmer his head in God's name, and let us praise God for his freak of judgment.

I do wonder why he has taken against "The Crier." You can never tell with the clergy: they often go for the right thing, sometimes because they are angels of light, oftener for some wrong reason; when they go against the right thing it is sure to be for a wrong reason.

By the way, Edy Craig wouldn't accept "The Crier" for the Pioneers when Florence Buckton[1] wanted her to do so three years ago; so perhaps her opinion is behind P. D's?

Anyhow she is first-rate, and I would trust her with anything of mine that she might want to do; also you. "L. & D." ought to look Baksty[2] and gorgeous.

With our love to you and Madonna Margharita,

164

PN to GB

Dymchurch, Kent
9 November 1922

My beloved Gordon

your delightful letter of Sept 19. to hand! I have meant to write so often and not done it and so many, many things have happened to tell you of since then that now I cannot regret it.

Did I never even write to thank you for the money for the prints —Oh dear.—and thank you very much. The poem is charming it is one of my greater ambitions to incur a dedication from Gordon but I cant think what to do to deserve it. Certainly I can perceive nothing dropped out at the top of the last page—how foolish of John. John has just given me his Preludes[3] all about himself, poor dear, and his lady But its rather dreadful, I can't quite get warm over them. They are beautifully worded but, but what is it? Am I quite insensible or has J.D not 'brought it' off altogether? So you knew The Stage *and* Queen Victoria! well you neither look nor sound like it Gordon.

...As to Benn's Shakespear, my dear, you'll never see it unless youve got a rich uncle who has to collect it. You have to subscribe for the

[1] See p. 84, n. 1.
[2] Leon Bakst (1868–1924), painter and designer for the Russian Ballet. His 'gorgeous' *Sleeping Beauty* was mounted at the Alhambra on 2 November 1921.
[3] John Drinkwater (1882–1937), *Preludes*, 1922.

whole lot 37 is it (?) plays at 3 guineas a piece. Of course its absurd & no good to anyone but there are whispers of a cheap edition and I believe my contract says something about me having a copy or so to myself. Lowinsky is a Florentine PreRaphaelite modern with an interminable appetite for detail, an amazing technique and some vision. I dont know which side up he's coming out because Ive only seen a little of his work but sometimes he is very interesting. As to S. Spencer we dont *quite* agree but I have a great respect for the 'little volcano' & used to pin my faith to him but it would have been better for him and us if he hadn't been born behind his time—what a stunning PreRaphaelite he'd have made. I can just picture him in the Rossetti circle!

A thousand thanks, dear bard, for such good offices with ladies of American magazines[1]—its really tremendously good of you to do it for me— and I'm relieved to hear we shall be above board with the ladies' board.

Thanks too for perfectly sound criticisms on Platform at dawn & Crier drawing. You're damnably right. For your relief, let me tell you the background was meant to be constructed—lightly—in the 'Platform' —not painted as at first conceived. And, yes, the 'Crier' has missed it but we'll pull it off yet. Margaret made the same objection as you before you wrote! But I didn't realise the interior was so fearfully wrong —I do now.

I say Gordon & Emily theres a whole book coming out next Spring on your little friends work![2] 34 half tone reproductions! The Benn Bros are doing a series of monographs on modern English Painters & Albert [Rutherston], who has been asked to edit, has invited me for one of the first lot. The others are—with the exception of Will, the heavy populars—to carry Will & me along—John, Clausen, Nicholson, Orpen —I'm not sure about Steer—I think so. Each bunch contains a young 'modern' surrounded by the arrived and accepted of men. Isn't it fun. England, at last, seems like doing her duty—or what every other country has done years ago. I have just been in Town collecting my things for the blockmakers and they are now ready. Another excitement is that the book of engravings—just completed—will come out before Christmas with Heinemann's[3] I wrote the prose poem pieces, Gordon, in a white heat of stress worry & hurry & I dont believe I should have ever got 'em written under any other conditions. You shan't see them until I send you the book with all complete. It is likely I do a book with F. M. Heuffer [Hueffer]—he wants to, his poems & my engravings, I should like it extremely as his verse pleases me a good deal.[4] So you

[1] This article, often mentioned in later letters, was for Miss Edith J. R. Isaacs of the *Theatre Arts Monthly*. See p. 148, n. 2.
[2] *Paul Nash*. Introduction by A. B. [Anthony Bertram]. Contemporary British Artists Series, ed. Albert Rutherston, Benn, 1923. [3] *Places*. See Letter 146.
[4] *Mister Bosphorus and the Muses or a Short History of Poetry in Britain. Variety Entertainment*

161

see we are full of larks & there'll be lots to show you soon. I haven't forgotten your drawing but I am just carrying out a new set and rather think you would like one from it more than any of the ones you saw last Winter—why not come & choose one—what about Spring—early spring, on the Romney Marsh? Always ready for you if the room isnt filled. Our devoted love to you both

165

GB to PN *30 December* [*1922*]
Paul,

There's a blasted idiot of a web-footed Dutchman who lives in a country of mud without a horizon; and in his expensive Theatre Show number of a double-Dutch-demi-cream art-magazine he has reproduced three of your dear delicious costumes for Mrs. Lear AND said they were done for Shakespeare's Lear. The thing will go all over Europe and I am sick to think our names might have gone with it together— and here I am left out. When I first saw it I was in a bloody mind to go to his vanishing fatherland and take his valueless life.

Can you do anything about it? I suppose you are in touch with him, so can't you bite him and make his days a discomfort, and make him print an elaborate apology in some future number—a statement of all the facts and his Batavian bumble-headedness?

If you could do something of the kind I would write sim-ul-taneous and worry him about the ankles; but it wouldn't be much good my writing alone, as he wouldn't believe me.

You don't know how badly I have treated you, and I daren't begin to tell you to-day. I was taken ill in London, and had to run home, and can't write much at once yet. I had your jolly letter just before we left home, and I meant to write from London. The American woman wants the article and lots of photographs.

Our love to you both and New Year wishes.

166

Dymchurch, Kent
PN to GB *31 December 1922*
My dear Gordon

our many many thanks for your new book. how charming of you to send it.[1] The idea is a very pleasant one which I should have enjoyed

in Four Acts. Words by Ford Madox Ford, music by several Popular Composers. With Harle-quinade, Transformation Scene, Cinematograph Effects, and many other Novelties, as well as Old and Tried Favourites. Decorated with Designs Engraved on Wood [12] *by Paul Nash,* Duckworth, 1923. [1] *A Vision of Giorgione*: Constable, 1922.

illustrating or decorating. One cannot read it over without being impressed by the atmosphere it creats so successfully and one becomes lulled into a sort of odourous & musical trance in which one experiences vaguely delicious sensations. It is full of colour too and sweet drooping lines. I feel I am dozing under a laburnum bush with an agreeable companion decked in a deep rose dress of silk while somewhere near—probably up a tree—someone is playing Chopin nocturnes on a clavichord!

I prefer, you know, as poetry

> O shepherd out upon the snow
> What lambs are newly born—[1]

which to me is one of the best things you or anyone else ever wrote. And I prefer also for subject your later gropings into the darker, further ages of the past in which you seem to go so far down that you come out the other end—which is *now*. To me the Gruach & some others touch more nearly the modern sympathies than all the rest you have done. I never got impressed by Britains Daughter[2] for instance & was always slightly sorry that of all your plays it should be selected to be produced to so critical an audience as the Old Vic. Fine as the verse is surely it is a play to read not to act. In fact its about the only one which *wont* act I should say. I hear the limited staging conceptions of Atkin[s][3] made an awful mess of the departure of the galleys. Oh dear I've been awfully unhappy about Britains Daughter! I look forward however to Gruach. It should go well and Basil Dean is very intelligent. Good luck to it. I am sending you a little later my book in retaliation—Places. Ford Madox Heuffer [Hueffer] has already told me what *he* thinks of the prose pieces & I confess I quite agree with him. But if they are largely nonsense they are more or less decorative nonsense & as their original use was for a decorative purpose they have this excuse. Heinemann's have done the book very well & in a certain way I am pleased with it—I hope you & Emily may be pleased too. Margaret & I send our love and all good wishes for a new year

[1] The beginning of GB.'s lyric 'In January'.

[2] *Britain's Daughter* was performed for the first time on 20 November 1922, at the Old Vic, in a bill with Massinger's *A New Way to Pay Old Debts*. A later production (1927), and more to GB's taste, was that by Tyrone Guthrie for the Scottish National Theatre Society in Glasgow.

[3] Robert Atkins (b. 1886), director of the plays at the Old Vic, 1920–5.

Dymchurch
New Year's Day 1923

PN to GB

My dear indignant Bard

here's an attempt to console you and I hope it wont bring on another fury.

I will bastinado the Dutchman all right and see if we cant get him to reproduce more costumes of your plays with an apology for the awful error issuing out of each ones mouth.

I am fearfully glad about the American woman—what photographs do you want & what have you already got, if any? We go to London for a bit tomorrow address. 176 Alexandra Mansions—Judd St Bloomsbury. W.C.1.

Love from us to you both. in haste

Dymchurch
[PM: 2 January 1923]

PN to GB

Its a grand frenzy Gordon and I'm sure the Dutchman deserves every word of it but W h o i s H e ? I am certainly not in touch with him or I should have flayed him alive long ago Let me have the fellows name address and the name of his magazine & he shall hear from me. I had just written to you.

P N

Very sorry to hear you have been bad again We do hope you are better

The Sheiling, Silverdale, Carnforth
27 January 1923

GB to PN

My Best Paul,

A happy happy new year to you and Bunty from Emily and me. I have sizzled in silence all this week in the delighted consciousness that you didn't know how badly I was treating you; but now that your joli book has gone unacknowledged a month, I feel you may begin to have a glimmering consciousness that you *are* being badly treated, and I'd better begin behaving.

Well. Just after your Nov. letter came we went to London for my rehearsals and were there a fortnight; and when the show was over we planned to go a-roving to Surrey and Kent—to Rye, Paul; to Folkestone, Paul; and verily to Dymchurch, Paul. But what happened was that we

struck the fogs in London, and they first put me to bed for half a week (from which I emerged only for my first night), and then, when we had started our travels, smashed me up at Hambledon (which is in Surrey), and after a week in bed there was nothing to do but run home. And I am only reviving now. I was a beast never to tell you we were so near, when we might have met even in London; but in London I was harried every minute, and I thought it would be all right when we should meet so soon. Pray make excuses for me, and let us hope I shall behave better when we go up for Gruach.

PLACES arrived safely and gave us great pleasure, both for its exciting self, and its testimony that you continue in favour with publishers, and because it makes us happy to feel that you had been thinking of us when your book came out.

I hope it is succeeding: but whether it does or not it will bring you still further reputation. We treasure the inscription[1] with its happy reminder that we have assisted at your progress from the first, and we thank you from our hearts.

And of course we love it because it contains your vision and your genius, as well as your increasing skill and virtuosity in wood-cutting. You know I don't believe in your denial of nature, and that I do believe it will hamper and obscure the appeal of your genius to future centuries that will not be so *au fait* with the moods and fashions of our moment as we are, and that while we live on earth there is a deep inner necessity upon us to express our sense of the rhythms and cadences of immortality in terms of the earth; so I am not going to worry you about that any more, but only refer to it to say that in this book I prize most the designs which are built on your marvellously fresh and vivid and tender observation of nature—and especially those with Bunty in, as you can't ever be ungracious to nature in her. So that my favourites are Winter Wood, Path Through The Wood; and then Winter, where the terms of your symbolism are happy and tender, and your textures so rich. And of your proses I like best the ones which accompany these blocks, together with the one for Black Poplar Pond. I like them a good deal—partly because they remind me what a good writer you have inside you if he hadn't had to take second place, and what dear delightful verses you used to make; but also for themselves. They have a beautiful close texture, and the right vivid feeling for words. I don't know what Hueffer[2] said against them; but he is usually fundamentally unsound, and when he is right it is for a wrong reason; and it seems to me the only things he could say with any validity would be that they

[1] 'To/My dear Gordon & Emily/from their young protégé/Paul.' The copy is now in the Aberdeen University Library.

[2] Ford Madox Hueffer, later Ford Madox Ford, poet, novelist, and first editor of the *English Review*, which began in December 1908. See Letter 164.

seem a little done on purpose, and that it is hard to give simply descriptive prose any other purpose. But having said that he ought to add that they are even swifter and clearer in vision than the engravings they accompany; and they give similar flashes of your rich and vivid world which I am always content to inhabit.

I like too the script in which you have lettered them; but you will have to think out an equally convincing system of capitals for your title-pages and covers.

And now I'm anxious to have Benn Brothers' book about you.

It is nice of you to say you will take the Dutchman in hand; I didn't suppose for a moment that you knew about his heart-breaking muddle-headed bungle, but I took it for granted that he would have been in touch with you when he was getting leave to reproduce your work, and that in consequence it would be easy and natural for you to reopen things with him. I hope it won't be difficult, in any case; for I confess I ache to have it corrected, and to have the pleasure of public association with you; for his absurdly expensive magazine goes all over the world. . .

Across the top of p. 20 are three large upright reproductions in a row of your costume designs for my

<p style="text-align: center;">Gormflaith King Lear Goneril</p>

and the false and scoundrelly description beneath them is "Drie Costumes Ontwerpen voor Shakespeare's King Lear ▢ Door Paul Nash (Engeland.)"

I suppose DOOR simply means "by". Lord, what a langwidge.

Well, on hearing you have written I shall follow it up with a dignified but not ungentlemanly complaint off my own bat. If you can get him to re-reproduce them with perhaps the other ones as well, as the only adequate apology, it would be a triumph of diplomacy, statecraft, and usefulness.

<p style="text-align: center;">. </p>

I liked very much what you said about my Giorgione book. I daresay than [that] in my heart I too care more about "O shepherd out upon the snow" than about those Southern langours; and I fancy I came North for good about the time I first heard of you.

But all the same I hold that poetry ought to include both Giorgione and the shepherd (Giorgione painted more than one shepherd, by the way)—and that I must be free of Juliet's garden as well as of the Blasted Heath, Juliet's bedchamber as well as Lady Macbeth's.

And most of the shy little book was done twenty-five years ago. I fancy Italy did not mean the magical things to your generation in its youth that it did to mine, and that so my book will never again mean to anyone just what it meant to me.

166

You are a nice dear delightful thing for being unhappy about Britain's Daughter, and I love you very much for caring so much. I'm afraid the press notices dejected you; but it doesn't do to pay much attention to them or the illiterates who write them. They don't know what they see or what they hear; and poetry baffles them, except in Shakespeare where they know what is coming all the time.

The play never had a chance: there were only 3 full rehearsals, as all the time was given to the other (much too long) play given the same night. Then mine came at 10.30, when the other play was over, and everybody was ready to go home. The end fizzled because the crowd was not big enough to keep up the necessary movement; the galley was all your friends said; the mad girl was inaudible and made a hole in the play every time she appeared.[1]

The lack of rehearsals was the worst: all the sections went very nicely, but there was no chance of getting them moving altogether. The play is over-written, as all poetic plays are; by the time we reached the dress-rehearsal I was just ready to begin on it, but there was no time left.

In spite of all, I enjoyed it and found it was just the kind of play I like: in the second week it was put in the front of the bill, and I made several cuts. I am told it went very well then—but the critics weren't there then. And if they had been they would have said they didn't like it because it was tragic. In Germany or Italy it would have been a success.

"Gruach" won't do any better. Basil Dean has it for his Playbox: I tried to find an opening for your mounting, but I hadn't a chance— the artist "on the strength" is doing it, as I feared. But it won't matter, anyhow; it will get 6 rehearsals, and poetry needs sixty; and then everybody will say that poetic drama is dead. But it is only the trade theatre that is dead, dead because it has learnt to exist without poetry.

I must stop and get my lunch. We send seven pocketfuls of love to you both.

.

170

From PN to GB, no heading [*end January 1923*]. He thanks GB for his 'noble letter'. He answers about material for reproduction in the American article which GB had raised in the last letter, in a passage which has been omitted.

[1] '. . . the whole production was wrong—unintelligent and unsympathetic' (*Letters from Graham Robertson*, 1953, p. 97).

171

From GB to PN, Silverdale, 9 February 1923. He tells him that the Scottish National Theatre Society of Glasgow are 'going to do *Gruach* on March 20th for five nights' and that they are 'friendly to the idea' of using his setting, but they want to know if he is expensive 'as they are hard up'. The rest of the letter gives their address and discusses reproductions for the American article.

172

PN to GB

Dymchurch, Kent
17 February 1923

Blessed Bard

a thousand thanks for your good offices I have written to the Glasgow conspirators offering to meet them half way—I have not yet heard from them but hope they wont rush me as I have much to do. I am particularly anxious to be alongside you when the curtain goes up—we have waited long for our duet! . . .

I am painting all day & every day now and have just cut out about half my unfinished canvi as they seem behind the point I have reached. You'll see some strange developments dear Gordon in the next two or three years but, I hope, for the better. Did I tell you we've got a gramaphone? I swopped a picture for it and its a duck—portable, in a little box with knobs on it. plays divinely quiet & good tone. So far our number of records is small but very select!

This is rather in haste because theres so much to get finished tonight.

Our love to you both

.

173

GB to PN

The Sheiling, Silverdale, Near Carnforth
24 February 1923

I'm afraid I'm a disappointment after all. I know what the Glasgow people have been saying to you; and I wish I could help it, but I can't. You believe I did my best, don't you? I did, really; but of course I can't dictate to them so long as I am satisfied they won't let me down; and even if I were to give them all they are to pay me it would not be anything adequate. The dismal truth is the same as usual, and they can't afford to pay much for scenery that they will only use five nights; and at bottom they want their enterprise to be a local one, I fancy. This is the first time they have done anything wanting special clothes

and scenery, and they have presented me with a *fait accompli* in the shape of a complete set of designs by one of their art-school masters; and as these are sound and unoriginal and will not hurt or obscure the play in any way I can only approve them. I fancy he is doing them for nothing.

I always go on hoping for the chance to come for us to make our appearance together; I thought I had it this time, and I am grieved to have failed again. You can be sure I shall not lose any chance by failing to draw attention to your designs as the ones that completely satisfy my requirements.

The trouble always seems to be the same; every theatre has a designer of its own. I hadn't a chance with Basil Dean—especially as the set for my play will have to be accomodated to an architectural frame that will suit other plays also.

These theatre-people depress me: wherever one comes across them they are running on tram-lines.

––––––––––

Thank you very much for the second parcel of designs .

.

One other point: the young 'oman clamours for some costume designs. Can't you send me half a dozen—a few of the Russian Ballet girls, and the first Mrs. Lear sketches for Gormflaith, Goneril, Lear, and Corpse-Washer which you shewed me at Dymchurch? I should certainly like some costumes.

We look forward to your picture-book avec empressement.

Hail to your Gramophone. What records have you got?

Please have you heard anything from The Flying Dutchman yet?

This letter would be full of my love for you, if some of it were not squeezed out by my regrets and mortification.

174

Dymchurch, Kent
PN to GB *4 March 1923*

Excellent Gordon

many thanks for your letter ... Its awful but I cant find any costumes! The tracings I made of the Mrs Lear dresses have utterly vanished—I have hunted everywhere in vain. The Karsavina ones I do not feel inclined to repeat indeed I have not time to make the drawings necessary for reproduction. I have let *you* down about the Dutchman I found out I had given general permission to reproduce my things on the form accompanying them so finding I had nothing to say I immediately & most selfishly forgot your grievance as well & forgot to tell you! Your reference the other day was a terrible shock. Do try & forgive me.

I quite understood about Glasgow & was very amused at the letter they sent you. I'm afraid one stands little or no chance as a free lance designer for the theatre of today so I think I shall share Craig's satisfaction by working for a theatre of tomorrow. Just now I can think of nothing but my painting. I think Ive got a glimmer of light at last.

We do hope you are well again my dear—any chance of a holiday in the South this year? Well dont fail to turn up for my show in May (1924) at the Leicester Galleries

Im falling asleep—so goodnight to you both

175

GB to PN

The Sheiling, Silverdale, Near Carnforth
9 March 1923

.

I am sorry you cannot do anything more about the costume-designs, as it means the article will be maimed and you will not get as good a show as you might have had. I feel something has got to be done; and as nothing else is available the only resource I can think of is the large flash-light of Karsavina and her entourage in the Truth About The Russ. Ballet [Dancers] . . . [1]

I wonder if we are playing at cross-purposes \about that Dutch magazine? I don't want you to assault the editor for printing your designs without asking you, so it seems beside the point that you have not written to him because you find you signed a general permission: I want you to praise the editor for reproducing you, and then to assault him for saying the designs were for Shakespeare instead of for me, and to require him to publish a contradictory paragraph in his next number. It would only need a short letter; and I'm really ashamed to be dogging you like this about it, and would do it myself but the editor probably would not believe me without your corroborations, as he has never heard of me. . .

You still haven't told me what kind of records your gramophone plays; but I really only asked because I wanted to know.

176

PN to GB

Dymchurch, Kent
[c. *mid-March 1923*]

thanks so much for your letter. I was away so could do nothing. I see youre adamant about the costumes so I must be good & do something. . .

[1] See p. 148, n. 3. Not used to illustrate the article.

PLATE XI

King Lear's Wife, *by Paul Nash, 1921. Pencil and colour wash,* $7\frac{1}{4}'' \times 6\frac{3}{8}''$
Probably a drawing for the model stage set for the play

PLATE XII

Gruach, *by Paul Nash, 1921. Ink and grey wash,* $7\frac{1}{2}'' \times 7\frac{1}{2}''$
First design for a model stage set for the play

I was just wondering what the devil to do when it occured to me to look in the box-room. There in front of me I found my lost sketches.

I have touched them up as well as I can. Dont send all if you think they wont look well enough but I particularly want the one of Mrs Lear reproduced & the corpus-washer.

So sorry I forgot to tell you about the gramaphone. it takes any size record 10 or 12 inch my stock consists of. double sided
Scarlatti—Mrs Woodehouse Schererezade Pachman—Chopin nocturns & foxtrots!

I hope to get a new one this week.

This is only a scrawl I shall have time to write a letter next week. Love to you both

177

The Sheiling, Silverdale, Near Carnforth

GB to PN *27 March 1923*

Your post-card found me in Glasgow, Gruaching for bare life; and when I reached home on Friday I picked up your beatific and beyond-dreaming-of parcel at the Post Office. Of course it is more than I ever clamoured for, and will do the job ideally; and there shall be bullying, exhortation, pertinacity or expostulation unuttered to the Yankees to ensure your receiving them back safely and undiminished.

I am especially and enormously pleased with the new design of Mrs. Lear herself: it is the grandest thing, at the very top of your form, and the kind of thing that goes right to my heart. The nighty is a piece of heavenly design.

Gruach in Glasgow was a dream of delight,[1] and when she came down the stair in her golden gown you could hear people catch their breaths, and a rustle of pleasure went through the house. It was all more than I should have dared to pray for if I had been a pray-er by nature; the Scotch voices are lovely, the Scotch players act with the intensity of people who are new to art and in a passion of love with it, and they got inside the psychology of my people as English players rarely do. I don't suppose I shall be in my present state of content when I have seen Gruach in London.

I admire enormously my perseverance in extracting from you some account of your gramophone records. When one has kept a gramophone for a dozen years, duplicates will accrue; so I have been looking through them and send you a bundle herewith in the hope that some of them may be things you want. They are all as good as new; for none

[1] *Gruach* was first performed by the Scottish National Players at Glasgow on 23 March 1923. Catherine Fletcher was Gruach, Robbie Wharrie played Macbeth, and Jean Taylor Smith was Fern.

of our records are overworked, and we usually play them with fibre
needles so that they don't wear. If any of them are the kind of thing you
don't like, you must be sure to tell me.

We ought to go to Cornewaile in a few days, and I'm dreadfully
rushed: so pardon me if I shut up right now.

Our love to you both.

178

Dymchurch, Kent.
PN to GB [*End of March 1923*]

Galumptious Gordon

You could not have thought of a more pleasing thing to do. Thank
you so very much—we are delighted. The records are all excellent &
much of the music new and surprising to me especially the Mendleshon
quartette. Margaret sends you her love and many many thanks. . .
I'm awfully pleased to hear of Gruach at Glasgow—I well know the
feeling of such acting & how unlikely, alas, you are to find it in London.
All the same it will be hard to smother the vigour and vitality of your
play if only you get someone alive & lovely for Gruach. Im quite
delighted that you like the drawing of Mrs Lear hurrah! well, dear
Gordon you shall have it for your own if you will accept a humble
something on account of a more 'important' drawing still owing!

I've just done some really rather much better things—in a few years'
time you'll be goggling your eyes out with wonder! If any get photo-
graphed I'll let you have some prints but its a tight time this year and
all extras are getting scrapped. This is only a hurried short letter, I
think in a week or a little later I shall be able to manage another parcel
to amuse you with. À bientôt dear Bard & Emily

179

From PN to GB, Pantile Cottage, Dymchurch [late December 1923]. He sends
him a drawing and hopes he finds it 'acceptable'. He inquires after the
American article and promises to write 'a decent letter after Christmas'.

180

The Sheiling, Silverdale, Near Carnforth
GB to PN *2 January 1924*

Caro Fra Paolo,

It is undeniably nice to have news of you and to hear of you inhabit-
ing a house of your own in that dream of a Dymchurch: and we hope
you are prospering as we would have you prosper.

I didn't write to you for Christmas because I didn't write to anyone for Christmas because we have been in Scotland Gruaching for the greater part of December and didn't get home in time. Think of "Gruach"—that high-brow drama—together with a Highland comedy, filling a musical comedy theatre in Glasgow on the Saturday night before Christmas.[1] If you heard the voices of the Scotish sirens you wouldn't wonder at our unwillingness to come home so long as they were turning me into celestial music nightly.

But I should have written to you long ago if I hadn't been feeling grumpy with you—so that I dammed your eyes frequently instead of writing. When I had worked so long and ingeniously and enthusiastically and devotedly and in spite of rebuffs to get you ensconced safely and profitably in the mansion of Our Mutual Friend,[2] I did think you might have told me when I had pulled it off instead of leaving me to learn it casually from an outsider—who also told me you had left Dymchurch for good.

So I consigned you to perdition—and went on with your article. It is only since I received your pacquet a week ago that I have heard from New York and the article has come to hand. I send it on in haste herewith, and shall be glad to know how much you like it and if you think it will do you good: a flourish at the end, commending you to American attention, has been cut off. The pictures and blocks are to return next week, when I will send all together.

We are honoured by your noble and welcome gift and thank you for it and its dear delightful inscription with both our hearts. It and the Benn Players' "Macbeth" from Ricketts have made our Christmas memorable. Of course we "find it acceptable", for it contains Paul's poetry and colour: and if I have to confess I don't understand your aim in art nowadays, I am none the less always happy when I see the least intimation of what our incomparable earth looks like to you.

How much would you really like us to visit you in your new cottage? If you want us at all badly we may visit Rye after "Gruach" on the 20th at the St. Martin's Theatre, and we could take you on or [our] way back.

· · · · · · ·

Your affectionate and elderly friend

[1] The Scottish National Players revived their production of *Gruach*, with practically the original cast, for a season in Glasgow and Edinburgh, along with Brandane's *The Glen is Mine*.

[2] Percy Withers. PN had stayed with him for the first time in May 1922 (Letters 152 to 156). He had been there again in June 1923.

181

I am full of sorrow & have damned my self far more I am sure since I got your letter than ever you did before you wrote it. I seem to be the occasional victim of pranks played upon me by my lesser nature Hyde-like lapses from grace which I am unconscious of till they are pointed out to me by friends or enemies. This latest atrocity makes me acutely miserable. I can only account for it to a certain extent. When I went to Souldern I thought I would write to you from there as probably youd like to hear about it all. This I was prevented doing partly because I was kept hard at work all the time—I made more than a dozen drawings in ten days—partly because I was writing to Margaret every day. She was to have joined me but had fallen unwell & this made me a little uneasy, & what time remained was absorbed by our delightful but exacting & difficult Percy with whom I talked argued contradicted & by whom I was cross examined, exhorted, congratulated lauded, censored, snubbed, & so generally excercised in point of wit, logic, tact, enthusiasm exctasy and indeed mere supply of breath that anything like a quiet half hour was not my portion. But the awful joke of it is that even had I found time to write to you from Souldern I verily believe my letter might have been innocent of the shadow of a sense of my very real obligation under the circumstances for the fact of my being so amusingly & profitably established in the mansion of our Mutual Friend did not seem then at all inevitably traceable to yourself —of course I knew nothing of the ingenious labourious machinery— the rebuffs. I wince dear Gordon to think of it.

No the two were quite disconnected in my conciousness & I must confess it is painfully true to say I might never have realised my debt save by a sudden flash of thought—all this might not have come about if— & then, why of course all this is due to my visiting Souldern to see Gordon last year! Yes you *must* remember I knew nothing of the hidden hand! After I left Percy Margaret was very poorly & we had rather a bad time but she pulled round & except for the fact that I got bothered & ruined one of Percy's drawings & dropped £10 into the bargain! we were not much the worse for it. Fortunately Percy loves the drawings I finished, the dear generous madman wanted to buy everything I drew almost—and the money for the three helped us along at a tight corner.

There is no reason why I should not have written & told you all this & much more which was news at the time—any day during the Summer & I have never had it really out of my mind that I must write to Gordon —why didn't I? That is where I stick I cannot explain.

Well Gordon I'm sure you'll love me again and forget I could be so

untrue & unfriendly I am most deeply grateful, quite inexpressively touched by your goodness to me & you know, good turns carry their own reward perhaps but it is certain I cannot hope to repay you for all those many done me directly & unconciously through the course of our friendship. Bless you.

I am delighted with the article.[1] You have written just what I feel is decent & just to say without making me feel the article is the work of a predjudiced friend. As to whether it will do me good I do not know. I do not greatly care for I have ceased to believe in myself as an artist who might or even should be in the theatre I remain 'the artist outside the theatre'[2]—a virtue of necessity? not only that but an honest position having no restrictions & hardly any disillusionments! For the moment I have had to put aside my stage & all the box of tricks & for this last year (1923) devote myself to work for my show and my engraving on wood. but I look forward to carrying out a few plans later on especially the Dymchurch drama of The Platform facing the Sea. . . . One thing about the article distressed me particularly—no reproduction of either of your models—what do they mean I sent them the *blocks* surely. It was one of the things I looked forward to in the whole affair—this is most perverse irony. My dear Gordon youve been rottenly handled all round. what can I do to 'make it up'!? As a writer of really dignified, convincing puffs you are supreme. I cant tell you how I admire the subtle insinuation of everything you could possibly think of to my credit—nothing is forgotten the more often I read the article the more I marvel at your entire thoughtfulness, engenuity & tact—the whole is presented with such authority beside Oh yes youve done me proud! Perhaps what intrigues me most is the opening sentence one of the longest I have ever read! To have evoked that pleases me considerably!

.

Our love & good wishes of every kind for the new year . . .

P.S. You are not to assume the elderly title it don't suit you.
P.P.S. The informant who told you Id left Dymchurch for good was a liar.

182

From PN to GB [PM: 15 [January] 1924]. He asks him whether they are to expect him about the 21st or 22nd. [This refers to the last paragraph of Letter 180.]

[1] See p. 148, n. 2.
[2] A reference to PN's article, 'The Artist Outside the Theatre', in *The English Review*, August 1922.

The Sheiling, Silverdale, Near Carnforth
16 January 1924

GB to PN

My own Pavel Vilyamovitch,

I loved your letter and was happy in having it: and I would proceed at once to answer it, if your post-card this morning did not claim first place.

It is dear and sweet of you to want us, and we want to come: but I must have misled you infernally if I let you think we should swoop on to you straight out of the arms of ReandeaN after the 20th. Dear Paul you are the jolliest friend imaginable to be willing to swallow us suddenly like that but I don't know why I ever set up for a man of letters, for I can never express the simplest arrangement in unmistakeable words: the truth being that I didn't mean to be immediate, but to approach you by way of sojourns at Haslemere, Witley, Shiffolds, Bognor, Rye or Folkestone. So alas we shall not see you next week; but its lovely of you to be willing to have us and to let us derange other plans for you. We earnestly hope we have not much inconvenienced you, for we didn't go for to do it.

Your letter was a joy and a pain to me: for I didn't mean my serio-comic effusion to make you feel sorry or reproached like that, and I didn't want to be thanked, and if you don't take all your thanks back at once I shall feel too ashamed ever to look at you in the face again.

Don't you see, my dear, I had only been feeling a little forlorn and out of it, and had to tell you about it? It had been, as it were, my hobby since 1919—I had invented so many ingenious ways of keeping the boat's nose to the pier when the stream wanted to carry it forward—I had humoured the blessed thing when it kicked and tried to put its behind where its nose should be—the snubs you so correctly diagnose were duly encountered, and countered by Freudian methods—and now and then I got my hand between the gunwale and the pier-timbers—so that when I suddenly found you had dropped into the boat while I was busy among the tackle with my back to you, I felt like someone who had gone up a step too many when going to bed in the dark: I had to express my disconcertment, but lor bless you I didn't mean nothing by it and you shouldn't ha' took no notice of my babble.

And mind you never thank me again, or I'll smash something.

I'm happy you think the article was all right and useful. . .

Now that you mention it, that sentence[1] is rather remarkable—almost masterly, don't you think? Yet I swear I never noticed there was

[1] See end of Letter 181.

anything singular about it: I have heard that shapely giants never look their size.

.

I fancy the poet is really better outside the theatre—just as you feel the artist is. I should be sure about it if it weren't for my beloved Scots: but anyhow I shall, I suspect, soon be outside the St. Martin's Theatre in particular, for I do not get on with its potentate. I almost begin to believe I am not respectful enough.

It is the noble Sybil [Thorndike] who reconciles me to the affair.[1] I hope we shall see it, but I have been laid up for the past week with a horrid lung and may not be fit to travel.

.

Ever your devoted but-almost-fifty-years-old
friend

184

Dymchurch, Kent
PN to GB [c. *20 March 1924*]

we should so much like to hear how you are—I do hope much better probably blooming again by now. I was so very sorry to hear you never got to see Gruach. I expect your Scots did it just as well & quite conceivably, much better. . . . I hear from Craig now & then Im glad he is so enthusiastic about your plays but then he should be & unfortunately he is not always what he should be. I cant make out what he's at but the Mask[2] is an extraordinary revelation of a kind of monomania. As far as I can see it's all written by GC under different names—I recall with a diffident smile my lonely & disasterous effort! But Craig is like the chap in The Way of the World who calls for himself waits for himself & leaves a message for himself. Only he writes to himself interviews himself & quotes himself to himself, and the whole thing wouldn't take in a child of four. I've just finished a new set of engravings one or two specimens of which I send for you to see & later, if you like them you shall have a set but as yet the blocks are with the printers.[3] My work towards my show is almost done. Some of it I think you will like some I fear you will tell me you do not understand—I dont know why! The

[1] On 20 January 1924 *Gruach*, with Sybil Thorndike in the name part, was staged by Basil Dean. Lascelles Abercrombie's verse comedy of the Trojan War, *Phoenix*, completed the bill.

[2] The *Mask*, Gordon Craig's periodical, 'a quarterly journal of the Art of the Theatre' (Florence, Italy), ran from 1908–29, with some suspensions and variations of subtitle.

[3] These were for *Genesis: twelve woodcuts by Paul Nash with the first chapter of Genesis in the Authorized Version*, the Nonesuch Press, 1924.

exhibition is to be on the 29th May—June is a good month I think so I am lucky.[1] In June O my dear friends we come to stay in

Cumberland!

so be prepared we shall descend upon The Shieling I warn you!

Our united & devoted love

185

GB to PN

The Sheiling, Silverdale, Near Carnforth
27 March 1924

Your letter filled us with alarm and dismay. Of course you will come to The Sheiling if you come to Cumberland: the alarming problem involved is SHALL WE BE THERE IN JUNE?

What part of June, Paul? June 3rd. is very like May: June 30th. is very like July. The mischief is that last December we promised to go to Arran or Mull or thereabout with some of my nice Scottish National Players in the end of June or thereabout, and while I am so far on the way I want to take the chance of going a little farther—Iona, Skye, Caledonian Canal, Inverness or so—and that will have to come in before or after the visit to our friends, just as they arrange it.

So we don't know what is to become of us yet: we shall be dejected and devastated if we are away when you come North: I couldn't invent a more real disappointment. We will try our most not to be: and to that end please tell us what your dates are likely to be, and what part of Cumberland you are making for.

We have been clinging to the idea of reaching Dymchurch this Spring in conjunction with other visits in Kent. But the infernal weather has held my lung back from recovery; the weather *has* been infernal; and during the last three weeks the anxiety and strain of the illness and death of Emily's last sister have swamped us and wrung us out and left us limp and unable to get far away. Perhaps we will go to Dymchurch in the Autumn instead, if you will have us then.

All this is preliminary to the purport of this letter. It mean't to begin by saying "Ooooooh!!!" to your engravings of The Creation, because I didn't know what else to say. They electrified us and made us jump: Blake's friends must have felt as we did when they saw some of his prints. There is no doubt about these: they leave all your other engravings so far behind as to be out of sight. They are works of unadulterated genius which it would be impertinent to criticise and ungrateful to do anything but accept. I doubt if giving way to inspiration in this way will bring you either popularity or emolument: but it will

[1] The exhibition was of thirty-six paintings and drawings and was held at the Leicester Galleries.

make you live as long as England lives. Of course I understand them: they are inevitable, and it is only when you do things with an optional element in them that I fail in understanding. And—equally of course—their astounding fidelity to Nature was bound to carry them on a surge straight to my heart.

Perhaps I like The Face Of The Waters most—it is shattering to see Creation going on like that; and perhaps Emily cares most for Birds and Fishes. But what we both say is "who are we that we should have preferences among these august things": we lay our hands on our hearts and thank you with both for letting us share so nearly at their birth, and for such a gift and the honour of our names written thereon.

Yes, Craig writes to me sometimes, and is dear and inspiriting about my plays, and illuminating about all he touches. I venerate him as the father and mother of the re-birth of the Theatre, the man who has fertilised the world to new ideas: but he is Moses looking into the Promised Land. He will never reach it himself.

"The Mask" is just what you say: it includes a mystical doctrine which is doubtlessly true, but this needs practising to be clear to the common run of men (whose acceptance has to be reached in the Theatre.) He waits for money: but it will be poor men (doing other things for a living) who will rebuild, recreate and reinhabit the theatre. It is time for him to Do: and he offers terms and makes laws instead.

People who were at "Gruach" say that it was the first success the Playbox has made: and it even got some good notices. But I doubt if it was what I wanted. Sybil clearly was superb, but there seems to have been little ensemble to give her a suitable setting: The Dean was evidently doing his best, but it had little relation to my needs and desires: the Press doesn't know what to ask for from poetic drama, and can't usually think of anything but blaming the Tortoise for being Slow. I'm really beginning to be indifferent to London productions or successes—one never gets enough rehearsals, or enough actors who know how to speak verse (If Only you could have heard the Scots sirens!). The Vic has a lot of rightness in it, but they can't afford to rehearse enough: that is all right with Shakespeare by now, as each play improves with each revival, and everybody is used to Shakespeare's little ways; but that puts them at sea with other people's verse when they haven't time to explore it. I've just withdrawn a production of "Lithend"[1] which seemed to be courting disaster: and I'm really thinking of not letting any more plays be done in all those London theatres organised for Society drama.

.

All our good wishes for it [your exhibition], and our love to you both.

[1] See p. 185.

186

[Dymchurch]
[PM: 1 April 1924]

My dear generous extravagant Gordon

you mustn't go off pop like this over your young protegé doings they really are far far short of my aim but it is jolly to set a neat[1] light to you like this and get covered with golden showers! I am so glad you like 'em, but you must see the whole set I only sent you a quarter if I remember right. Some of the others I fancy you wont like so much. I have tried perhaps impossible things but I feel the whole lot do hang together pretty well. They came quite easily one after another and I know they are much better engravings technically. If I can I will secure you a copy. The book is published by The Nonesuch Press— should be out quite soon. . . . I sympathise with you in your disgust of London productions. I think they are hardly worth while for your work which requires for its production both imagination and study the first seems very rare among London producers and the second they have no time for. But it is good news that Athene Seyler is going to have a theatre She's a rare bird is Athene. Our love to you—and our deep sympathy with dear Emily

187

From GB to PN, Silverdale, 31 May 1924. He apologizes for not writing before about the proposed Nash visit. He has been ill and laid up at Withers's—'Souldern's inhabitants were so many angels of kindness'. They are going to Scotland and therefore there is no hope of their meeting as they will not be back until 'just before the August rush'.

188

176 Alexandra Mans:, Judd St, W C 1
[18 June 1924]

PN to GB

My dear Gordon thank you so much for your letter. We have just come from a visit at Souldern which was distracting but delightful the house being full of nice young female things and a general air of frolic. You should have seen Percy in fancy dress as an 18th Century buck! In spite of the distractions I brought away some drawings and Margaret got on very cleverly with Our Mutual Friend. . .

The show hasn't done at all badly considering all things—anyhow

[1] A questionable reading.

it seems to have surprised people agreeably and made a good impression generally—nearly all the sales, too, were to strangers, which is always a good thing to happen. . . . Just had a letter from Theatre Arts Monthly asking to see more theatre designs & telling me I had an interested audience over there watching my work—rather an alarming thought! All due to you Gordon and many thanks to you for it. We both send our love to you both . . .

189

From PN to GB, Alexandra Mansions [20 December 1924]. He sends 'only a line—as they say—' to announce that they are off to Paris the next day. 'I've lots to tell you but that must wait too. life is almost too full—and so much is irksome and looks like leading nowhere.' He has *King Lear* to illustrate for the Players' Shakespeare.

190

GB to PN

The Sheiling, Silverdale, Near Carnforth
4 May 1925

I wonder sometimes if Dymchurch is under-the-Marsh instead of under-the-Wall; and you with it.

On the whole I not only trust not, but I believe not; the fault being mine that I have not heard. For four stodgy months I have meant to acknowledge your Christmas missive; but I couldn't do it at the right moment, as you were in Paris and consorting with Derain and I had no address; and by the time you could have returned it was no time to wish anybody anything about Christmas or the New Year; so I determined to write you a letter on your own merits. But instead I went to London to see "Midsummer Eve,"[1] and then drifted about in Surrey, and meant to reach Rye and Dymchurch and Folkestone but was discouraged by some weather. So my plan of seeing you instead of answering your letter didn't come off, and I was in a worse bog than ever. And I've been trying to write ever since except when I was having inflammation of the gall-bladder.

I'm really sorry for so many failures: and Emily and I do wish you all the Happy New Years there are—or absolutely every one that is left, at any rate. And we do mean to reach Dymchurch next time.

But, O, Paul, I have developed the queerest habit of turning to the North, just as if I had a magnet in my inside. (That's an idea, a positively enlightening notion: it would explain, among other things, the

[1] Perhaps a performance by a group of amateurs. *A Stage for Poetry* states that the play was first performed by The Arts League of Service in 1930.

continual horrid feeling that I have too many things in my inside, and all in the wrong places.) And we are preparing now for another Summer there: and I know—O, I know better than anyone can tell me—that, if I go to the Isles Of The Blest without writing that letter to you, you will never get it.

For one can't write letters there, and if one tries the Place does things at one. I tried to attend to business there last Autumn; but an important document vanished while I stepped from the window to the fire (there was no one in the room but me) and could never be found; so I had to stop—there is no use in trying to stand up to things like that.

Wherefore I shall be more careful this time when I reach Eilean Skianach. Anyhow I'm making sure by writing to you before we start: and if the Place purloins me and you never hear from me again you will know I meant well.

I wonder what you are doing? I do tenderly hope you weren't much Derainged in paris. In default of a chance to look round your studio we trust we can be in London for your next show.

There is nothing to chronicle of me. I have at last removed that bookful of old things from my chest and conscience, and it looks deceptively like the Poetical Works of somebody or other;[1] and some dear and eminent people have given me a large medal with my name on it;[2] so now I repose upon the peaks of middle age and have laid my nevertoo-laborious pen aside for good.

Somebody even called me an Edwardian the other day: which of course put the lid on me, didn't it?

How I long for the day when I shall see your "Gruach" model carried out: I still feel poorly when I think of the Playbox. But you'll have to find out how to make some clothes that are good enough for the lovely scene.

We send ever so much love to Margaret and You.

191

PN to GB

Dymchurch, Kent
22 April 1925[3]

I feel if I dont try & start this letter now I shall be damned for ever. Dont you know the feeling that a long long overdue letter to someone far off brings to you of heavy, over-burdening debt, till you frighten yourself into one more procrastination! I dont mind with most people

[1] *Poems of Thirty Years*, Constable, 1925.

[2] Presumably a medal of the Royal Society of Literature.

[3] PN frequently began a letter and left it unfinished for a considerable time, which clearly happened in this case. The letter was therefore not posted until after he had received the preceding letter from GB.

but a letter to you is a special affair—or I like to try to make it so—and I begin to think of all the things youll like to hear about and I worry over what I can find to send you & in the end I realise its going to take an hour & a half & I let it wait until there is more time or it will be scamped or have to go without any odds and ends to amuse you & that wont satisfy me. You see, dear Gordon, how it comes about. In the old days I had leisure and I mean to have leisure again, now I'm driven & it dont suit me a bit. When I was a painter I had the evenings for amusing myself now Im a bit of a painter & a pedagogue[1] & a lecturer & a designer for the theatre & for textiles and a plugging engraver to boot. But it wont do. So Ive quite firmly resigned my usher's job at the Royal College of Art & I'm not going to lecture again if·I can possibly afford not to & when my present jobs for books are cleared off Im going to settle down to paint again. One job by the way is the set of scenes for Lear. You can imagine that was no light undertaking. Now at last they are designed. I spent the Easter holidays building models & drawing from them—5 scenes. I wonder if you'll like 'em. I must somehow let you see them. Crikey what a play it is!

. . . here endeth the first attack upon this letter

And then before I had time to renew, your dear letter arrived & shamed me thoroughly! Thank you so much for it—it was charming of you to write. I loved hearing about the Blessed Isles which must indeed be your spiritual home. What I did not like hearing about was your visit to London—seeing as how you never notified us of same. I met Bob Trevelyan at a concert months & months ago—before Christmas it was & he said you were coming up & were sure to stay at an hotel opposite the British [Museum] and we plagued their lives out there with constant enquiries but you never came or even warned them you might come, so we thought you must have changed your mind. Do remember we are so often in Town that its always worth telling us you are going to be there too.

I must get that bookful of old things—you aren't an Edwardian at all you're the Sitwells' Godfather! Ive just been reading the 13th Ceasar[2] and the echo of your voice is certainly there. Sacheverel does seem[3] to me to be a poet, very much more of one than almost any of the newer people—am I wrong?

As for the peaks of middle age—perhaps they are really the peaks of Parnassus. I only hope they are moderately comfortable.[4]

[1] He had been an assistant in the School of Design at the Royal College of Art since September 1924.
[2] *The Thirteenth Caesar and other Poems*, by Sacheverell Sitwell, Grant Richards, 1924. [3] MS. seemed.
[4] See Plate XIV. The effect of the original drawing is heightened by touches of red and blue chalk.

Just before I left Town last week I posted you a selection of photographs of more or less recent paintings* I wish I could have sent some originals but I send everything now to a convenient agent as soon as I feel it is complete enough. It helps me to forget it & leaves me the feeling of always looking forward to the next which will be quite different and much much better—also he sometimes sells things, in fact recently he has done me rather proud. I am less & less concerned with picture-making & more & more interested by this elusive something which a painter pursues in painting, an engraver in engraving, a draughtsman in drawing or for that matter any artist in any art. My only side line—designing for the theatre—is not out of my course for I find in building scenes & making drawings from the models I learn more about tone & the 3 dimensional magic than in any other way but the theatre remains my only connection—as a painter—with literature —that is, my only concious connection I have still a certain amount of the literary stuff in my aesthetic system! But once one has begun to find the plastic values all other considerations seem irrelevant.

My interest in the Theatre, however—as a means of dual expression —has increased lately and there is talk of a book being brought out on my theatre work—outside the theatre. My wish dear Gordon— should it be published[1]—is to dedicate it to you—please may I? I will write you more fully on it when it has grown a little more but I believe I can promise you an entertaining volume! One of the contents, with your permission, will be a set for your 'Riding to Lithend' to my mind the best poetic drama you have written *for the stage.* Why has no one in London ever put it on, surely it has better acting qualities than most of the others?[2] I enclose one of four engravings for scenes to the Ring— shortly to be published in a book.[3] I felt this one—which I think is the best, might rather especially appeal to you—I do hope so. Margaret sends her love to you—we are anxious about these dark hints as to your health—poor Gordon you always write so cheerfully I never know really how you are—I do hope no worse in any way?

Well, I wish I could see you both—until we meet our united love & good wishes to you & Emily

ever your affecte young friend (of 36!)

*When you return them do mark a few you would like—if any! & I'll send them

[1] It was not.

[2] Produced by Terence Gray at the Cambridge Festival Theatre in 1928, to GB's complete satisfaction. See *A Stage for Poetry*, pp. 10–13; there are also two illustrations.

[3] *Wagner's Music Drama of the Ring*, by L. Archier Leroy, with four wood-engravings by PN; Noel Douglas, 1925.

192

GB to PN *21 May 1925*

My dear Fra Paolo,

Your letter this morning, with Years of news of you in it, was a huge pleasure.

And of course it will be the pride of my heart to see a book of yours—and a book of stage designs too—dedicated to me. My Dedickers are a rare and choice company that any man might be arrogant about, and you will not diminish their lustre; while the addition to my honours will be notable and noticeable—and will, I trust, make many people properly jealous. You know I thank you, dear Paul, and that I await the event with a genuine thrill every time I think of it.

And after your wonderful Götterdämmerung invention you can be sure I shall be doubly excited and insistent to see you doing my "Lithend." But I hope your high opinion of it does not mean that you think of omitting the Mrs. Lear and Gruach models? I simply couldn't bear that, for plays can rarely have had mountings that shew so completely their author's intentions as these do. If you even toy with such a notion I shall buy a set of bagpipes and play Lochaber No More and MacCruimin's Lament and MacIntosh's Lament and Clanranald's Lament on your doorstep and under your window until you promise to let me have them.

And please do put the costume designs in that the unprincipled Dutchman said belonged to Shakespeare, so that my right to them may be made manifest.

I fancy "Lithend" has never been done because of the difficulties of mounting—especially with regard to the fight. The lady at the Passmore Edwards Settlement took it on a year and a half ago; but the way she talked about it made me anxious for her to take it off, for I really cannot afford any more of these bungles by people who think that a poetic drama ought to be handled in the same way as one of Galsworthy's masterpieces. And presently it was obvious that she was scared herself and didn't know what on earth to do with it; and you can imagine the ardour and enthusiasm with which I helped her to relieve herself of it.

I like you to like it so much, and I believe it contains something for the stage; but I am pretty sure that the words of it are not so much "du théâtre" as those of my later plays are. And it hasn't anywhere just that kind of surprise in it that there is when Gruach comes down the stair unexpectedly in the golden gown: again and again that has been an enchanting moment as the audience caught its breath in audible surprise over all the theatre.

You are a dear to send me this "Götterdämmerung" design, and to

know that I shall like it. It shall be cherished among my precious treasures: for I have not before seen any design for this scene (isn't it Act III. Scene II?) that comes so near to what I desire for it as this does. I wonder if you have done Act III for the Valkyrie? That is my next favourite scene: and I am inordinately curious to know if you have had to tackle the problem of what a Valkyr maiden really looked like.

And all this time I have ungratefully not told you what an agreeable home-coming your large and thoughtful parcel made for us the other night. We had been in Glasgow for the week-end—consorting with celebrated actors, celebrated lakes, celebrated mountains, and cele-brated musicians—and the train that was bringing us home broke down, and we had a most exhausting kind of journey: and you don't know how cheering the sight of your commodious parcel was to two poor elderly draggle-tails. It brought a kind of nostalgia for those lovely lost days when the Cartmel postman used to stagger up the garden under the burden of your newest drawings: you must not scent a re-proach or an unkindness here, Paul—we know that a distinguished artist at the height of his career, with all kinds of people keen about his work, cannot send drawings wandering about the provinces as the student could; and I am only telling you how pleasant it was to be so reminded of old times and old hopes that have been so fulfilled.

.

... It is nice of you to say we may have some prints: in case it proves convenient, the ones we should like and value much are Tree Group 1912 (an always admired friend); Night Tide; Souldern Pond (one of your high-water marks); The Shore (1923); and The Lake (1921-4.)[1]

But a photograph we always covet especially is one promised us at Dymchurch of Bunty putting her hair up before a Portsmouth window long ago! Pardon my mentioning it: you did set me off, you know.[2]

.

You deject me by what you say of getting the literary stuff out of your aesthetic system: the idea seems to me a vast hallucination, and re-minds me of the old woman who taught her horse to live on a blade of grass a day. You seem to me on far more real ground when you speak of "the elusive something which a painter pursues in painting"; for I say with Alfred Stevens "I know of but one art", and that "elusive some-thing" seems to me to be what a writer pursues in writing also. The significant thing to me is that the thing in a bad picture which we con-demn as "literary" is just as bad and out of place in literature. And,

[1] The painting later called *Chestnut Waters*. At this date it contained a recumbent nude afterwards painted out.
[2] Mrs. Paul Nash is unable to identify the picture referred to.

though a picture may be built without any "literary" references, I believe that inevitable "literary" references will one day be evolved from it if it is a vital picture: but that ties itself on to my other (by-now-firm) belief that it is impossible to construct a picture that, *au fond*, does not make references (conscious or unconscious, intentional or instinctive) to the eye's experiences of external nature.

O, Paul, the peaks of middle-age are as uncomfortable as any other peaks. I am so pleased with your assurance that I do not present myself to you as a back number; and also with your idea that I have some affinity with the Sitwells, for I have always felt that Edith's desire to write beautiful nonsense did rather tie itself on to certain divarsions of my youth (although I daresay she had never heard of me then); and I feel with you that Sacheverell's "Thirteenth Caesar" is rather in the same world with me. I certainly agree that he counts for a good deal more than most of the new men—and especially than those of the academic kind.

.

I must stop: we send very much love to you and Margaret, and are firmly and pathetically and trustfully hoping that we shall all meet again one day. And it was a nice letter, Paul.

.

193

Iver Heath, Bucks.
as from
Oxenbridge Cottage, Iden, Sussex
PN to GB [*1 January 1927*]

I cannot remember whether I have already sent you this little engraving—you will tell me I hope if I have—and I will then find you something else. Margaret and I are now settled near Rye on the other side of the Marsh from Dymchurch. You would like our cottage I think for it is both a garden house and a ship to live in, full of sun and wind. It stands on the high ground of the Iden Cliff looking over sloping fields to the hills below Fairlight. I have become a gardener to my surprise and spend my time between painting and digging. Wont you come to stay with us when you are next in the South we should love to see you there. I have had a hard year with Margaret ill but now she is much better altho' a new trouble has come to us with the illness of her Mother. So I must go and live alone for a while as Margaret has to stay here to be near her Mother. It is sad when our parents get near the end my own Father is getting old—nearly 80—we cannot expect to have him with us much longer. On the other hand our mutual friend Percy seems

to have grasped a new lease of life. I stayed there this summer & found him a new man—what a curious family it is. I cannot help laughing at them tho' I am fond of them all. My work grows at least in variety. I am now very interested in designing for textiles. There is a workshop now at Hammersmith where I can get them printed and the craft is a fascinating one. I wish you could see some of the results there is quite a strong movement in textile production just beginning which might produce something worth while if apathy does not kill it. Your North for instance is a slow moving community—I suppose it will buy our pictures and other efforts of modern English art when we are dead and careless but it was otherwise in the days of Rossetti and Madox Brown. I hope to find a market in America in time it is just beginning to buy my paintings so that in a year or two I shall try to arrange a show over there. I thought you might like to have this photograph of a Souldern drawing—the alarming envelope is from a device engraved on wood & repeated. Our love to you & Emily & our best wishes

194

The Sheiling, Silverdale, Near Carnforth
GB to PN *[Early January 1927]*

Your charming New Year pacquet and its agreeable envelope were a pleasure to us both, and we were glad to have news of you after so long an interval of silence. We wish it had been better news though, and that one of the reasons for the silence had not been the ill-health of Margaret.

You don't say what is the matter with her, but it must have been disagreeable to be so prolonged, and anxious too; and we do trust that she is not only well now, but safely well and able to stand the strain of Mrs. Odeh's illness.

You and she are, like us, at a disagreeable time of life, when one has to watch one's parents fail and withdraw: it is a dismal time, and has a feeling of leaving one very much in the battle-line, with the sensation that after a fleeting interval it will be our turn next. My own parents are fragile and visibly diminishing and make me think of Dixon's "Thou goest more and more To the silent things":[1] they aren't quite as old as your father, but I imagine the tenser Northern climate ages people more, and they seem to relinquish one thing after another and live in a narrower area. I hope your father has not the physical discomforts that mine has, and that he still enjoys life and wants to go on enjoying it.

· · · · · · · ·

What a number of lives the Mutual has! It must be very gratifying to

[1] The opening of R. W. Dixon's 'Ode on Advancing Age' (*Selected Poems*, with a memoir by Robert Bridges, 1909, pp. 132–5).

everybody, the way he refuses to leave them. Did you find him really on a high road of health again? We ought to have gone to see for ourselves this year, but some other engagement always would get in the way.

We were delighted when the photograph of the Souldern Watering-Place fell out of your parcel: it has always seemed to us one of your very best drawings, and the very best of the Souldern ones, and I have always wished for a reproduction of it. We offer you all our most cordial thanks for it, and also for the two "Ring" engravings, which are toppers. I have always thought that "Götterdämmerung" set the very best invention for that act that I have ever seen.

Which brings me to the confession (as you invite it) that you have sent it to us already, and that in consequence I should like to avail myself of your offer to send me something else instead and let me return it! If you had a similar print of your Walküre design, I should certainly like to exchange it for that: for the Walküre is particularly my opera, and I have often wondered what you made of it.

Or would you like to put in the Siegfried print as well, and I'll send you a copy of my collected poems as soon as the new edition is ready.

.

I don't think you can expect the North to support modern art as it did in the days of Rossetti and Madox Brown: all the English blood Rossetti had in him was Yorkshire, and Brown's stock came from still further North, and both their romance and their peculiar tense actualism appealed to something racial and natural in their Northern patrons: while on the other hand the Modernist movement with its denial of nature moves them not at all except by the thin veneer of it practised in some Art Schools.* When one gets to Scotland one is puzzled by the inhospitality shewn to modern art on every hand: thirty years, fifty years ago, Scottish collectors bought Manet and Monet, Degas and Courbet, the Marises and Corot and Monticelli eagerly; but their sons don't want Van Gogh and Matisse and Cézanne: they too want Corot and Maris and Manet. Scottish collectors, in fact, seem to me to want nothing but art (the best of its kind, certainly) based on the actual facts and vision of every-day life: and the little band of modernist painters in Edinburgh—Fergus[s]on, Peploe, Cadell[1]—do not attract a great deal of belief and support, although they have among them one very promising man, Cadell.

*Also there is the continued bad trade in the industrial North which leaves no one with much money for art.

[1] John Duncan Fergusson (1874–); Samuel John Peploe (1871–1935); Francis Campbell Boileau Cadell (1883–1937).

I must stop and go to bed. We do trust Margaret will keep well, and that the anxiety about her mother will not continue. And we send you both our love, and our wishes that this New Year will be kind and fortunate for you.

<div align="right">Your ancient friend</div>

<div align="center">

195

</div>

PN to GB [c. *mid-February 1927*]

My dear Gordon

it was a very great pleasure to hear from you again not that I could expect to have a letter before. I know I am to blame. It is very embarassing to know you have already had a print of the Wagner but it is acountable even so. Frankly I am uncertain how much of my recent work you care for—I know a gulf has gaped between us so far as aesthetic sympathies are concerned and your occasional references to modern work makes me uneasy when it comes to considering my own in reference to your tastes. So I always plump for the Theatre! There I feel we can always meet and 'deny Nature' together! How much I should enjoy a talk with you—I was most interested by what you said of the Scotch and modern painting—that fifty years ago they bought Degas & Manet & Corot and today they still want Degas[,] Manet & Corot—which by the way is an extravagant way of going on for the Scotch. Now I wonder why—not that Cezanne, Matisse & Van Gogh— by the way Matisse has got into the wrong century surely—not that any, however, are cheaper to buy or less profitable to invest in but the immense revolution they represent in vision design, paint—a new world—just ignored! And then, Gordon, you seem to buck em up! "Scottish collectors—want nothing but art—the best of its kind certainly—based on the actual facts & vision of every-day life". But you dont surely mean that Cezanne, aye, and Van Gogh did not base their art on the actual facts of everyday life though I grant you they had more vision than either Manet or Degas & very often more than Corot whose vision certainly became extremely limited. But what I need explained more than anything is the modernists movement's *denial of Nature*, really I am not being just captious I very much want to know what you mean to convey by that phrase—so one day when you feel like it let fly!

I shall of course send you the Walküre print & the Siegfried but I do not think they are so good—still I wont miss the offer of the collected poems. Tentatively also I shall try you with another kind of design & when my book comes out I should like you to have that. You must certainly come to Rye in the Spring so that we can see you—at present I am alone here as Margaret is nursing her mother who is seriously ill. I have just been elected a member of the London Artists' Association

which may be rather a good thing it give[s] me a very good agent and a guarantee of a few pound a week whatever happens. It may just make all the difference as I shall be able to give more time to painting & save eternally spending it over 'jobs'

Our love to you both & very best wishes

196

The Sheiling, Silverdale, Near Carnforth
GB to PN *21 February 1927*

I was glad to have your letter the other day; likewise your indignation—which took me *that* aback, I assure you.

But I haven't any ambition to "let fly", I assure you. I shouldn't know what to let fly at, for one thing.

However. First, and most embarrassing is the duplicate print: I am returning it herewith, with real unwillingness—I never before sent back a gift, and especially a gift inscribed to me: but it might be simply tiresome of me to want to stick to it twice over, when your impressions must always be limited and you may want one for someone else. Beside, I do want the Walküre and Siegfried.

So here it regrettably and indubitably is: and I'm enclosing the copy of the book[1] to pack it securely and prevent the post maltreating it. I hope you will not miss any old friends in the book: I miss one or two of mine, but I couldn't get them right in time for press and so had to leave them for another edition.

And I hope you will not think I have spoilt any old friends you do find: I have not tried to make any of them less conceited, but I felt bound to give them the advantage of whatever skill I have acquired since they were born—to help them to say more completely what they always meant to say.

I note you promise to send me your book in exchange—I didn't know you were doing one, so it will be doubly welcome.

As to your fraternal and affectionate invitation to a scrap:—I don't see why I should. It is true where you see a revolution in vision I only see a change of recipe; and that nowadays we have to emphasize others of the eternal qualities of works of art than our fathers did, in order to keep their emphases from becoming stale and dead and to give them a fallow time for recuperation, but I think that art is weakened if we emphasise our chosen qualities so much that we lose their balance with the other eternal qualities; and that I feel Manet and Gauguin paint like gentlemen, and Millet and Van Gogh paint like peasants or labouring men, and I love them for it because gentlemen and peasants live

[1] *Poems of Thirty Years.*

191

real lives and so interest me—while Monet and Cézanne and Signac and Matisse paint like bourgeois, and bourgeois are always a little dull and say important things that do not convince me; and that you seem to believe that progress in art is possible, just as progress in Science is possible, whereas I believe that art has always been complete since it first began to be expressive and that local variations of method such as anatomy, or perspective, or volumetry, or geometry, never change or vary the things an artist can say.

But in spite of all these things I don't see why we should fight; for I was not attacking you, or setting out my point of view, but simply and only trying to make graphic the mind of the North Country commercial man interested in art, so that I could answer your query as to why that kind of man was not supporting contemporary art as he used to do. And my unlucky phrase about Denying Nature was used half as expressing his opinion, and half (I give you my word) because I thought it expressed yours too.

I really thought it would commend itself to you, and was not at all using it as backhanded criticism. And even in the most ultimate resort it had no intention of denying that modern artists often found their work on nature, but was meant as a simple recognition of the fact that they use nature to help them to abstract form or absolute form which believes in itself at the expense of the way things actually shape themselves.

I want to go to London to see the Flemish pictures;[1] but the weather is against me, and nowadays I keep a devil in my liver which makes every Winter a tiresome struggle to get enough to eat. We hope Mrs. Odeh is better now, and that you are no more widowed. And we both send you our entirely Natural love.

Your aged friend (I was 53 yesterday—isn't it a damnable business?)

197

I should have written long back to thank you for the book of poems. It was charming to find old friends—I must say at once it is very difficult for me to write intelligently because for some strange female reason Margaret will read extracts from the classical dictionary aloud. Also to refer to many poems is not easy because your book has been lent. Upon rereading them I found myself inclining to a preference for the less ornate & the less conciously romantic. I found the songs divorced from their surroundings (the plays) not so satisfying but on the other hand one of my favourites of all poems is the dedication to Thomas in

[1] Exhibition of Flemish and Belgian Art at the Royal Academy.

The Riding to Lithend. Margaret still has for her favourite The End of the World. So sorry I frightened you with my indignation! I love your distinctions about painters it is very interesting and suggests a lovely new game. The gentleman, the bourgeois and the peasant all thro' the ages. It would make an awfully good article for the Burlington, Gordon! The book I refered to is one in the series published by The Fleuron, 101 Gt Russell St.[1] (in case you havent seen any) So far they have done Jack, Gilbert Spencer, Gertler & Dobson the sculptor, the next will be Duncan Grant & myself. I enclose a new engraving & we send you our love

198

GB to PN

The Sheiling, Silverdale, Near Carnforth
28 March 1927

Your pacquet arrived safely this morning and was rent open with excitement, haste, and satisfaction. Thank you very much indeed for completing our Ring series for us: they are all worthy of each other— and because the Ring is to me the greatest thing which the 19th century achieved in the arts I am happy to have the ideas of your admirable instinct for the theatre about it.

And thank you too for your new flowers. You speak of lovely new games: I always think one of the loveliest would be to create new flowers, discerning their laws in doing so and not making them in accordance with human laws. Painters could do this so much better than the nurserymen and court-florists do: for which reason I enjoy your exploration of the possibilities very much indeed.

An interval devoted to getting out your "Genesis" prints to see which they are—and a longer interval spent in enjoying them all over again. They are The Face Of The Waters, Let The Dry Land Appear, Creation Of Light, and Fish And Birds. What toppers they are, Paul: nobody has ever beaten you at it, they are inspiration neat and understanding undefiled. Blake and Rossetti would have loved them as I do. And the understanding comes so completely out of the medium. I wonder what [it] would be like to live continually at the level of such perception and apprehension: I suppose it would be like trying to walk into the fiery furnace—one would come to a sudden end unless The Lord were willing.

I suppose it ought to count as one of the highest compliments of one's life that you thought my songs better when you read them in my plays than you do when you see them separately, considering that their purpose was to exist in plays. But I was puzzled that you should like the Lithend dedication better than those of Mrs. Lear and Mid. Eve. Mid.

[1] *Paul Nash.* Introduction by Anthony Bertram. British Artists of Today Series, 1927.

Eve seems to me the best of the rhymed ones. You seem to despise me for being an ornate Romantic: but I'm really always that—and if there is any virtue at all in my friend Abercrombie's brilliant book on "Romanticism",[1] you are an even bigger Romantic than I am.

I do wish I could remember what I said in my last letter that made you think me frightened of your indignation. I can't for my life remember; but I give you my word that the impression made on me by your previous letter was that you had—not frightened, but misunderstood me.

Anyhow you can be relieved, for I wasn't frightened. Now that health has occasionally looked in at the window on me, I find in myself an impish relish to drink delight of battle with my peers whenever a fair chance offers: but on that occasion I was only and sincerely puzzled by the crude misfit of the classification which the New Vision had made of me, and could only protest feebly like an old-fashioned Radical being driven off to vote in a Conservative carriage-and-pair by a deaf coachman. Now don't go and say I called you a deaf coachman: you are so obviously not one.

We are pleased to know by your speaking of Margaret's classical studies at your side that Mrs. Odeh is better and her anxieties relieved.

The other day in a book on the Sheila Kaye-Smith country I found a picture of "Oxenbridge House, Iden":[2] is it your agreeable dwelling-place.

Our love to you both.

<div align="right">Your affectionate but elderly friend</div>

· · · · · · ·

199

<div align="right">Oxenbridge Cottage, Iden, Sussex</div>

PN to GB [27 December 1929]

I feel if I dont write to you this moment you will get beyond my reach. The awful thought haunting me is that I dont know when I last wrote. Probably as long as a year ago. Well I will suppose so. It has been a grim disasterous year. In February I lost my dear father He died full of years—having passed 80—and to the end was vigourous and clear in his mind. One is grateful for that but the loss is there—it leaves a void. Apart from personal loss I felt acutely the pathos of my fathers death. —Do you think I shall see the Spring, he said. His going broke up our old home at Iver Heath—my stepmother[3] could not afford to live on

[1] Lascelles Abercrombie, *Romanticism*, 1926.
[2] Presumably Col. Buchanan's house, Oxenbridge Farm. See p. 122, n. 3.
[3] See p. 33, n. 2.

there if she had wanted to so we are now involved in the complicated business of trying to sell Wood Lane House. This has meant a lot of trouble and much expense as the house had to be modernized and 'done up' generally. For God's sake if you hear of any Northerners pining to live in our Southern park-land—remember Iver Heath—I can always send you particulars and photographs. Added to the trials of house property are the mysteries of stocks and shares, the bore of legal confabulations and so on. Altogether I have floundered about in strange waters this year. The unpleasant sensation of floundering has been variated by 'coup sur coup'—not quite the bludgeonings of Fate but some pretty shrewd taps from the jade (why is Fate always a jade). Finally when both of us—Margaret & I not me & the jade—were breathless bloody and considerably bowed our dearest friend[1] was seized with a horrid malady and only just escaped alive. There are yet four days of the year to run. We have staggered thro' Christmas with nothing more tiresome—if anything could be more tiresome—than toothache and an extraction with gas (Christmas Eve) and we have now a brace of chills to go on with—probably the roof will blow off on the last stroke of 1929 and we shall feel the year has been nicely rounded off.

All this is dismal reading and really, of course, there have been many bright intervals such as the whole month of health, peace and superb weather we enjoyed at Iden in the Summer. Work has been going on with certain developments but there have been too many interruptions for a productive period. I have a new dealer now who owns the best gallery in London. If you are ever in London do take a look at it—
—73 Grosvenor S[t], Paul Guillaume Gallery. It deals primarily with modern French masters at fabulous prices but I must admit I get a very good show and most sympathetic treatment. Since the success of my Leicester Gallery exhibition last year I have been able to raise my prices a little and to sell rather better but I have failed to conform to the average collectors conception of me—the label on my back—by experimenting in new directions—in two years time my present work will be accepted but at the moment it looks rather like languishing in the Paul Guillaume cellars. However we had a bright little flutter in America the other day, when I sold two of my paintings out of my group at the Carnegie International Ex[n] and was awarded a peculiar prize of 300 dollars which is given annually by the Allegeny County Club for the best painting of Flowers or a Garden. And this was presented to my picture of a bowl-full of dead sea holly! The picture is reproduced in the Fleuron book—by the way dear Gordon *did* I ever send you that little book??[2]

I have just had an ecstatic letter from Percy—there surely never was

[1] Ruth Clark. [2] See p. 193. The picture was *Sea Holly*, pl. 16.

quite such an enditer as the Mutual. . . . I must wind up this journal now. The enclosures are a few odds and ends I turned up the other day. They seemed to be essentially your odds but also I rather liked them *as* odds or I would not let them go to you. The corpse-washer I'm sure you once said you'd like to have. Anyway they make a little parcel and I dont like sending you a letter without a parcel. Please give my love to Emily— Margaret sends her love to you both.

200

GB to PN *6 January 1930*

Dear, Very Nice Paul,

Thank you so much for your welcome letter, and the familiar looking accompaniment of parcel which made me think of your first one and feel twenty years younger.

I can't exactly make out why it is, but I always feel fond of you when I have occasion to think of you—and your pacquet made me think of you. In justice to myself, I must tell you I think of you quite often without a pacquet.

We did, for instance, last August Bank Holiday week-end. We spent it with the Goldsworthys at Point-In-View;[1] and Mrs. Goldsworthy took us to see Wood Lane House, and I saw the back gate and the trees that I knew so well in drawings; and I hung about that back gate and felt sentimental and wished you were there.

We heard of your father's death, and we were sorry with you. We wish we had come there when you were there.

My parents are all eighty-two and delicate; a breath would blow them out, and yet they don't ail anything and are lively and happy. My father of late years has turned tyrannical, insisting that he won't let us go out of England for fear he might be taken ill while we were away. But I felt that wasn't good for any of us; so I have accepted an old invitation to Vienna, and we talk of going in May.

.

I am grieved you had such a confounded sort of a year—and doubly so because we had the gorgeousest one that ever was. I had a job in Glasgow in April, and from there we went first to Forres—to find a climate milder than our own, all primroses and laburnum; and then into the wild places of Wester Sutherland, where we sat still for weeks and basked in unbroken sunshine all May and into June: I think that place of fantastic mountains would have enchanted you as it did me,

[1] See Introduction, p. 1.

and you wouldn't have been able to keep your hands off them—
thousands of feet of splintered and spiked rocks rising straight up out of
the plain like molar teeth the wrong end up—and each one isolated a
mile or two from the rest, not leading into each other.

We were home for 19 days and then set off to London to rehearse a
sort of ballad-plays I have been writing for the Oxford Recitations
(where I have been helping Masefield for some years); and then to
Boar's Hill to play them. We did them again in London in the Autumn
with some success one night; but they didn't come off as well as they did
on Masefield's Elizabethan stage with two levels. They are rather
queer plays, and the London proscenium and switchboard and large
stage didn't suit them: they seem to be written for anybody but actors
to play anywhere but in theatres: and yet they are no good for amateurs,
for they need trained speakers, especially in the choruses.[1]

I think I am getting somewhere with them. But actors and theatre-
people don't care about them: dear John Drinkwater came to the
London show as my guest, and then wrote an attack on us in *The
Spectator*, which I thought was very odd manners. We are reading aloud
Lockhart's life of Sir W. Scott in the evenings and thought of John when
we read how Jeffrey attacked Marmion in *The Edinburgh Review*, and
Scott asked him to dinner, and afterward as he went away Lady Scott
said "Good-night, Mr. Jeffrey: I hear you have been abusing Scott in
the Review, and I hope Mr. Constable paid you very well for it."

I had better send you the book of my playlings.[2] Indeed I thought
of it long ago, but four dozen things distracted me. You will guess what
fun we had making Snow dresses[3] and Wave dresses,[4] and buying stuffs
by the hundred yards.

Which reminds me to thank you for the enchanting contents of *the*
parcel. Thank you very much, dear Paul: I am properly grateful for
such fine things, and I wish I could see the Corpse-Washer carried
out—in stiff black cloth. The other drawings delight us all the more
because we never had money enough to see your M.N.D volume in
Benn's ruinous series: your forest is exciting, and the fairy a real en-
chantment. But tell me—where do you find a dressmaker to build a
satisfactory costume from these subtle, slight, delicate hints. I wish I
knew of one.

.

I forget—I didn't finish about my playlings.[5] They are oddly all

[1] Two of the duologues ('A Parting' and 'The Return'), later part of *Scenes and Plays*,
were chosen as test pieces for the Oxford Recitations of 1928, and printed in the syllabus.
[2] *Scenes and Plays*, 1929. [3] For *Ardvorlich's Wife*.
[4] For *The Singing Sands*.
[5] GB divided his plays into two groups—plays for a *Theatre Outworn* (up to and
including *Gruach*) and those for a *Theatre Unborn*, of which *Scenes and Plays* is the first

wrong in a theatre; they need a bare open platform and a background of curtains. And even curtains don't always do: I believe the best thing would be a set of 4-leaf screens 12 feet high, that one could paint differently for different plays. But never at any time realistic scenery or an attempt at an illusion of real life. Just screens, and few floods or spot-lights; and carefully made single pieces of formal design to symbolise whatever is required. I tried all sorts of ways to suggest a ruined castle in "Towie Castle",[1] with realistically painted and cut screens; but in the end I scrapped them all and had two plain 7ft. screens made, grey on one side gold on t'other, and I use one side or the other according to the colour of the background I get.

Only one theatre-man will interest himself in my experiments, and that is Terence Gray of the Cambridge Festival Theatre.[2] He is about to build a theatre in London (with the stage in one corner!), and he says he is going to make a little theatre for my plays on the top of the big one!

· · · · · · ·

We also looked in on the Mutual in the Summer: he was going pretty strong then. Their present line is that I reduce Emily to exhaustion the way I drag her about the country; but don't you believe it.

· · · · · · ·

As to when you wrote last, I don't think it is a year ago: I fancy it is three. And then it was I who wrote last, accepting your offer of the models of my plays. But when you said nothing more I thought you had probably found a destination for them at South Kensington or some such place; and I hoped you had, for they can be so much better and permanently cared for there.

. . . Our love to you and Margaret, and may your New Year be kind and fortunate.

201

Oxenbridge Cottage, Iden, Sussex.
PN to GB *11 January 1930*

you put a chap to shame. You know, I cant quite understand what happened: why haven't I written to you for 3 years? And is it really true that I have not written for 3 years?? I have all the sensations of Rip

collection. These needed no picture-frame stage or built-up scenery. GB explores his views on poetic drama in his *A Stage for Poetry*, 1948. See *Poems and Plays* by GB, 1953, pp. 16–19. [1] *Scenes and Plays*, 1929.

[2] There is some account of Terence Gray ('a dark, stately young man like a Spanish grandee') and his exciting productions at the Cambridge Festival Theatre in GB's unpublished *Chronology*.

Winkle, whatever they may have been. There can be no doubt something odd happened in my head which seems to have shut the Gate of Smaragdus which leads to You and Yours and then lost the key. I have positive recollections of peeping through the bars from time to time, even of rather irritably shaking them but a kind of complex-inhibition or one of those states of mind one can pick up for nothing these days—prevented me from hunting for the key with any diligence. I remember once thinking of sending for a locksmith,—making a fuss. In the end it was abracadabra that did the trick—literally magic letters! I was going thro' my box of correspondence and came on some from you which was not put up with the main body—a stoutish bundle it is since 1908 or somewhere thereabouts—well I was reading over your letter—& God knows theres no one can write a letter like you—& I thought My God why have I got so out of touch with Gordon—I must do something about it and Margaret said, yes, youve neglected Gordon disgracefully, I cant imagine what he'll think of you. You are an *awful* man. And so I am, strike me purple! Well my dear old spiritual pastor & master I beg you have a try at forgiving me—but I see you are as sweet as ever—not a word of nastiness in your whole letter—not a

reproach even. It was a very amusing letter too. I laughed a good deal over the Mutual passages—I did once turn on him a bit one very sultry luncheon when my temper was excited by a monstrous meal of heavy meats steamed pudding and heavy Burgundy. . . .

Of course I heard all about you spinning poor Emily round and round

199

the country; I got the impression of some awful Old Man of the Sea—
Really one's friends are marvellous. As for John Drinkwater, he's
a very poor fish these days. But what a charming person he used to be
when he lived in a cottage with a dear homely sharp tongue wife and
wrote innocent verse and suffered from indigestion. I shall never forget
those harsh vegetarian lunches and John rising from the table with a
preliminary hiccough or two and reciting with a deep humming burr
'The birrrrd in the corrrrrn is a marrrrvellous crow,' or 'my garden is
alight with currants red and white—' It had a charm. But that's all in
the past. I am very interested in your Plays & Verses I have read three.
They seem to me full of a beauty I am not quite in touch with through
sheer lack of experience. I enormously admire the art of their construc-
tion & a queer thing behind it all which sits like a brooding spirit
'making the works go round'. I will not say more before I have
thoroughly read all the pieces but I thank you very much for sending the
book which I am happy to add to my collection of Gordon.

I got a horrid fright when I read what you had to say about my
theatre models. Another instance of complete aberration. I imagined
I had told you. When I came to examine the models (they had travelled
half round England & one had been abroad) I found them so damaged
from that & coated with dirt from their years board in an attic in
London that I realised I must practically re-make everything. This I
could not face, it would have meant hours of time. So I broke them up.
Some day I will make a new model for a new play. In the meantime I
am going to send you a sort of consolation, so dont weep. For the
moment I can only send you the little book I thought you already had.

I do hope you will like the look of some of the pictures but I have developed a good deal since 1926 & the new work has gained something I think. I started writing this letter directly I got yours but as I only have bits of the night to write letters in it has taken all this time—

Our united love to you & Emily. ever your comparitively middle aged young friend

202

The Sheiling, Silverdale, Near Carnforth
GB to PN 6 March 1930

It is a dandy little book, and I don't know why we missed it before. Thank you so much.

I like your prize picture, but even more I like the other sea-holly one, No. 10.[1] I feel somehow as if I had seen that one, tall and pale, when perambulating at Mrs. Trotter's.[2]

But most of all I vote for No 14, the trees with the undemonstrative pond. The planes and counterchanges in the boughs are lovely and wonderful—and all your own. I feel as if you could have got at this enchantment of design all by yourself, and if you had never heard of those tiresome ffrenchmen. ('Scuse—I didn't mean to go off like that.) Jack's Chilterns make me feel very nice too in your versions of them: and Mrs. Daglish[3] is obviously an attractive work of Paul's and God's.

Thank you again for the nice dear book and the comments.

Now is the Winter of my discontent. We have been in Glasgow—playing at my little plays; and the fog got us. I just missed pneumonia, but my lung is sufficiently explosive.

And I ought to see T. Gray producing my very ancient "Laodice and Danaë" along with Yeats's dance-drama at the Lyric Hammersmith on the 28th: but I doubt if I can crawl there by then.[4]

I send you a little picture of my Snow-people:[5] I could really do Something on these new lines of mine if I had a permanent place to do them in and could go on all the time.

Our love to you and Margaret.

Yours affectionately
Giordone Bottomelli (A.D. 1387)

[1] *Still Life*. Also reproduced in R. H. Wilenski's *The Modern Movement in Art* (Faber, 1927, p. 86). No. 14 mentioned below was *Pond in the Fields*.

[2] Dorothy Warren, who ran the Warren Gallery in Maddox Street.

[3] The only surviving portrait in oil by PN. Alice Daglish is the wife of the wood-engraver, Eric.

[4] Terence Gray directed his company from the Festival Theatre, Cambridge, in the production. *A Stage for Poetry* (facing p. 9) has a photograph of the stage set designed by Doria Paston. The dance-drama by Yeats (in which Ninette de Valois appeared) was *Fighting the Waves*, a recension of *The Only Jealousy of Emer*.

[5] The chorus in *Ardvorlich's Wife*, dressed in white.

From PN to GB [*PM: Nice 25 March 1930*]. They are sorry to hear he has
been ill again. They are on holiday in Toulon and Tamaris and now at
Nice. They expect to be home on the 6th April.

204

New House, Rye

PN to GB [c. *28 December 1930*]

 your post card[1] reached me just at the beginning of our moving
operations & delighted as I was to hear from you I confess I deliberately
'shelved it'. Now it is Christmas & passed Christmas and we are at last
in our new home which I have given you no news of as yet. Well, it
became imperative to house Margaret's father[2] somehow & somewhere
& suddenly the some*when* of the problem which had been such a con-
venient phrase turned into another word—shorter and not at all com-
fortable—literally, the word *now*.

 And then a kindly Providence showed us this house which, true, is not
in the country but so near it that we can console ourselves Pop, too
would never have 'gone' in a country house & we had long since
abandoned our building schemes. In short with a little compromise of
our ideals we accomodated ourselves and Pop. So here we are in a
great house with electric light, central heating, two bathrooms & all that
sort of pleasant thing and I am a freeholder—rather bothered and be-
wildered but with at least a room to myself to work in—for the first
time in my life. Of course Margaret & I have desperate moments of
wishing ourselves back in our cottage—free & easy but I suppose, since
her father had to be looked after sooner or later, this is not a bad way
of solving the problem. One thing we have which is an endless joy—
a view over the Marsh such as few houses can claim. You look right
across to the Folkestone hills and just below runs the Rother & a little
to the South you see the harbour with the sea chopping about beyond.
We have a small eccentric garden, too, walking down the cliff in terraces
—enough of a plot to keep me out of doors—where we can sit in summer
and gaze.

 I am sending you an old book[3] which perhaps you may like to have
but, please, if you already have it will you tell me and at the same time
say if by chance you have or have not my other one—the Lear of the
same series for I would send you that instead if you cared to add it to
your library. I am afraid these books are not so expensive as they look!

[1] Missing. [2] Mrs. Odeh had died in January 1928.
[3] *The Midsummer Night's Dream*, illustrated by PN for the Players' Shakespeare, 1924.

PLATE XIII

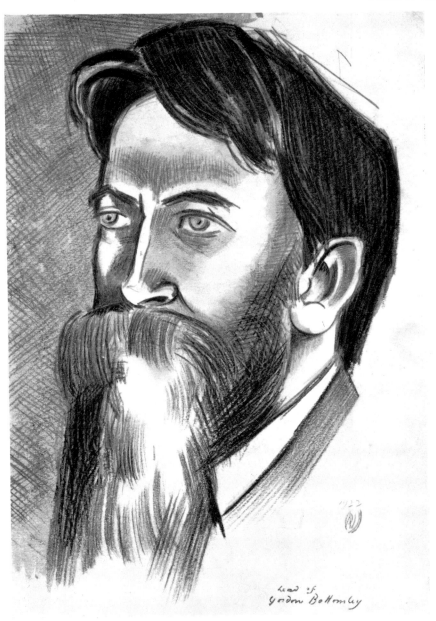

Gordon Bottomley, by Paul Nash, 1922. Pencil and coloured chalk. $13\frac{7}{8}'' \times 9\frac{7}{8}''$

PLATE XIV

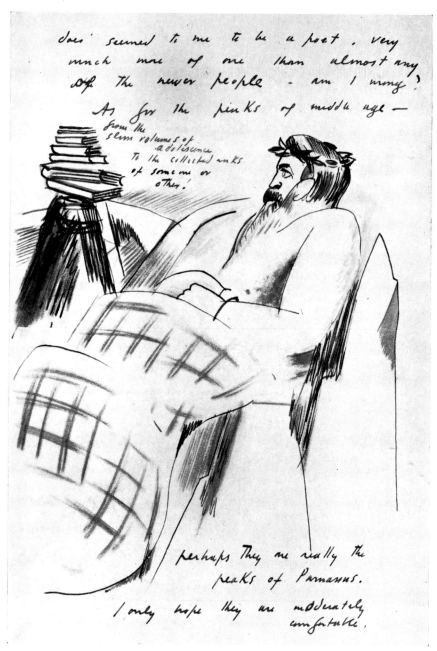

Facsimile of Letter 191, from Nash to Bottomley, 22 April 1925. The reverse of the second page

I hear you can pick them up for very much less than their published price but I thought you just might not have The Dream & I remember you admired the designs. I am just starting a glorious task—the production of an illustrated Sir Thomas Browne's Urn Burial & Garden of Cyrus—30 drawings & a cover design.[1] Rather the opportunity for something dont you think? Margaret sends her love—someday you must both visit us here. . . .

Our best wishes to you & Emily for the new year my love to you ever your young friend

205

The Sheiling, Silverdale,
Near Carnforth, Lancs.

GB to PN *30 December 1930*

Your noble pacquet and equally welcome letter arrived this afternoon; and I have spent nearly all the rest of the day on them with great contentment.

.

We haven't known either of your volumes, and it is still nicer of you to give us the choice; but now that we have seen the "Dream" we shouldn't like to let it go, or to contemplate being without it. So we will happily settle it as you have decided: and here are our true thanks for such a noble celebration of friendship.

Of an old friendship, for this is the twenty-second Christmas since first we wrote to each other, and since I returned your very first parcel of drawings.

Now one comes to think of it, you *were* my young friend then: but now we seem both of an age, and to our youngers I suppose we both seem comfortably Olympian!

WELL: it makes me happy to have been in at your beginnings, and to have lived to see you so universally recognised.

I think I ought to offer you something in return, on receiving such a gorgeous piece of your handiwork. But what have I? Did I ever send you my large volume of selected poems including the revised version of my old "Phillis", which I dedicated to you because you begged me to include it?[2]

Perhaps not, as you already had most of it in "Smaragdus". If not,

[1] Edited with an introduction by John Carter, Cassell & Co., 1932. The typography was by Oliver Simon. The illustrations were made from collotypes and coloured under the supervision of Harold Curwen from stencils cut from PN's hand-colouring of an original set of collotypes. [2] *Poems of Thirty Years.* See Letter 143.

would you like a copy now? I have reason to be grateful for your advice, for "Phillis" in her furbished dress has been praised by rather special people—and no one ever looked at her before.

．　　．　　．　　．　　．　　．

You have been in the foremost of our thoughts lately, for we have been reading you on the theatre in The Theatre Arts Monthly.[1] Of course you are right all the time. The theatre doesn't want the poets, either, and all my thoughts are centred now on getting poetry performed without the theatre's mechanism—and also without the mechanism of realistic acting. A bare platform, a semi-circle of high screens, two moveable floods AND beautiful clothes and speaking—these give me most of what I asked from the theatre.

Emily joins me in love to you and Margaret and in wishes that your New Year—and many New Years—are to be fine and fruitful and fortunate. And my thanks again.

206

From PN to GB, Rye, 6 January 1931. He sends 'only a scrawl' to acknowledge the last letter and say he has not got the collected poems.

207

New House, Rye, Sussex
28 February 1931

PN to GB

Beloved Gordon

I was sadly disappointed when the last chance of seeing you was gone.[2] As I told Emily, I was made late that morning by two telephone conversations forced upon me one after the other just as I was ready to leave. Breakfasting I had found impossible. I did not reach bed till early morning for I was sitting in a black, polished room drinking rum and listening to Bumps Greenbaum—Goosen's [Goossens's] brother in law—talking about music & musicians with a special reference to 'Peter Warlock' who had been his great friend.[3] This was rather interesting so the night soon wore away I got to your hotel ten minutes

[1] 'I Look at the Theatre', *Theatre Arts Monthly*, 1930, pp. 1051–5, in which PN comments on the patience of English audiences: 'Either they simply do not care, or they are incapable of discrimination.'

[2] Either a letter concerning the proposed meeting is missing or the Bottomleys had telephoned from London. There was certainly some telephoning.

[3] Philip Heseltine (Peter Warlock), 1894–1930, musician. See *Peter Warlock: a Memoir of Philip Heseltine*, by Cecil Gray, 1934.

before ten & they told me you had already left. So I pursued you to the Persians[1] but after almost an hour you did not seem to be there so then I could do no more about it. I did not get much out of the Persians they are not quite what I like, the eyes goggle in the head with wonder but the heart leaps not—at least so I find. I hope you did better.

At last I have had time to look more closely at Poems of Thirty Years. I am glad you included so many small things—especially the dedications which often seem to me to express so much putting me into touch where—at this long time since—I find myself groping. For many of these poems belong to a period of my own life with which I have lost touch and this makes me rather sad or irritated. I think I still like my early favourites. The last of Helen always impressed me very much —Phillis I read with the same pleasure. I did not see where you had mended her so you must have done it very skillfully. There are lots of poems I remember vividly and have met here happily as one meets old friends. Others I have found which never became quite my friends, we bow rather gravely and pass on. But I think it is the impression of a mind which I feel most and I have always loved your mind, Gordon. It stimulated me when I was young and I have never lost the sense of its peculiar power—its radiance. The poetical expression of that mind seems to me, who must have read pretty well everything you have written, happiest, most sure, most triumphant in the dramas. In them poetry concentrates to a purpose, is less decorative, has a sheer force which packs it tighter than the moulds of the verse forms. I express myself badly I expect—I do not think it is the forms of the poems which matter to you but you seem essentially a big gun—a long range gun not a quick firing piece or a Stokes vollier or even & especially not a deadly rifle & certainly no sort of pop-gun. So I like you best when you're putting over a barrage & preferably a 'box' barrage. However this may well be all nonsense—& in any case it does not mean I look askance or askew at this volume of thirty years poems because of course I am delighted to have it. . . .

I have a full time before me[,] a show to work for next year & a visit to America in the Autumn where I go to represent G.B in the International Exn of the Carnegie Institute. And all the time the business of keeping the head above water goes on—I do wish I could some day really float! Well, I must wind up as there is much to do. Margaret sends her love to you both & again thank you for the book—

[1] The exhibition of Persian art at the Royal Academy.

The Sheiling, Silverdale,
Near Carnforth, Lancs.

GB to PN *7 March 1931*

My dear Paulo-post-futurus,

(which I think means the letters I hope to receive from you in the future by post.)

A letter from you always makes me feel pleasant inside; so here are my thanks for this one lately to hand. I believe it is as you say—the time when we were Both Young (do you realise I was only 35 when you sent me your first parcel of drawings?) did some thing to us both in creating an atmosphere to which we can still resort fruitfully.

And it is especially on account of that that I mourn because I am afraid you think my behaviour last week was a little less than kind. I mourn; for I meant well.

I should like to persuade you I meant well. I realised that the breakfast idea wouldn't be practicable for you; but when I mentioned 9.30 to 10 a.m. I meant it was really all I could manage, and that I could just manage half an hour then. I knew I ought to be out by 9.30, and I felt I could postpone it as far as 10; and it never occurred to me that you would think I had mentioned it as a vague range for your arrival time on a visit that we could happily continue later into the morning. So when the hotel clock pointed to six minutes to ten I said to Emily "He will never come now, for only a five minutes talk, when he knows we must leave him at ten. I am sure we might as well go now."

So we went; and I suppose you must have come from the Gt. Portland St. side, as we kept a sharp look out all down All Soul's Place.

I'm dreadfully sorry, Paolo; but you get to London so easily and often that you don't realise how one packs every minute of London tight with the things to be done when, to begin with, it costs one three pounds to get there—and God knows what to exist there when one hasn't a flat of one's own.

I'm dreadfully sorry about the Persians, too; for I know I told you we were going there. But that was a corollary of the other. We had several things to do on the way there; and dedicating that half hour to you put us forward into the time of traffic blocks; so that by the time our preliminaries were over there didn't seem time to make the Persians worth while—it was to be our second visit, and on purpose for the little paintings; so we did a few more odds and ends, and then it was lunch time.

I mourn; but it wasn't quite our fault, my dear.

I had to go to the Persians alone next day. Yes, they make my heart leap all right: but I found myself liking the earlier, clumsier, rather

larger miniatures most of all—and the later ones most when the man hadn't had time to put the paint on and had left the enchantments of his drawing uncovered.

I believe graphic art always comes to me more naturally than volumetric art. I'm not insensitive to the latter: I can look at it until understanding and enjoyment begin: but the other is the country where I live myself, and there I don't even need to remind my sympathies to keep awake.

Perhaps that is why I like the Persians. And why you feel you have gone so far from me and your younger self.

I liked what you say about "Poems Of Thirty Years": it is such a very old gift horse that to look it in the mouth is really the most felicitous way of handling it. What you say is very just, too, and not far away from the realities of it. It contains so many things I shall not do again— narrative poems, for instance: yet, if you compare the first Phillis with the second one, you will see I know much better now how to do a narrative poem than I did when I first wrote Phillis.

And up and down the book I fancy there are frequent signs that I was learning how to do the plays.

Especially now that I have discovered I have no use for plays that are just photographs or realisations of life. I wish you could see my new plays.

.

We always talk of getting to Rye: I hope we shall manage it before long, and have a better chance of a talk than unkind London gave us. In the meantime, we send you and Margaret our love.

209

New House, Rye, Sussex
19 December 1931

PN to GB

My very dear Gordon

Yes, I have a gramaphone but why are you so dejected?[1]—except that all of us are rather down in the mouth—[2]. . . We are so busy we have hardly time to worry. I have become a sort of second rate Roger Fry these days, as art criticism and such is one of my few means of livelihood,[3] and poor Margaret is doing all the cooking. But I'm told

[1] A letter from GB is clearly missing.

[2] Drawing of PN, MN, GB, and EB all 'down in the mouth', with a thin caricature at the side—'As for old Percy he sounds awful.'

[3] He was writing regularly in *The Week-end Review*, a weekly periodical founded and edited by (Sir) Gerald Barry, of which the first number appeared on 15 March 1930. Its last number appeared on 6 January 1934, when it was absorbed into the *New Statesman*. PN's first contribution was in the issue of 6 December 1930. He also contributed irregularly to the *Listener* from 29 April 1931. See *Paul Nash* (1955), by Anthony Bertram, bibliography.

I dont write so badly for a beginner and Margaret is certainly a good cook. We had a lovely time in America the Yanks were sweet to us and New York is really beautiful. I didn't make any money out of them because I was just the British representative on the Carnegie Institute Jury with all expenses paid but I made what they call 'contacts' which is a pleasant & possibly provitable thing to have done. I wish you could see America it is a stimulating place and delightfully dotty. Forgive a hurried letter I am compiling a small book—which I will send you when it comes out.[1] My Christmas card will be late this year so dont fret.

Our warm love to you both

210

The Sheiling, Silverdale, Carnforth
GB to PN *21 December 1931*

Caro Paolo,

Bless you for your illustrated letter that made me feel young again. I am a noodle for not remembering you had gone into Rye: I knew it quite well once, but I had never confided it to my address book: I wonder my card ever reached you.

.

Things have been happening to us: the last one is that Emily broke her right wrist last week, and we are carrying on on the other. But my dejection didn't allude to personal things: I was only just casually feeling rather sick of the universe, and rather hopeless about the future of a civilization that has mechanised itself too well—and will presently reject the arts because every creative artist is necessarily an exceptional being and always contradicting the pattern. It is pleasing to hear of your emulating Roger Fry: tell me where you are doing it, and Ill attend to you. It's a rum thing, isn't it, that our beautiful public will attend to what another artist says of an artist's pictures, and put down their cash to hear him, when they won't buy the pictures?

But there's one thing you can't do, my Paul: you can't paint like Roger.

(Here you should hear me do my Chaliapine laugh!)

Well, I'm happy you have a gramophone: for I want you to have the records that wouldn't exist but for me.

"The Curlew"[2] at that Warlock concert enchanted me so completely that I didn't rest until I had persuaded the N.G.S. to record them. And

[1] Presumably *Room and Book*, The Soncino Press, 1932.
[2] See p. 204. *The Curlew*, for tenor voice, flute, English horn, and string quartet, 1924. The words are by W. B. Yeats.

as we met at the concert I feel you ought to have a set of them as a Sooveneer.

So Here They Are with our love to you and Margaret—hopeing as 'ow you will 'ave a merry Xmas and no flies on it, likewise a fortunate New Year—with The Situation behind us all.

Yes, I would like to see about as much of America as you did, lucky fellow! To get in—and then to get out again—how perfect! I'm dejected you didn't write to me from there.

But we send you both our love; and I am yours in venerable affection

211

PN to GB

New House, Rye, Sussex
[late December 1931]

Beloved Gordon

what a superb present! We find it difficult to thank you. It is very good of you and you have given us both great pleasure. I am so glad you made the Gramaphone people do the 'Curlew' for it is a unique thing. Warlock's genius for interpretation is really astonishing; his song is more Yeats than Yeats, apart from being most musical. Whenever I want to feel one and twenty again I shall play the Curlew because it recalls, like nothing else, the emotions of those days when I first read the Wind in the Reeds.[1] I find myself wondering what I can send you in return. Not by way of retaliation because I am down & out. I have taken the count & am content to give you best—completely floored by 4

discs. But I have in mind a something you might like to add to your collection of odds and ends &c. To go on with I am sending this

[1] *The Wind among the Reeds.* PN wished to illustrate this book in 1913 and had an interview with Yeats, but nothing came of it.

book which although not new has perhaps escaped your eye or your grasp.[1]

Gordon, your letter was perfect! we loved it. I have had many letters from you and I have hoarded them all—but your Christmas letter was one of the most delightful ever written from one chap to another. I will send you a few articles to amuse you. I feature in The Listener and the Weekend Review

Our love to Emily & our best wishes & blessings for you both

212

From PN to GB, Rye, 15 January 1932. He sends him what he describes as 'my first, or almost my first, design for a scene—apart from the drawings I made earlier still for your plays.' [This was probably *A Platform Facing the Sea*, now in the collection of Mrs. Paul Nash, reproduced in *Theatre Craft*, No. 5, 1920 (Supplement to the *English Review*), edited by Hermon Ould and Horace Shipp. A different version was reproduced by Ould in an article 'New Tendencies in the Art of the Theatre' (*World's Work*, June 1922).]

213

at The Shiffolds, Holmbury St. Mary,
Near Dorking, Surrey
GB to PN *2 February 1932*

I am afraid you thought I was too long in acknowledging the noble present you made us of the Nash-Armstrong book:[2] so I daren't even think of what you are thinking by now, when I have left so long unacknowledged the beloved drawing too.

.

We thank you enormously for both your gifts, which shall be always treasured. The book is a fine one, and we knew absolutely nothing at all of it except the last story, seen once in a magazine; and nothing at all of your share in it.

O, yes, the cover-paper[3] I did know: two or three years ago I bought two sheets of it at a book-binder's in Cambridge, and then two sheets more from the farded lady at the Warren Gallery. But that was all, and

[1] See Letter 213.
[2] *Saint Hercules and other Stories*, by Martin Armstrong, with five drawings by Paul Nash. The Fleuron Ltd. [1927]; 310 copies.
[3] Designed by PN for the Curwen Press.

we are so glad to have the pictures—and Martin Armstrong is always one of my admirations. So you can be sure we were pleased.

And you can be doubly sure we are pleased about the drawing: for it pleased us long ago when Hermon Ould reproduced it in "The English Review", and now—seen long afterward—it has all its old charm and its quality of stimulating the imagination. Thank you very much indeed.

It is a pity there was no one in the Bub-ub-british Theatre at that moment to take you and use you hard: there was something present in what you were then doing that would have yielded new qualities in stage-practice. Probably you would have come to a deadlock with our actualistic stage, though: I think you were working toward a 3-dimensional stage, as I unconsciously was even then. The theatre didn't want either of us: but O, Fra Paolo, what fun you and I could have if we had a large room of our own with a bare platform not quite at one end, and could do what we liked without audiences.

You will see whence I write—and the dear place is peopled with ghosts out of the old times, so that we even see you sitting on the hearth-rug. It is all different now, having been added to at both ends, and being at least one third larger.

The Trevelyans send you kind remembrances; and Emily and I our love and our real thanks.

<div align="right">

Yours always,
Gordon.

</div>

Did I ever thank you for your notices of exhibitions? I really like them, they are deft and agreeable and *most* admirable in tone. I like the way you dwell on what you like—a lesson to critics. And I am infinitely obliged to you for an introduction to that joyful Frenchman B—taud:—[1] I can't remember the rest. But one of the "Listeners" you sent had your article torn out: I didn't enjoy that one nearly so much.

<div align="center">

214

</div>

The Sheiling, Silverdale, Carnforth, Lancs.
17 January 1938

GB to PN

Well, My Paul,

This[2] is as charming and generous of you as ever; you never waver in your loyalty to that time when I was the elder and you the beginner—and every time your remembering puts aside so graciously and genially the salient facts that you are famous in your own right, and that we are

[1] Presumably refers to PN's article on André Bauchant (*Listener*, 3 June 1931).
[2] Presumably a lost Christmas letter after a long silence.

pretty much the same age or a little more by now, that I own to a glow of mixed kindness and pride. And your remembering always says so appreciatively that I did have a little hand in clearing the way for you, that I am sure you will not mind a little of my pride in your achievement and position.

Of course we ought to have written oftener than we have done of late years; but we are both at the time when the world is too much with the fellows who know they have something of their own to do, and correspondence becomes a task-master—so that the letters one most wants to write are the letters that never get written. Also, since *we* (E. and I),[1] have begun to run about—making up for all those immobilised years—I never seem to catch up with the things waiting at home to be done.

Anyhow, I protest entirely that the ways your genius have taken have nothing to do with my failures to write. I own that the period when you seemed to like to group little puff-balls of colour in mysterious relationships did not say as much to my angular Northern mind as your earlier work did. I own, too, that I do not feel any need to be Surrealiste; and that you are the only Surrealist whom I care about. Still it is to be put down to my credit that when I met your "Mansions of the Dead" in the "Manchester Guardian," I giggled and knew what you were up to —and cut it out in admiration.

And, so, we always remember to be *au fait* with you; and, as I was saying, the essential thing is not that we sometimes find ourselves not travelling the same way as you, but that we can always count on your periodically doing something that speaks to our old hearts as of old— and that tells us that Paul I (eldest member of your Dynasty) still survives and possesses the creative energy that can always delight us.

You tell me to take heart because you are now on the short way home (to the kingdom in which we first met); so I feel really entitled to remind you I once wrote to you that the best place for an artist to work in is his own parish, but that it is not enough for him until he has gone right round the world and entered it from the other side! Was I truly a prophet?[2]

Well, there isn't much published about you that we haven't, and we are happy and prideful to add this new large monograph to the rest.[3] Of course you know which plates we like best; but you will (won't you?) put it down to my credit that I did cut out "Mansions of the Dead" unbeknown to you. And I am bound to enjoy the way in which the

[1] The words 'E. and I' are written in the margin.

[2] See p. 46.

[3] *Paul Nash. A Portfolio of Colour Plates*, with an introduction by Herbert Read, published by the Soho Gallery, 1937, in their series of Contemporary British Painters edited by D. A. Ross and A. C. Hannay. The picture on the back was of Iden, not Iver Heath.

Dymchurch shorescapes yield up such fineness in reduction. And you will not blame me for suddenly rejoicing at seeing a Souvenir of Ivor [Iver] Heath on the back cover. And, of course, you will not mind my liking the picture[1] on the front cover for being so nearly geese.

I have a natural reluctance to own that Herbert Read[2] is anywhere near good enough to write about you at all; . . . but certainly he does bring a certain—and an unusual—understanding to his consideration of your art, and says things about you that I find myself taking seriously and appreciating as praise.

Still, I shall find myself happier when I am reading your auto-biography;[3] and I hope fervently that my various maladies will let me live until it is out—and a little longer. I, too, shall enjoy going back to that time when you "get to me," and shall also find it "very warming".

For the rest we grow older; and love the same things and people and painters and poets; and I make another play now and then (which you will see when they get it into volumes), for that still unattained First Folio which I mean to call "Plays For A Theatre Unborn." But most of every year we are away: much in Scotland; in the Spring for the past four years in Greece—and we hope to be there in April again and see Crete.[4]

By the way, I am now your rival: I take photographs, and I know you do also, for last July I bought your "Shell" Dorset book[5] at the Boutique Moderne in St. Andrews and saw your photographs there. *They are quite good*: but I am enclosing you some of the marvels which I take!!! With my love.

I think we should have met before now if I hadn't got into the way of thinking you lived at Rye. I am so pleased you are back in London[6]— and we will try to find your sumshus house on the very first opportunity. That will most likely be in the last week of March, when we are making for Toulon and our Hellenic ship—going a few days earlier than the rest to spend them at Avignon. But I will let you know if we are pausing in London.

In the meantime, do get on with your autobiography. Have you put in the time of your first show, when Carfax's paid you with golden sovereigns, and you and Jack made patterns on the carpet with them. Well, thank you again for your valued gift and your letter—both of

[1] *Encounter in the Afternoon.*

[2] Sir Herbert Read, born 1893: poet and critic.

[3] The fragment which PN completed was published posthumously as *Outline.* See Introduction, p. xv.

[4] As he grew older GB became less of an invalid and with EB's help travelled widely.

[5] *Dorset.* Compiled by Paul Nash. Shell Guides Series, Architectural Press [1935].

[6] PN had moved to 3 Eldon Grove, Hampstead, in 1936.

which we shall treasure. Our love to you and Margaret; and may your New Year be a fine and fortunate one.

<div align="right">Your same old Gordon.</div>

P.S. A year or two ago I found myself at the same house as your old Bolt Court teacher, Cecil Rea. He shook his head over you—but was obviously proud of you.

.

215

3, Eldon Road, Hampstead, N W 3

PN to GB [Early March 1938]

My Gordon

Thank you for a lovely lêtter, as only you in the world could have written—so full of warmth & wit It is March and I am wondering if there is the smallest chance of you passing this way and being able to perch here a moment. A luncheon, just to stoke you up on your migration. It is a comical somersault of Fate that you & I have changed places. Here I sit propped up with quite as many pillows as you used to have Im sure & envy the picture of you trampling about the far world like a lusty young elephant. Static Paul, mobile Gordon. Of course Im not such a prisoner as you used to be but the damned disease is pretty crippling & has managed to rule out most pleasant adventures for the last five years—I mean anything like going out of England has been impossible. But now we have at last reached the point where I can hope to escape. Every thing has been tried, the asthma is certainly less & a warm climate may just do the thrick and release me. Forgive me running on I did not write to you for that. I cant remember the name of your house at Cartmel and the full address oddly enough and at the moment I cannot lay my hand on your early letters which are preserved in some box we have mislaid. I have just done the bit about you & me in my geogbiography I may send you a copy to approve of. It is not very long but very poignant, and you will pop up again later on.

I had a terrific letter from the mutual the other day he's really rather sweet. Have you stayed at that Mill yet[1] . . .

This letter has been hanging about not getting posted. It is being 'rushed' to you at once as the journalists would say. Send me a card about the ancient address.

P.S. I *was* pleased about you & the Mansions of the Dead & I'm still grinning about *so nearly geese*

[1] The Withers had moved to Epwell Mill, Banbury, where PN had first stayed in 1935.

The Sheiling, Silverdale,
Near Carnforth, Lancs.

GB to PN *10 March 1938*

O, Paul my dear, what a dreadful thing. We *have* heard asthma and you mentioned together in the past: but we thought it was long over, and never, never did we have any idea that it was dogging you chronically in this way and limiting you so cruelly.

Is it some legacy of that old, terrible Dymchurch illness? (We were through the edge of Dymchurch a fortnight ago, and thought of our time with you there first of all.) The thought of my own illnesses never troubles me as those of my friends do: I was so well broken in that I could usually find something to do that I vividly wanted to do: but so few have that apprenticeship, and I can feel the discomforts and restrictions of the others far more than I ever felt my own.

And even I am not wholly clear of the old days. My old lung still dislikes working hard; and I have started a gastric + gall-bladder business that certainly is not immobilising, for it requires me to exercise when the lung says "No"—but is more frightening in other directions.

.

WELL! I was happy to have your gift and delightful Christmas letter; and we have been intending to take the first chance of seeing you that we could make. On our way home from Kent we meant to manage it: but we had only been one night in London when we were called home by the grave illness of my delicious ninety-year-old mother. (And alas, Paul, she died this morning after days of torment.)

But we will try to see you soon: for several Aprils we have gone sailing about the Greek islands: we hope to go again next month, and we WILL try to see you in coming through London—at the end of this month if possible; but if we only have one night then, we will manage the meeting a month later on our return. I hope you will not be trying your new wings just then!

Of course I am keen to see myself in your mirror. The blessèd house's name and address was: Well Knowe House/Cartmel/via Carnforth.

.

Give our love to Margaret, and believe you shall see us before long.

Yours affectionately
Gordon.

P.S. I did hope you would pat my head a little for my photographs: and you never mention them!

217

From PN to GB, no heading [Summer 1939]. He wants to know where to send the typescript of his autobiography.

218

GB to PN

<div align="right">

The Sheiling, Silverdale, Carnforth
26 August 1939

</div>

"Even in my ashes live their wonted fires"; and any day gives me a decided lift if it brings me a Communication from you.

Thank you Very much for the magazine:[1] if I had known it was out I would have had it long ago, but you give me my first news of it, so I am grateful to you for that too.

It (I mean your share of it) is attractive and delightful—which means that it helped me back into the years when you were young and I was still rather young, and life was illuminating and illuminated, AND nohow beastly. I didn't know about Image[2] before, and that bit is especially gracious and charming.

Also my eyes *ate* ravenously the grand old pyramids drawing: that particular pen-technique of yours always enchanted me with its richness—so that I felt compensated for discovering that you only got the back of the patterned fabric that was Rossetti.

Of course I wanted to go on with the tale of you immediately, and I grieve that that nice young Cobden-Sanderson's business has gone down and let you in. That came as a great surprise to me, for I thought him solidly established and of great reputation by now. But times are crool 'ard just now, and one quite often feels a gush of warm sympathy even for publishers.

We *have* been away most of the time since Easter—more than a month in Norway, where we travelled beyond the Arctic Circle, and saw the (enviable) Lapps *in situ*: and we only reached home last week.

So that this *is* the moment when I could welcome the type-script of your memoirs; and I shall be more than grateful for the loan of them...

Immortality creeps in on me: I have also a considerable place in Ricketts' diaries and letters, which the elder Cecil Lewis has now in the press with Peter Davi[e]s.[3]

[1] *Signature*, No. 9, July 1938. It contained an article by PN called *Openings* which was an instalment of his autobiography, *Outline*.

[2] See p. 7, n. 1. The incident connected with Selwyn Image now appears in *Outline*, pp. 81 and 82.

[3] *Self Portrait: Letters and Journals of Charles Ricketts, R.A.* Collected and compiled by T. Sturge Moore; edited by Cecil Lewis, 1939.

I am happy you mention my new book—both because your singling out of the Plague play[1] cheers and warms me; and because I had been reproaching myself for not getting-off your copy—so that you nearly received another!

.

I do hope your asthma has not been active with this inhuman Summer. One good thing is that the army will let you alone as well as me this time. All the same, I should enjoy making a bull's eye on Hitler as much as ever I have enjoyed poetry. Our love to Margaret and you. Your old original Gordon.

219

The Sheiling, Silverdale,
Near Carnforth, Lancs.

GB to PN 29 March 1941

Would you mind telling me where you are; and where The Lady Margaret is?

And how your chest has stood this gruelling Winter? And what you are doing? And how much you have done of it? And how much contact you have made with my other air-painter, Alan Keith Henderson?[2] And where you are?

It was Keith who told me late in 1939 that you and he were to work for the Air Ministry; then, later, that he had seen you in London, and that, together, you had concerted a plan of campaign. Then he went off to The Kingdom Of Fife, and settled in the city of Saint Andrews; and I thought I might be hearing of you there also. But I never heard of you again; and presently he returned home to the Western Highlands.

And we do want to know what this unsettling earthquake of a time has done to you; and if you can bear it, or if it has started your chest weakness again. And, in short, where the Devil you are. . .

I began this war with my war-work of old time—seeing other men's work through the press when they had to march away; but that did not last very long, and since then I have found nothing to do except grow old. Being no use to our country, Emily and I do that sitting alone at home—trying to keep well so that we shall not need nurses who can be better employed getting people better who *can* do something; and refraining from travelling because in this place we must be our [own] fire-watchers (or the place would be a good-going bonfire before the village knew about it.) So we have never slept away from home since the war

[1] *Fire at Callart*, published in *Choric Plays*, 1939.

[2] Alan Keith Henderson (b. 1883), painter. His portrait of GB is in the Carlisle Art Gallery.

began (we were then newly back from the Malvern Festival, little thinking it would be our last Burst!)

For lack of something better to do, we are growing old sooner than we need have done. However, there's no need to dwell on that, it can't be helped: what is worse, there is no spirit for working nowadays. And That can't be helped, either; and it matters more. So we keep our teeth into Hitler as well as ever we can, and hang on grimly from day to day.

Do tell me if you two have been able to hold on to Eldon Road; or if you have been bombed out. And that you are still pretty safe and well. And when your memoirs will come out; or if the war has dished your chances for the present.

Anyhow, here is our love to you both; and I am your all-the-same affectionate old Gordon.

It was such a pity the war came when it did: I had just begun to write Comedies, and was doing it pretty nicely.[1]

220

106 Banbury Road, Oxford
PN to GB [17 April 1941]
My beloved Gordon

this is really a very strange thing. Yesterday I went over to see Jack at Meadle—he is just off to his new 'hush' job in the North. As I sat down to lunch I saw a letter on my side plate 'boasting' as journalists like to say—and well might it 'boast'—your inimitable caligraphy. It was the most delightful surprise. But we must be getting telepathic in our wise old age, for while you were enquiring so tenderly where the devil I'd got to I was trying to get off a decent sized letter to you telling you & trying at the same time to make my peace & generally explain myself away. As usual I never finished this letter and now damn me if I can find it! So this is being rushed to Silverdale while I have another frenzied search.

It was lovely to hear from you—here I am interrupted & must put off finishing what I was to say until tomorrow We too are sitting down & getting old. We are rather unhappy because we are so unfit and we have got through all our money. We cant see very far ahead. We feel we have no right to live on obstinately as two burdens or casualties Personally I never expected to survive so long[,] I imagined that if war came that would be the end of everything. Well it hasn't turned out like that, but I cannot see any future. It would be different if we had health but we're just a couple of crocks—fairly bright crocks, still

[1] Probably a reference to *The Falconer's Lassie*, printed in *Choric Plays*, 1939. GB's best-known comedy is *Kate Kennedy*, 1945.

with a bit of glaze on them, but crocks for all that. You heard of my
a[e]rial adventures from that nice creature Keith Henderson. I must
write to him. The Airmen liked my pictures, not so the Air Ministry . . .
Our Relations became somewhat strained eventually but when they
baled me out at about 20,000 ft. as it were, Sir Kenneth[1] Clarks Com-
mittee[2] rose as one man & hissed & booed (because I was supposed to
be doing rather well with my air subjects, nearly everyone liked 'em,
even 'high- brows'. So Minnie the Moocher[3] stepped in & took me on
& now I work for M of I in a very free lance sort of way with a market
for my work nice & eager to purchase if all's well. But no fixed salary.
So long as they buy I dont mind but everything is very precarious.
I have found letter No 1.[4]

221

106 Banbury Road, Oxford

PN to GB [c. *end of March 1941*]

The last I heard of you was from a letter written to Keith Henderson
when he & I were official art buddies in the Royal Air Force—or
thereabouts. Of course there is no reason why I shouldnt write all the
letters I mean to write to you, except that I dont write the other letters
to those other dear friends who deserve them.

I am just a lazy lout, a double crossing, four flushing procrastinating
lizard. But when I happen to read an old letter from yǒu & am re-
chaufeéd by its steady glow I feel *less* than a lout or lizard even, I sink
steeply in the levels of life. I feel it were best for me to shrink back into
my shell or 'put on my hat & crawl under a snake.' You know Gordon I
am now as old as you were when you wrote many of those letters—
listen "Your aged friend (I was 53 yesterday—isnt it a damnable
business) Gordon["]⁵

I shall be 53 in May! yet a moment ago I was still thinking of you as
the sage & myself as the young artist seeking advice. I dont say that I
thought of you as ever elderly, because you never are or can be, except
in these inscriptions. but I seem to have gone on quite inconsiderately
considering myself as young. Am I that most trying of all forms of life
a peter-pan! God forbid. Be your age! as the Yanks say.

Well, dear sage, you have written me some beautiful letters, I have
them all I think—and they contain some excellent wisdom, apart from
their quite admirable expression & lovely style. You may remember I
was trying to write my 'life', I am still trying but I have got a little

[1] MS. Kenneth's. [2] The War Artists' Advisory Committee.
[3] Ministry of Information. [4] Presumably that which follows.
[5] Quoted from Letter 196.

further. When the war began I was badly eclipsed. I stopped painting
& writing & invented a new job for myself, a wild affair which was
near being the end of us since it turned out a monster that devoured
time energy and all our spare money It was called The Arts Bureau
in Oxford but I dont suppose you ever heard of it & it would be a bore
to describe it now. Enough to say we tried to find jobs for artists where
they could be intelligently used. And, one way & another we did do a
lot of useful spade work I think. Then when the Central Institute for
Art & Design was established—I was one of *its* special committee as
well—the A.B.O turned over all its dossiers etc to the Institute. By
that time my air job descended on me, of which elsewhere. I am still
deeply interested in air subjects—especially those a[e]rial creatures—the
fighters & bombers. I am sending you a photograph of one just to make
your beard curl. Presently I will send you one of my big picture just
finished *Totesmeer*

But I started out to write about the happy, hazy past—yet, not so
hazy perhaps I have been living in it considerably lately & only the
other day was describing my visit to The Shiffolds when I first met you
& Emily. I was waiting until this bit is typed to send off the whole book
so far as it has got—as I meant to do so long ago. Now maybe it would
come in handy to amuse you in a dull hour. Also dear Bard—or should
it be Skald—do you remember when Morris went to Iceland they
welcomed him v[ery] warmly & he was described in the local paper as
William Morris, Skald, which made Rossetti laugh so much he nearly
had a fit. Henceforth he said Topsy must never be called anything else
& 'The Bard' must descend to Swinburne.—well anyhow what I want
is your permission to quote from some of your early letters to me, may
I please?

There is another more exciting thing to say. Jack is now posted very
far *North* The Royal College of Art where I held a queer special teaching
job up to the war is removed to the *Lakes*. Jowett,[1] the Principle, has
suggested I might go up there for a week some time. Also I can travel
anywhere I want to & have my fare paid so long as it can be on M of I
matters. What more natural than a visit to the Shieling—I hasten to
add—only for a night or only for half a day—probably in these times
altho' you will be frank about that. I plan to get Margaret along as soon
as she feels rather better Wouldn't it be fun! Our united & individual
loves to you both & severally

.

[1] Percy Hague Jowett (b. 1882), painter, one-time headmaster of Chelsea School of
Art, Principal of the Royal College of Art (1935–46).

222

I am pleased you have had some little anxiety about non-arrival of your letters . . . but . . . your twin-letter arrived with inglorious promptitude and in unimaginative safety. I should have replied before, but on that day I had started for Lancaster before the postman arrived, and did not get your letter until my return at nearly-supper-time. And I should have written yesterday; but, being Sunday, we went off to an amateurs' dress-rehearsal half-way to Preston—and that also ate up much time.

For which reason let me waste no more, but get down to practical things and the pretty news in the end of your letter. If you find you are actually passing through Carnforth to Keswick, of course we should be unhappy if we do not get a look at you, too. In peace time it was a thing easy to manage, and one or other of our Scots friends used to do it from time to time; but nowadays Bradshaw is in an indescribable state, and the journey plus us will almost certainly take you two days! That is no drawback, however: our only trouble is that we cannot entertain you entirely here, as we are servantless and in a state of permanent picnic. (The only war-work that seemed feasible to us was to look after ourselves, and not keep any servants from being nationally useful: so we are doing that.) But nowadays one of the local hôtels has become better than any of them used to be, and the landlady can usually let us have a room for our guests; so we take them to the hôtel, and we can still have them here most of the day.

The only thing is that the hôtel is popular with evacuees, and soon begins a permanent holiday season of people on leave as well. So, when you know you are coming, tell us the day to take the room for as long ahead as possible.

．　　．　　．　　．　　．　　．

Well, you are still not as old as we are! Possibly you will always seem to us the exciting young fellow you were: you will be young for ever in our consciousness (however long *that* lasts!) Perhaps on that account we shall enjoy your autobiography more competently than anyone else who knows you.

And of course we are still vividly interested to see ourselves in your pages. Of course you can use any of my letters that you want to use: I will only add that I shall be happier if the letters you choose are not too long to quote complete: when things are cut or edited, something always goes wrong.

And, in fact, I shall LIKE to turn up in your book! I agreed to W.

Rothenstein using letters of mine in his third volume—and was enormously impressed when he included the whole of a long one in defence of my choice of subjects, a real "Apologia".[1] I thought it looked very well.—much better than I could have expected if I had known.

Well, we send both of you our love pending your appearance in our North.

Your original affectionate old Gordon.

223

106 Banbury Road, Oxford
PN to GB [*Early May 1941*]

it was a relief to get your letter. I had a horrid picture of you poor dears fire fighting on the top of your wooded hill—something rather grand and Blake-like which I should like to illustrate some day but should hate to happen in reality. This is a very short letter to beg of you something I forgot when I wrote. Could you produce the negative or at least a print of the photograph taken of me at the Shiffolds in 1913. As I recall it it is about the best early photograph ever taken & I want to include it in my book. Can you help me?

I will send my typescript up to date early next week. I appreciate what you suggest for letter quoting and will do my best. . .

We think it is noble but terrifying of you two to live quite alone. We can't I know—not as we are at present and we hope you wont tax yourselves too high. By the way Jack is not at the R.C.A Ambleside He is a pukka captain in the Royal Marines on a hush hush job somewhere in Scotland at this moment. You know of course he is also an A.R.A! He didnt like being an official artist for the Admiralty—couldnt do anything he said & just went on nagging until he got back into active service . . .

Was there ever such a chap.

.

224

The Sheiling, Silverdale, Carnforth, Lancs.
GB to PN *11 May 1941*

That is a grand idea of yours—the fire-fighting one? Why not do it as a pendant to your early masterpiece of An Angel Fighting A Devil—

[1] *Since Fifty: Men and Memories, 1922–1938. Recollections of William Rothenstein,* Faber, 1939. The 'apologia' referred to, dated 15 October 1920, is on pp. 124–8.

also on a hill-top?[1] The Devil of course becomes The Fire: the only difference would be that you would have to put Two Angels in this time—a big one and a little one. er.

The odd thing is that while you were thinking these thoughts, we *were* looking for an incendiary bomb. Last Sunday—a week ago to-night, the moonlit sky was dark with The Locusts: across the water a great patch of landscape was glowworm-thick with them—and brighter: then they died, and red fires began. For four hours H.E. bombs crashed. All at once there was a giant hiss and a bang nearer, and a good deal of our bedroom ceiling came down smack onto the bed and the floor!

I had heard the whole series of sounds; but the ceiling woke Emily and she said sadly but collectedly "That's another picture down"—from which you will divine our usual, permanent anxiety.

But I cried in frenzied tones to the midnight air " 'Tis an incendiary" and leapt from bed at the telephone.

Our rustic fire-fighters arrived in five minutes—very smart work, really, and highly creditable; and certified duly that we were not on fire anywhere, and that no bomb could be found.

Next day they made another search—and could not find a hole in the roof!

It appears that our ceiling's temperamental behaviour can only be attributed to blast from a half-ton bomb that had been dropped on the railway but only hit the golf-course.

I ought to apologise for planting this anti-climax on you: but I assure you in friendly earnestness that you would find the hole in our bedroom-ceiling satisfying and convincing.

But to your request, which pleased me with its echoes from long ago: of course I should like you to use the photograph, and to have a little share in your book in still another way.

I soon identified the photograph, and remembered how I took it: there is another, in which Bob Trevy [Trevelyan] and I "support" you —but I spoil it, my "condition" just then was lamentable. think, only two waists among three men. You are beautiful in that one, too: but certainly the upright one where you are standing alone is much the better for your present purpose.

.

Do you remember when I gave you my "Gate of Smaragdus" about 1912, that you told me that you and your young friends at The Slade read it aloud to each other—and nominated me "The Grandfather Of The Sitwells"?

Well, I meant to tell you in my last letter that a little while ago Edith Sitwell asked my leave to use some of those early forgotten poems

[1] *Angel and Devil* or *Combat*. See Letter 2, postscript.

of mine in a new anthology—and told me that that same "Smaragdus" had had a strong influence on her beginnings. So I told her about you and the "Grandfather"—and she said it was perfectly agreeable to her!

.

Our love to Margaret and you.
The Same Old Gordon.

225

The Sheiling, Silverdale, Carnforth, Lancs.
GB to PN *23 May 1941*

Not on your life, my most Post-Futurussy Paul,[1]
It is the truth that I cannot be quite sure whether I destroyed the other negative or not; but I also own that I am not going to look for it until your book is out. My character and attainments would be desthroyed on me for ever if you took a fancy to putting that one in your book: and you might, for you are as handsome as usual in it, and Bob is fit to be seen. So I reely couldn't risk blotting the book. I would even rather see there your defamation of my middle region which another photograph inspired in you—a caricatura in blue and orange chalks (the latter for my beard.)

No. Just go on being pleased that I had cherished the negative you wanted. . .

In the meantime I agree that my Sitwellian date is utterly out of it; and pray note that it was wholly my date, and in no way Edithian. I see she published her first book in 1915, and the Family began "Wheels" in 1916; so the meeting at which you produced my book (I swear to the essence and core of the story) must have been when you were home from the front, on leave or with a batch of drawings, and meeting your Slade co-evals in London.

No more to-night. I must now black the house out.
Your affectionate, but no longer luminously bearded
Gordon.

.

226

From GB to PN, Silverdale, 29 May 1941. He sends prints of the photograph of PN alone.

[1] A letter seems to be missing in which PN asked for the photograph of himself with GB and Trevelyan.

227

From GB to PN, Silverdale, 30 May 1941. He sends a further print after
the negative has been intensified.

228

106 Banbury Road, Oxford

PN to GB *[Early June 1941]*

you are a good chap, tremendous technique & great results! Actually
you know, the intensified print has intensified the modelling from the
eager young face to its detriment so I shall use the spotty one & the
experts whose job it is will tidy it up & clean & press my tweed bags
when they make the collotype. I am immensely grateful to you. Of the
other one in which you show more of your figure than your vanity will
allow I confess I had thought to mask all other figures & get an en-
largement of my head if it was worth enlarging. So may I still beg to see
the print. I will show it to no one if you are bashful.

The bit about meeting you & Emily is now written—so I think you
had better have the Typescript to date as you wanted to read it & as
I am anxiously eager for your opinion.

The other day I spent a week in Gloucestershire meaning to work at
a Fighter Station while staying with some friends.[1] The Air Ministry
made rather a muddle for me & the visit to the station fell through but
my hostess & I carried out our original plan of taking tea with the
ancient draughtsman W.R[othenstein] at Far Oakridge. Of course he
was found living in *the* most perfect Cotswold house & enchanting
garden with superb prospect & additional houses (including John
Drinkwaters old cottage added to) to take his married progeny. . .
We had seed cake for tea & it was fun seeing all the old treasures
especially the Rossetti gems. Will showed me a most interesting photo-
graph of the Found[2] studies you had sent him. Im writing a small
something about Kelmscott Can you answer these questions Who was
the model for The Blessed Damozel pictures?[3] Were they painted at
K.[4] Do you know of any 'nature' poems which came from D.G R out

[1] PN stayed with Clare Neilson (Mrs. Charles Neilson) at Madams, Upleadon,
Gloucestershire, in May 1941, to which visit this letter must refer. He stayed there
frequently in the war years and the name Madams played a large and sometimes
mystifying part in the titles of his pictures at this period.

[2] See Letter 229 for GB's remarks on this photograph of a panel in his possession
(now with his other pictures in the Carlisle Art Gallery). One of Rossetti's attempts to
paint *Found.* The 'two scraps' are the woman's head and the calf in the cart.

[3] Alexa Wilding.

[4] Started at Kelmscott, continued at Aldwick Lodge, Bognor, and completed at
Broadlands, Hants, in 1876.

of Kelmscott[1] Am I too great a nuisance. M.S follows I have to give it a final nervous vetting before I part with it.

229

The Sheiling, Silverdale, Carnforth, Lancs.

GB to PN
15 June 1941

See, my Pavel Vilyamovitch, how I indulgently do all you want—or as near as makes no difference!

I had a mischeevious misgiving that I had destroyed the other negative last month for my own dear sake; but as soon as your letter came I hunted through the old bundle once more, found it to my surprise, hurried it off to Lancaster, told the man I wanted two enlargements (one from negative after intensification) by return of post, and sat down to wait.

The man cheered up, and lost only one post. Unfortunately in that one post, I spat a mouthful of blood at bed-time quite in the manner of twenty years ago: not with the old tragic circumstance, but annoyingly. It has cost me a few days in bed for caulking purposes; so I am rather slow with the prints after all. Here, however, they are—before I can be up and about again: I am hoping they are still in time.

.

Edith Sitwell? You are right: her first book was 1915. But that was the extent of my error. That "Grandfather of the Sitwells" phrase of yours must have arisen from some gathering of you and your co-evals in a war-time studio: and not in Slade days, as I said at a venture.

Kelmscott! You can interrogate me with advantage on this, for Emily and I stayed there a good many times: and May M.[2] let me rummage! You can put these poems down to Kelmscott for certain:—

"Sunset Wings": "Down Stream": "A Death-Parting".

I also greatly suspect that superbity "The Cloud Confines"; also the "Insomnia" group; and the single stanza lyric "Possession." But I cannot adduce any proof.

There was a queer oak-grained locked box which M. M. opened for me. She told me that most of its contents had been in that house ever since Rossetti's days. Among them was a lined M.S. book in limp black morocco, containing an early M.S. of "Rose Mary", with a slight

[1] Rossetti was at Kelmscott from 12 July to early October 1871 and from late September 1872 to late July 1874. Poems written there (mainly during the first period) seem to include certain sonnets for *The House of Life*, *Rose Mary*, *River's Record* (called *Down Stream* in 1881), part of *Soothsay*, *Sunset Wings*, *The Cloud Confines*, and the sonnets *Spring* and *Winter*.

[2] William Morris's daughter and editor of his collected works.

variation in the name of the knight. I feel almost certain it was written at Kelmscott: Wm. Rossetti says it was done about 1871, and even that date would fit. But I got an impression which I cannot justify now that it was even slightly earlier than that. (You will remember it did not come out until the 1881 volume.)

"Found"? I do not believe that the photograph which Will R[othenstein] shewed you is of "studies." They are on a panel about 12" (nearly) square, painted on a beautifully laid ground; *and the two scraps fit into the whole design in their right places.* We believe it was meant to be the original version of the picture; with figures on the scale of Holman Hunt's "Awakened Conscience": but the two bits were painted from nature in different places, and he couldn't unite them! So he scrapped the panel, and started on a larger scale.

Tout à vous—et Marguerite. ("Ah quelle est belle, la Marguerite",[1] as you are studying the Pre-Raphaelites.) Musn't write any more tonight, Paolo.

<div align="right">Your old ancient Gordon.</div>

N.B. The photograph. You will see I have suppressed the intolerable me. But I have left Bob attached, because he is nice. I am responsible to him, nevertheless, and I note you say you intend to mask off all figures other than your own. But you'll be a darrlin', won't you, and set me down as the photographer?[2]

P.S. Do you ever reach as far as Percy's Mill?

<div align="center">

230

</div>

<div align="right">

106 Banbury Road, Oxford

[c. *25 June 1941*]

</div>

PN to GB

Most dear Gordon

ever your generous self! Thank you so very much for the last photographs.

My God did I ever look like that. I wonder I escaped. Frankly I prefer the rather fresh fatuous fellow of the first photograph & then there is something uncomfortable about Bob standing there so solidly & you as it were just round the corner or a few paces to the right but not seen, like a ghost. I shall use the first which whether you did or not I shall say you took, of course.

And now after all this there is no hurry because Fabers dont like the

[1] The refrain of 'The Eve of Crecy' from Morris's *The Defence of Guenevere, and Other Poems,* 1858.

[2] It appears from the next letter that this was not used: that reproduced in *Outline* (p. 96) is therefore the one referred to in preceding letters.

idea of publishing in 2 volumes & I dont really but I was in a panic.
But nice de la Mare[1] says they like the book so much they dont mind
how long they wait for it & he feels it will be interesting whenever it
comes out. This rather releases something in me which was twisted &
I feel much more like writing a whole lot more now. I do hope you like
what is done so far. It starts off with—

How do we distinguish the oak from the beech, the horse from the ox,
but by the bounding outline? How do we distinguish one face or
countenance from another but by the bounding line and its infinite
inflections & movement Leave out the line, and you leave out life
itself; all is chaos again

<div align="right">William Blake.</div>

O dear Mother Outline, of Knowledge most sage
'What's the First Part of Painting? She said 'Patronage'

<div align="right">Blake.[2]</div>

from this springs a preface which I have now to alter as it was for the
2 vol. idea. I want to get this off to you to day as I am going away for a
week. Here is a photograph of my last painting for the M of I—oh
dear I *must* write to Keith Many thanks about Rossetti 'dope' more
of that anon Our love to you & Emily

<div align="right">Your agéd but risilient Paul</div>

Madams
Upleadon
Newent
Glos.

Do send me a postcard to let me know how you are I was very dis-
tressed again about the lung acting queer

<div align="center">

231

</div>

<div align="right">

The Sheiling, Silverdale, Carnforth, Lancs.
28 June 1941

</div>

GB to PN

M.S. arrived safely. Contents Gorgeous.

<div align="right">Votre toujourjours
Gordon.</div>

P.S. Bravo!

Being of a trustful nature, I have put down your address as you give it;
but I do not understand it.

[1] Richard de la Mare, a director of Faber & Faber.
[2] This opening was not retained.

<h1 style="text-align: center;">232</h1>

PN to GB, Oxford, st. swithin's (and its raining). [*15 July 1941.*] He is glad GB likes *Outline.* He has more to say about the photograph and enlarging a part of it. It is not absolutely clear whether he has reconsidered using the group. He wants the MS. back but not for ten days, as he is going away. He asks if he has photographs of early drawings—'the Lithend one' for instance.

<h1 style="text-align: center;">233</h1>

<div style="text-align: right;">

The Sheiling, Silverdale, Carnforth, Lancs.

16 July 1941

</div>

GB to PN

My Dear Paul Revered,

I gave myself to your Outline as soon as it came—and I trust that my card reached you and conveyed the idea that I was happy about it. Since then I have done more than one re-reading; but all last week I was held up by our having a friend at the hotel—my only free time was after supper (he went off for the evening at the hotel dinner-hour), and then I was too un-fresh to write to you as I wanted to write.

He went off on Monday; and now I have read you all again, and Emily has read you; and we, both of us, rejoice in you and offer you all our congratulations on a shapely and harmonious job, beautifully done. (I wish I could draw a quarter as well as you write.) There is an engaging clarity everywhere that Blake might have praised, and a debonair mannerliness totally beyond him: your people live attractively (even Walker of St. Pauls, getting only two lines, is vivid): and your conversations are as concise and alert as though you had written much for the stage.

I don't wonder at Faber & Faber & Faber Unltd. accepting it at once: they would have been moles to miss it. It is sure of an enchanting success. And now your Synopsis makes me agog (not to say ravenous) to finish it. I can see there are high lights and high jinks to come; and I am all a-tip-toe to be at 'em!

You suggest that I write fluently; but I am all at a loss what to say about the noble place you have given to us. Of that pride of place we are, quite literally, proud; and we thank you with our united elderly hearts. I can only hope that I helped you to start as much as you say I did; I am deeply gratified by the status you give me in your narrative, and I am frankly looking forward with particularly happy anticipations to seeing the book in print! I only wish it could tell of the keen pleasure I had in those years in watching your genius open out—and all the exciting stages of it: the Lethe angel; The Angel Fighting The Devil; The

Archer Against The Stars; Isopel Berners; the Blake wood-cuts;[1] the Genesises.

I still have a grudge against Billy Richmond for short-circuiting your rich, revealing figure-work. However right he was about your landscape, I am still convinced that he wanted to suppress your figure-work by Royal Academy (Victorian) standards.

Here, however, I am reminded, I meant to dwell over-leaf on the especial virtue of your section which tells how your Idea-Of-Landscape developed in you. It was a difficult thing to do, and you have netted its subtleties perfectly: there is a mystic of a fine order in you (which is why you clove to Blake and discarded Rossetti); a quality in you which I can only regard enviously, as I need it and lack it ("This warm kind earth is all I know"—which is why I clove to Rossetti more than Blake.)

By the way, I am here moved to say that I feel the Rossetti whom you accepted and then rejected was really a half-Rossetti of your own, who barely touches *my* Rossetti of Rose Mary, Sea-Limits, Cloud Confines, The Wood-Spurge, The King's Tragedy and the little early Dante's Dream.

This does not mean I want to modify the Rossetti pages in your book: I am completely content with you as you are.

There is only one word in your book with which I disagree. When you first went to the sea-side with your nurse, you say the seagulls "yell". They don't: they yelp! (Emily doesn't agree!)[2]

O, yes, there's one word more. I can't find it now: but when you go through the latter part again and come to "liaison" (as a verb), I wish you would look it up and see if it will carry the meaning you put on it. If it does, I shall be ready to apologise.

I am looking forward to seeing which letter of mine you mean to print. I don't mean I want to vet it, or anything like that: I can only remember ascribing your Angel and Devil verses to Browning, and I am quite keen to see what the advice of mine was which you think worth reprinting. How your pages did bring back those days, and made me wonder what had become of Pellew and Wilkie—and where your sister Barbara is.

II 20. vii. 41.

Well—and then I got into trouble, and your letter wasn't finished, and your parcel wasn't sent off; and I'm dreadfully sorry if I have upset your plans and inconvenienced you. It wasn't my lung, either; it was my loathsome gizzard that protested it couldn't hold anything, and my head would go round and round. And round. Now I shall get

[1] PN made no woodcuts connected with Blake. GB must have been thinking of the pen drawings based on *Tiriel*. See end of letter 117 and GB's comments in 118.
[2] Nash kept 'yell' (*Outline*, p. 41).

all this ready for registering, and post it on the 26th. when your ten days will be nearly up; and start it off to get to Oxford the same time as you.

If I had taken a second sheet the other day I should have gone on to say that I willingly accept all that you have written in the parts about me, and am agreeable for posterity to read it. But I do not admit that Yeats was the influence behind "The Crier By Night!" If it looks so, that is owing to the influence of Fiona MacLeod (which I admit in the second song): beyond that I think both Yeats and I were influenced by Maeterlinck's "L'Intruse", which is enough to account for anything in common. (As far as I remember "The Wind In The Reeds" was not published when I wrote "The Crier".)[1] And behind all that, one strand in the theme owed a little to a prose-tale by W. G. Collingwood of Coniston, "The Bondwoman." The main theme is a local legend out of a guide-book.[2]

By the way, another thing I like enormously in the book was your handling of your father: it is charming, and in a way unique. It is very difficult to be fair to one's father: at least, I have found it so—and mine was a better man than I am. You make me wish I had known yours.

.

I must not forget to thank you for the admired and cherished photograph of your Dead Sea of German aeroplanes.[3] It is one of your masterworks, and I am adding it to your early War Album with ravenous relish.

I cannot help wishing you would return in your "well-matured" years to drawing men and women. Does there ever impinge on your waking consciousness in the virgin dawn of some paradisal Summer morning that you once promised to make me a replica of your exquisite drawing of Margaret doing her hair? It will be only twenty years ago in December, at Dymchurch Underthewall; but I still grow old more quickly than you, and I think of it with longing. Quite often.

We unite, ardently and appreciatively, in all possible assurances of our most distinguished regard; and I can only hope you will always think as gently of

The Old 'Un.

P.S. Have you intentionally telescoped those two Winters at The Shiffolds? I take it that you have. The first time you came was soon after your Carfax show, and must have been about November, 1912; and

[1] Nash did not remove this suggestion. See p. 233, n. 3. *The Wind among the Reeds* was published in 1899, *The Crier* in 1902.

[2] The tradition of a Celtic water-spirit, *The Crier of Claif*, that haunted the narrows of Windermere near Ferry.

[3] The large oil *Totes Meer*, now in the Tate Gallery.

that was the time of the famous Ears Incident. The Easter visit didn't come off because we went home in March. Bob was in China that Winter and Spring: you did not see him until the second Winter when we were only there from October 1913 to the first week in February, 1914. I think you came down before Christmas.

234

From GB to PN, Silverdale, 25 July 1941. He announces dispatch of MS. with long letter, No. 233.

235

106 *Banbury Road, Oxford*
PN to GB [*Early*] *August 1941*
Beloved Gordon
 your most generous lovely tribute should have been acknowledged long before this only I, like you, got a duty dig from my particular devil which rather knocked me sideways

 By the way, I am infinitely concerned about *your* dig & do hope no major awfulness has come out of it. Such a gizzard & a revolving head sounds too unfair.

 What you say of my little half a book is all I could wish & more than I could hope for. I fairly lapped it up. I liked enormously being called a mystic but not (as it were) at your expense! That is not just, though I agree about our individual cleavages & what you go on to say about our Rossetti. Curiously enough, I have only lately had a *review* of D G R and fallen in love with him all over again. But altho as a man I enjoy all of him right up to the end & am never tired of hunting for bits of him to piece together, as an artist, I now draw a strict line. I stand bare headed before the early water colours & nearly all the work The Siddal seemed to inspire. The sumptuous oils of the Fanny period now rather bore me and, altho I think it is fascinating to study, the long gradual decline which must have begun about the time he met Jane Morris really breaks my heart. That goes for pictures, I think, but *not* poetry. Im with you all the way with all those you mention & more and if I wanted to find an example of a PreRaphaelite picture by Rossetti I should choose the poem the Woodspurge. What a strange manifestation was PreRaphaelitism! *Nothing* like what it is supposed to be. The other day I had a quite new idea about it and someday I should like to write it down & illustrate it with pictures & poems. The *Germ* is the thing dont you think? If only it could have born fruit from its true

232

stock There indeed the mystical element evaporated, or was changed into such a different form that the vision was lost for ever. . .

About my figures. From time to time, & particularly recently, people, & even painters, have nagged me to pull myself together & consider figures or parts of them as subjects for pictures. Margaret cheered when I read out the bit in your letter! Well, I am vaguely trying but you know I dont draw figures because I dont find a place for them in my pictorial expression not naturally that is. I need a method perhaps I shall find one. Someone suggested I should draw people like landscapes—there is something in that dont you think.

<p style="text-align:center">Gordon Craig . . . I mean Crag.[1]</p>

While I was writing & vaguely looking out into the garden a blackbird making a sudden gulp at a double engine dragonfly carelessly bumped into another bird who was simply furious.[2]

My dear Spiritual Pastor & Master I will put all that right about the Crier. I know what it is. I read it just after the Wind in the Reeds I should have been careful to see dates of publication & I am grateful to you for showing up the mistake. It shall be a lesson to me. Your explanation of the supposed similarity is interesting but I will change my sentence a little so that it is quite clear that the Yeats 'influence' is my personal impression & then not an influence so much as an affinity.[3]

I was so particularly pleased that you found the references to my father happy. I hope to build up gradually a firm picture of him as he occurs throughout the book. I think you would have liked him. He was a dear fellow.

. . . I am now trying to press on with the book by writing a piece each morning before I begin to paint. But always at my back I hear Time's winged charriot hurrying near & always over my right shoulder & out of the corner of my eye stands a canvas $74 \times 48''$ on which I am painting the battle of Britain—a vast aerial composition now definitely commissioned by the M of I

Last Word

What in God's name is the ancient vow to make you a replica of Margaret doing her hair? The terrible thing is I have forgotten *everything* about it I dont recognise the drawing. Could you make a sketch of it? This *is* a knock out swipe. I fear the chances are that if it refers to one of the very few early drawings of M. the original will be with the

[1] Pencil drawing of a frowning mountain. [2] Pencil drawing.

[3] Whatever change PN may have made from the draft in question, he did not do what he here says he will. The passage in *Outline* (p. 84) is: 'I had lately been reading Yeats' early poems, *The Wind among the Reeds* . . . When I began *The Crier* I soon realised by whom it was inspired.'

rest of her collection housed for her at the Ashmolean & pretty inacessable, now.[1]

Again let me say how charmed & warmed & encouraged I am to have your praise, & even more, your lovely perceptive commentary on the book. I am delighted too to know it 'gets' Emily.

My love to you. I very much want to hear how your Tract turns out to be. And I must examine that telescopic time table at Shiffolds It is partly intentional only. I had forgotten I made *2* visits! Isnt that odd.[2]

<div align="right">Your over matured young friend</div>

236

The Sheiling, Silverdale, Carnforth, Lancs.

GB to PN *12 August 1941*

Thank you ever so much for your enchanting letter, which really made me feel young again, in spite of being still fixed in bed inTractably —and which gave me a large Pleasure, partly because it proves all over again what a large area overlaps in our two outlooks on the arts, but also partly because I am happy to have Given Satisfaction in reporting my reactions to your Book. Perhaps, though, I ought not to receive too much credit in the latter respect, for I obviously couldn't help it with so irresistible a book.

We are grieved that the angel and the demon on your mountain summit are still fighting for your throat, and that the clawing demon has been getting in another hook. We hope you are clear of him again by now.

.

"Lithend" and the little "Sleeping Beauty" shall be my aim as soon as I am up and about; but I am glad the need is not immediate, for I am in for a slow business with this duodenum, I fear. I might add The Rosebud Girls In The Garden, I suppose?[3]

I bask in Margaret's approval over that matter of figure-work— for, indeed, and after all, that kind of figures you were very good at when that goblin Sir William Pauvremond interfered with your psychology. For your feeling that you don't "find a place for figures in your pictorial expression" never occurred to you until that Academic tempter insinuated his oily whisper in your ear: you just put 'em there,

[1] See p. 186, n. 2. The 'vow' must have been given verbally or in a lost letter.
[2] PN left the two visits telescoped in the MS. from which *Outline* was printed.
[3] See Letter 232.

PLATE XV

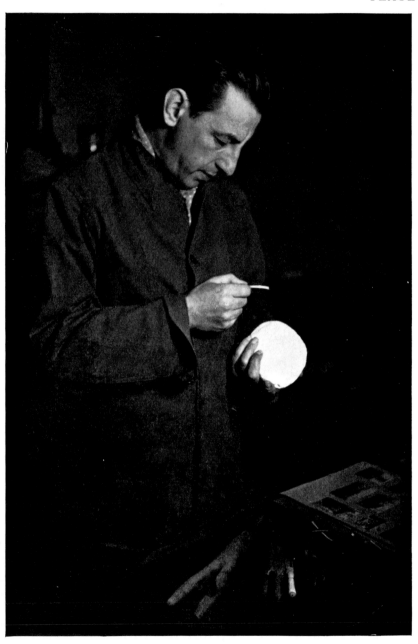

Paul Nash, c. 1934
Photograph by Ramsey & Muspratt

PLATE XVI

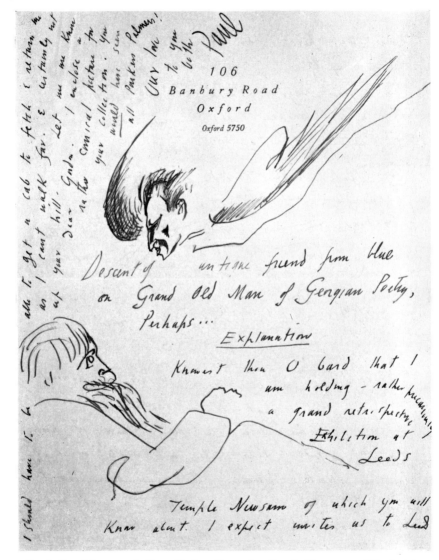

Facsimile of Letter 246, from Nash to Bottomley, ? early June 1943. The first page

and they were all right. Only S'William made you believe they were outside: put 'em back, and they will be all right.

Who, by the way, has your noble Archer Shooting Against The Stars? Surely that ought to go in?

If Margaret is interned in the Depths of the Ashmolean, there is clearly no use in worrying you for years! I seem to remember a background of window-panes and Brighton (or was it Hastings?) beyond. (Or Littlehampton?) There was a mirror; and young Margaret in a discreet and comely underbodice doing her hair, with her arms beautifully raised above her head. All in the finest style of art. I do hope you haven't lost it.

I am thankful we agree about Rossetti after all; for of course it is only in the early water-colours that all of him is there. (By the way, you will know there will be *eight* seldom-seen glorious ones at the Tate after the War? The Beresford Heaton collection.) And they are perishing through the glycerine drying out of his moist water-colour paint used as oil. I think the future will know Rossetti as we think of Giorgione— a rich legend, a list of lost works, a few doubtful attributions, and an all pervading influence in his lifetime and for a while longer. If it is not so, it will be on account of his having been so much reproduced.

I allow about four of the large ladies: especially the one of Fanny called "The Blue Bower", and the one of Mrs. Morris as Mariana with the page singing; the enchanting colour would bowl me over, if there was nothing else. But, speaking generally, that time was all decline. It set in decisively with that time of terrible brain-storms in 1871 (by the way, have you look[ed] at W. Bell Scott's "Autobiographical Notes", Vol. 2?[1] No one knows how accurate they are—but he was *there*, and they are deeply interesting.) I am impressed by your idea that the decline began with the arrival of Mrs. Morris: I never thought of that before, and I do not quite like the idea, but I have to allow there could be something in it—eventually, that is, not immediately—for then Mrs. Rossetti had still some 5 or 6 years to live, and that influence lasted beyond her death to the last of the little water-colours in 1867 or so.

But the langour certainly came in with Mrs. Morris (and it swamped Burne-Jones too). As to her general influence, though—have you seen the amazing set of photographs of her posed by Rossetti in-and-out of that celebrated tent on the back lawn at Cheyne Walk? In a way, one couldn't offer a more convincing proof of the strange power in Rossetti: they are taken by a professional photographer, hampered by the cumbrous awkwardnesses of wet-plate photography, but no professional photographer has ever been known to obtain such effects by himself. Really, they are among Rossetti's finest pictures, with that

[1] *Autobiographical Notes of the Life of William Bell Scott: and Notices of his Artistic and Poetic Circle of Friends, 1830 to 1882.* Edited by W. Minto, 2 vols., 1892.

queer, rich vitality burning everywhere—and there are the essences of most of those heavy languorous canvases, nevertheless; along with some that he didn't paint.

The Pre-Raphaelites?[1] I believe that in their beginnings they were the reawakening of an essentially British art, lost sight of ever since the Puritans won the Civil War and checked aristocratic patronage; when that returned it brought a destructive French influence with it. Have you seen the panels of the Hexham screen (circa 1400–1450?) You could hang them with early Madox Browns and Hugheses in a P.R.B. room! And there's the Gorleston psalter. And the alabaster Annunciation at Wells. And windows at Ripon with panels like early Rossettis—yet 15th. century. And the story-windows at Malvern Priory. And the paintings in the Chapter House at Westminster.* To me they all hang together; and that was the spirit that came back into the three first P.R.B's as they looked at Hunt's book of engravings of the Orcagnas at Pisa. And that fills your brother Jack!

But their pitch was queered by piety and photography. That intense observation of detail was part of their means, but it only served them while they were passionate about it: it dried up into accuracy in Hunt and Millais, and Rossetti couldn't quite do that trick by himself and without their first-hand eyes. Madox Brown simply suffered from quite dangerous constipation, and you could never be sure of them.

And the Industrial Age got hold of them, and bribed them to standardize their success. And that was all.

Let us not blame them too much—Giotto and Francesco di Giorgio and the Lorenzettis and Botticelli and Paolo Uccello (that name might fit you) never had to contend with such an enemy as The Industrial Age.

PAUL (soliloquises) "This is a very long letter, Margaret. I *doo* wish Gordon was better".

I am always better than I might be; and your affectionate

Gordon.

* And that Elizabethan miniature of a young poet with a flowering spray across his doublet at South Kensington. And portraits at Penshurst. *And* the Wilton Diptych, which I refuse to believe French.

[1] GB probably knew more about the Pre-Raphaelites, even to their remote ramifications in literature as well as in art, than anyone else in his day. But he could not be persuaded to set it down.

236

237

P.N to GB

Most dear Gordon

I feel I must shoot this off to you now or there is bound to be a hiatus where I shall get lost with the words at the end of my tongue.

First let me say how grieved I am to hear of your duodenum reverse I hate the idea of you being immobile again after your enormous frolics. I shall try to find you material to make up a packet as of yore. Give me a few days.

Now, in order, as they come.

.

Sir William Richmond's influence. I must set this right in your mind. The old man never said a word *against* my figures only *for* my backgrounds. When I came to look at the landscape for itself I found it enough. I had then no use for figures. That has gone on until this day. That is why I say I find no place for figures in my pictorial expression.

But I do not mean I shall leave it at that. I may yet find a way of using figures naturally to express ideas. I do not think, however, I shall return to making the sort of picture you like so much. For some time I have found objects a great inspiration & made something new therefrom I hope. Next it may be some kind of human figure—indeed I am aware of a sort of groping

That picture of M. still baffles me.

Now Rossetti. No, no I did not mean that decline began before Lizzie's death. If it had begun, equally the fire of her inspiration was still burning in Rossetti. No I was thinking that with L's death & the growth of that strange other 'influence', decline set in and, by the time R went to Kelmscot, he was doomed & his work beginning to show every sign of decay. It is wonderful you should mention the photographs for it raises a faint hope in me that you may know of some means of getting at them other than digging them out of the 'evacuated' archives of the Victoria & Albert Library (where I saw what I *think* you refer to though I did *not* know Rossetti was responsible for the poses. That is *frantically* interesting to me & I agree of course that they are among Rossettis finest pictures. *What a chap you are Gordon*! All this granted & healths' all round and no heel taps—(a heel tap a heel tap I never could bear it Then fill me a bumper, a bumper of claret who uttered that?) *Where did you see these photographs, are they reproduced anywhere.* Do let me know.

The Pre Raphaelites. Yes thats it; *originally* an awakening of British art. You take my breath away a little with your list of all the things that hang together but I agree in the main.

Brother Jack? You mean his first things otherwise I cannot see much connection. But I should like to make out quite a few more cases for their intentions & unconscious purpose. You're dead right on the quality of their fate—photography again—that is interesting—I am not sure about it this time—I thought the detail obsession was mainly Ruskins wrong headedness. Standardized success. Yes that's true. Thats the real bogey.

Paul's soliloquies on turning the page Oh I thought there was more which may be selfish but is the true measure of my appreciation of your generous letter writing.

By the way, I have just literally put into practice that detestable process know as '*con*tacting'. After I dont know how many years, principally because I felt too tired to cope with him sooner I contacted the Mutual! He came up from the mill stream like any trout who's been tickled-to-death forgave me in a breath (No, I mean—rather longer-winded than *that*) but was quite absolutely sweet considering how filthy Ive behaved, poor P. We are to meet soon

Our love to you both

your discursive pal

238

The Sheiling, Silverdale, Carnforth, Lancs.
GB to PN *19 August 1941*

Thank you enormously for your joli letter: it cheered me enormously. I even felt younger for it—probably because in it you approved my notions in the main.

Appropriately, the new enlargement of your portrait arrived by the same post. Here it is with my love, and I hope it will serve your purpose. . . .

The rest of the contents of my pacquet will not surprise you, as you have seen those Mrs. Morris photographs already at the V. &. A; but they need a little comment, all the same—and here I am in bed on a wet morning, with a vacant disposition: I have read "Arms And The Man" since breakfast (and have been surprised to find myself thinking the latter half might be much better done), and I cannot think of anything better than devoting the rest of the morning to Mrs. Morris—and you.

I first heard of them 30 years ago in a catalogue of Everard Meynell's Serendipity Shop, which listed a set in a portfolio for about £.7. I couldn't raise the cash, but I remembered when, 10 years later I saw twenty or so portraits of Mrs. Morris, framed in one large mount in a way to make the least of them, hanging on the staircase of May Morris's little house on Hammersmith Terrace that her mother had moved to

238

from the big house on The Mall near by when her father died. They were badly faded (and, I suspected, badly laid down), and I urged on May the importance of doing something about them before it was too late. She agreed. I heard no more until, just nine years ago, we were climbing about the picturesque attics at Kelmscott with her, when we suddenly came on them in their mount, but frameless, on a pile of odds and ends of furniture. She picked up the mount and said "Do you think you *can* do anything with these?" I replied "Someone had better try: it is now or never"—and she said "Then do it now", and I brought them home. (I remember how Emily and I broke up the mount on the Kelmscott dining-table to make a handy parcel!)

They were a mess and no mistake when we got the front mount off, being mounted with patches of glue, with other patches on their margins where the front mount had come: so I spent a long time on rephotographing them before touching them. Eventually I made a surprisingly decent album of them, which is now in the B.M., or the Bodleian, or wherever the Morris collections went when Kelmscott was so unfortunately and unnecessarily stripped. And after all it was not so urgent as I thought; for Sydney Cockerell[1] learnt that the original negatives are intact in the possession of William Rossetti's daughter Sra Angeli in Rome: for that reason I suppose she has copyright over them, so you had better keep these prints of mine to yourself—of course I had no notion at the time, and my only idea was to safeguard any of the originals that might go wrong in dismounting. But I have my record: and it is as well that that original set was saved.

I didn't do anything with my negatives except get one set of good enlargements for my Rossetti scrap-book; and that is too heavy and precious for the post nowadays, or I would have sent it for you to look through. But I have found a handful of the preliminary contact prints, and one or two bosh shots at enlargement which you may think better than nothing; and eventually I may be able to find a few more for you in the welter of things that fills this house. In the meantime, if you will use a strong reading-glass on the little prints you will get a good idea of the originals, the detail in the negatives is often first-rate.

I am glad you agree that they ought to rank high among Rossetti's works! May Morris was explicit, to the effect that Rossetti had in a photographer called Parsons from the Brompton Road (or Fulham Road, perhaps: that is the only word about which I hesitate); and the man took all these portraits under Rossetti's supervision and instruction on the garden-lawn at the back of the Cheyne Walk house.

Well that's that. And I am glad you agree about the initial stages of

[1] Sir Sydney (Carlyle) Cockerell, b. 1867. Secretary to William Morris and to the Kelmscott Press (1892–8), Director of the Fitzwilliam Museum, Cambridge (1908–37), literary executor of Morris.

the P.R.B. being a movement of the spirit toward a British art. I doubted if Ruskin ever counted for much (no more than any critic ever does!) Those engaging young men were doing what they gloriously liked; and when a powerful pen-ally turned up, they of course gave him his head and humoured him. My reading of Ruskin is that he took for granted all worth-while painters were poets (which is why he was so down on the Dutch pub painters!): after that preliminary assumption he was keen, not just for detail, but for passionate observation. We never get a straight argument from our dreary writers on art about the Pre-Raphaelites because some of the latter were mystics and some realists, and the said writers have never recognised this: in my opinion the essential point is that the mystics wanted to do their work by (among other things) passionate observation, and their really inspired use of detail recorded at a feverishly high tension attracted the realists—who took on the tension for the sake of the detail. There was a paradisal moment when it didn't matter who was painting the picture, he was speaking with the spirit that was descending on them all. Of course it couldn't last: they fell away from each other, believing they could do just as well apart: until there was only Holman Hunt left, still putting down detail industriously, and believing that he was keeping up the tension faithfully because he was doing it with more and more rigidity. There is something to be said for cold fury; but nothing for cold accountancy practice.

Especially when the old firm had failed. The works closed down: the partners divided up the machinery and plant among them, each still making a comfortable living by regular demonstrations of how his bit of the machinery used to work: but it was Rossetti who was left with the high-pressure boiler and the fire under it as his share.

It was a tragic petering out—and even for us who came after. Why did it fail? Was it the P.R.B's fault for seeing their aim so uncertainly? I feel that most of the blame probably should fall on their patrons, the new-rich industrial middle-class—who were uncertain in *their* aims.

I do rather hold to my diagnosis of "photography", too. Look at a late Holman Hunt of a boy inside a French window; and a Millais just on the down-grade "The Highland Lassie" (I think)—a Scotish river-side with two small puppets, a country girl and a Scots Guardsman, which is startlingly like the colour-photographs we do nowadays—as indeed "The Blind Girl" out of Millais' good time also is. It seems to me that the *aspect* of a photograph (then a new thing) must have startled those young art-students into realising that a new way of *looking* [at] a picture was being shewn to them—that incredible accuracy must have seemed superhuman, and a new ideal to strive for! It instigated them with ardour to a new, higher pitch of observation—and in doing that feverishly they put such passion into it that it literally became

supernatural and revelatory of themselves rather than of the thing observed.

(By the way, when you have been at the V. &. A. Art-Library, have you ever looked at the portrait photographs done by the Scotish por-trait-*painter* D. O. Hill R.S.A. about 1843? If not, take your first opportunity—they are eye-openers.)

It would be fun to work out a whole ancestry within our island for the P.R.B's—I only put down a few high lights in my last letter. The "Wise & Foolish Virgins" side of Blake is obvious—but, of course, Rossetti acknowledged that influence; but have you seen the early woodcuts and the little water-colour "Environs Of A City" by his disciple Edward Calvert? And the little early oils of *his* friend S. Palmer?

I was thinking of Jack's early compositions, and his sense of contour—rather than of a technical likeness. *And* his animals, which would have delighted the sculptors of Wells, and the scribe of the Aberdeen "Bestiary."

My God, Paolo, see what you have let yourself in for. How can I stop. I must try. Here goes. Your ancient, with a contrite heart,

Gordon.

I wouldn't think of contradicting you about S'r William: indeed I recognised at the time that he was not animadverting on your figure-work, but simply ignoring it by an intentional concentration on your landscape-work. But I didn't dream that that was Victorian Inno-cence and Integrity in him: I thought it was just undiluted Guile.

Of course I realise that if you come back to figures it will not at all be to the point at which you left them. But that doesn't diminish my Interest!

.

P.P.S. I also enclose a print of a bit of our unfinished 'Found"—oils on panel.

239

106 Banbury Road, Oxford

PN to GB [c. *late August 1941*]

Blessed Gordon

The shock of receiving Mrs William Morris in 12 different positions fairly crushed me: I have only just recovered my breath! Are these prints really 'for keeps' I am deeply grateful. I do think you have done a *wonderful job* in reviving Janie. You must be a very cunning old con-juror to get these results with your camera. Of course my first impression remains, for when I looked at these photographs, or some of them in the

Library at V & A I confess to a physical recoil. In a way Jane is positively frightening the powerful negroid character influencing the creature is surprising and almost sinister. Marsielle was my first thought! Look at the full face seated figure, or the hedge hog pose. And think how Rossetti transfigured[1] this outlandish girl into something so romantically refined that it made an everlasting legend of beauty.[2] But I wonder what the old boy *really* felt about her and her Baudelair[e] beauty. For she *is* beautiful in a very disturbing way. I wonder what another painter would have made of her, say Corot. Rossetti came nearest to a confession of his own reaction I feel in Astarte Syriaca but even here the head is too refined, too literary-romantic The trouble with D.G.R I suppose was that by the time he got going with Jane his commercial senses were riding pretty high and he was painting for his market. Still theres no doubt that this strange creature got under his skin and he was affected in a complicated way but rather to his detriment as a creative artist. It was Lizzie who really inspired Rossetti dont you think—it sounds rather nonsense to talk of women being an 'inspiration' to such an extent as we assume with D.G.R. but he got most of his pictorial art out of a few females and it was much more than a matter of useful models. Do you think he took any photographs of Lizzie? Or Fanny?

The rest of your letter dealing with the P.R.B. has fascinated us both. It is a brilliant commentary. I wish you would get down to it & make a book of the subject. If you dont, at least let me quote you if I write an article. I shall add a foot note to the effect that you're the only chap who *really* knows about the P.R.B. & á propos 'Rossetti left with the high-pressure boiler & the fire under it' would make a nice subject for Max. Ruskin was all right when he was for passionate observation. I was thinking of his criticism on the Royal Academy Exn (PreRaphaelitism etc) wherein he seems obsessed by enthusiasm for naturalism symbolism and Sunday school sentiments to a simply sickening degree. It may not have meant so much to the Brothers but it infected the public with a vaccine of confused thinking (is that a confused metaphor) which poisons them to this day. I capitulate on photography. I was not looking at it hard enough. I expect you're right. That early brilliantly defined photography has a beauty which must appeal to any artist for its quality & indeed has from time to time been intelligently exploited by painters other than PreRaphaelites Octavius Hill is one of my particular heroes. I reviewed a book on his work for the Listener[3] years ago when I was art critic jointly with Herbert Read. O.H *took* some absolute beauties. I think this book only

[1] MS. stransfigured. [2] Small drawing in text.
[3] A review of *Octavius Hill* by Heinrich Schwartz (Harrap), *Listener*, 24 February 1932.

242

dealt with his photography I dont know his paintings. And fancy *you* asking *me* if I knew Calvert & Palmer! Look here this is going to let me in for 2 more sheets, you'll never get this letter at that rate because this one has taken a week So next time for Sam & Edward of whom I am full particularly now as I re-read & re-viewed both of their lives & pictures about a month ago. What a couple of pets they were I'd love a good heart to heart talk with you about the Ancients[1] but alas another day my ancient from your brother ancient Paul.

.

240

From GB to PN, Silverdale, 13 September 1941. He refers to PN having suddenly telephoned him about a possible visit at the next week-end. He has since inquired, but the hotel is full until the middle of October.

241

The Sheiling, Silverdale, Carnforth, Lancs.
GB to PN *11 October 1941*

Most dear Paul,

This envelope was packed for you and addressed to you before our agreeable but tantalising telephone-conversation, in response to your gorgeous letter then just received. Then I put off using it when there seemed a chance of continuing by word of mouth; but I had better be getting on with a line to accompany it, before you forget what you said in your last letter—for the Hotel continues to be hopeless. We have been after rooms for various other guests, but all they will give us is a single bed for two nights next month. A year ago they were useful and always had what we wanted: I think the difference is made by young officers on leave, who come seriatim and bring their families. Of these there seems to be a waiting-list: one can only sigh for another and a better year!

Which we could all do with, any way.

No: I doubt if I shall ever write on the Pre-Raphaelites now. There are so many of my own subjects that I want to tackle, if the War would only unfreeze me; and my time is shorter than it was. Also, prose is hard physical labour (as verse is not); and if I use myself in that way I want to do a treatise on the performance—released from realism—

[1] 'The Ancients' was the name adopted for themselves by a group of young painters which included George Richmond, Samuel Palmer, Edward Calvert, and Frederick Tatham. They regarded Blake as their prophet.

of (my) poetic drama.[1] So I shall never get to the P-R: and the world fills up so rapidly with unprincipled, temperamental, subjective books about them (such as the impudent fabrications in Larg's "Trial By Virgins"[2] regarding Rossetti, belittling Lizzie—whom I agree with you in regarding as The One) that I feel to lack the energy needed to lift them out of the way before one could get down to it.

But it cheers and comfortably inebriates me to find myself in agreement with you about these people, and their young purpose, and their lost way; and to babble to you about it; and, if anything I say is grist to your mill or power to your elbow, to see it appear under your wing will make me quite happy.

I do agree, and profoundly, that Lizzie was the cataclyst who made possible all Rossetti's finest conceptions: I think he knew it, too. One has only to look through the 1st. edition of Marillier[3] to realise how incontrovertible that is: and the extent of her power is seen in the way in which she provided a type for him, yet did not limit him to it.

The change comes with his first drawing of Mrs. Morris: another artist might have done it. While Lizzie lived he was like two artists, as different, say, as Burne Jones and Simeon Solomon: when Lizzie has died she fades gradually for 6 or 7 years, with Kelmscott Mrs. Morris becomes paramount—and in the end, alas, standardised, which Lizzie never was.

It is only since I last wrote to you that I have realised the full significance of Mrs. Morris; for though she changed his style, she was not the first to supervene on Lizzie. I have just received a lamentable, incompetent book from America about the Fanny story, embodying his pitiful, helpless, rather naïve and innocent letters to her;[4] and I learn from it that Rossetti had found her and was using her as a model six years before Lizzie's death, which I had not realised: the early books left one with the impression that Fanny began with the lonely man in Cheyne Walk. But she comes into his work before then: her head is in "Found" —eventually at any rate, I am not sure even now as regards our fragment: she had evidently far more power over him than Mrs. Morris had, yet she did not cause the jolt and lesion and "solution of continuity" in it which Mrs. Morris did. God rest them all.

[1] This was to become *A Stage for Poetry: my Purposes with my Plays*, 1948: privately printed for him by Titus Wilson & Son, Kendal (the publisher of his first book of verses). He called this book his 'extravagance'. Most of the limited edition was presented to friends and societies interested in dramatic work.

[2] Published in March 1933.

[3] *Dante Gabriel Rossetti: an Illustrated Memorial of his Life and Art*, by H. C. Marillier, 1899.

[4] Perhaps *Three Rossettis: Unpublished Letters to and from Dante Gabriel, Christina, William*. Collected and edited by Janet Camp Troxell, 1937. See also *Dante Gabriel Rossetti's Letters to Fanny Cornforth*, edited by P. F. Baum, 1940.

I am sending you two larger prints of the Parsons photographs—some of my first dud shots, but all I have loose. I don't mind your shewing them to friends privately; but, as I was telling you before, when I did them it was in the belief the negatives had perished. Now that I know William's daughter in Rome has them, I do not know what the position is about copyright. Certainly, if you want to reproduce any of them, I am sure you will be safer if you do so from the prints in the V. and A. Library by the Librarian's permission.

These two prints seem to me the most overpowering ones: the sitting one might be some tragic tzigane from Eastern Europe, chafing at having to wear decent clothes and be civilised!

About ten years ago Emily and I had an odd experience. We met a girl* in the wildest part of the Perthshire Highlands from whom these photographs might absolutely have been taken: the illusion was heightened by her wearing dresses that might have been her mother's. She was a gamekeeper's daughter, keeping house for an acquaintance of ours only a couple of miles from her father's cottage. Our acquaintance was an oldish man, who had retired to his isolated house on the death of his wife: he is a scholar and loves music and likes his recluse life. The previous Winter he and the girl had been isolated and cut off by colossal snows for nearly two months, and reduced to a bag of meal and a gallon of whisky. The interesting thing was that she was a magnificent young puma, apparently smouldering with exasperation at her lack of animal satisfaction; and he was not only not noticing it, but never had noticed it. We were told she had never seen any life except that of that lonely countryside. Two months after our visit she gave our friend notice and went off to London: I often wonder what young Rossetti she is provoking into genius.

I mention her because her astounding, minatory beauty was not accompanied—so far as we could see—by either mental activity or the least liveliness of disposition. She reminded me of a passage in Henry James's letters, telling of a Sunday afternoon call on the Morrises in Queen's Square, "over the shop", soon after leaving The Red House. Mrs. Morris had toothache and was on the sofa, and he refers uncomfortably to "this dark smouldering woman, with her dark medieval toothache" (or words to that effeck, I haven't got it quite right)—matching the Parsons-Rossetti photographs to a marvel.[1]

* About 25—not girlish; lithe and commanding.

[1] *The Letters of Henry James*: selected and edited by Percy Lubbock, vol. i, 1920, pp. 17–18, letter to Miss Alice James of 10 March 1867. The whole description is curiously apt to the astonishing photographs. Here is part of it:

'Oh, ma chère, such a wife! *Je n'en reviens pas*—she haunts me . . . Imagine a tall lean woman in a long dress of some dead purple stuff . . . with a mass of crisp black hair heaped into great wavy projections on each of her temples, a thin pale face, a pair of

But the trouble is, that those who knew tell me Mrs. Morris was mild and easy-going, well-read, humorous and fond of a joke. There is a story of her planning an ingenious trap to make young G. B. S.[1] eat suet-pudding, after he had made a nuisance of himself to her with his vegetarianism. When she had seen him plumb into the trap, she told him all about it, and wound up with "And it is very good for you".

Your reference to D. O. Hill as Octavius Hill suggests that you have been looking at Peter Quennell's "Victorian Panorama". The Hills there are certainly good, and include some that one finds nowhere else: but, all the same, beware of them: nearly all are cut down and their proportions falsified, to the real artistic depreciation of the compositions.

How stupid of me not to have divined that you would be Oh Fay (that's French) with Palmer and Calvert, and endearingly sound about both Samuel and Edward. They were, as you say, Pets. Did you re-read all the three lives of Samuel which his son has left us? I am not sure that the late one in the S.K.[2] catalogue isn't much the best: he lets out all the family sorenesses which he smoothed out of the other two! But the second one is mainly worth while for the correspondence—and the first one only because one gets a good impression of the "Folding The Last Sheep" etching. Have you looked at the two little monographs on the etchings issued by the Print Collectors' Society?[3] If you have you will have grinned a sardonic witherish grin at the way I spread myself over the preface of the 2nd. one; but I give you my Sollum Word that I never meant to, I was inveigled into it. At the same time you would see our two drawings reproduced; but I warn you they are not of a size, as they appear: only the lower one is anything like full size.

That is the better of the two monographs, Griggs' catalogue being much more thorough than Martin Hardie's. Griggs had the Virgil

strange sad, deep, dark Swinburnian eyes, with great thick black oblique brows . . . After dinner . . . Morris read us one of his unpublished poems . . . and his wife, having a bad toothache, lay on a sofa, with her handkerchief to her face . . . around us all the picturesque bric-a-brac of the apartment . . . and in the corner this dark silent medieval woman with her medieval toothache.'

[1] George Bernard Shaw (1856–1950), dramatist.
[2] South Kensington, Victoria and Albert Museum Library.
[3] (i) *Samuel Palmer, being a lecture*, &c., by Martin Hardie, R.E., R.I. Print Collectors' Club, Publication No. 7, 1928.
 (ii) *A Catalogue of the Etchings of Samuel Palmer*, with Introduction, Notes, &c., by Russell G. Alexander. Print Collectors' Club, Publication No. 16, 1937.

The second of these monographs contains in its Preface a two-page quotation from a letter by GB. Alexander's Catalogue was based on that of F. L. Griggs, the etcher, who formed a large collection of Palmer's etchings, including the four Virgil plates, not catalogued by Martin Hardie. See Letter 245.

plates, and had de-steeled them: he was always promising to take proofs for me—but I had only received one of them when he died—and that not "The Waters Murmuring" for which I lusted.

Etchings never put me in a passion: but Samuel is so easy to collect —and so hard—that I had to have his. Easy because he did so few—and hard because there is always only one published state, and that trade-printed; and the only proofs worth having are the few trials which he pulled while working on a plate.

By the way, we once had the luck to get one of the little Shoreham water-colours. I'll enclose my photograph of it—it is all brown and gold trees and moon and corn, with the little gleaners in bright Russian colours. . . .[1]

Much love to Both from Us.

<div align="right">Your ould Antient Gordon.</div>

No: I am not better. And now there is a devilish gyroscope started in my left ear.

N.B. D. O. H[ill]'s paintings are smooth and like chromos: one asks "Are they hand-done?"

<div align="center">242</div>

From GB to PN, Silverdale, 28 April 1942. He explains that he has not written for some time because of his wife's illness and his own. He has now photographed some of the PN drawings in his collection and makes technical comments on the prints.

<div align="center">243</div>

<div align="right">106 Banbury Road, Oxford
[PM: 12 May 1942]</div>

PN to GB

Beloved G

I cannot get a letter off to you so this card must run a-head to greet & thank you for your wonderful packet. I am overwhelmed, & quite staggered to find what I was capable of. When Margaret saw the Sleeping Princess[2] she exclaimed indignantly *its cheating*—meaning I suppose, I had been cribbing from D G R which of course I most incredibly had!

This must go off at once and my letter will follow soon. We are very relieved to know you are better again Our love

[1] *Harvest Moon* (Carlisle Art Gallery). [2] *Sleeping Beauty* (Carlisle Art Gallery).

244

From GB to PN, Silverdale, 17 June 1942. He thanks him for a private view card for an exhibition in London. Water-colours by PN, Redfern Gallery. He asks if he has received a parcel of photographs.

245

The Sheiling, Silverdale, Carnforth, Lancs.
GB to PN *29 April 1943*

Dear Pavel Vilyamovich,

What a surprise—right and left, both barrels;[1] the sight of your calligraphy, and this overpowering print. A red-letter day. I believe I haven't had a letter from you since we were for two months in rooms while Emily was ill in the Nov.-Dec. of 1941.

Your present pacquet is handsome amends, even for that. I shall own to you that I have a pallid reproduction of The Plodding Rabbit: for 20 years Sturge Moore used to babble to me of these early Palmer-Virgils, and their unapproachable virtues, and the tragedy of their being lost. Then he suddenly sent me an "Apollo"[2] with news of them and reproductions. In spite of that I am more grateful for your print: it has in it so much more of the vivid vitality of the drawings, and I feel I am seeing this one for the first time.

If you can get *all* the Oxford Palmers[3] photographed you will be doing a good turn to your country, and a still better one to me. I know them: when Kenneth Clark was at Oxford he shewed them to me: I coveted unboundedly the little oil, I do wish it could be photographed.

Well, hurry along with your promised letter and plenty of news of how you are and what you do; and whether you have done the next volume of your memoirs.

There would still be no news of us, except that my old lung still deteriorates a little, slowly, and that I am now in my disgusting 70th year—if it had not been that, a fortnight ago, Emily and I handed over our monotony of fire-watching to the village policeman for a night or two, and, like the cat in the nursery-rhyme, "have been to London to see the Queen". And that much news you may have picked up in some daily paper already. I have even got into this week's "Picture Post", sitting between Edith Sitwell and Vita Sackville-West on the stage of the Æolian Hall; but I shall not blame anybody if you find this is The Only Intimation, for to tell the truth we are only tiny blobs functioning

[1] Letter from PN evidently missing.

[2] An illustrated monthly magazine begun in 1925, devoted to matters of art and collecting. Sturge Moore's article on Palmer is in the number for December 1936.

[3] In the Ashmolean Museum.

as a sympathetic background for the Laureate. It was, in fact, a Poets' Reading for the French-In-England fund, got up by the Marchioness of Crewe and the Sitwells: and all the Poets and Emily were presented to Her Majesty, who is even nicer than one thought, and absolutely the perfect listener. The block in the P.P. was taken at the opening: after the interval I was included in the Royal party, in the place occupied by [Walter] de la Mare in the P.P., next to Princess Margaret Rose.

The affair, with its attendant parties, took all our time, and we managed to do very little in London; and now we have descended upon our mountain height from our recent exalted position. And now

Over To You—

with our benediction on you both, my dear young friends.

Your venerable friend

246

106 Banbury Road, Oxford

PN to GB [*Early June 1943*]

Descent of antique friend from blue on Grand Old Man of Georgian Poetry, Perhaps . . .[1]

Explanation

Knowest thou O bard that I am holding—rather precariously—a grand retrospective Exhibition at Leeds

Temple Newsam[2] of which you will know about I expect invites us to Leeds where we perch for at least one night on Friday 4th. Now, I can never forget how years ago Margaret & I travelled to Leeds & after breaking our journey there came on by stages to your magical nest on the top of that little wooded hill where sure enough was the poet brooding over the landscape—a place of pure enchantment unequalled in my recollection here or abroad[3]

Well what I am getting at is to discover whether there is any chance of putting up at your Inn for a couple of nights in the week beginning 6th—We plan to return to London for Whitsun or we may be driven back to Oxford. It would be lovely to see you both if you could bear it.

I should have to be able to get a cab to fetch & return me as I cant walk far, & certainly not up your hill. Let me[4] know dear Gordon. I enclose a rather comical picture for your collection. You *would* have seen all Parkers[5] Palmers!

Our love to you both

[1] See Plate XVI.
[2] Temple Newsam House, a museum and art gallery on the outskirts of Leeds. The exhibition was open from 24 April to 13 June 1943, and included seventy pictures painted by PN between 1921 and 1943.
[3] Pen drawing of this 'brooding'. [4] Me, repeated.
[5] K. T. Parker, Curator of the Ashmolean Museum, Oxford.

Bed.

GB to PN *Monday.* [*Early June 1943*]

We hated to send the telegram when your letter came this morning— but there was no help for it. An ulcer turned up in my stomach last week and bled, and I am still not free from pain and exhaustion, and threats of further sickness. We are at its mercy, and I am no good for anything until it quietens down and I can move more; but of course I should let you know if it did that within any reasonable time. It is such an ideal occasion and opportunity for our meeting, with you and Bunty so near and all; and to have to miss it is exasperating, and sickening.

Your Rossetti is a surprise, and very welcome for my book: I thought I knew all his subjects, but I don't know this. I'll ask Graham Robertson[1] as soon as I can.

Don't be annoyed that I had the Palmer already: it was a poor little block by the side of your big photograph.

Many many thanks for both. Our love and regrets to you both.

Yours affectionately

Gordon.

I haven't had a gastric ulcer before, and haven't a technique for coping with it yet!

248

From PN to GB, Oxford [*Early June*] *1943.* Acknowledges last letter with sympathy and regret.

249

The Sheiling, Silverdale, Carnforth, Lancs.

GB to PN *23 June 1943*

Dear Fra Paolo,

I have been rather hoping we should be having a line from you, safe home again, to tell us you were so. Your report of your journey down, when you were on the telephone in Leeds, was alarming; and I was visualising you as stricken with asthma—and in Leeds, of all places— just when you ought to be gathering your harvest of praise.

.

We were not long in London, neither of us being very equal to things even then; but I daresay that you will have heard that I came off

[1] Walford Graham Robertson (1866–1948), artist and author. See *Time Was* (1931), a book of memories. Twenty-one pictures from his fine Blake collection are now in the Tate Gallery.

pretty well at the Reading—if only for the mere fact that people could hear me! You would have been amazed to see W. J. Turner[1] go on and on and on, long past the time alloted to him (he nearly used up two other people's time, too, and no one could stop him!), and quite inaudibly all the time except for a faint snarl. At last the Chairman nipped in when he seemed to be at the end of a poem—he was changing his M.S. page, at any rate—and cut him out with applause which everybody took up enthusiastically. I never before saw a poet look so surprised.

I came off better than he did, at any rate; and Her Majesty was especially gracious to both Emily and me. So we came home almost feeling there were young laurel leaves growing in our agèd hair.

I was quite cheered to have managed the journey so well, and began to envisage further jaunts, and another sight of Scotland at long last, as the Summer went on. So when Easter was over, and May was here, it was simply horrid to slip back, first into a touch of the old trouble with my left lung, and then with this new alarming business in my gizzard, with black blood alacritously leaping out of my gullet, instead of red ditto. out of my windpipe. Surely this versatility in the elderly is most unusual.

I revive imperfectly—indeed, I "Came Out" again on Monday, when a lively antique cousin of Mrs. Goldsworthy (bless her) came from Morecambe for a couple of hours. But I am pretty cheap still.

Your unknown Rossetti charmed the bad days. I still cannot make out the subject, but it was evidently done about the same time as the similar "Taurello" one—so it must be very early.

Well, as I was saying, do tell us you are all right, and safe in the arms of Oxford again.

<div style="text-align: right">
Your affectionate old

Gordon.
</div>

250

The Sheiling, Silverdale, Carnforth, Lancs.

GB to PN *13 May 1944*

My Paul,

Please do you still possess those two *English Review* blocks of your perfect models for "King Lear's Wife" and "Gruach?" And, if you do, will you please allow me to purchase them; for I have important need of them?

This is the way of it. Being reduced to silence by the impact of war on my fructive mind—and also by further discordance in my inwards—

[1] Walter James Turner (1889-1946), poet: musical critic to the *New Statesman*, 1916-40.

I have been alleviating my helpless inarticulateness by composing a fractious and revolutionary prose treatise on my intentions in creating plays that can be played anywhere except in theatres. It will be a veritable TOME. It *is* to be. I intend a copiousness of illustration that will (a) make a noble work with little aid from language; and (b) whizz up the production-costs until no publisher will look at it, and I shall have to issue it by subscription—or my own generosity.* But thus I can, at any rate, do just what I like for once—that is, if you look on my scheme with favour, for (if I am to tell the truth revealed by the progression of my career) a substantial factor will be your designs for my plays (By Your Leave). There will be a touch of Ricketts (mostly sketches out of letters—and, by the way, did you read his "Self-Portrait"); a touch of Dulac;[1] but cornucopias of Paul (By Your Leave);[2] and, when I come to the dresses for Mrs. Lear, I mean to run to colour plates, Regardless. But in the first place, I do earnestly hope those two little blocks of the models exist; and that I may buy them—for the photographs of them will not reproduce very well.

I will not add more; for I had another haemorrhage at Easter; (it wasn't much, but when the thing begins there is no knowing how long will be needed to stop it); and I am still struggling among the correspondence that piled up on me when I could not write much. So here is just the Assurances Of Our Most Distinguished Regard to Margaret and you, from your ancient, original Gordon.

* I suppose an edition of about 250 copies, 4to., and "the type distributed".

251

PN to GB [*PM Oxford 17 May 1944*]

I was relieved & happy to hear from you. Poor Gordon what an imposition for you. I think your plan is splendid. I shall be most delighted to take part & help you in any way I can. I have already found Mrs Lear's block but it looks scratched to me. I am hunting now for Gruach I did not know I owned either! And of course you are not to *buy* them, they're yours if I can find em both. What I'd like most would be for us to reproduce the *original* the old Crier.[3] I am sending him along for you to see. Margaret somehow *pinched* the book from poor Mrs

[1] Edmund Dulac (1882–1953), illustrator and stage designer.
[2] There are six colour-plates and seven half-tone after PN's designs in *A Stage for Poetry*. See p. 244, n. 1.
[3] Reproduced in *A Stage for Poetry*.

Garrulous G! I have just posted what I was keeping back to go with a long letter, my Penguinised ego (2/6)[1]

Hope you'll like some of them.

Love to you my Ancient from your nearly ancient old British Master (Will is reported to have said of me—a sort of minor master)

252

106 Banbury Road, Oxford
[c. *26 May 1944*]
PN to GB

My Gordon

Im terribly sorry I cant find the Gruach block but I have this photo which I believe would make a tolerably good $\frac{1}{2}$ tone. Also here* is Mrs Lear's block & the precious copy of the Crier with my original illustration. Looking at it again I still feel I should not be ashamed of it's publication if you aint. Perhaps the Crier is not to be of the number, but I sincerely hope so.[2]

.

... We have weathered the winter & begin to live again these warm days though no sooner has one said that than the cruel cold wind is back at one's throat and despair returns. I suffer infinitely from climate not so much in body as in spirit. I have come to love the seldom sun as much as my poor Margaret & to fear & detest the grey and the cold— the quisling wind that creeps & strikes. I hate the treacherous wind. Today was extravagantly hot. All the flowers burst out: all the little jewels of the rock garden flashed in the sunlight. We had a little lunch party alfresco, Margaret had been very clever & got a chicken & a piece of bacon and there was plenty of asparagrass for all—and even enough sauce tartare which is a rare achievement. What a greedy letter

I will not write more now as I see to my dismay I have bumped into Whitsuntide which means I cant send off a registered packet until Tuesday. So I despatch this word with the Gruach photograph, the rest will follow. I do hope you are in better form. I forget if warm weather is kind to you or how it is, for now—a day later—Summer has come on us in a mad blast of Whitsun heat. Our love to you & Emily

> * under separate cover.

[1] *Paul Nash.* Introduction by Herbert Read. Penguin Modern Painters Series, edited by Sir Kenneth Clark, 1944.
[2] For the paragraph omitted there is a drawing of The Mutual 'among the Shades or in the Clouds perhaps with a special cloud desk writing long cloudy letters.'

253

The Sheiling, Silverdale, Carnforth, Lancs.

GB to PN
28 May 1944

Paolo Mio,

Thanks to you—ever so many—for your letter, and your news, and your fraternal kindness to my Project. It is really good and kind of you, and I am grateful. And as many thanks all over again for your Penguin: I am all the happier to have it from you, as I had already bought it along with the three others when I saw them reviewed in The Observer—when I wished that yours had an inscription like all your other monographs in my complete collection. Now the *tout ensemble* is *tout* again, and I shall give the other copy to some other fortunate fellow.

I cannot make up my mind which collection I like most—this or the Benn. Both have your Menin Road masterpiece (4); but on the whole I think the Pen(guin), not the Benn, on account of those terrific "Sea" pieces 9 and 27.[1] Nothing minor about these, whatever Will says, where he sits Evaluating Us in his Cotswoldy retreat. Also I am impressed by 24;[2] and I love 18[3] because it looks like a stage-design for me.

But the one which goes straight to my heart is none of these, and not masterly; but I would give a lot to fetch back all that went with it, so you know which it is.[4]

By the way 16[5] raises in me associations you will never guess, in spite of the Wittenham Clumps in the rear: it has almost a complete resemblance to the weathered lump on the island of Delos which was once the torso of the Delian Apollo.

.

There was one thing in your letter which took my breath away, by the way in which it reproduced my thought of some weeks earlier.

The thought was a wish that when dear Mrs. Goldsworthy sent me her "Crier" to look at about 35 years ago—half dismayed that you had made such a mess of it, half excited and hoping I should think the drawings wonderful (it was not the pages bearing the drawings which were Such A Mess)—a wish (as I was saying) that I had been more sympathetic with her about the state of the book, and had offered to replace it for her with a clean copy. Instead I told her she was fortunate; and returned the memorable volume with my praises.

So I could have reproduced that frightening, beardless Crier as a moral lesson to all the producers who insist on dressing him in a beard—irrespective of what I had written.

[1] *Winter Sea* and *Totes Meer.* [2] *Moonlight Voyage: Flying against Germany.*
[3] *Landscape from a Dream.* [4] *Falling Stars.* [5] *Landscape of the Megaliths.*

254

And I began making plans for getting into touch with Esmond G. and trying to borrow the book for reproduction—little knowing that Margaret had steeped herself in crime for our sake. Thanks to her thoughtfulness and your good-will I shall now arrange in elation to include that drawing in the book. But your offer of it—or suggestion of it—seemed uncanny as I read of it.

La Suite Prochainement.

Here is a warm day at last, and we can sit out. But I am not well: and for no particular reason—except Winston. Winston will really finish me yet, if he goes on and on, amid this general tension, chuckling to himself about the practical joke he is someday going to plan (*sic*) on Hitler.

But while I am here I send you my love—and some to Margaret for pinching the book.

· · · · · ·

254

Oxford

PN to GB [*26 June 1944*]

My Gordon here's a not very good book for you as a token—that's the mode today! . .

This is also to say let me have just a postcard telling me you got the *Crier*. It did reach you, didnt it. I was reading your Lithend last night; a fine play with great opportunities. I was glad to have your warm comments on some of the Penguin pictures—well I haven't done yet I hope & I may yet have time to do better. But I hope you dont think I do not value my first drawings. I am nearer to them today in one sense than I was ten years ago. The poor old Mutual is in a bad way he writes very self sorrowfully these days. I roused him a bit by bartering a water colour for some bottles of Beaune & a couple of genuine Jubilee port—rather a daring proposition but he was beginning to torture himself (& me) about his depleted capital & all that, so I said

> Let me achieve the very near divine
> by turning watercolour into wine.

· · · · · ·

Im very concerned to hear of your state of health. Let me know how you are. What a lovely little poem you wrote our dear Thomas—[1]
Here in the North we think of you—twixt laurel boughs & apple boughs —how nostalgic that is for me.

Yours affectionately

[1] 'To Edward Thomas'; the dedicatory poem to *The Riding to Lithend* (30 June 1908). It begins 'Here in the North we speak of you' and ends with the wish
'That you would seek this old small house
Twixt laurel boughs and apple boughs.'

255

The Sheiling, Silverdale, Carnforth, Lancs.

GB to PN *28 June 1944*

My Blessèd Paul,

It is a black business, and I am genuwinely sorry. The precious, and (really) belovèd book is safe—and as impressive as ever; and the block seems to me good and useable; and I think the little print will yield another block, but, if not, I have a long-ago print from the same negative which *will*. And of course I ought to have told you so the instant it arrived: and I truly intended no less. But I am still running after myself, and getting nothing done; so that I am continually being swamped by business letters; and a True Believer in Scotland wanted to help me with some photographing needful for my book; and some people in Leeds have been wanting to make me a Litt.D. (which of course I couldn't bear to let slip past me, as I am already a D.Litt (Dunelm.)[1] Well; so I reposed on your consciousness that you had registered the precious consignment, and would be sure to take its all-rightness for granted until you could hear from me. T'wasn't either nice or grateful of me: I'm sorry now: but I did mean better: do forgive me.

.

I have been meaning to tell you that I should like to reproduce your "Lithend" drawing as well—I give, as reason, in my text that, although it was not a stage-design, it is done with so much feeling for the stage that it could be useful in an actual mounting of the play.[2] How agreeable of you to be reading "Lithend" just now! Yes, I do think that poem is not a bad portrait of Edward: much better, at any rate, than the belittling ones that people write of him now.

It was at Well Knowe, too, that your parcels used to arrive. I shall put that too into a dedicker someday: I should have done it before now, but the Scotish things always had a Scotish billet.

About mounting "Lithend.' I cannot remember if you ever went to Terence Gray's Festival Theatre at Cambridge; or otherwise saw his system of tall cylinders and flats for mounting heroic legends. It really worked very well with "Lithend"[3]; at any rate it would cost a fortune to mount it as well on the basis of the facts shewn in the enclosed reconstruction of a Viking house.[3] But these things you will see in my book.

.

You handle the Mutual better than I do. Well, he isn't the only fellow whose cash is depleted; but you have found a way to make him forget it and benefit you both. He gets his picture cheap because he

[1] Conferred, *in absentia*, in June 1940. [2] See Plate III.
[3] Reproduced in *A Stage for Poetry*.

256

bought his wine at pacific prices; while you get your wine in spite of its fabulous value. Percy, however, wins, I do think! But the couplet is rich and rare: he ought to have paid cash for the poetry!

It reminds me of Ricketts' miracle. Do you know that?

When he was youthful but bearded, old F. Shields[1] met him in the King's Road, stopped him and asked him if he would sit for Christ to him in the wall-paintings he was doing in the little chapel along the Bayswater road. Ricketts agreed and duly turned up there. Shields painted and painted all the livelong afternoon: then he said we will have tea and a rest. From a bunker he produced materials for a sufficient party, boiled water, filled up the tea-pot. "Come along to the table," he said, "and I will pour out." He did, and out came hot-water. "O Dear, O Dear" he said "I have forgotten the tea: wait, I will get it." Ricketts laid a hand on his arm as he rose and said "No: my miracle." And I am *tres* affectionately,

<div align="right">Your old original Gordon.</div>

256

The Sheiling, Silverdale, Carnforth, Lancs.

GB to PN 15 November 1944

Do you periodically curse me for:

(1) forgetfullness;
(2) negligence;
(3) indolence;
(4) indifference; or
(5) emulating Margaret?

I swear to you in sad sooth that none of these motives has been detaining your property from you all this time. The curst weather puts me out of action periodically with gastric catarrhs that always have a paralysing sequence of arrears; and, on the top of that, the negatives I made quite promptly from your "Crier" drawings have been held up for weeks and weeks by the jobbing photographer in Lancaster who does my enlarging. And simply because he had to wait for his next ration of paper.

.

There is little news: the petrol stoppage immobilises us more than most people. We are reduced to an occasional journey to Lancaster for hair-cutting or Morecambe for imperative fish; and we make this fit in with a film or a poorish play. I seem to spend most of the rest of the

[1] Frederic James Shields (1833–1911), artist and friend of Rossetti and Ford Madox Brown. For his work in the Chapel of the Ascension, Bayswater, see *The Life and Letters*, edited by Ernestine Mills (1912).

time in bed—bearing up against food restrictions and bedevilments. Sometimes I think that vitamins in wrong places are my greatest danger!

How are you? I do hope these vile climates are not so deleterious to your breathing arrangements as they are to mine. You See if we don't have lovely weather after an Armistice—if we are here for it. In early September liberty seemed close at hand; so now waiting is worse to bear. Much!

One thing we did, three weeks ago. We went to Leeds for the day for me to be Dee-Litted at the University. What a pity it did not happen when you went to Leeds, too. . . .

We got it all in in the day—lest I should be ill next morning and unable to get home! N.B. I am now three Doctors; but you can't tell, however hard you look.

We still hope to behold you and Margaret again: in the meantime we send you our affection, jointly and severally.

257

[*106 Banbury Road, Oxford
Late January 1945*]

PN to GB

Beloved Gordon

I am a worthless worm to neglect you so. And then I found you thought *you* were behindhand—it would be comforting were my conscience less in revolt. As it is, I am scourged by its just reproaches. Firstly let me say how grieved we were to hear of your reverses in health—that is now so long ago that I dare hope you have pulled up again, you seem to have a marvellous recuperative power now & then. But I suppose your damned malady is a cat & mousical one like mine— it lets you go & it claws you back. But to livelier matters. I, too, seem to be heading for a monument. A publisher wants to do a really comprehensive book on my work with a quite staggering number of illustrations, many in colour. He is even now ranging over the land hunting down paper.[1]

. . . Among introductions & prefaces there is likely to be a collection of Opinions—extracts from articles etc. Among these I should so much like to include something you have written. I find to my dismay I have no copy of the article you wrote on my Theatre designs for the American

[1] This proposal was not completed before Nash's death. The work he did on it was largely the basis for the Memorial Volume edited by Margot Eates—*Paul Nash: Paintings, Drawings & Illustrations*, with essays by Herbert Read, John Rothenstein, E. H. Ramsden, Philip James, and Richard Seddon, 1948.

magazine.[1] Would you be an archangel & lend me your copy, hopefully supposing you to have one—Then if we both agree it would be to our mutual credit & satisfaction I would take a nice slice from there. It was a pleasant shock some while ago to hear the mellifluous Mr Joseph Macleod[2] referring to Doctor Bottomley. for the moment I [was] taken off guard—who the devil is Doctor Bottomley among the Poets I grumbled, when I remembered suddenly you had said you were being made several Doctors here & there for reasons I couldnt distinctly recall. Now you say you are 3 Doctors, which is enchanting but doesnt it discourage your own Medical Practitioner some what. I think its nice to be a Doctor when you are unrecognizable as you say. The only honour which has come my way in the Autumn of my life is that of being made an Honorary Member of High Table of Christ Church, Oxford during the period of my residence in the city. I was forlornly filling in details in a World Incyclopedia from U S A the other day when the idea of entering this piece of information nearly overwhelmed me

We, too, have been in the wars lately. Last Autumn Margaret, after a long term of good-natured indifference on the part of her lady doctor who explained all symptoms as mainly pschycological became suddenly quite ill with some sort of poisoning. She was hurried off to the Acland[3] & plugged with M & B to an alarming degree but it saved her & she recovered in a superb manner. We got away at last for a holiday to a cosy hotel[4] on top of Cleeve Hill outside Cheltenham. The air is very reviving there after Oxford, and the relief from house work & all that sort of thing helped a lot. So we went back at Christmas, and then Margaret spoilt it all by taking a smart header down a small flight of steps which was quite dark & desperately dangerous. Well, she smashed her wrist, poor lamb, but why she didnt break her neck, only the merciful God can say. We then stayed on for the period during which the arm had to be in plaster of Paris. It was a ruinous business but I was able to make a number of landscapes water colours of the very interesting prospects from the windows of the hotel. Now we are back—the hand seems to be working all right altho' it is still tender & a little awkward. I meant to send this latest effort *Counterpoint* long before this but it came out too late for Christmas & then we got all messed up by the accident. Do give me your *critical* view of the essay.[5] (That will be a irksome bother perhaps—some time when you feel expansive & with a little spare time) . . .

Just room to say goodbye & send our love to you & Emily & our fervent wishes for your recovery

[1] See p. 148, n. 2. [2] B.B.C. critic.
[3] The Acland Home, Oxford. [4] 'The Rising Sun'.
[5] *Aerial Flowers*, by Paul Nash, published in *Counterpoint*, 1944. Republished as a pamphlet (Counterpoint Publications, Oxford, 1947).

GB to PN

My Blessèd and Bounteous Paul,

I had been long wishing for news of you—and you do take a lot of waiting for; but when your cornucopias come they are so nobly cornucopious that I immediately feel they have been worth waiting for! And this is a grand one, even for news alone—and there is so much more than that.

We wish the news were all good, though; and we send all our sympathy to Margaret for the dreadful addition she has had to the dreary war-time strains—and Emily, especially, because she too broke her wrist once (but not in war-time), and knows what a nuisance of an inconvenience it is.

(Emily went on doing her house-work with her other hand—the calamity in her case being without complications; and grew ingenious with it. She even said to a caller that she had begun to wonder why we need to be made with two hands. The caller replied "Because we ought to have spare parts, of course".)

Well, I am properly fascinated by the idea of a large, authoritative monograph on you, with a full-page plate every other page, and about 12″ to 15″ high and about 4″ thick. Be sure that if any concurrence of mine can forward your plan, you can count on me.

.

To my own surprise I have unearthed a copy of the American magazine; so I send it at once herewith. Let me have it again when you have made the extracts you require, as I have kept it for several things; also, I see I shall need my article again.

But what writing, my dear Paul: I blushed when I saw that opening sentence again, on whose length you teased me long ago.[1] I remember that, about that time, I was on a crusade against over-punctuation. However, I have undone the consequences as far as I can, by breaking up the sentences: I earnestly trust I have made the article more useful to you.

But how I wish I could draw as well as you write. Many, many thanks for the magazine, for the sake of your accomplished, debonair, entrancing article; it is beautifully done, and full of artistry and illumination. I found myself wondering if it is really part of Vol. II of your Autobiography? The part about levitation impressed me, for my father had the same experience in his boyhood. At the time he had spinal paralysis, and lay motionless; but *while waking* he could at command give himself

[1] See p. 148, n. 2, and p. 175: the opening paragraph of 19 lines is one sentence.

delightful sensations that he was floating in the air above him to places where he wanted to be.

He was a potential mystic;[1] and I begin to believe that you also are. Between you, I can only envy and long to be like either or both. I fancy that explains when I do not understand some of your later pictures; but there is always a difference between yours and the similar things other fellows do, and our bond still holds. With you the imaginative, almost spiritual colour satisfies me, and the delicate surface-qualities. All your flowers satisfy me, as much as Chinese flower-paintings do—except the colour-plate, which I simply do not believe in. It is not you; and it is ordinary and too easy. Why do you tolerate, even encourage, such rudimentary work? To begin with, they cannot even come near the original, when they print the blocks on that shiny china-clay-loaded paper with which chocolate boxes used to be covered; and no chord of colour is rightly struck on it.

.

My Medical Practitioner? Aha, Paolo: he is just an M.B. of Edinburgh, and doesn't get a look in. Sometimes I think he doesn't quite like me: and yet I don't look any different.

As for your Christ Church High Table—I can match you, having myself the equivalent distinction at Christ's College, Cambridge.....

Please send us better news of your Margaret; and we hope that this infamous weather has not stirred up your torment—and that it eases with time.

259

PN to GB

[*106 Banbury Road, Oxford*
c. *late February 1945*]

My Gordon

I cant bear sending bald information so have gotten up, as Yankees say, one of Pauls Patent Picture cards of a subject you may not have seen & may be rather up your avenue.[2]

.

. . . frankly I dont want to quote from this article. It isnt at all like you or me. Im sure you rather feel that..... So may I find another way, a quotation from a letter or letters—much more interesting & more *real*. By the way, all this is not *your* fault or wholly mine. The whole thing is out of date & anyway I only did very few theatre designs worth

[1] And a Swedenborgian. GB's account of his father—*Alfred Bottomley, 1848–1931*—will be reprinted.

[2] *The Nest of the Phoenix*. This letter has a reproduction of *The Nest* pasted in. The omitted passage which follows gives dimensions of PN's drawings in *The Crier*, for which GB had asked in an omitted passage in the preceding letter.

considering but one was for Mrs Lear & we'll stick to her & *you* on *her*. I'll hunt through your letters I think I have all of them.

In the end this becomes not far short of a letter. So I will try and make it adequate for a few more of the things I have to say.

First my warm welcome & thanks for Kate.[1] A gay easy, jolly, affair with the poet giving himself away all along the line! Obviously you've fallen in love with your heroine. What a long, long cry back to the Crier. I like you best in your bogies. But I like to feel you enjoying writing Kate Kennedy.

I was also very glad you liked my little piece in Counterpoint. Alas, one has little control over colour reproduction but you know, apart from the arty tarty paper, the reproduction is quite good. Paper! Oh hell you know what we're all up against

This seems the only spot to say goodbye on with our love to you both

260

From GB to PN, Dans le lit. Wednesday [early March 1945]. He thanks him for the last letter, and agrees about the American article and the letters.

261

The Sheiling, Silverdale, Carnforth, Lancs.
GB to PN *17 March 1945*
Caro Paolo,

I descended yesterday, clothed and in my fretful mind: so here come the drawings as desired. . .

About "The Crier" drawings. Beside the big one, whose use you approved and blessed, I *had* thought of using the one on the title-page: but your veto would be final. Are you sure, though: it seems to me distinctly to adumbrate an apprehension of sur-realism—and, as such, to be rather a feather in your cap. But one day, you will not reproach me for leaving it out—will you?

You know, Beato Paolo, that you are like everyone else, and have fallen for my daughter Kate (though secretly)—in spite of looking down upon her aloofly. I am dejected: I expected you to say "Yes Gordon. . . . Isn't the girl a rather obvious charmer? The boy seems to me to be the one that is really well done—and, at that, far harder to do. . . ."

Only one man has said that: and I had believed there might be two, with you.

[1] GB's comedy, *Kate Kennedy* (1945).

262

Alas, life is like that: but one never gets used to it.

I send you my love, though; and I have even begged a bit from Emily to put in with it.

<div align="right">Your venerable admirer</div>

262

GB to PN

<div align="right">The Sheiling, Silverdale, Carnforth, Lancs.

27 March 1945</div>

Very dear Pavel Vilyamovich,

The other day I bought a book about Wagner's "Ring" by one Leroy, for the sake of some illustrations by you.[1]

There were not so many as I hoped for; but all that was there was treasure-trove, in spite of your insisting so constantly on the acuteness of everything; and I am writing to remind you of them for your book, in case you have not been thinking of them in that light.

They are topping—running Appia[2] close, and once or twice getting ahead of even him: and I want to dwell on them to-night because, when the War has subsided and there is a return to Wagner, there will be a revulsion against the customary ways of mounting him—producers (rarely having any real ideas of their own) will be on the look-out for new ways, and if your designs are on the spot there is no reason why you should not be the Master to cash in on the demand.

But not by merely reproducing these austere little blocks; draw them again as full-page plates in full colour—your colour can always clinch things for you!—and reproduce them Hors Texte. And bless me for the result.

<div align="right">Your Old Believer</div>

.

263

From PN to GB, Oxford, 2 April 1945. He thanks him for his last letter. 'Those Wagner woodcuts are very insistent and acute.'

264

From GB to PN, Silverdale, 21 July 1945. He writes about photographs, inquires how PN's book is getting on, and says that his cannot because of the paper shortage. The postscript is: 'If you set a female secretary

[1] See p. 184 and note 3.

[2] Adolphe Appia (1862–1928), the celebrated Swiss stage designer whom Komisarjevsky described as the originator of three-dimensional sculpturesque settings (*The Theatre*, London, 1935).

to acknowledge this print as you did the other one—a secretary to me, Paolo—I will appear under your bedroom-window at midnight, and howl until dawn, and the milkman takes it up. . . .'

265

PN to GB

[106 Banbury Road, Oxford
c. late July 1945]

My poor Gordon

did I really send you one of my mechanical letters! do forgive me. I am quite distraught these days. Life becomes increasingly difficult, the struggle intensifies, never eases. I am so glad to feel you are in better trim on the whole. . .

Thank you so much for the new & excellent print. This is the very first plate of my volume, & I am including another early drawing *Under the hill*.[1] But all the theatre section has had to be cut down. It will include now a single figure costume—Lear, & the model of Mrs Lear—that is, of your own. In the course of assembling this book all sorts of queer things happened. I re-discovered my early life, how good it was & How complete in a way. When I came to look into the early drawings I lived again that wonderful hour. I could feel myself making those drawings —in some ways the best I ever did to this day. And because of this I suddenly saw the way to finish my 'life'—half of which you have read & been so generous about—I feel I could make a complete thing by taking it up to 1914—just up to the war. After that it was another life, another world Later I might write another autobiography but does one want to write an autobiography. I would as soon take my pocket knife & cut my own throat as Carlyle said Tell me your thoughts on such a view (mine not Carlyles). But I have decided already & told Dick de la Mare. He was sad, I thought, but resigned. Which brings me to that horrid little man ——. —— is a small fat man with a perpetual sniff as if he had come out without a hankerchief or did not use one on principle. He used to write quite fairly *critically* & he has been handsome to me on more than one occasion. But the ugly bug of Journalism—what I know we both understand as journalism—was in his blood. And then suddenly he was a conspicuous writer nay, an *authority* on art & then—but you know . . .

I cant get this letter off. It was meant to accompany this edition of the Wagner designs I found for you—But there are other odds & end[s] to go & they have failed me. I must send them on. Love to Emily & to you both [from] Margaret & your aging, devoted

Paul

[1] See Illustration VI.

266

GB to PN *27 August 1945*

Your handsome little cornucopia gave me great pleasure—and made me feel us both young again. The proofs of the Wagner block are so much better than the machine prints in the book; while this particular "Lady From The Sea" I had not; and it rounds off those you sent me long ago, very nicely. So thank you truly for all.

But most for your letter. You don't age—not in your letters at any rate; your perfect phrasing defies time, and continually delights me. I always feel more like carrying on when one comes—and did especially when the war-years began to threaten to get me down.

I am particularly attracted by your contemplation of your beginnings from the outside. Yes, it *was* a wonderful hour—and to me too, when the parcels came. "The best you ever did to this day"? Well, as good as any you ever did, at any rate; for they could not be bettered. And especially the lovely lost Margaret doing her hair before a sea-side lodging-house window! You for a long time and Stanley Spencer for a minute were the only true heirs of the Pre-Raphaelites, for you carried Something forward from where they left off. I hope Billy Richmond was damned. . .

As to your starting another (I suppose a more succinct) autobiography —even to please Faber's—I am sure you are right to turn it down. Also, I do not too much believe in coming right down to the present (compare Will's Vol. 3 to his important Vol. 1.) :[1] the perspective inevitably alters, memory has not graded things by its atmosphere. In my opinion your intention to write up to 1914 will make a complete and shapely thing: you can start again from it in due course sometime if you like: in any case you have achieved a really rather marvellous and understanding account of a young artist's seed-time and germination that will be a classic—I have not abated any of my respectful admiration for what I have read; I am only anxious to read some more.

.

With the assurances of Our most distinguished consideration to both of you.

[1] Sir William Rothenstein's memoirs appeared as two volumes called *Men and Memories* in 1932. This was followed in 1939 by a third, called *Since Fifty: Men and Memories*.

P.N to GB

106 Banbury Road, Oxford
[? *early April 1946*]

Beloved Gordon

I hope this bit of roguery hasnt reached you by another route—it should have gone sooner but I am still rather gradual in my functions & slow in getting off the mark.

It is slightly unreal sometimes to be alive I was, apparently by all accounts so near being dead. In fact I have no right, I am told, to be what I very nearly am, quite recovered.

You & I between us have enough of illness to preclude exchange of confidences—did you ever see that nice cartoon by Peter Arno of the two eunuchs taking coffee together with the caption 'Did I ever tell [you] about my operation?'

Well, I had no operation but I did have pneumonia with variations such as speechless flu, Endorma [oedema] & a small packet of dry pleurisy to top up with. It all began with the stalwart reliable guaranteed heart beginning to show signs of strain. Really, Im a war victim, Gordon! I painted so many outsize pictures for the M of I that the strain crocked up my heart which of course I suppose had been already coughed into a slight decline by my bogus asthma. Margaret suspected some of this but I was then under a fool of a (temporary) doctor who took no notice of my swollen ankles & funny feet. So Margaret took me to Horder[1] (who turned out to be a fan of mine and was charming) & *he* said—this chap's trouble isnt asthma so much as strained heart put him to bed for a month to start with. So I was put into the Acland & forced to rest for five months—& I suppose that saved me for I had that in reserve against the pneumonia that suddenly struck me down in January. It was Margaret who insisted I couldnt die when the specialist said I must. You dont know him says she hes a creative artist & he still has some work to do—just like that! And the doctor seemed impressed. But, think of it, they all went home that night and left me quite alone to face the crisis. I was lightheaded & spent the hours in & out of some other world. Margaret was marvellously calm & by our side the old yeoman stock fought for us. To cut a damn long business short the old stock took the strain & got us through in spite of the horrid later developments & the 151 M & B's I was given. Let us draw a veil. I am gradually recovering enough to work but I am very much hipped in some ways, not allowed to stand, must sit to paint evermore cant walk much & so on. *And* the cost. The oxygen tubes[,] the night nurses (5 changes) the body washers, the pills, the draughts the doctor (miraculously cheap bless him) the specialist the foods & whisky & on & so on & on for

[1] The first Baron Horder of Ashford, b. 1871. The consultation was on 25 July 1945.

eleven weeks. And I have not been able to work since last October until the other day when I began again on some very small drawings. But just before the first knockout I managed to finish two largish paintings which earned me a round of applause & sold themselves almost at once I will tell you about them next time I write & send some photographs—

All this about myself, but how are you mon vieux? what have you been up to. . .

I do hope you & Emily have been well & happy—please be merciful & pardon my long silence. I often think about you—here is an age old snowed under letter because it is rather a good portrait of you[1]

All our several & united loves

Paul.

268

P.N to GB

106 Banbury Road, Oxford
[? late 1941]

My monstrously illused but belovéd Gordon

it will be hopeless to try to explain why I havent written to you for months. I distinctly suffer from neurasthenia in the matter of letter writing—unless it's chronic laziness But in any case it is always the few I want to write a nice long letter to who suffer and you are the greatest sufferer or the most neglected shall I say because of all people I like to write to you & one can only make something out of a letter if it can run on easily & not be inhibited by the noise of Time's winged charriot hurrying near.

I began this weeks ago months now Years *now* look at the paper! It has lain in a drawer been transferred to a case, moved into another place—all for to get written on & despatched at the *next* opportunity

And again its ages since I wrote that but I'm damned if I'll be done so here goes once more.

I often worry about you wondering how you are, living in the precarious way you described[,][2] hurling fire bombs out of the window (this is being written in the train)

lovely long letter arrived this morning. look here it is!

Many many thanks—but very grieved to hear bad health news

I swear I'll write back.

269

*Margaret Nash to GB
and Mrs. Bottomley*

106 Banbury Road, Oxford
Sunday [14 July, 1946]

Dearest Gordon & Emily.

You may have had a shock, for which I grieve, hearing of Paul's *merciful* & *peaceful* journey to other worlds & spheres of the mind—I am

[1] It follows as Letter 268. [2] Drawing of this.

heart-broken, but completely reconciled to my fate, as he would not have been able to work, or even to endure life with his glorious courage & enduring sense of beauty & poetry. He was able to paint to the last hour, & was only beginning to take a very short way on the road of utter helplessness & horror—his heart was worn out—but never his mind, nor his eye nor hand had yet ceased to respond as obedient & faithful servants to his will.

You & Emily who warned me so many years ago, thirty-two in fact to the day—that I was undertaking a serious task in marrying Paul & guarding so great an artist—will understand I have tried with many failings to carry out my part in this tragedy & great achievement. I have now little more to live for, & only long to be with him. The funeral is at Langley Church Bucks near Slough on Wednesday July 17th at 3 p.m. where he is to be buried with four generations of his family—those fine ancestors who made him love England—

<div align="right">Your devoted
Margaret.</div>

270

The Sheiling, Silverdale, Carnforth, Lancs.

GB to Margaret Nash *17 August 1946*

My dear Margaret,

We valued your beautiful letter, and especially your thought and feeling for us, and our connexion with Paul's youth, in writing to us among the first. It must have been as great blow to us as to nearly any of Paul's friends, to read in a morning paper that he had died, although we knew how much shaken he was in health; for at that very hour I was hoping for his promised answer to my letter of a few weeks ago.[1] Some day I hope you can tell us if anything unexpected happened in those last days: was he unexpectedly worse after reaching Bournemouth —or had he been worse than he told us, and you had taken him to Bournemouth to see if that would help?

I felt I must not trouble you at the time, especially as I was hoping that the letter I wrote as soon as we heard (only now I remember that the evening broad-cast came before the newspaper) would have crossed in the post with yours—so that you would know how much Paul and you were in our thoughts.

And when your letter came we were entangled in a "Summer School" in Edinburgh; and on that account too I felt I must wait until I could write from a quieter place.

(Well, I am doing it now! For after a fortnight of quiet rest at home) here I am laid up with a little, mysterious haemorrhage—for which we

[1] Several letters seem to be missing at the end of the correspondence.

cannot account, except by the rationale of rationing and "a balanced diet!" I weathered the war not-too-badly; but now it seems to be all "nasty after-effects".

Did Paul become worse through war-tensions and strains? He was so gallant and resilient that one could not always tell from his letters. And even since the war began, and in spite of his disabilities, he had extended his fame. I thought how proud you must be when you read the notice in *The Times*, of such exceptional and important length in this time of thin newspapers.[1] Even the lean and emaciated "Daily Telegraph" (which is easiest to obtain here, in a Manchester edition) gave him four inches more than any painter had had for years—author T. W. Earp.[2]

This will be the saddest time for you, while your life is still geared—in your splendid devotion of so many years—to helping him in his works and days; with the sudden realisings that he is not there. On the other hand, few people can ever have had more comfort and consolation from the knowledge of the long, long time through which you had served his genius, and absolutely had made his work possible by your happy selflessness.

Were we (or I) really so cheeky, thirty-two years ago, as to give you advice about marrying an artist? What an odious prig I must have seemed. Yet, a dim memorial flavour of that time suggests to me that I meant far less than you suspected! I fancy that, though my language may have been an attempt to avoid references to crude facts like bread-and-butter, I really only meant that if you were resolved to marry an artist you had better make up your mind that there might be occasional difficulties in Making Ends Meet. . .

But now you will be amused to reflect that Paul made mounds more money with his brush than I did with my pen: and, also, that whenever I have attempted that kind of prophecy, I have always proved to be Wrong.

And all the time you have the serene consciousness that no woman ever put faith in her Artist to better or more superb purpose than you did with Paul.

.

Emily and I send you all our affection and sympathy, and I hope you found my letter at 106 when you returned to Oxford.

Your old friend
Gordon.

[1] 13 July 1946. A further obituary was contributed by Mr. Archibald Russell, Clarenceux King of Arms, on 23 July. He had been an intimate friend since the nineteen-thirties.
[2] 13 July 1946.

INDEX

271

Lyric Theatre, Hammersmith, 201.

MacDowell, Edward, 13 & n. 3.
MacLeod, Fiona, 231.
Madams, 225 & n. 1.
Maeterlinck, Maurice, 231.
Manchester Guardian, The, 97, 100, 212.
Mann, Harrington, 28.
Marsh, Sir Edward, xv, 66 n. 1, 70, 130, 131, 135, 147, 156.
Masefield, John, xiv, 197.
Mask, The, 177, 179.
Matthews, Elkin, 24, 34, 37, 38, 39, 113, 117.
Meynell, Everard, 238.
Meynell, Gerrard, 112 n. 2, 116.
Millais, Sir John, 116, 134, 236, 240.
Ministry of Information, The, 98, 219 & n. 3, 220, 233, 266.
Monck, Nugent, 40 & n. 2, 41, 43, 49.
Monro, Harold, 113 & n. 2.
Montague, C. E., 98.
Morris, Jane, 232, 235, 238, 241, 242, 244, 245, 246.
Morris, May, 226 & n. 2, 238, 239.
Morris, William, xi, xiii, xv, 18, 220, 226 n. 2, 227 n. 1.

Nash, Barbara, xv, 6 & n. 3, 36, 46, 60, 63, 230.
Nash, John, xv, 6 & n. 3, 24, 67, 68, 98, 112, 131, 143, 146 & n. 2, 150, 201; book on, 193; exhibitions, 65, 66, 69, 70, 113, 126, 213; GB's comments on, 37, 56, 59, 101, 106, 108, 109, 116, 117, 130, 138, 236, 241; PN's comments on, 61, 110, 120, 238; Rothenstein, William, comment on, 63; war service, 72, 82, 218, 220, 222; works by, 36, 38, 58, 103, 121, 124.
Nash, Margaret, 76, 86, 103 n. 1, 120, 180, 192, 193, 194, 207, 208, 252, 253, 255, 266; activities, 82 n. 2, 141, 142, 152; collection of, 4 n., 30 n. 4, 33 n. 1; comments by, 161, 193; drawings of, 59, 61, 94, 165, 186 & n. 2, 231, 233, 235, 265; engagement and marriage, 54, 55, 76, 77, 78, 79, 80; finances, 59, 76, 77, 78, 82; illnesses, 174, 187, 188, 259, 260; letters to and from, 57, 126, 267, 268; meeting with GB and Lakeland tour, 56, 57, 70, 72, 73, 94, 249.
Nash, Paul:
Books by: *Outline*: GB's help with and

comments on, 213 & n. 2, 216, 221, 224, 227, 229, 230, 231, 233, 234, 262; illustrations in, 1 n. 3, 4 n., 9 n., 30 n. 4, 44, 48 n. 2, 53 n.; writing of, 214, 219, 220, 222, 225, 227, 228, 229, 232, 234, 261, 264; references to, xv, 5 n. 2, 27 n. 1, 85 n. 3, 216 n. 2; *Places,* 136, 137 & n. 4, 156, 161 & n. 3, 163, 165; *Room and Book,* 208 & n. 1; *Shell Guide to Dorset,* 213; *Sun Calendar for 1920,* 113 & n. 1, 117 & n. 3.
Books illustrated by: *Genesis,* 177 & n. 3, 178, 179, 180, 193, 230; *Images of War,* 104 n. 1, 115; *King Lear,* 181, 183, 202; *Loyalties,* 104, 105 & n. 1, 107; *Midsummer Night's Dream, A,* 139, 140, 141, 145, 148, 158, 160, 197, 202, 203; *Mister Bosphorus & the Muses,* 161 & n. 4; *St. Hercules,* 210 & n. 1; *Seven Pillars of Wisdom, The,* 156 & n. 1; *Urne Buriall,* 203 & n. 1; *Wagner's Music Drama of the Ring,* 184 & n. 3, 185, 189, 190, 191, 193, 263, 264, 265.
Books on: Bertram, Anthony, by (Benn), 161 & n. 2, 254; (Faber), xv n., 112 n. 2, 207 n. 3; (Fleuron), 193 & n.; Eates, Margot, ed. by, 44, 258 n.; Read, Sir Herbert, by (Penguin), 253 & n. 1, 254, 255; (Soho Gallery), 212 & n. 3; Salis, John, and Montague, C. E., by, 97 & n. 1, 100, 108.
Industrial Art: bookplates, 9, 10; pattern papers, 210 & n. 3; textiles, 188.
Miscellaneous writings by: *Aerial Flowers,* 259 & n. 5; *André Bauchant,* 211 & n. 1; *Artist outside the Theatre,* 154 & n. 1; *Bad Plays, Bad Art,* 148 & n. 1; *Dream Room,* 17 & n. 3, 18. *Openings,* 216 & n. 1.
Pictures (including engravings) by: *Alice Daglish,* 201 & n. 3; *Angel & Devil,* see *Combat; Archer, The,* see *Night Landscape; Barbara Nash,* 46, 60; *Battle of Britain,* 233; *Black Poplar Pond,* 165; *Canal, The,* 121; *Chestnut Waters,* 186 n. 1; *Combat,* 4, 5, 7, 12, 32 n. 3, 33, 222, 229, 230; *Dream Room, The,* 28 & n. 3, 29; *Elms,* 101 n., 130 & n. 2; *Encounter in the Afternoon,* 213 & n. 1; *Falling*

* These pictures cannot be identified by known titles.